Crowds and Democracy

COLUMBIA THEMES IN PHILOSOPHY, SOCIAL CRITICISM, AND THE ARTS

Columbia Themes in Philosophy, Social Criticism, and the Arts presents monographs, essay collections, and short books on philosophy and aesthetic theory. It aims to publish books that show the ability of the arts to stimulate critical reflection on modern and contemporary social, political, and cultural life. Art is not now, if it ever was, a realm of human activity independent of the complex realities of social organization and change, political authority and antagonism, cultural domination and resistance. The possibilities of critical thought embedded in the arts are most fruitfully expressed when addressed to readers across the various fields of social and humanistic inquiry. The idea of philosophy in the series title ought to be understood, therefore, to embrace forms of discussion that begin where mere academic expertise exhausts itself, where the rules of social, political, and cultural practice are both affirmed and challenged, and where new thinking takes place. The series does not privilege any particular art, nor does it ask for the arts to be mutually isolated. The series encourages writing from the many fields of thoughtful and critical inquiry.

Lydia Goehr and Daniel Herwitz, eds., *The Don Giovanni Moment: Essays on the Legacy of an Opera*

Robert Hullot-Kentor, *Things Beyond Resemblance: Collected Essays on Theodor W. Adorno*

Gianni Vattimo, *Art's Claim to Truth*, edited by Santiago Zabala, translated by Luca D'Isanto

John T. Hamilton, *Music, Madness, and the Unworking of Language*

Stefan Jonsson, *A Brief History of the Masses: Three Revolutions*

Richard Eldridge, *Life, Literature, and Modernity*

Janet Wolff, *The Aesthetics of Uncertainty*

Lydia Goehr, *Elective Affinities: Musical Essays on the History of Aesthetic Theory*

Christoph Menke, *Tragic Play: Irony and Theater from Sophocles to Beckett*, translated by James Phillips

György Lukács, *Soul and Form*, translated by Anna Bostock and edited by John T. Sanders and Katie Terezakis with an introduction by Judith Butler

Joseph Margolis, *The Cultural Space of the Arts and the Infelicities of Reductionism*

Herbert Molderings, *Art as Experiment: Duchamp and the Aesthetics of Chance, Creativity, and Convention*

Whitney Davis, *Queer Beauty: Sexuality and Aesthetics from Winckelmann to Freud and Beyond*

Gail Day, *Dialectical Passions: Negation in Postwar Art Theory*

Gerhard Richter, *Afterness: Figures of Following in Modern Thought and Aesthetics*

Boris Groys, *Under Suspicion: A Phenomenology of the Media*, translated by Carsten Strathausen

Michael Kelly, *A Hunger for Aesthetics: Enacting the Demands of Art*

Crowds and Democracy

THE IDEA AND IMAGE

OF THE MASSES

FROM REVOLUTION TO FASCISM

Stefan Jonsson

Columbia University Press New York

Columbia University Press
Publishers Since 1893
New York Chichester, West Sussex
cup.columbia.edu
Copyright © 2013 Columbia University Press

Library of Congress Cataloging-in-Publication Data
Jonsson, Stefan, 1961–
 Crowds and democracy : the idea and image of the masses from
revolution to fascism / Stefan Jonsson.
 pages cm. — (Columbia themes in philosophy, social criticism, and the arts)
 Includes bibliographical references and index.
 ISBN 978-0-231-16478-8 (cloth : acid-free paper) —
 ISBN 978-0-231-53579-3 (e-book)
 1. Popular culture—Germany—History—20th century. 2. Popular culture—
Austria—History—20th century. 3. Politics and culture—Germany—History—20th
century. 4. Politics and culture—Austria—History—20th century. 5. Collective
behavior—Political aspects—Germany—History—20th century. 6. Collective
behavior—Political aspects—Austria—History—20th century. 7. Democracy—Social
aspects—Germany—History—20th century. 8. Democracy—Social aspects—Austria—
History—20th century. 9. Germany—Intellectual life—20th century. 10. Austria—
Intellectual life—20th century. I. Title.

 DD238.J66 2013
 306.20943'09041—dc23 2013000641

c 10 9 8 7 6 5 4 3 2 1

Jacket designed by Thomas Ng

References to websites (URLs) were accurate at the time of writing. Neither
the author nor Columbia University Press is responsible for URLs that may
have expired or changed since the manuscript was prepared.

They were everywhere, and belonged nowhere.

—KRACAUER

CONTENTS

ILLUSTRATIONS

PREFACE

No new book is needed to declare that German and Austrian culture between the wars was shaped by "the masses." In all surveys and histories of the eventful years from the revolutionary uprisings in November 1918 to the Nazi takeover in 1933 there is a chapter or section devoted to them. They are usually discussed as revolutionary crowds or as fascist mobs or as urban multitudes engaged by the new phenomenon of "mass culture" or as the rising anonymous middle classes or, again, as an object of anxiety pervading the zeitgeist. The prominence of the idea and image of the masses in this period has been thoroughly discussed. It has been illustrated and judged. It has been viewed as a self-evident feature of the historical landscape. We have grown accustomed to look upon the interwar period as an era of crowds.

Strangely, however, few authors have connected the theme of the masses to Weimar history in any deeper sense. They loosely hint at the German revolution, fascist propaganda, swarming Berlin streets, Bauhaus programs for

cheap housing for the working classes, or other phenomena that serve well
to illustrate the period's obsessive talk about the masses but not to clarify it.
Even more strangely, no one has sought to organize these images and ideas
of the masses by relating them to one another and to subsequently subject
them to theoretical analysis in an attempt to find out what, if anything,
they have in common—except that they all exemplify some typical German
condition of modernity.

In this book I construe "the masses" as a global issue affecting all areas of
interwar German and Austrian society. I argue that the compulsive treatment
of this theme can guide us toward a defining historical predicament of both
states. The problem was felt in all spheres of life and concerned the political
and cultural organization of state, nation, and society in its most basic sense.
The problem is a well-known one: how to effect a transition to democracy.

Of course, just as little as we need a new book to tell us that people
in interwar Germany and Austria debated the masses, we need one to
show that these societies had trouble instituting democracy and that the
transition failed. What may be needed, though, is a study that connects
these observations to each other. This is what I seek to accomplish in this
book, but I also try to do more than that. I try to constitute the connec-
tion between the masses and the transition to democracy as an explanatory
framework that allows us to see both the specificity of this historical period
and the general problematic that it has passed on to posterity. According to
the explanation I offer, the specificity of interwar Germany and Austria is
the way in which the masses were turned into a general signifier for most,
if not all, cultural endeavors. The mass was the dark sun, unapproachable
for all the heat it emitted, around which scholarly studies, aesthetic experi-
ments, political activities, and social programs moved in the vibrant and
violent cultures of interwar Germany and Austria. Or so believed those
who explored the distant planet of the masses. In reality, however, that sun
was nothing but an optical illusion generated by the energy from conflicts
erupting in the social terrain beneath their own feet. These conflicts had
to do with the agonizing transition toward democracy. By analyzing Ger-
man and Austrian culture and society in the interwar years, this book will
also offer perspectives on the more general problem—which has become
ever more pressing while I have been writing this book—of carving out a
politics of liberty, equality, and solidarity between the poles of revolution-
ary utopianism and fascist repression. For "the masses" have today again

become a cause of concern, as so-called austerity programs are imposed in one nation after another and, predictably, people are taking to the streets to protest being pushed into poverty. Portrayed as disorderly and misin-fomed, these crowds are, according to the elites, a threat to such politi-cal stability as is needed for the markets to calm down and the economy to recover. Voter influence or democracy as such is described by leading European politicians as deceitful and unpredictable, undermining the very preconditions for investments and growth. This, then, is the moment when interwar Germany and Austria merits our attention. In his history of Ger-man film, Siegfried Kracauer described these societies as being caught in a double bind between tyranny and anarchy. Firmly convinced that these two options were the only ones, dominant circles of Germany and Austria fatefully embraced authoritarianism and accepted dictatorship, in the fear that society would otherwise fall apart.

Like my previous book *A Brief History of the Masses: Three Revolutions* (2008), which charted the long trajectory in the European conception of the masses from 1789 to 1989, this book about the masses in the interwar period arranges readings of seemingly disparate texts and events into one interdisciplinary and multidimensional montage. This strategy is based on a conviction that informs both books. Aesthetics teaches a lesson about politics and society that politicians and political experts are predestined to deny and that often remains hidden for those who are living in that society. What lesson? That the political arena always will fail to represent society. That the borders that determine who may be seen and heard in public life are contested. Democracy, the representation of the people by the people, is an unfinished process, marked by a constant struggle to sort out the proper representatives of the people. This is the political lesson of the aesthetic works that have concerned me in this history of the masses. They map and make visible those very borders that separate citizens from masses, human being from beast, and they show that these borders are at best contingent, at worst genocidal. But the power of aesthetics lies not here only but also in its ability to imagine a society where the borders are redrawn, thus remaking the system of representation so as to make room for people previously dislodged from political space. Surely, this capacity also explains the intensity of aesthetic experimentation in German and Austrian culture during the interwar period, as well as the strong attraction it exerts on later generations.

I began writing this book during a two-year fellowship at the Getty Research Institute in Los Angeles, at that time concentrating on the mass uprisings in Vienna in 1927 and Georg Simmel's sociology. Some ten years later, these sketches have attained their proper shape and placement, framed by a historical and political context that I did not fully grasp as I embarked on what was then simply a critical history of mass psychology and crowd theory. In that early stage of my research, I saw these branches of knowledge as distinguishable and interesting theoretical formations that could contribute to an understanding of the civil wars, ethnic cleansings, and genocidal military campaigns that marked the latter part of the 1990s. Today, by contrast, I see mass psychology as well as general crowd theory as vague and intriguing phenomena that offer no clarification of social movements or political issues but rather are problems in their own right—problems, moreover, that have less to do with the causes of extremist collective movements or the mobilization of religious and ethnic communities than with the precarious institution of democracy itself.

Crowds and Democracy is thus the outcome of a project that has grown out of bounds in unpredictable ways, to the effect that a number of essays and even an entire book have branched off as separate undertakings—most importantly, *A Brief History of the Masses*, which is tightly coupled to the present book—but also an ongoing project on contemporary ideas of political universality and collective action in which I hope to bring the discussion on crowds and democracy closer to the present moment.[1]

Needless to say, over a decade of more or less intense research and writing has left me indebted to a number of institutions and individuals. I especially want to recognize the Getty Research Institute and its resourceful staff and excellent librarians, along with the Wissenschaftskolleg zu Berlin, which, during my year-long stay as spouse of one of its fellows, provided me with all the books and documents I needed and much more, in addition to the department of Germanic languages and literatures at the University of Michigan, where I taught as visiting professor and learned from brilliant colleagues, and, finally, Linköping University, my current academic home, where I have been able to bring this project to a close, aided by the university's skilled librarians and inspired by the outstanding research collective at the Institute for Research in Migration, Ethnicity and Society (REMESO). I am also indebted to colleagues affiliated with the Crowds Project at the Humanities Lab of Stanford University and to former colleagues at the Department of

Aesthetics at Södertörn University. I have benefitted from the services of the National Library of Austria and the archives of the Labour History Society, both in Vienna, the library of the Humboldt University (special thanks, there, to Ute Mousa) and the archives of Akademie der Künste in Berlin, and the National Library of Sweden and the Labour Movement Archives and Library in Stockholm. Financial support in the final phase has come from the research program Time, Memory, Representation, funded by the Bank of Sweden Tercentenary Foundation. A special grant from this foundation also helped me, at the very last stage, to revise the manuscript and obtain the necessary illustrations. I acknowledge the support of these institutions with gratitude. I am also thankful to the expert staff of Columbia University Press, above all Wendy Lochner, Michael Haskell, and Christine Dunbar.

Thanks are also due to a number of individuals whose comments, advice, suggestions, and invitations have left their marks on this book: Kerstin Barndt, Petra Bauer, Jonathan Beller, Catherine Benamou, Erik Berggren, Gabriele Brandstetter, Kathleen Canning, T. J. Clark, Heinrich Dilly, P.-O. Enquist, Geoff Eley, Martha Feldman, Lydia Goehr, Julia Hell, Fredric Jameson, Dan Karlholm, Wolf Lepenies, Reinhart Meyer-Kalkus, Maria Lind, Chantal Mouffe, Richard Meyer, Toril Moi, Johannes von Moltke, Inka Mülder-Bach, Anders Neergaard, Ernst Osterkamp, Michael Roth, Charles Salas, Allan Sekula, Jeffrey Schnapp, Anders Stephanson, Neferti Tadiar, Håkan Thörn, Sophie Tottie, Ann Wegner, Peter Weingart, David Wellbery, and Jasmina Založnik. I am grateful to Sara Danius for intellectual inspiration in the early stages of this work. Aris Fioretos not only gave precise feedback on the final draft but has supported and improved my work throughout. I also thank Peo Hansen for years of inspiring conversations and collaborative work. For her accurate feedback and unfailing commitment, and for her faith in historical and political praxis, I thank Patricia Lorenzoni, *minha querida*.

Finally, a note on terminology is needed. Etymology is indispensible for understanding the terms that are central to this book: "crowd," "mass," and "masses," usually put in the determinative: "the crowd," "the mass," "the masses." It is instructive, for instance, to know that "mass" derives from Greek *maza*, which means "dough," and that "crowd" harks back to the old Germanic verb *kroten*, which means "to press," "to push." However, etymological and semantic analysis is poor guidance if we wish to know what was meant by these words in interwar Europe. Despite the period's numerous

efforts to define them, they never fit into any terminological grids. I am thus in the awkward position of writing a history about a notion and phenomenon—the masses—that elude standard scholarly exactitude. Still, since I am interested in how these terms were used by German and Austrian intellectuals in the 1920s and 1930s, I must use them myself. But I make no attempt to provide my own definitions of "crowd," "mass," and "masses." For reasons that will become clear, I think such definitions are impossible, and this book is in one sense an explanation of the very impossibility to give coherent meaning to "the masses." The reader is therefore asked to accept or, at best, learn from the constitutive lack of conceptual consistency that characterizes my own and everyone else's use of these words.

An additional problem is that the English word "mass," in singular, sounds far more awkward and technical than does its German original, "*die Masse*." Sometimes I have therefore rendered this expression as "the crowd" or "the masses" rather than "the mass." As will be seen, however, *die Masse* (the mass) was centrally important as an organizing signifier in German and Austrian public discourse. There is no other way to convey that centrality except by finding an English equivalent and giving it equal weight in my own text, and that equivalent must be "the mass." However, in expository sections, where I am focused not on any specific texts but on generalities, I variously use "mass," "masses," and "crowd" without making any sharp distinctions but always mindful of intellectual clarity. In all translations from the German, and wherever conceptual rigor is called for, my terminology is consistent. For instance, in the German sources "*Masse*" (mass, crowd) is sometimes used in distinction to "*Menge*" (crowd, multitude), and in such cases "mass" is the obvious English choice whereas "*Menge*" is then translated as "crowd" or "multitude."

Crowds and Democracy

1

Introducing the Masses

VIENNA, 15 JULY 1927

1. SHOOTING PSYCHOSIS

There was no question of issuing any warning before the firing started.
The panic, which now arose, is beyond description.

At eight o'clock in the morning of the fifteenth of July, 1927, Vienna's electricity workers switched off the gas and electricity supply to the city.[1] Public transportation, communication, and production came to a complete halt. It was a signal: People left their work places and living quarters and began marching toward the parliament. Joining them halfway was Elias Canetti, later to become one of Austria's most distinguished writers and a Nobel laureate: "During that brightly illuminated, dreadful day," he wrote, "I gained the true picture of what, as a crowd, fills our century."[2]

The march was sparked by a court judgment concerning a killing that had occurred on January 30 of the same year in Schattendorf, a village in Austria's Burgenland near the Hungarian border.[3] A group of social democrats had marched through town. Throughout the 1920s, such manifestations took place almost every Sunday in nearly every town and village of Austria,

a country split between the socialist movement and that of radical conservatives supporting the governing coalition and often organized in the local defense corps, the *Heimwehr*. As the Schattendorf social democrats passed the tavern of Josef Tscharmann, the watering hole for a gang of right-wing vigilantes called the *Frontkämpfer*, the Front Fighters, rifles were fired from a window. Matthias Csmarits, a worker and war veteran, and Josef Grössing, an eight-year old boy, were shot in the back and killed.

On the fourteenth of July, the jury of the district court in Vienna pronounced its verdict. The accused were the two sons of the innkeeper, Josef and Hieronymus Tscharmann, and their brother-in-law, Johann Pinter, all members of the *Frontkämpfer*. It was incontestable that they had fired at the demonstrators. They had confessed this themselves. It was incontestable that two people had died. The verdict of the jury was "not guilty."[4]

"A Clear Verdict," declared the *Reichspost*, the organ of the governing party, the following morning. "The murderers of the workers acquitted," ran the first-page headline of the *Arbeiter-Zeitung*, the major social-democratic newspaper, which published a fuming editorial by Friedrich Austerlitz. "The bourgeois world is constantly warning of a civil war; but is not this blatant, this provocative acquittal of people who have killed workers, for the reason that they were workers, already by itself a civil war?"[5]

Austerlitz expressed the sentiments of the working classes in Vienna, and this day they acted in accord with their passions. Their demonstration was not preceded by planning or announcements. It caught the leaders of all political parties off guard.[6]

The immediate goal of the workers was to voice their dissent in front of the parliament. Before reaching their destination, they were struck down by mounted police. Many began to arm themselves with rocks and sticks (see figure 1.1). The police responded by making arrests and brought the captured to their quarters on Lichtenfelsgasse. Demonstrators next attacked this station to force the release of the detained, overpowering the police and setting the building on fire. Meanwhile, the police had lined up outside the nearby Palace of Justice, on the assumption that this symbolic seat of the law was the demonstrators' primary goal but not realizing that, by now, the police force itself had become the target. Attacking the police chain, the demonstrators besieged the Palace of Justice and forced their way into the building, some carrying containers with gasoline.

At 12:28, the fire department received the first emergency call from the flaming Palace of Justice (see figure 1.2). Fire engines were promptly

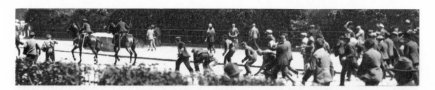

FIGURE 1.1 Mounted police fighting violent demonstrators with cobblestones and sticks, Vienna, 15 July 1927. Unidentified photographer. *Source:* Austrian National Library. ÖNB/Vienna. 449671-B.

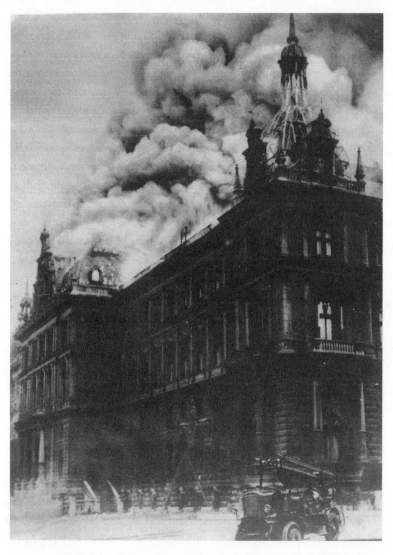

FIGURE 1.2 The burning Palace of Justice, Vienna, 15 July 1927. Unidentified photographer. *Source:* Austrian National Library. ÖNB/Vienna. 229.324-B.

dispatched, but the crowd—its number now exceeding 200,000—refused to let the vehicles pass. The chief of state, Ignaz Seipel, and the chief of police, Johann Schober, decided to arm 600 officers with rifles and gave them order to march toward the turmoil. Around 2:30, just as the demonstrators had yielded way to the fire engines, the police started shooting. By this time, Otto Bauer, the leading theorist of Austro-marxism and chairman of the Social Democratic Party, had reached the site:

> I and some of my friends saw the following. A lineup of security officers progressed from the direction of the opera toward the parliament, a true lineup, one man beside the other separated by one to two and a half steps. At this time Ringstrasse was empty and only at the other side of Ringstrasse a couple of hundred people were standing, not demonstrators but curious onlookers who had been watching the burning Palace of Justice. Among them were women, girls, and children. Then one unit approaches, I saw them move forward, rifles in hand, persons who for the most part had not learned to shoot, even when firing they leaned the butt against their belly and fired left and right, and if they saw any people—there was a small group in front of the building of the School Council and a larger one in the direction of the Parliament—then they fired at them. The people were seized by frantic fear; for the most part, they had not even seen the unit. We saw people running away in blind fear, while the guards were shooting at them from behind.[7]

Gerhard Botz, the principal historian of the July events in Vienna, speaks of a "shooting psychosis."[8] The police shot demonstrators, spectators, and their own. They fired at men and women, at children and the elderly, at fire engines and ambulances. When calm was restored, eighty-five civilians and four police officers had been killed, and more than one thousand people were injured (see figure 1.3). One of the responsible officials, vice chancellor Karl Hartleb, admitted that the scene sometimes looked like a rabbit hunt.[9] It was soon revealed that the ammunition distributed to the officers were so-called dumdum bullets, with uncased noses designed to expand upon contact with the target. The doctors attending to the wounded in Vienna's hospitals related horrendous sights of bodies with wounds that appeared to have been inflicted from a distance of less than one meter.[10]

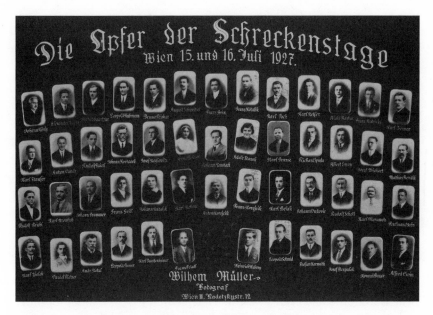

FIGURE 1.3 "Victims of the Day of Horror." Postcard commemorating about half the victims of police violence on 15 July 1927 in Vienna. *Source:* Collection of Stefan Jonsson. Copyright 1927: Fotograf Wilhelm Müller, Vienna. Photo: David Torell.

It was a price worth paying for the restoration of order, the bourgeois establishment of Austria believed. The Automobile Club of Austria expressed their gratitude by donating 5,000 schillings to the police. The chief of police likewise received financial compensation from the Association of Bankers, the Central Association of Industry, and the Chamber of Commerce. The Grand Hotel in Vienna reassured potential guests that the "unfortunate events"—"instigated by communists"—would in no way affect the comfort offered to foreign visitors. Dozens of police officers were decorated with medals of honor, tokens with which the upper classes encouraged the force that had protected *their* idea of society.[11]

Meanwhile, communists and left-wing social democrats believed that the July events were the sign of an imminent revolutionary situation. Soon, they thought, they would take advantage of the opening to realize *their* idea of society.

The fifteenth of July 1927 saw the breakdown of the democratic forms that had until then contained the political passions of Austria's postimperial

society. Created by the decree of the victors of World War I, the young republic was ruled by a Christian conservative government that had barely managed to stake a course through the postwar chaos. Thanks to the parliamentary cooperation of the social democrats, the government had resolved the crises caused by the destruction of the old Austro-Hungarian Empire, establishing between the working classes and the bourgeoisie a precarious equilibrium that held off the threat of civil war and gave the democratic institutions room to maneuver. July 1927 changed all this. From now on, the upper classes would associate the workers' idea of a good society with the raging masses or the Bolshevik revolution, and these masses would see, in the *burghers'* idea of a good society, the flashing muzzle of a gun.

Yet what emerged from the ashes of this class struggle was a vision of society that triumphed over both socialists and conservatives: a fascist front, superior to the socialists in mobilizing the people and better than the conservatives in maintaining social order. For the only force to truly benefit from the July events was the *Heimwehr*, the local militias. In order to consolidate the regime against the socialist threat, Austrian authorities, private donors, and the fascist governments of Italy and Hungary increased their financial and political support of this paramilitary force.[12] The *Heimwehr* thus grew into a political force that could gradually realize its fascist ideal of an Austria purged of Reds and Jews. In sum, the fifteenth of July 1927 was a turning point in Austria's history.[13]

2. NOT A WORD ABOUT THE BASTILLE

On Stadiongasse he jumped up on the heap of stones, which was there at the time, opened his coat, stretched out his arms widely, and shouted to charging security forces: "Shoot here, if you dare to!" And the unthinkable happened. The forces fired a volley at the defenseless man—covered in blood, he fell down on the stone heap.

"Fifty-three years have passed, and the agitation of that day is still in my bones," Elias Canetti remarks in his memoirs. "It was the closest thing to a revolution that I have physically experienced. Since then, I have known quite precisely that I would not have to read a single word about the storming of the Bastille."[14] Canetti was so influenced by his experience that he spent the larger part of his life investigating the behavior of "the masses."

His investigation was not concluded until 1960, when he presented the results of his research in *Masse und Macht* (*Crowds and Power*), one of the most ambitious works of twentieth-century intellectual history, and maybe the most enigmatic.

If Canetti today is regarded as the very model of the solitary intellectual struggling to understand crowd behavior and collective delusions, we must not forget that his efforts were part of a collective undertaking. In political life as in social life, "the masses" has become a battle cry, wrote German theologian Paul Tillich in 1922.[15] Virtually every thinker, writer, scholar, artist, filmmaker, and journalist of Weimar Germany and Austria's first republic was preoccupied by or obsessed with the masses. All of them struggled with or against the masses. Some of them elaborated full-blown social theories and aesthetic programs, not to speak of political organizations and ideologies, on the basis of the social agent that they designated by that term. In all areas of interwar society, the mass was seen as the mother of all problems, if it was not seen as a promise of all solutions.

The masses? "No one could avoid encountering them on streets and squares," writes Siegfried Kracauer in his history of the German film, recalling the situation after World War I. "These masses were more than a weighty social factor; they were as tangible as any individual. A hope to some and a nightmare to others, they haunted the imagination."[16] What was the nature of this agent? Why were "mass" and "crowd" deemed as fitting denominations for it? How come all branches of European art, culture, knowledge, and politics of this period worried so deeply about it? How come intellectuals and artists of no matter what background unanimously asserted that the masses, as novelist Alfred Döblin put it, were "the most enormous fact of the era?"[17]

The following pages will analyze, discuss, and explain the production and recycling of the category of the mass in interwar Europe. We will see that the mass functioned as a description of a certain social agent—an agent, however, whose true nature was highly disputed and whose location in the social terrain remained uncertain. But we will also discover that the mass was a political idea and an aesthetic fantasy, in some cases even an ontological category, without any firm denotation in reality.

The sheer ambiguity of the word goes some way toward explaining its frequency in the culture of the Weimar Republic and interwar Austria. In one magnum opus of Weimar sociology, Alfred Vierkandt lists all that was meant by the "mass" in the 1920s:

1. Mass = followers as opposed to leaders, 2. Mass = average people as opposed to those above the average, 3. Mass = lower strata (uneducated) as opposed to higher strata (educated), 5. [*sic!*] Mass = uprising or any temporary association as opposed to group, 6. Mass = association, class, social stratum, race, or the like, where often no distinction is made whether what is meant is a group (as a totality) or a series of similar individual beings forming something like a species, 7. Mass = temporary association of people in a state of strong excitement (as in ecstasy or panic), in which self-consciousness and higher spiritual faculties strongly regress (and without sign of any collective consciousness in the sense of a community).[18]

When someone spoke of "the masses" in the 1920s, the statement may have been an expression of common prejudice against the lower classes, but it may also have been an expression of social anxiety brought on by the war, the economic crisis, the appearance of women in public affairs, the rapid industrialization, or the bad times in general. Moreover, the statement may have carried a scholarly pretension of explaining the current state of affairs, but it may also have been used to voice social criticism, to confess the speaker's utopian aspirations, to argue for urban renewal, to assert that history was headed on the wrong path and that the world had become a dangerous place, or to warn against the degeneration of the human species and the German race. Whether the word intended one thing or another depended entirely on the context and attitude of the speaker. The word could, in fact, mean one thing just as well as another, which is why—and Vierkandt stressed this point—so many speakers found it so useful and adequate for expressing whatever social views and opinions they held.

The first thing to realize about "the mass" as a term and about the masses as a social phenomenon in the interwar period, then, is that both were unclear and ambiguous. But the difficulty in asserting the meaning or nature of the mass should not be seen as a weakness on the part of those who spoke about the masses or as an error that could have been corrected by a more rigorous sociological and historical analysis. Instead of deploring or denying the contradictory references to the mass, the contradiction should be accepted, or even emphasized, as an indication and symptom of the historical predicament of interwar Germany and Austria. For the difficulty in defining the term reflects the greater difficulty in describing and

representing the society that those who used the term sought to grasp. In the last instance, the conceptually confused and politically contested signification of "the mass" thus brings us face to face with a social and political crisis affecting the very mechanisms by which these societies sought to reconstruct themselves as coherent and meaningful political and cultural entities, thereby giving a meaning to their existence after the defeat and destruction suffered in World War I.

"In the 1920s, the shakiness of the Weimar Republic demanded the urgent reinvention of politics and culture," writes Michael Steinberg.[19] Another historian, Eric Weitz, asserts that "Weimar politics were loud, contested, unruly, and strikingly democratic." Parties and movements of all stripes could find representation in the Reichstag, and they all used the new media and new art forms of radio, photomontage, illustrated press, microphones, and film to carry their messages to the most remote corners of the country. "Politics became 'mass' in an unprecedent fashion."[20] The sociologist René König, describing the main hub and hothouse of the new situation, states that Berlin of the 1920s was "a focal point of social disorganization."[21] Similar assessments were given by many witnesses of the era: "The question as to what order is must in its most fundamental sense be posed anew. It must be understood that our life has become provisional, without any fixed point to rely on."[22] This was "a Republic of instability," says historian Rudolf Morsey.[23]

A word for multiple purposes, "the mass" was indeed the ideal rhetorical vehicle for intervening into the struggles surrounding the overriding problem of Germany's Weimar Republic and Austria's first republic: how to circumscribe the new sovereign of the people? How to shape the content of the damaged and leaking container of the nation? How to understand democracy? In a word, how to reinvent politics? In this situation, the mass served as the preferred conceptual tool for social scientists; it was also the ideal slogan for politicians, and it was the chosen image for artists and writers, who all struggled to represent a society in flux and a people in upheaval.

It would therefore be wrong to posit the Weimar or Viennese masses as pregiven *facts* of history that may be grasped and classified by the social scientist, reported by the journalist, visualized by the painter, pictured by the photographer, or narrated by the novelist. The meaning of the masses was shifting and multiple and always conditioned by the perspective of the observer. Strictly speaking, it is to be doubted whether the masses ever

existed. Yet notwithstanding the problematic epistemological character of the term, it is certainly the case that it indicates a recurrent if not dominant *theme* of interwar European culture. Essentially, this theme concerns the problem of how society ought to be described, depicted, and represented, and by whom.

The theme made itself manifest in two broad areas. First, in the political area, "the masses" were seen as the central problem, and sometimes also as the universal solution because of the violent legacy of the German revolution in 1918–1919 and the introduction of universal suffrage. The revolution and the ensuing unrest brought many German cities to a situation verging on civil war. Opposing classes, parties, militias, unions, and interest groups from all layers of society involved themselves in the struggles over the right way of representing the postimperial German nation. "The first days of the Republic were accompanied by bitter conflict, similar in nature to a civil war, between rival views as to the shaping of the new order; more adverse conditions for the foundation of a democracy can hardly be imagined," states historian Eberhard Kolb.[24] Most interpreters described these conflicts for political representation as a mass struggle or a struggle of the masses. This political instability set the pattern for years to come, and in all attempts to understand or reshape that pattern, the masses were the central concern. On this point the Right and the Left agreed: power was from now on linked to mass mobilization.

The second area in which the masses became an obsessive issue was that of modern German culture itself, particularly its two newest and most dominant features: urban life and technologically mediated media, or *mass media*, as became the current term. For unlike other metropolitan centers in the West, it was not until the 1920s that the German society and its capital were transformed by the typical features of metropolitan life, all the way from heavy traffic and urban congestion to the rapid expansion of cinema, radio broadcasting, and illustrated print media. Some intellectuals thrived in this environment. Others were appalled; Joseph Goebbels described Berlin West and its main thoroughfare Kurfürstendamm as an area "of corruption and decay, . . . of inner emptiness and despair, with the patina of a Zeitgeist sunk to the level of the most repulsive pseudoculture."[25] In this context, too, development and change were explained as consequences of the new social form of the masses, whose tastes and habits were connected to the emergence of the cultural landscape of the metropolis.[26] A new "cult of

distraction" came into being, gathering around its arenas, cinemas, music halls, amusement parks, and similar venues a mass of customers now counted in thousands, if not millions. The major arena was of course the street itself—"stuffed full with people and more people . . . the black throng of people," in Goebbels view. The street constituted a new theme for writers, artists, photographers, and filmmakers, and it also served as a new market place for printed mass media. In Berlin alone there were in 1929 no less than 2,633 magazines and journals, and 147 daily newspapers.[27] In this situation, and politically as well as culturally, the masses became an argument unto itself. "The fact that there are four million Berliners cannot be overlooked," Siegfried Kracauer summarized this crowded state of affairs.[28] As Sabine Hake has analyzed in detail, the rapid rise of this German metropolis, planned and built to accommodate a new human subspecies called "the masses," endangered the self-understanding of those members of the bourgeois public sphere most firmly committed to humanist ideals and the value of education, high art, literary culture, and individual *Bildung*.[29] As is evident in German and Austrian architecture and urban planning, the masses were a collective subject that profoundly transformed the appearances and functions of the city itself.[30]

Another crucial aspect of the idea and image of the masses in the interwar period was their gendered nature. "Crowds are everywhere distinguished by feminine characteristics," Gustave Le Bon had stated already in 1895.[31] Drawing attention to this feature, Andreas Huyssen speaks of "Mass Culture as Woman," explaining that around the turn of the last century public and scholarly discourse "consistently and obsessively genders mass culture and the masses as feminine."[32] As we shall see, the positing of the masses as feminine had to do with the fact that crowds and women alike were believed to lack rationality and self-control, and it was generally held that both acted in accord with their instincts and emotions. Since the emerging urban and popular culture seemed to target precisely such allegedly lower mental faculties of pleasure and sensations, this culture was frequently described as a symptom of an ominous process of feminization and massification, which entailed the disintegration of public life, the collapse of society, the symbolic castration of masculine authority, and a surge of revolutionary hysteria and emotional promiscuities of all kinds. Regulating or preventing this process became a priority for many interwar intellectuals and politicians. The methods employed included policies of crowd control

and measures aimed to police and restrict women's sexual and political emancipation, including a range of educational, biopolitical, and disciplinary initiatives and institutions.[33]

"The great Weimar intellectual and creative figures were, then, preoccupied with the meaning of 'the masses' and 'mass society,'" concludes Eric Weitz.[34] But this also means that an inquiry into the meaning of the masses in interwar German and Austrian culture easily broadens into a general history of these societies. This may be the reason that no one has yet produced a comprehensive analysis of the masses in Weimar Germany and Austria's first republic. There are some excellent studies of the notion of the mass in the interwar period. But most of them are limited in scope because they study the "mass" either as a theoretical concept in sociology and social psychology or as a political idea promoted by totalitarian ideologies. Most of these studies also suffer from the same theoretical weakness and ideological ambiguity that marked the concept of "the masses" as it was usually defined in European culture of the interwar period. Thinkers and writers tended to define the (feminine) "masses" as the opposite term of an idealized norm of (male) individuality.[35] Hence, the emergence of the masses was automatically judged as a threat to the ideals of individuality, personal cultivation, male identity, and rationality; as Paul Reiwald succinctly put it in his "handbook of mass psychology" of 1946: "The individual—or, rather, individuality—perishes in the mass."[36] Although later scholars have not always accepted this definition, or even have rejected it as unscientific, their critiques often remain framed by it.[37] That is to say, they have only addressed the particular *individualistic* notion of "the masses," that is, "the masses" as the opposite of individuality. While this approach is understandable—for it was this notion that dominated the scholarly and political jargon of the period—it fails to register that the interwar discourse on the masses also connoted a more multiple, malleable, and contradictory phenomenon than the one that thinkers and scholars tried to circumscribe in their conceptual systems.[38]

One of my aims in this book is to relate this dominant notion of the masses to the powerful images of the masses that circulated in the wider cultural, literary, and artistic field. I am especially interested in the masses represented in art, photography, cinema, literature, theater, dance, and architecture. For I am convinced that the *aesthetic* images of the mass in Weimar culture tell us far more about the *political* conflicts and *historical* predicament of this society than we are likely to pick up if we limit our

interest to the references to the masses found in the scholarly and political context. References to the masses of the latter kind should be approached with suspicion, for even when they are presented to us as neutral sociological concepts they are notoriously vague, always defined in relation to other equally vague concepts such as individual, group, class, people, and organization. At best, the mass here figures as a *pseudo-concept*: a fiction disguised in the high jargon of social theory, a social theory ever biased by ideology, or a social classification colored by opinion.

As a concept, "the mass" is therefore a meaningless term. As a historical sign, however, "the mass" is loaded with meaning. If we want a full idea of the historical dynamics of interwar Austria and Germany, of its aesthetic achievements, its radical experiments in cultural creativity and political organization, and its forces of destruction, there is no better way than to investigate the various meanings and roles attributed to the masses. The objective of this book is to bring all these images and ideas of the mass into a comprehensive analysis and coherent historical narrative.

This narrative begins on November 23, 1895, when the sociologist Georg Simmel reviews Gustave Le Bon's *Psychologie des foules* in the Viennese weekly *Die Zeit*. It ends in 1939, when the Austrian writer Hermann Broch submits a forty-page proposal to the Center for Advanced Study in Princeton, in which he demands that a Research Institute for the Study of Political Psychology and Mass Insanity be founded: "Everybody knows the insanity characterizing our time; but nobody knows the causes of this political madness."[39]

Between 1895 and 1939 the meaning of "the mass" is taken to its limits. For Simmel, writing in 1895, the term operates within a limited field located between positivist sociology, clinical psychology, and public policy. For Broch, writing in 1939, the same term refers to metaphysical powers that govern the fate of humankind. All branches of knowledge, from criminology and pedagogics to demography and theology, must be coordinated to investigate this power, Broch argues. In fact, he wants the entire university system rebuilt to "fight the mass-psychological threat."[40]

What happened between 1895 and 1939? We may have a rough idea about the historical processes behind the transformation. Yet it is not clear why these processes were deposited into the meaning of a word, "the mass." Nor is it clear why this word came to absorb such huge quantities of intellectual and artistic energy. The efforts to understand the mass yielded a highly impressive list of works. To Broch's *Massenwahntheorie*, we may add

Sigmund Freud's *Massenpsychologie und Ich-analyse,* Wilhelm Reich's *Die Massenpsychologie des Faschismus,* Paul Tillich's *Masse und Geist,* Theodor Geiger's *Die Masse und ihre Aktion,* Siegfried Kracauer's "Der Ornament der Masse," Vilhelm Vleugels's *Die Masse,* Arnold Zweig's *Caliban, oder Politik und Leidenschaften,* Theodor W. Adorno's *The Authoritarian Personality,* and, somewhat later, Elias Canetti's *Masse und Macht* and Hannah Arendt's *The Origins of Totalitarianism.* The analysis of the crowd was also furthered by sociologists such as Leopold von Wiese, Gerhard Colm, and Max Weber; by left-wing theorists like Georg Lukács, Rosa Luxemburg, Walter Benjamin, Karl Kautsky, and Bertolt Brecht; and also by right-wing thinkers such as Oswald Spengler, Ernst Jünger, Carl Schmitt, and Martin Heidegger. Not only writers and thinkers inquired into the problem of the mass. Consider the cinema, photography, architecture, visual arts, theater, and dance of the Weimar Republic: here, too, is a huge body of works expressing a firm conviction that the masses inaugurate a new era. For instance, a quick glance in the collections of any European museum of modern art provides sufficient grounds for realizing that numberless visual artists of the 1920s took the crowd as a new object of representation. Often simply entitled "Die Masse" or the like, these paintings and drawings show how the motif of masses prompted artists to invent new methods of representing society. The same pertains especially to German and Austrian film and performing arts of the interwar period.

It exceeds the capacity of a single author to review this work in its totality. But the contours and properties of the totality may nonetheless be grasped by exploring a string of representative examples. In this way, it should be possible to identify not only the various meanings attributed to the masses in interwar culture but also the positions claimed by people who were dismissed as masses.

What's the point of my investigation? The 1920s was the era of the masses. Yet it is rarely recognized that the masses were of vastly different kinds. By stressing and examining the heterogeneity of the ideas and images of the masses in interwar Germany and Austria, we will better understand why these years were at once the most disastrous and the most creative of modern Western culture. It will also shed light on pressing political and cultural concerns of our present time. In line with historian Detlev Peukert's conclusion to his interpretation of the Weimar Republic, we may here see Weimar Germany or Austria's first republic as "an archetypal instance of the

history of democracy: a compendium of democracy's virtues as well as its vices," which encourages us "to refine and elaborate our own traditions of democracy."[41] In this sense, we have hardly begun to digest the lessons that this culture transmitted to posterity through its lasting achievements and its horrendous failures.

My aim, therefore, is not only to analyze and discuss some of the various ideas and images of the masses that circulated in interwar Germany and Austria. I also want to explain the prevalence and dominance of the masses in public discourse of that era. I will seek to do this by connecting the discourse on the masses to the "democratic problem" of that time, that is, the problem of representing the political passions and interests of the people in adequate political organizations, cultural institutions, and aesthetic forms.

This approach has crucial implications. For if it is correct, it means that an understanding of the profoundly ideological figure of the masses in European history is indispensable not only for those interested in the history of populism, totalitarianism, fascism, and revolution, not only for those seeking to situate Weimar culture in relation to the grisly system that replaced it, but also for everybody concerned with the future of democracy. The richness and density of the discussion on the masses in interwar Europe must not be seen merely as a prelude to Nazism, Stalinism, and World War II, but as an archive of ideas about society and collective life that we have not yet fully worked through. Until recently, historical scholarship stated that the Weimar Republic was "doomed" from the outset as it harbored contradictions that its democratic constitution was unfit to resolve and thus inevitably resulted in dictatorship.[42] Similarly, and all too often, the study of interwar ideas of the masses has been reduced to a study of fascism. Conversely, the study of Nazism has often been reduced to a study of the masses.[43] The following chapters seek to correct this view by proposing that the masses also reveal the eternal problem of democracy. The historian Heinrich August Winkler emphasizes this point in his monumental history of the working-class movement in Weimar Germany: "At the center stands the question about the chances for success for Germany's first democracy."[44] Buried inside each idea of the masses, then, is not necessarily a fascist, communist, or totalitarian kernel but simply an idea on how to *represent* society; how to channel socially significant passions into adequate political, cultural, and aesthetic forms; or how to understand and explain socially significant passions sociologically and psychologically. While many

of the notions of the mass that circulated in interwar Germany and Austria functioned to block the broad majority from gaining representation, other notions explored ways to empower the *demos*, to put the people at the center of the picture.

3. EXPLAINING THE CROWD

> I went up to the commander and yelled: 'for God's sake, at least avoid
> shooting at the ambulances! Not even during the war did anyone shoot
> at the Red Cross!' The police officer replied: 'With your permission, I'm
> shooting at the Red Cross!'

Around 1895 an entire scholarly discourse crystallized around the efforts to understand the collective behavior of human beings. According to the French and Italian social scientists that launched this discourse, the growing influence of crowds transformed all sectors of social life. Whether they spoke about railways, urban congestion, the introduction of the lay jury in legal proceedings, universal suffrage, athletic events, workers' strikes, urban riots, the growing circulation of newspapers, poverty, or the expansion of primary schooling, they tended to see a common denominator behind them, neatly summarized by Gustave Le Bon in his book of that year: "The age we are about to enter will in truth be the era of crowds."[45]

According to Le Bon and his colleagues, all that was new or emerging in society apparently involved collective action or gatherings of great numbers of people. They described these crowds as irrational and potentially violent, threatening everything that made civilized society possible. To understand the new era there was a great need for a general theory or a set of general concepts through which different crowds and different instances of crowd behavior could be systematically compared. A theory was constructed: mass psychology.

Mass psychology drew its materials from many sources: Hippolyte Taine's positivist and profoundly conservative history of modern France; Hippolyte Bernheim's and Jean-Martin Charcot's studies of insanity; Emile Zola's naturalist inventory of the mores of the working classes; and the sociological theories of Gabriel Tarde, Victor-Alfred Espinas, and Henry Fournial, whose ideas evolved in close connection with the criminal anthropology of Italian social scientists like Scipio Sighele.[46] The discourse

was codified in Le Bon's enormously successful *Psychologie des foules* from 1895, soon translated into English as *The Crowd: A Study of the Popular Mind* and also into many other languages. Primarily mediated by Le Bon, mass psychology was first applied by social technocrats, medical doctors, and military officers worrying about the health and discipline of workers, soldiers, and the working classes in general.[47] Soon it came to influence the social sciences more generally, contributing not only to the constitution of social psychology, as in Wilhelm Wundt's *Völkerpsychologie* (1900–1920), William McDougall's *The Group Mind* (1908), and Sigmund Freud's *Mass Psychology and Analysis of the 'I'* (1921; *Massenpsychologie und Ich-Analyse*), but also in Germany to the emerging theories of modernization that had been developed by the first generation of German sociologists, such as Ferdinand Tönnies, Max Weber, and Georg Simmel. From this point on, and always with or against Nietzsche's enduring "declaration of war against the masses," the theory split into many directions, which I will discuss in due order and in depth throughout the following pages.

As will be shown, mass psychology was assimilated with the political discourse of fascism. However, mass psychology also turned the opposite way, as it provided left-wing theory with instruments for analyzing fascist ideology. Furthermore, mass psychology merged with mainstream German sociology of the 1920s. And in the hands of independent thinkers and philosophers such as Elias Canetti, Hermann Broch, Martin Heidegger, Karl Jaspers, Hannah Arendt, and others, the discourse was transformed into social theories in their own right. The wide diffusion of mass psychology and mass sociology encouraged a certain way of viewing and describing society, especially its emerging urban and proletarian milieus, which saturated journalism, social commentary, political discourse, and literature.

Most important, mass psychology offered a convenient tool for explaining the social disorder and violent events that characterized the interwar period throughout Europe. German and Austrian politics was dominated by competing efforts to apprehend and control the social aspirations and political passions that frequently erupted in clashes among the working classes, fascist militias, and the apparatus of state violence. Those who wrote or spoke about these events usually singled out "the masses" as the cause of the unrest or quite simply as the villain.

The July uprising in Vienna is a case in point. Most if not all observers of the burning of the Justizpalast conveniently explained the event

as an expression of mass action. In their view, the violence of that day was a portent of the ultimate "rebellion of the masses," as was the title of Spanish philosopher Ortega y Gasset's best-selling book of the same year. To be sure, alternative explanations of the conflict also circulated in the public sphere, although they were pushed to the margin and silenced. Indeed, there are few historical events that have elicited such a rich intellectual aftermath as the fifteenth of July 1927. I have already mentioned Canetti, whose entire career was shaped by the demonstrations. First, he wrote the novel *Auto-da-fe* (*Die Blendung*, 1935), which literally relates how bourgeois culture burns to the ground, and then also his magnum opus, *Crowds and Power* (1960), which shows how great collectives possess an agency of their own, be it destructive or intelligent, independent of any kind of leadership.

Sigmund Freud was not at home in Berggasse on the fifteenth of July but on vacation at Semmering. Reports about the violent uprising nonetheless found their way into his texts and affirmed his pessimistic outlook. Would man ever learn to live, without leaping at the throat of his neighbor? Also, in Robert Musil's masterpiece *The Man Without Qualities*, the July insurrection is recorded in chapters about a spontaneous uprising that marks out the novel's climax and turning point. Similar events haunt the characters in Hermann Broch's trilogy *Sleepwalkers*, but transferred to a new setting in the German Revolution of November 1918. Heimito von Doderer, for his part, addressed the July events directly in his major novel *The Demons* (1956), which culminates in front of the burning Justizpalast.

The person who was most profoundly influenced, however, was the publisher, critic, and playwright Karl Kraus. In a series of satirical essays, theater plays, and grammophone recordings, Kraus launched a campaign against the authorities that he held accountable for the violence. He collected reports and eyewitness accounts and published a massive volume of documents consisting of first-hand testimonials of what had occurred, some of which I have used as epigraphs for the sections in this first chapter. Let us return, then, to that bright and dreadful day, to see how it illuminates the specific presuppositions and prejudices contained in the discourse on the masses, as well as the historical and social concerns that may account for its enormous impact on interwar culture and society. And let us as our point of departure take another of the newspaper quotes collected by Kraus:

The mob that heaved itself around the Palace of Justice, howling and eager to loot, had transformed itself into a swarm of hatred. Its rage had turned into the fear of the weak, its demand for revenge into cowardice. It crawled away into the alleys to take cover.[48]

Many observers of the fifteenth of July in Vienna believed that the spontaneous violence was a result of the primitive state of the laboring masses, a primordial and creaturely "mob" with terrifying qualities. Needless to say, this was a simplification, but one that was preferred by many as an escape from seemingly irresolvable conflicts. If we look at the background, the uprising appears to be the culmination of a situation that had been building up over many years. By 1927, Austria's upper and middle classes and rural population had begun to benefit from the severe measures undertaken by the government to reorganize Austria's economy after World War I and the inflation of 1923. In the working classes, by contrast, the rate of unemployment remained above 10 percent, and in the Vienna region, as high as 30.[49] Another long-term cause of the demonstration was the accumulated effect of previous confrontations between socialists and right-wing radicals. On at least four occasions, social democrats had been killed or injured in such clashes. In all cases, the perpetrators had walked away unpunished.[50] Austria's working classes reckoned that the law was an instrument of class oppression.

The workers' discontent was magnified by the fact that this situation of unemployment and legal discrimination contradicted their expectations that empowerment was within reach. The labor unions and the Social Democratic Party controlled the material and institutional infrastructure of Vienna.[51] Ernst Fischer, cultural editor of the *Arbeiter-Zeitung* at the time of the July uprisings, described the party in his memoirs, asserting that "never before, and never since, has there been a social democratic party that was so strong, so intelligent, and so attractive as the Austrian party was in the mid-1920s."[52] The support of the social democrats had increased with each new election, creating the hope that they would shortly rule by absolute majority. Still, in 1927 these expectations remained unrealized, partly because the Christian conservatives, noting the growth of the social democratic electorate, became increasingly unpliant.

This class tension was, in turn, a legacy of Austria's defeat in World War I and the destruction of the Austro-Hungarian empire. After the war, the political, administrative, and economic apparatus broke down, so much so

that, with the treaty of St. Germain in 1919, as one historian puts it, "the whole *raison d'être* of Austria . . . seemed to have been irrevocably destroyed."[53] Historical and literary documents suggest that the citizens of the truncated state experienced the postwar years as a collective trauma.[54] Large parts of the population did not trust the state as their representative. All sides reserved the right to arm themselves for future contingencies, conjuring up the specter of civil war as a pretext. Wealthy estate owners financed private armies. The right had its own paramilitary in the *Heimwehr*. The social democrats had a paramilitary wing in the so-called *Schutzbund*. On March 2, 1927, the conservative government attempted to disarm the *Schutzbund*, provoking a brief crisis that further increased the social democrats' distrust of the authorities.[55]

Thus, the general political background of the demonstration on the fifteenth of July was a panorama of interlinked minor and major causes and motivations that were so complex and variegated that they would seem to preclude any unified explanation of the violent event. Even if they were all added together, we would still lack an explanation that could measure up to the tremendous impact of the event itself. Yet as many reports and accounts of the time seem to prove, it was precisely this lack of a coherent historical causality that tempted intellectuals and politicians to posit the agency of the masses or of a collective mind as an explanatory model. Only a homogeneous and unidirected force, they seemed to argue, would be able to cause such a massive effect.

This indicates a general feature of the interwar discourse on the masses. The line that separated a psychology of the crowd from a metaphysics of the crowd was often a thin one. When stating that the crowd acts as one being, mass psychology delivered not a substantiated social theory but something comparable to the explanations found in mythology, where giant events are read as acts of giants. Consider the following description by Canetti: "It wants to consist of *more* people: the urge to grow is the first and supreme attribute of the crowd. It wants to seize everyone within reach; anything shaped like a human being can join it."[56] In mass psychology, whether in Le Bon, Tarde, Freud, or Canetti, social agency ceased to be a "he," "she," or "they." Instead, social agency became an "it," which was strangely plural.

The mass psychologists had a name for the mysterious agency that drove men and women to coordinate and mimic the acts of one another. They called it a "collective soul." They quarreled about the true nature of this soul

of the masses. Some regarded it as an essential quality of all collectives; others saw it as a projected quality, introduced after the fact to explain collective human behavior. Whether a collective consciousness uniting all members of any given collective was really seen to exist or whether it was ascribed to them by external observers makes no great difference here. What is more crucial is that this interwar debate posited the collective soul as a theoretical figure, which turned the nebulous category of the mass into an intelligible phenomenon and which allowed for a conceptual analysis of it. Stated differently, the collective soul was a *representation*, conjured up by the observer's need to explain an effect so immense that it far exceeded the combined agency of the innumerable agents and circumstances that caused it. Experiencing the July events, Canetti and others believed they saw a collective mind in action. "I became part of the crowd, I fully dissolved in it, I did not feel the slightest resistance to what the crowd was doing."[57]

Yet, like all accounts of the crowd, Canetti's is a reconstruction, noted down in afterthought by an individual working through his memories and ideas. As his memoirs reveal, Canetti's thoughts on the crowd presupposed an ascetic and aesthetic isolation from the rest of humanity. Canetti here explains that his interest in the masses began a couple of years before the burning of the Justizpalast. His first ideas about the masses came to him as an "illumination" on a solitary walk in the winter of 1924–1925:

It was night; in the sky, I noticed the red reflection of the city, and I craned my neck to look up at it. I paid no attention to where I was walking. I tripped several times, and in such an instant of stumbling, while craning my neck, gazing at the red sky, which I didn't really like, it suddenly flashed through my mind: I realized that there is such a thing as a crowd instinct, which is always in conflict with the personality instinct, and that the struggle between the two of them can explain the course of human history.[58]

This flash of inspiration, Canetti asserts, propelled him to devote thirty-five years to the study of the crowd. He admits that he at this time did not know "what a crowd really is."[59] In order to find out what a crowd was, he isolated himself in a farmer's house in the Alps, or this is at least what he relates in his memoirs. On his first morning in the alpine setting, he sat down at a table in the garden, taking out the only book he had brought along, Freud's

Mass Psychology and Analysis of the 'I.' Embarking on his revision of Freud's theory, the twenty-year-old Canetti was to replace Freud's sexual drive with what he calls the *Massentrieb*, or "crowd instinct." Freud and Le Bon had been blind, he believed. Neither thinker had known the crowd from the inside. As for Canetti, "I had never forgotten how *gladly* one falls prey to the crowd. . . . I saw crowds around me, but I also saw crowds within me."[60]

Yet Canetti's intention to represent the crowd from within, as an experiential phenomenon, is called into question by his account of his own intellectual procedure. "I had made up my mind," he writes, to "have the crowd before me as a pure, untouched mountain, which I would be the first to climb without prejudices."[61] Canetti here figurally repeats the mental operation of his adversaries, Le Bon and Freud, because his descriptions betray that his theory, too, presupposes a radical separation of the rational mind from the passionate masses. Interestingly, Canetti states that it was during these days of hard discipline, divided between Freud's mass psychology and solitary mountain hikes, that he became a true individual: "During those days I also won my independence as a person."[62] Quite literally, Canetti gains mastery as an individual by intellectually conquering the masses.

Canetti's passage shows how his first attempts to analyze the crowd were predetermined by a certain conceptual structure that is characteristic of mainstream mass psychology from its inception in the 1890s and through the 1920s. As a consequence, the crowd comes across less as a transparently described actuality than as a reflection of the conceptual limitations that govern the analysis. A first limitation is obvious enough to go unnoticed: mass psychology presupposes a radical distanciation from its object. Cannetti fantasizes having the masses before him as an untouched mountain. Le Bon and the French mass psychologists regularly described the masses as a remote people, if not as a savage tribe.

Canetti's example also reveals a second conceptual limitation, typical of most writings on the mass: the mass was always constituted in opposition to a notion of individual reason. Consider the following statement of Le Bon: "The substitution of the unconscious action of crowds for the conscious activity of individuals is one of the principal characteristics of the present age."[63] Le Bon asserted that the individual is related to the crowd as conscious activity is related to unconscious action. The precondition of such a characterization is the Cartesian concept of the individual as defined by consciousness. For Descartes, the opposite of consciousness was the passions.[64]

The mass psychologists repeated the same distinction. Assuming that the individual was characterized by consciousness, and that the crowd was the opposite of the individual, they concluded that the crowd must be characterized by what was opposite to consciousness, that is, by unconscious passions.

Thus, as long as human nature was defined in terms of rationality, and as long as rationality was defined in terms of individual consciousness, the crowd would, by default, come across as an agent of passions. Stated differently, the definition of the masses as a matter characterized by its passions was an inverted mirror image of the definition of the individual as a mind characterized by reason. In this context, the crowd occupied a position analogous to that of the primitive, the feminine, the infant, and the barbarian, all of them instances of the Other of Western rationality and all of them being linked by a shared definiens: the passions. From Gustave Le Bon until our day, "the masses" has been a term pressed into service whenever the theoretician has addressed social processes that seem to erode differences, challenge authorities, and unmake rational distinctions. "The mass" has always been the eclipse of reason and the enemy of the well-ordered polis.

What all this amounts to is that most efforts to analyze "the masses" are intrinsically connected to the problem of representing the passions. As a site of malleable passions, the crowd cannot represent itself coherently. It calls for representation by someone who can grasp its true nature and present it in intelligible form, notably the intellectual. Moreover, the crowd calls for *political* representation by someone who can speak on its behalf and convert its passions into political demands, notably the leader, *Führer*, or party. The crowd cannot speak; it screams. And its screams must be translated into rational speech by an individual acting as its representative.

4. REPRESENTING SOCIAL PASSIONS

Just as she was kneeling down over the wounded, the fatal bullet
was fired and crushed the back of her head.

In *The Origins of Totalitarianism* Hannah Arendt asserted that the masses are strangers to the arena in which political matters are rationally resolved. This is the reason the masses were a crucial factor in bringing totalitarian movements to power in the wake of World War I not just in communist

Russia but also in fascist Italy and Hungary and eventually also in Nazi Germany, according to Arendt.[65]

Arendt's argument has been as influential as it has been disputed.[66] This is not the place to enter the discussion she launched about the causes of some of the greatest catastrophes in European history. However, we must attend to her assertion that fascism and communism would have been unthinkable without the emergence of the mass and mass mentality. As Arendt stated: "Totalitarian movements are possible wherever there are masses who for one reason or another have acquired the appetite for political organization."[67]

Arendt defined the mass as people who feel superfluous or indifferent to the political process. They are not held together by common interests, common backgrounds, or shared political goals:

> The term masses applies only where we deal with people who either because of sheer numbers, or indifference, or a combination of both, cannot be integrated into any organization based on common interest, into political parties or municipal governments or professional organizations or trade unions. Potentially, they exist in every country and form the majority of those large numbers of neutral, politically indifferent people who never join a party and hardly ever go to the polls.[68]

According to Arendt, Hitler's, Mussolini's, and Lenin's movements were successful because they found new ways of organizing these scattered and dissatisfied majorities into political communities based on feelings of belonging to a chosen class, race, or nation.

Hannah Arendt's theory of totalitarianism is thus founded on a certain notion of the masses, modeled on the social situation in interwar Europe. This notion presupposes two ideas that we will encounter throughout this book. The first is that the masses were generated by processes of social disintegration—caused in turn by historical processes of urbanization and industrialization—that dissolved the previous class system and unraveled "the whole fabric of visible and invisible threads which bound the people to the body politic."[69] Arendt here repeats an argument that was the backbone of most theories of mass society from the early twentieth century onward. The argument has problematic implications for democracy both as a general theory of governance and as it was put in practice in the Weimar

Republic, for it posits democracy (popular sovereignty, universal suffrage, equal representation, and a leveling of political hierarchies, for instance) as a symptom of precisely that social disintegration that also led to the emergence of totalitarian mass politics. Many thinkers of the interwar period argued along these lines, though they were far more explicit than Arendt as they openly blamed the newly instituted democratic systems for the rise of the masses.

Whether this argument is true or not depends on what we understand by "democracy" and "masses." Here we encounter the second basic idea in Arendt's notion of the masses as a substratum of totalitarianism. Arendt defined the masses as those lacking voice and seat in the system of political representation. The mass was defined by its position "outside all social ramifications and normal political representation."[70] The decisive issue is, of course, *why* the masses were outside the arena of political representation. Arendt attributed the reason to the accelerating process of disintegration that destroyed old social bonds and alienated individuals from those forms of representation that previously were available to them. But we may also consider an alternative idea that suggests a more dialectic understanding of the relationship between masses and representation. According to this idea, the masses stood outside the political arena not because inevitable historical and social developments had placed them there, as Arendt suggested, but because the mechanisms through which the social body represented itself were set up so as to exclude certain parts of the population from the political arena. Moreover, it was precisely by representing some people *as masses* that this exclusion was justified and maintained.

This also answers a different question never raised by Arendt. Why were men and women who stood outside the political arena called "masses"? The answer is that this very designation—present at all levels of public discourse and in most fields of political and academic life—fulfilled a discriminatory function: the definition of certain segments of the population as masses justified keeping them outside the political and cultural arena. In early-to-mid-twentieth-century Europe, the masses thus constituted an instance of negativity vis-à-vis the bodies and beings that appeared within the field of representation. The mass was a supplement, a rest, a remainder consisting of that part of the population that could not be given social, political, or cultural form. Why not? Because the mass had no means to represent itself.

It consisted of men and women without access to the discourses and institutions that determined how society represented itself.

Hannah Arendt's description of the masses therefore cannot be seen as a neutral designation. As a category, the mass is intrinsically political. The word reveals the uneven relation between those who speak for society as a whole and those who follow, obey, or resist. Seen in this way, Arendt's definition indicates exactly the terminological function of "the mass." It is an index of social agents and aspirations that lack space, voice, and representation in established political institutions and assemblies. That these social agents and aspirations were called "masses" is a fact of history, just as it is a fact of history that the exclusion of these social agents and aspirations was legitimized by calling them "masses." Yet rather than accepting and consolidating such designations, as Arendt did, we must wonder how they were produced and why they were so strongly upheld. Once this question is asked, however, we immediately realize that the masses have always been produced through the ways in which certain social agents and aspirations have been represented—politically and intellectually—in modernity. Instead of defining the mass as those without representation, we should investigate how the mechanisms whereby any given community represents itself, politically, intellectually, or aesthetically, necessarily produces a remainder, a group of agents and aspirations that cannot be accounted for by the dominant mode of representation. Furthermore, we should explore exactly how the community justifies the fact that certain groups are excluded as "masses" and thereby deprived of possibilities to represent themselves as citizens, individuals, or people.

I am now able to clarify the conception of the mass that underlies the argument of this book. The only way to give analytical coherency to the category of the mass is to see it as a side-product of the specific ways in which *socially significant passions* have been represented—politically and intellectually—throughout the modern period. By socially significant passions, I mean the affective aspects of human labor and the libidinal need for social recognition that form the binding medium of society and hold collectivities together. The act of representing such passions, I want to suggest, structures the social field by instituting a distinction between representatives and represented. This distinction also effects a biopolitical distribution of power and of knowledge between social agents, determining which human beings will be excluded from cultural and political institutions and

hence subsumed and concealed under the notion of "the people," "society," "population," "the masses," or some such designation of the social body, and which will be included in those institutions and hence able to ascend to the position of society's political and cultural representatives. For this reason, the act of representing socially significant passions can be seen as an originary mechanism of politics, as the cause of power—comparable to the distribution of presence and absence, rationality and irrationality, civic agency and subalternity within the public sphere.[71]

In Europe at the end of the nineteenth century and the first decades of the twentieth, this distribution tended to assume the form of a distinction between individual citizens and masses, the latter defined, typically, as a social matter characterized by its passions, the former as a mind charac- terized by its reason and hence capable of executing power by rationally representing the passions of the masses. "Masses"—and not just "masses" but "individuals," too—were here created through the ways in which an always already existent collectivity (human beings knitted together by ties of affect and desire or by socially significant passions) sought to constitute itself as state, people, nation, or polity by particular modes of representa- tion. Those "masses" that intellectuals and politicians struggled to represent throughout modernity were, it will thus turn out, fabricated by their own acts of representation.

This argument does not imply that "the masses" are an "effect of dis- course" or a "historical construction." But nor do I imply that "the masses" are a reality or essence. The "masses" can be posited as an *effect of repre- sentation*, with the proviso that this representation occurs on several social levels, some of which are palpably concrete. The representation may thus be discursive, as in scientific and literary accounts *about* "the masses." The representation may also be political, as in the system of representative democracy at the beginning of the twentieth century. The representation may, moreover, be economic, as in the capitalist mode of production where labor is represented in the form of surplus value extracted by the capitalist.

These modes of representation are not necessarily congruous. For instance, a theoretical representation of society may contradict the insti- tutions of political representation or the economic system in which labor is socially represented as exchange value. Germanic languages are able to distinguish these modes of representation either as forms of *Darstellung*, speaking *about* someone or something (and at the same time "putting

something forth"), or as forms of *Vertretung*, speaking *for* or *on behalf of* someone or something.[72] English is deprived of the possibility to clearly signal the difference between the two but, in return, is able to mark that the two are often interconnected. For there are cases where discursive, political, and economic systems of representation are aligned to contribute to one and the same effect. One such case is the production of a phenomenon called "the masses." This explains why "the masses" are always construed as absolutely peripheral in relation to positions of centrality that accumulate not only political power but also aesthetic, intellectual, ethical, and economic values.[73] Again, Vienna in July 1927 allows us to see how the boundaries were drawn.

5. A WORK OF MADNESS

In the afternoon on the 15th of July Rudolf Kreuzer and his wife walked across Ringstrasse in the direction of the Schiller monument. The street was calm, with only a handful of peaceful pedestrians. Suddenly, a volley was fired near the Schiller monument. The couple ran toward the opera. There came another volley. One shot hit the woman in her neck and injured her spinal column, causing a general paralysis.

According to Heimito von Doderer the violence on July 15 was an apocalypse. As I mentioned earlier, Doderer is one of the great Austrian chroniclers of the burning of the Palace of Justice, along with Elias Canetti and Karl Kraus. Conceived in 1927 and finished only in 1956, Doderer's novel *The Demons* (*Die Dämonen*) introduces a multitude of characters, relating their lives and relationships over more than 1,300 pages.[74] What links one person to the next is not so much a plot in the conventional sense but the detailed account of emotional bonds, social rituals, ties of kinship, financial debts and credits, cultural values, and political opinions, which, in addition to the various institutions adapted for the cultivation of these relationships—bank, opera, café, restaurant, university, salon, library, boudoir—constitute an identifiable social class: the Viennese bourgeoisie of 1926–1927.

To say that *The Demons* is a novel about the bourgeoisie is also to say that it is *not* about the masses. Or is it? By construing the July demonstration as a global apocalypse threatening the bourgeois world, Doderer

inadvertently exposes the perspective from which the July events were typically viewed and denounced as an act of the savage crowd. Doderer's whole oeuvre is structured by a distinction between what the author calls "actual reality" and "second reality." The latter indicates a realm of ideological fantasies and psychological obsessions. Described as "the dominant factor of our time," the tendency to escape into a "second reality" makes a person unable to answer for his or her own fate. Such persons rush headlong toward some imaginary aim and eventually make a painful crash landing.

In private life, such delusions result in perverse behavior. Doderer's primary exhibit is Kajetan von Schlaggenberg, a writer with anarchic leanings, who hungers for fat, middle-aged women, the sizes and looks of whom he catalogues with the rigor of a racial scientist. In public life, the belief in a "second reality" expresses itself in political radicalism. "That man becomes a revolutionary," says Doderer's alter ego, who "perceives realities too vaguely because of his own poor eyesight" (492; 486).

In contradistinction to such delusions, Doderer reclaims the legacy of personal cultivation, the virtuous path toward self-transformation that is at one with a harmonious adjustment to "the order of the world." Doderer's narrative mobilizes the humanist credo of Pico della Mirandola, whose rendering of God's command to Adam may be taken as the central message of *The Demons* as a whole: "You will define your own nature. . . . You can descend to the depths of brute creation or rise to the heights of the divine, according to the decision of your own soul" (672; 658).

In *The Demons*, this credo entails a ban on collective undertakings: "Everything would soon depend upon the individual, . . . it was incumbent on the individual, for a time at least, to take his place exactly opposite every sort of collective" (893; 889). Collectives are a "second reality," Doderer's narrator argues, because the collective is the result of an uncertainty about one's self that forces a person to identify with others. These identifications remove the person from his or her unique individuality and shape him or her according to humanity's lowest common denominators—"commonness, crudeness, baseness. We are already on that path" (494; 488).

Doderer's narrator puts his individualistic credo into the mouths of the few workers included in the novel: "In our party newspaper," says one worker with obvious reference to the *Arbeiter-Zeitung*, "all I ever read is 'the people,' 'the masses,' and always 'the masses.' It's the masses that matter, the

masses that count. But I'm not the masses, I'm a human being by myself. And that don't mean a thing to them" (582–83; 572).

The hero of *The Demons* proves the same point through fantastic individual achievements. Leonhard Kakabsa, at the beginning an uneducated worker who seeks comfort with prostitutes, one day happens upon Scheindler's *Latin Grammar for Schools*. Within a year, he is fluent in Latin. His scholarly aspirations gain him access to the salons of the bourgeoisie, where he meets the love of his life. His efforts are also crowned by material success: a wealthy prince hires him as librarian of his book collection, and Leonhard leaves the factory and enters a scholar's career. With undisguised devotion, the narrator chronicles how he is "transformed step by step from a crude and lawless barbarian into the equivalent of a rational and logical citizen of the Roman world" (601; 590).

The Demons culminates on the fifteenth of July. In the long final chapter that describes the events of that day, the narrator brings together all his characters one last time, moving from one to the other in rapid succession, relating everyone's emotions, thoughts, and acts, making sure to let their individual contours stand out against the sky of burning political passions. It is a day when deals are closed, relationships confirmed, and all loose threads tied up. It is through Leonhard's eyes that we first see the demonstration. "An immense crowd of people" that "looked like a moving wall" approaches the university library where the former night-shift worker is studying (1212; 1224–25). Among the demonstrators are Leonhard's old comrades. He has no wish to join them. They pose a menace to his newly won independence. "It might be sensible to lock up," he tells the doorkeeper of the library. "The library—such treasures—Pico della Mirandola . . ." (1213; 1226–27).

The Demons seems to offer a plural representation in which the demonstration is viewed from several street corners, windows, and balconies at once. Each witness contributes his or her account, the result being a collaborative view of the whole. The best viewpoint is reserved for the narrator himself. He is posted, field glasses in hand, in an apartment directly facing the Palace of Justice. "We no longer saw only the fleeing people; in running the crowd dissolved into innumerable individual dots; the scene became 'pointillistic,' and the intensely glaring sunshine emphasized that illusion. Now too we caught sight of the first victims; suddenly the square was spotted here and there with them, dark bundles in the sunlight" (1262; 1278).

On closer consideration, however, this seemingly pluralistic represen-tation is prepared and constrained by the philosophical thematic that separates "secondary realities" from the "actual reality." The characters who actively participate in the demonstrations are without exception those who indulge in a "second reality." They are portrayed either as criminals or as deluded fanatics, and ultimately they are personified by the most despicable character in the novel, the murderer Meisgeier. Rendered as a rat from the netherworld, Meisgeier ascends to Schmerlingplatz in front of the Palace of Justice through the sewers, motivated only by his lust to kill as many police officers as he can.

The multiplicity of perspectives is thus a narrative illusion. The reader will inevitably identify with the perspective of the onlookers, who hold on to their individuality. One such point of view is exemplified by the young historian René Stangeler, who sees a chaotic mass of people living out their ideological delusions. Imprisoned in "the rigid, isolated second reality," both the demonstrators and the police act with ruthless intolerance, knowing "precisely how things should be and whom they ought to shoot at, and why" (1237; 1252).

A second perspective inviting the reader belongs to the novel's fascist characters, who judge the violent disorder as a confirmation of the urgent need of their own political order: "Let them knock each other's heads in. All the better for us" (1307; 1323).

A third and dominant attitude is exemplified by those who are utterly indifferent. Few of Doderer's figures are aware of what is happening around them. When informed about it, they hardly care, as they see no relation between their own lives and the "bundles" on Schmerlingplatz. "'Why, is there shooting . . . ?' . . . Quapp looked wide-eyed at Géza. 'Why—what has happened . . . ?' she burst out. 'I'll tell you all about it some other time, Quappchen. Salvos in honor of a dead boy'" (1249; 1264). Indeed, the major-ity of Doderer's figures experience the event only as an absence of trams in the street or when trying to switch on their lamps and coffeemakers.

A biographical reading would show that these three points of view and the values attached to each—that is, the disinterested view of the historian, the cynical view of the fascist, and the indifference of the loving couple, Géza and Quapp—could be traced back to the political views that Doderer him-self embraced at some point during the twenty-five years he worked on the novel.[75] In the mid-1930s, Doderer, at that time a convinced Nazi, planned

to have the fifteenth of July demonstrate the pernicious influence of Jews, whose presence, as he saw it, caused Vienna to split into rivaling fractions, a scenario that would justify Hitler's anti-Semitic laws. In the early 1940s, however, Doderer converted to Catholicism and came to embrace an explicitly antipolitical and archconservative attitude. This was then followed by a period of renewed interest in history, now evaluated from the point of view of individualism. The fifteenth of July thus emerged as a regrettable example of the ways in which men and women are blinded by ideologies.

The Demons can contain these and related perspectives because it presents itself as a "diary of a collective entity" (6; 9). The narrator explains that several minds and pens have submitted the material to his chronicle. This is what makes *The Demons* so remarkable: it develops a genre of its own—a diary of a collective entity—through which it manages to incorporate and exhibit the psychology, values, attitudes, and everyday life of an entire class. The representatives of this group have, to be sure, some sense of community. At the beginning, they even refer to themselves as "*die Unsrigen*," or "our crowd." Yet what distinguishes this collective entity is, paradoxically, that the voices contributing to the chronicle do not see themselves as a "we," much less as a class, but as a set of autonomous individuals. Consequently, *The Demons* is not just a collective novel but a collective "novel of apprenticeship"; it is the bildungsroman of a group and, it should be added, an almost exclusively male group. At the outset, Doderer's people seek comfort in the company of one another, in the "second reality" of their own group. The novel chronicles how they evolve from this stage to a higher level of existence, where they all—or at least the successful ones—attain a solid sense of reality by realizing that they carry the key to their happiness and freedom within their own individuality. As Leonhard states with explicit reference to the inability of his comrades to free themselves from the collective: "The gates to freedom often stand wide open, and no one sees them" (1295; 1311).

Doderer's program of personal cultivation, however, can prove its superiority only in contrast to the more primitive stage that it surpasses. This is why July 15 is central to *The Demons*; it represents precisely that primitive stage: the rule of the masses, blinded by ideology, confined to a second-rate reality:

> They did not march because the murderers of a child and war veteran were getting off scot-free, but because the child had been a worker's child and the veteran a worker. The "masses" were demanding class

justice, against which their leaders had so often cried out. The people stormed against the verdict of a people's court, against their own verdict. That broke the backbone of freedom; from that point it was maintained in Austria for only a short time, and artificially. The so-called masses have always been fond of settling in a compact group upon the branches of the tree of liberty which tower into infinity. But they must saw off these branches; they cannot help themselves; and then the whole tree collapses. Sit where he will, the man who listens to the "masses" has already lost his freedom. (637; 624)

The Demons is pervaded by a fear of the masses. As Claudio Magris suggests, it may even be marked by a fear of history.[76] This being said, the novel's depiction of social reality is so comprehensive, almost exhaustive, that it cannot help presenting its ideal of an antipolitical individualism as being in itself a political choice, the choice of a particular class. Thus, *The Demons* in fact explains the collective violence on the fifteenth of July—not, however, in the way that its author and narrator explains it but rather, in spite of itself, in the way in which it exposes precisely those values and ideas that predestined a large part of Vienna's citizens to experience the workers as a palpable menace, to misrecognize them as a raging mob that must be suppressed. When read against the grain, Doderer's novel discloses the July violence as the outcome not of any "mass insanity" but of what Baudelaire once called "the madness of the bourgeoisie."[77]

6. INVINCIBLES

This achievement, which cannot be highly enough estimated . . .
can also be attributed to the fact that the Police Department of Vienna
once again has proved itself to be the most steadfast protector of the
order of the state.

Barely had the corpses been removed from Ringstrasse when Chancellor Ignaz Seipel issued an official statement in which he praised the police department as "the most steadfast protector of the order of the state." Liberal and conservative newspapers—*Neue Freie Presse, Reichspost, Wiener Neueste Nachrichten, Neues Wiener Journal, Wiener Allegemeine Zeitung*—rapidly established this view of the fifteenth of July as the truth.

In a series of essays published in his journal *Die Fackel*, Karl Kraus condemned the establishment for its silence and its support for the chief of police, Johann Schober. The citizens of Vienna had witnessed the slaughter of eighty-five innocent civilians without raising their voice. Even worse, they believed that it was reasonable to murder in order to "protect the republic."

Since the journal's foundation in 1899, Kraus had used *Die Fackel* as a tribunal, with himself as the incorruptible judge of humankind, fighting slack common sense, political mediocrity, and corrupted language with his inimitable satire. The July events infused his satirical capacity with a primordial rage. Kraus mustered all his intellectual powers to expose what he saw as the real nature of Austria's celebrated bulwark of republican liberty and justice: a legal system that exercised justice by acquitting murderers and by murdering those who dared to protest. Worse still, no one seemed to mind: "No one in this society, not a single person, has felt himself called to stand up and confess: the red flames on the sky over Vienna on July 15 must fade before the shame over the deeds and the cannibalistic well-being of a governmental authority and a bourgeois public whose sole concern at the moment was the negative impact on tourism."[78] The nature of our monstrous condition can be measured, Kraus wrote, by the fact "that just days after Vienna has been turned into a *Nadererhölle* it is still possible for a liberal power-licker to editorialize about 'this distinguished, earnest Man, this good-hearted, this the most humanitarian of all chiefs of police.'"[79]

The July events fueled a campaign that Kraus already had going against Schober and Vienna's press. Shortly before the Schattendorf process, liberal and conservative newspapers had criticized the death sentence of Sacco and Vanzetti in the United States, but now they did not dare to speak out against a similar abuse of the legal system in their own homeland. As for Kraus's attack on Schober, it had its origin in 1924, when the police chief had allowed Imre Bekéssy, a Hungarian newspaper owner who made a fortune in Austria by blackmailing companies and individuals, escape from trials in Austria.[80] How could it be, Kraus asked, that the government and the upper classes still unanimously supported Schober although he had set free a major criminal and killed innocent civilians?

To protest against the situation, Kraus consolidated his journal into a parallel seat of the law. On September 17, 1927, he let post on the walls all over Vienna a bill, signed with his own name and addressed to Schober, demanding that the chief of police resign (see figure 1.4). Elias Canetti

An den Polizeipräsidenten von Wien
JOHANN SCHOBER

**Ich fordere Sie auf,
abzutreten.**

KARL KRAUS
Herausgeber der Fackel

FIGURE 1.4 Karl Kraus, poster calling for the resignation of the chief of police Johann Schober. *Source:* City Library of Vienna, Wienbibliothek im Rathaus, P 13321.

describes in his memoirs how he walked from one poster to the next: "And I felt as if all the justice on earth had entered the letters of Kraus's name."[81]

Kraus's poster was only the first in a series of public assaults on Schober, culminating with the satirical drama *Die Unüberwindlichen* (1928; The invincibles), which ruined Schober's record for all posterity. The efficiency of Kraus's tribunal depended entirely on his satirical genius. As all writers of satire, Kraus earned his right to condemn the present by endorsing the ideal. Like all true satirists, he was authoritarian, and, like all true satirists, he rested his authority on a utopian ethos.

Kraus condemned the biased justice of Austria in the name of a higher justice. He went on to relativize the alleged impartiality of the Austrian press in the name of a higher impartiality. In so doing, he exposed that the seemingly sober common sense of the upper classes was a mere disguise for their self-interest, their prejudices, and their irrational "fear of the elements"—a fear that prevented the bourgeoisie from seeing society clearly.

By revealing the passions underlying the Viennese establishment's support of the authorities, Kraus also stripped bare the jargon about the dangerous masses. He established that the opposite term of the rioting masses, far

from being rationality or justice, was something else, namely, the political passions of those who govern and those who benefit from this government. It was a simple but crucial discovery: "the masses" is a category that is always embedded in the field of power.

The symbolic tribunal of *Die Fackel* thus issued two related verdicts. First, it delegitimized the political and legal representatives of the young republic: the legal system had ceased to represent the law, and the political government had ceased to represent the people. Second, it cracked down on the ideological and epistemological hegemony of the press and the civil authorities. Through an act of discursive emancipation, he freed the men and women who had been protesting from the stereotypes that had enabled the government, the police, and the press first to mistake them for "criminal elements" or "violent masses," then to confront them with excessive violence, and, finally, to justify such repressive measures by continuing to refer to them as "masses." Against this story about Order's defeat of Anarchy, Kraus mobilized another stylistic skill that he had developed into an art form. He broke down the allegedly homogeneous opponents in the struggle into their constituent elements, unfolding before the public an extensive montage of eyewitness accounts, testimonials, and citations. Of the ninety-two pages that make up Karl Kraus's first essay on the July events, "Der Hort der Republik" (The bulwark of the republic), the first forty-eight contain an arrangement of quotations from victims, witnesses, participants, journalists, commentators, and protectors of the state. The multiplicity and heterogeneity of these fragments demonstrate the inadequacy of such categories as "the masses" to describe the demonstration.

According to Gerald Stieg, Kraus's montage constitutes an intermediary stage between the political event itself and a literary rendering of it, as would come to full expression in *Die Unüberwindlichen*.[82] The pages of *Die Fackel* would thus allow a glimpse of *history* in the process of becoming representation, or fiction. However, Kraus's technique also moved in the opposite direction, working through an already fictionalized representation produced by the Viennese press and the government so as to bring the reader face to face with the sources. Informed by ideas similar to those of Brecht, Benjamin, or the constructivists, Kraus's montage subverts the dominant fiction about the dangerous masses and the steadfast police. It dissolves the homogeneous representation of the event and prompts a fresh look at the ideological contradictions that had been weeded out in official accounts.

Where the news media and the government had construed the July events as an act caused by one homogeneous agent, "the masses," Kraus regarded this agent as multiple individuals, and he attributed the cause of the violence to the uniform ruthlessness of the authorities, embodied by the chief of police. Johann Schober's achievement was a magnificent one, Kraus concluded. He protected the Glory of the Republic by massacring its citizens.[83]

7. MIRROR FOR PRINCES

The management of the Gleichenberg Health Resort offers healing cures to the security forces without payment, a number of hotel owners and innkeepers have pledged to provide police officers with complimentary meals and lodging.—The Chief of Police has accepted the offer.

The various authors who wrote about July 15, 1927, in Vienna depicted the masses in radically different ways. Kraus and Doderer construed the protesting crowds from opposite ends, as it were, with Doderer looking at the event from afar through his field glasses and discovering a pointillistic scene consisting of colored dots, and with Kraus moving in on the drama to record the first-hand impressions of the men and women participating in it. Elias Canetti offers a third point of view. Like Doderer, Canetti employed "the masses" as a name for humanity's primitive impulses. In contradistinction to Doderer, however, Canetti saw no way of escaping or denying them. To do so would entail a kind of psychic self-mutilation, a self-inflicted impoverishment, as these collective impulses are a constituent feature of the human being. In Canetti's novel Auto-da-fé (Die Blendung), which was also conceived in the light of the burning Justizpalast, the masses are no remote phenomenon but always close upon the body and its senses. Indeed, the mass is one with the individual, every individual, for it exists within him. As a character in Auto-da-fé clarifies: "We wage the so-called war of existence for the destruction of the mass-soul in ourselves, no less than for hunger and love. In certain circumstances it can become so strong as to force the individual to selfless acts or even acts contrary to his own interests. 'Mankind' has existed as a mass for long before it was conceived of and watered down into an idea. It foams, a huge, wild, full-blooded, warm animal in all of us, very deep, far deeper than the maternal."[84]

It was this "mass," intrinsic to the human subject and anterior to individuality, that Canetti would examine in his dramatic works, *The Wedding* (1932; *Hochzeit*) and *Comedy of Vanity* (1933; *Komödie der Eitelkeit*), and above all in his magnum opus, *Crowds and Power* (1960; *Masse und Macht*), in which he traced the forms of appearance and modes of formation of "the mass" throughout human history. In Canetti, the mass equals the social instinct and it thus forms the basis of individuality. Individuals who attempt to repress the mass by taking shelter in their individuality will always find that it returns to haunt them. This is what happens to the hero in *Auto-da-fé*, the bookworm Peter Kien. Like Doderer's characters, he believes himself to be securely separated from the masses by virtue of his immense erudition.

However, as Canetti's narrator establishes, *Bildung*, or education, is just a "*cordon sanitaire* for the individual against the mass in his own soul."[85] An individuality like Kien's, constructed as an absolute value and erected in opposition to "the mass," inevitably results in self-destructive paranoia. Peter Kien is eventually consumed together with his library in a great fire, just like the Palace of Justice, the symbol of a law erected in opposition to "the people," was set ablaze in July 1927. Where Canetti lets Peter Kien's bourgeois apartment go up in flames, together with the librarian himself, Doderer's librarian, the former proletarian Leonhard Kakabsa, safely watches the burning Palace of Justice from his terrace. For Canetti, the human subject is both individual and mass and goes under if he or she chooses one over the other.[86] For Doderer, the human subject must choose.

Of the three writers, Heimito von Doderer clearly stands closest to the dominant idea of mass psychology as it was codified by Gustave Le Bon and perpetuated into early-twentieth-century social thought. Given Doderer's definition of the masses as opposed to individuality, and given his view of individuality as the support of rationality, he is compelled to represent the crowd as disorderly and destructive, as an agent of leveling passions that must either be raised by education or struck down by suppression. The masses in Vienna were typically represented in conformance with this cliché, which is demonstrated with particular clarity by visual renderings that were intended as deterrents against the Left. In a poster made by Rudolf Ledl for the Christian socialists and the *Heimatswehr* in the election campaign of 1930, for instance, the rebelling masses were personified as an insane and raging pyromaniac, setting fire to Austria as a whole (see figure 1.5).

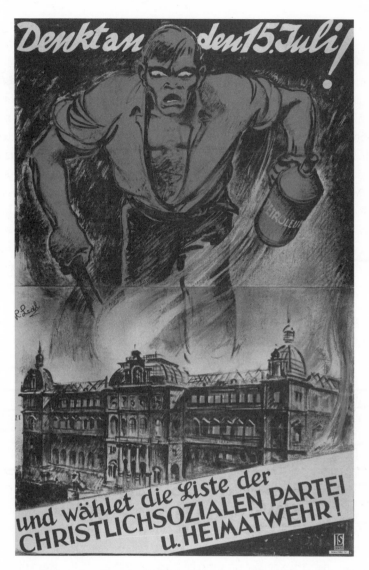

FIGURE 1.5 "Remember the 15th of July! And Vote for the List of the Christian Socialist Party and the Homeland Defense!" Austrian election poster, 1930, by Rudolf Ledl (198 x 126 cm). *Source:* City Library of Vienna. Wienbibliothek im Rathaus, P-366.

At a deeper level, however, the mechanisms of representation in Canetti, Kraus, and Doderer disclose a more intriguing pattern. Their texts reveal that it is the ways in which they represent the social passions of the fifteenth of July that determine what content they give to the "the mass" as well as "the individual" as social agents. As we have seen, the notions of mass and individual change depending on how these writers situate themselves as representatives of the political passions activated by the demonstration and depending on the narrative forms and perspectives they employ to represent the event. Their acts of representation thus seem to produce the phenomenon, the mass, that they claim to represent. With each new form of representation or depiction, a different mass will appear.

What is suggested by July 1927 is that regimes of political and cultural representation exist in contradiction to "the masses." Under peaceful social conditions, this contradiction assumes the form of equilibrium. But the contradiction remains at the heart of every political and cultural system, as the dominant regime constitutes itself in opposition to "the people," or "the masses."[87] In this view, the latent or actual contradiction between the regime and the people is the trace of an originary structuring of the social field, which institutes political power as such. The originary structuring of society is an act of representation whereby someone becomes the representative of others, thus instituting a distinction between representatives and represented, between sovereign and people, government and subject, ruler and ruled. On the cultural and psychological level dealt with in mass psychology, this division manifests itself precisely as a distinction between individuals and masses.

This division is never quite stabilized; it must always be managed, controlled, and reasserted through rituals of power. The accounts of Canetti, Kraus, and Doderer demonstrate how in times of crisis the same division generates violent confrontations. Doderer and Kraus also disclose, from opposite ends, the social and material factors that decide the ways in which the population is divided between the two poles. Those who consent to, or collaborate with, the ruling regime will be situated as individuals in relation to this power. Those who resist the ruling power or turn their back on it, that is, those who are external to its hegemony, will be situated as "the masses," a denomination that justifies whatever programs of education, persuasion, and domination the state finds appropriate in its effort to preserve and extend its hegemony.[88] The discourse of mass psychology has

fulfilled a crucial role in this project, where it has functioned as a virtual textbook in statecraft and the art of ruling, a twentieth-century counterpart to Machiavelli's *The Prince*, advising leaders how to rule by channeling the ✓ passions of the crowd.

8. WORKERS ON THE RUN

There were forty-eight dead there, among them a single woman.
This woman was my wife. There I finally found her; there I found
the terrible truth.

One scene from the fifteenth of July 1927 in Vienna was preserved in several photographs. I first saw this picture in the archives of the Labour History Society in Vienna. It is a long-range camera shot down the Ringstrasse (see figure 1.6). In the foreground, the avenue is empty. Scattered debris on the pavement suggests that the place has been deserted in

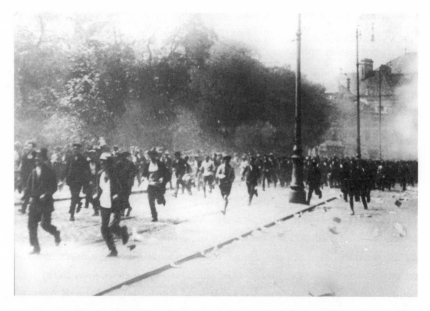

FIGURE 1.6 Panic-stricken demonstrators and onlookers fleeing from police gunfire, Vienna, 15 July 1927. Unidentified photographer. *Source:* Austrian National Library. ÖNB/ Vienna. LW 74.632–B.

a hurry for some unnatural reason. In the background we see what Doderer's Leonhard Kakabsa saw on his way to the library: a moving black wall, an immense crowd of people emerging from far away and curving toward the left flank of the picture, at which point the crowd drops out of view as it passes the extremity of the camera angle. Unlike the crowd approaching Leonhard, however, the masses we see in the photograph are not approaching at their own pace but in wild flight. Whatever it is that they are fleeing from, it is hidden from view by the black mass of their own bodies.

The next picture reveals the source of their panic. This photo was published in Germany's major illustrated magazine, *Berliner Illustrirte Zeitung*, a couple of weeks after the demonstration (see figures 1.7 and 1.8).[89] We see the same segment of Ringstrasse but a few seconds later. The photo is perhaps shot by the same camera. The position of the photographer is roughly the same, although the lens has turned rightward in order to capture the action at the other side of the street. Also, the crowd is now closer, almost running into our face. At the right front two young men are running, their attire indicating that they are workers. Not far behind, mounted police are racing forth with their sabers poised above their heads and ready to strike. This image is more dramatic than the first one because it offers a direct view of the antagonists. The impression is heightened by the fact that the faces of the workers are blurred, either because they are too close to the camera or because they are obscured by the shadows from nearby buildings. The police officers are also fuzzy because they are too far away. We can make out only their most prominent features, their helmets, their number, the raised saber, the hooves in the air giving the impression of assaulting speed, but the rest is dimmed by a hazy background (smoke?) and the dark-gray buildings at the far end of the street. Given the composition, in which the demonstrators occupy the foreground, one of them even illuminated by a ray of sunlight strangely bursting through the haze, the caption in *Berliner Illustrirte Zeitung* is perplexing: "Mounted police while evacuating a street [Berittene Polizei bei der Räumung einer Strasse]". There is no word of the workers running for their lives, leaping from the page toward the reader. There is just mention of the police making a clean sweep. The attitude toward the masses revealed by the editing of the magazine is thus the same as in the action of the police. The workers are made invisible by being forced to disappear. Or worse, they are removed and eliminated, from the Viennese street as from the Berlin magazine.

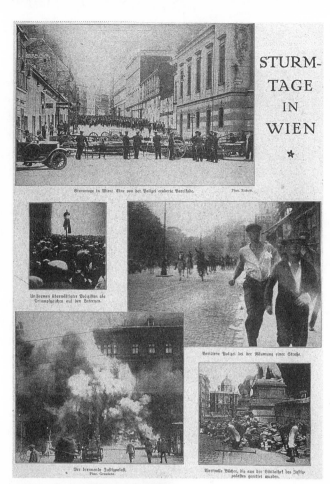

STURM-
TAGE
IN
WIEN

*

Sturmtage in Wien: Eine von der Polizei eroberte Barrikade. Phot. Nitsch.

Uniformen überwältigter Polizisten als
Triumphzeichen auf den Laternen.

Berittene Polizei bei der Räumung einer Straße.

Der brennende Justizpalast.
Phot. Gesandene.

Wertvolle Bücher, die aus der Bibliothek des Justiz-
palastes gerettet wurden.

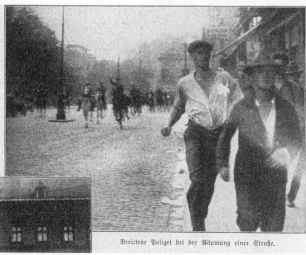

Berittene Polizei bei der Räumung einer Straße.

FIGURE 1.7 *(above)* "Days
of Storm in Vienna." Page
from *Berliner Illustrirte Zei-
tung,* July 1927. *Source: Berliner
Illustrirte Zeitung* 36, no. 30 (July
1927): 1190. Photo: David Torell.

FIGURE 1.8 *(left)* "Mounted
Police While Evacuating a
Street." Detail. *Source: Berliner
Illustrirte Zeitung* 36, no. 30 (July
1927): 1190. Photo: David Torell.

Now consider the third picture. The motif, camera angle, and composition suggest that this image is a print from the same negative as the one just described (see figure 1.9). The same men are running toward us, the same mounted police are chasing them with their sabers. Photographs two and three are by all measures identical. But the third picture is nonetheless entirely different. This version was published in an album put out by the Social Democratic Party to commemorate the victims of the police violence.[90] For this purpose the picture of the running workers and the attacking police was retouched. The facial traits of the running workers, the contours of their bodies, and some details of their clothing have been filled in with pencil or black ink. Thanks to this visual "enhancement," the demonstrators come across less as a compact dark mass and more as ordinary men trying to get away from the police. The police officers have not been afforded the same benevolence. The only thing that has been retouched in their section of the picture is the saber, highlighted with white colored pencil, to the effect that it shines like an electric rod or some supernatural instrument of torture. Recall the caption in *Berliner Illustrirte Zeitung*: "Mounted police while evacuating a street." In the social democratic album the demonstrating workers are quite literally put back into the picture. The caption states: "Police officers on horseback break the demonstrators apart [Die Polizeireiter jagen die Demonstranten auseinander]".

Already in an ordinary newspaper photo we thus see how the masses appear differently depending on how they are visually represented. This illustrates what I have already stated about Doderer, Kraus, and Canetti. In an ontological sense, they all experienced *the same crowd*. Still, the masses they wrote about were different because they were conveyed through differing modes of literary representation.

When juxtaposed, these three photographic images thus demonstrate something they are unable to reveal one by one in isolation: the masses that they pretend to show are not really there, do not really exist, but are an effect of the ways in which the human collectives who took to the street in Vienna on the fifteenth of July were represented. In this regard, three things seem decisive: First, the masses will change appearance depending on the presence or absence in the representation of the force or factor that explains their behavior. The crowd running down the street in the first picture appears irrational and erratic as long as we do not see the mounted police. Second, the masses appear as masses only when seen from a dis-

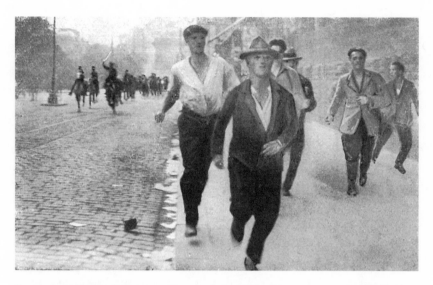

FIGURE 1.9 "Police Officers on Horseback Break the Demonstrators Apart." Uniden-
tified photographer. *Source:* From Julius Braunthal, *Die Wiener Julitage 1927: Ein Gedenkbuch*
(Vienna: Verlag der Wiener Volksbuchandlung, 1927), 18. Photo: David Torell.

tance, that is, only by an observer who is not part of the collective; the
masses will thus change as that distance expands or contracts. Third, the
obliteration of facial traits seems necessary in any representation of masses.
This is the rationale that must have informed the somewhat clumsy attempt
to retouch the running workers by filling in their facial traits and delineat-
ing the contours of their bodies so as to ensure that they are perceived not
as an amorphous mass but as separate individuals.

In this simple yet fundamental sense the masses seem to be an effect
of an act of representation that obeys basic principles of optics and per-
ception. As we have seen, a crowd is any large number of human beings
perceived from a distance. Conversely, any large group of human beings
will, when perceived from a distance, appear as a crowd. Moreover, people
cease to appear as individuals and start to appear as masses exactly at
the moment when the distance separating them from the perceiving sub-
ject is so great that this subject no longer distinguishes their faces. This
implies that people who are able—or can afford—to put sufficient distance
between themselves and the majority of others tend to perceive this major-
ity as a crowd.

According to Klaus Theweleit, fascist ideology contained two contradictory notions of the masses.[91] On the one hand, there was the "block," its passions completely represented by the leader and all affections contained. The block was an armored mass, drilled and disciplined, violently cut to shape in order to fit the representative units of the soldier, the army, the race, the nation, and *das Volk*. On the other hand, there was the swarm, a mass not yet dammed up and disciplined and whose presence threatened to dissolve the hierarchic units of the fascist order. This was the Jewish mass and the Gypsy mass or the mass of hysteric females and irremediable communists, all of them associated with miscegenation, transgression, femininity, and egalitarianism. Fascism transformed the distinction between "individual" and "masses" into the rigid relation between *Führer* and *Volk*, the latter purged of all signs of difference. An avid reader of Le Bon, Goebbels explained their relationship: "Leader and mass, that's no more of a problem than painter and paint. To form a mass into a people and the people into a state has always been the deepest meaning of true politics."[92]

Drawing on Deleuze and Guattari, Theweleit calls fascism a "molar" mobilization of the masses. The goal was to transform the swarm into a block by purifying the passions of every subject so that it was transformed into a clean and uniform unit, which could then be assembled with other such units into larger entities, the result being the enormous blocks of bodies that parade, endlessly, before the party elite in Leni Riefenstahl's legendary film *Triumph of the Will* (1935). In contradistinction to this, Deleuze and Guattari suggest the idea of a "molecular" mass, characterized by an infinite multiplicity of plural agents whose heterogeneous flow of passions forms rhizomatic webs that transgress all boundaries.[93]

The distinction between the molar and molecular organization of society would thus correspond to the two extreme alternatives available for representing social passions.[94] A molar politics is one where a single political representative irreversibly represents all socially significant passions. A molecular politics is one where the passions are not represented at all. It would conform to a society without political representation, in which there would be neither individuals nor masses but only singular human beings.

The movement from molar to molecular roughly corresponds to the trajectory of this book. In this chapter I have portrayed the mass as event, and I have also introduced the dominant view of the masses that lay behind the violence of 15 July 1927. This view construed the masses as the negation of individuality, reason, and responsibility, as bundles on the pavement or as

a moving wall. In the following chapters, I will explore other ways of repre-
senting social passions and social formations, be it as masses, collectives, or
some other social substance. First, I will discuss attempts by Weimar social
scientists to transform the mass into a scientific category and to establish
a discipline of mass sociology. Through readings of Hermann Broch, Ernst
Toller, and Sigmund Freud, I then examine various authoritarian interpre-
tations of the masses, all of them related to but not identical with how
fascist politics and culture mobilized masses by drilling them into an *army*
or fusing them into a *people*. The most intriguing of all interwar ideas of
the masses, however, were those that did not see the mass as the negation of
individuality. In chapters 3 and 4 I discuss writers, artists, and intellectuals
who redefined the mass not as the antithesis of the individual but as the
original cell of communal perception and action. Or they went even further,
positing the collectives called masses as a promise of emancipation from
oppressive social and cultural identities.

The structure of this book thus forms an arch, one end planted in a hier-
archical conception of society, in which the mass is rendered faceless by the
overshadowing presence of a leader or an elite, the other end, in a horizontal
view of society in which the mass transforms itself through acts of collective
self-representation. At this end—as Paul Tillich maintained in his treatise on
religious socialism *Masse und Geist* (1922, Mass and spirit)—"there no longer
is any 'mass' and no longer any 'personality,' but only human beings carrying
within themselves substance and form in indissoluble unity."[95] The move-
ment across this arch matches the transformation undergone by the photo of
the running workers in Vienna as it passed from the unknown photographer
to the illustrated pages of the Berlin magazine and on to the editorial offices
in Vienna, where an unknown designer in the graphics workshop put back
what had been removed from the picture, the human essence of the running
workers, though not quite able to make it fit where it had once belonged.

9. LASHING

Then they started firing their guns into the City Hall, because a few
people behind the gate had shouted, "Pfui!"

There is another photograph from the fifteenth July 1927 in Vienna. This
one is taken in the morning and it shows a large group of the workers at

Vienna's gas and electricity plant just before they set out on their march to the city center. The workers seem determined and a bit insecure, and they have not lined up in rows or columns. Two of them are carrying a handwritten banner: "Protest dem Schandurteil. Wir greifen zur Selbsthilfe. [Protest the shameful verdict. Now we help ourselves.]" (see figure 1.10).

People helping themselves? Is that another way of expressing the origins of democracy? At eight o'clock on the fifteenth of July 1927 the workers switched off the gas and electricity. What were halted were not only public transportation and energy supply but the whole machinery of communication and representation by which the Austrian government wielded its power. The uprising was spontaneous, a display of political passions under nobody's command. The signal was issued by the electricity workers, to be sure. But once set in motion, the demonstration had no leaders, no guiding slogans, no manifestoes, not even any firm demands. There was only a passionate wish to turn the city into an arena in which the workers could enact their anger, disappointment, solidarity, and sense of justice. This enactment short-circuited the institutionalized structure of political representation. The demonstration consequently lacked unity and order because unity and order can only be brought about by representing the passions in specific forms. Vienna's masses chose every form. Passions of anger and self-interest, normally coded as illegal, blended with the passions for justice. Solidarity and gasoline entered the Palace of Justice side by side. In brief, the events on the fifteenth of July were a realization of a mass politics marked by spontaneity and heterogeneity, no leader being at hand to stir the passions of the crowd.

Singular human beings who use their bodily presence to represent their social passions are always the principal enemies of the State, writes Giorgio Agamben. Whenever and wherever such manifestations take place, one may be sure that, sooner or later, "the tanks will appear."[96] From this angle, the fifteenth of July also saw the realization of the very opposite of the spontaneously acting heterogeneous crowd. In fact, it was a rehearsal of that violent suppression of social passions soon to be realized under fascism. The perception that guided the decision of Austria's government and Vienna's police authorities may be compared to the vision of the rightist militias who curbed workers' councils and communes all over Germany during the winter of 1918–19. As Klaus Theweleit has discussed, these warriors saw the restless proletariat as pure formlessness, in relation to which

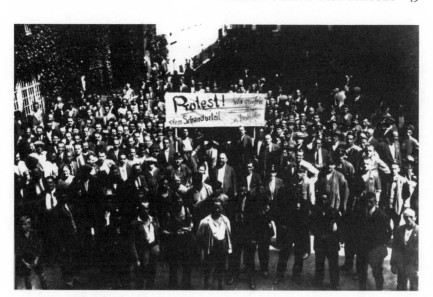

FIGURE 1.10 "Protest Against the Shameful Verdict." Demonstrating workers on the morning of 15 July 1927. Unidentified photographer. *Source:* Austrian National Library. ÖNB/ Vienna. LW 74.627-B.

they erected their own masculine individuality. This is how one member of the militia, Ernst von Salomon, viewed the revolting workers: "The face of the mass, rolling sluggishly onward, prepared to suck anything that offered no resistance into its mucus whirlpool. I had no wish to succumb to the maelstrom. I stiffened and thought 'scoundrels' and 'rabble' and 'pack' and 'mob,' narrowed my eyes to scrutinize their moldering, emaciated figures. Like rats, I thought, wearing the dirt of the gutter on their backs, scrabbling and gray with beady, red-rimmed eyes."[97] In 1918, as in 1927, the phantom face of the mass called for retaliation: "If the troops don't fire at precisely the right moment, if the troops lose their nerve, they are crushed and trampled within seconds. In this case, the troops did fire, the demonstration was broken apart."[98]

Of all the perceptions registered in the eyewitness accounts from the fifteenth of July, the sounds of the day seem to have made the strongest impression. The noises record the affections circulating within the social collective, tracing a curve from the peoples' display of their passions to the state's display of its force. In the first hours of the morning: the

disordered cacophony of the masses—"Pfui! Booh! Shame!" After noon: the stunned silence of hundreds of thousands of people watching justice being reborn in the flames from the Palace of Justice. Then, as evening drew near, the rifles' call to order: "This sound was like a sharp line, the snap of a lash."[99]

2

Authority Versus Anarchy

ALLEGORIES OF THE MASS IN SOCIOLOGY

AND LITERATURE

10. THE MISSING CHAPTER

With the French Revolution and the advent of democracy, a new actor entered the political arena: the people. Almost a century later, with the consolidation of the organized labor movement, or the so-called fourth estate, this political force was successfully promoting universal suffrage, social justice, and the establishment of democratic sovereignty.[1] Not everyone welcomed this social and political transformation. Many feared that the treasured voice of the people foretold the wicked rule of the mob. As ordinary people slowly worked their way into the political arena, the elite claimed that the stage of history was invaded by threatening masses.[2] The scholarly discourse of crowd psychology was an expression of this development and a reaction against democracy. From the outset, it exhibited an antiliberal and antidemocratic tone. In his 1959 overview of theories of mass society, the American sociologist William Kornhauser called this an "aristocratic"

theory as it expressed "an intellectual defense of elite values against the rise of mass participation."[3] Along with this discourse came an array of terms and opinions that journalists, writers, and the educated classes appropriated and made part of their political worldview, especially their understanding of the lower classes.

Surveys of crowd psychology tend to dwell first on its French and Italian origins, usually establishing Gustave Le Bon's *La psychologie des foules* (1895) as the doxa of the discourse, and often disregarding the more important research contributions of Scipio Sighele's *La folla delinquente* (1891) and Gabriel Tarde's *Les lois de l'imitation* (1890) and *L'opinion et la foule* (1901). The historical reviews then jump to Sigmund Freud's reinterpretation of Le Bon in *Massenpsychologie und Ich-Analyse* (1921). Freud's essay is typically seen both as a continuation of Le Bon's theory and as a new departure, out of which come the various theories of the masses of the 1920s and onward.[4]

These surveys tell a continuous story where little changes between the understanding of the masses in late-nineteenth-century Paris and the debate on the masses in interwar Germany and Austria. In fact, most analyses of crowds and crowd behavior in modernity still enroll Le Bon as their guide as the discipline of crowd psychology continues to serve as leitmotif for the analysis of crowd phenomena, no matter what society and historical period.[5] Of course, it is no falsification to construe crowd psychology as a continuous discipline with a specific genealogy of founders, traditions, branches, and intrinsic preoccupations. It is to be doubted, however, that this kind of history of ideas offers interesting approaches to interwar European history and culture. Nor is it certain that canonical crowd psychology serves us well as a master key to historical events of any kind. When Weimar ideas on "the masses" are analyzed in relation to this theory, the historical specificity and contextual references of the Weimar discussion is often occluded.

Late-nineteenth-century crowd psychology was confined to clinical psychology, public policy, and history writing. The Weimar discourse on the masses, by contrast, concerns society in its totality. It addresses the future of humankind, often unfolding entire metaphysical systems, as is the case with the theories of Sigmund Freud, Elias Canetti, Hermann Broch, and Oswald Spengler, or large-scale mappings of society as a whole, as in Weimar sociology before and after the First World War.

A crucial chapter is therefore missing in existing histories of the masses. Between the turn of the century and 1920 lie at least three events that shat-

tered inherited assumptions about society and politics: first, the estab-
lishment of universal suffrage in most Western countries (in Germany in
November 1918), brought about by the dual force of the workers' movement
and the women's movement; second, World War I, with its patriotic frenzy;
third, the Russian revolution, which many Europeans perceived as the ulti-
mate "revolt of the masses," especially so in Germany, which experienced
its own wave of socialist revolutions in 1918 and 1919. A population fatigued
by war, poverty, and unemployment now unseated traditional political rep-
resentatives, from the emperor to local mayors, opting instead for a social
organization in accord with principles of self-government and participa-
tory democracy. Of course, all these processes had to have a tremendous
impact on both the intellectual and the popular view of the masses.

What happened between Le Bon's 1890s and Freud's, Spengler's, and
Canetti's 1920s was not just a transformation of the idea of the mass but
also a transformation of the idea of individuality in relation to which the
mass had been viewed, analyzed, defined, and denounced. Intellectuals
writing about the masses in the nineteenth century were lodged securely
in their belief in individuality. When trying to define the masses they typi-
cally described them as a negation of their chosen mode of self-definition.
Positing themselves as independent individuals defined by reason, ethical
responsibility, and erudition, crowd psychologists asserted that the mass
lacked such faculties. It was irrational and ruled by passions.

With the exception of Durkheim, however, French sociologists of the
1890s failed to develop any properly sociological conception of collective
life forms. Social phenomena were explained as the products of the psycho-
logical interactions of individuals. One such product was the mass, defined
as a union of individuals governed by communal passions and agitated
by emotional suggestion to the extent that their individual identities were
swept away. By affirming that members of a crowd lacked individuality—
reason, identity, character, culture—crowd psychology usually served to
dispute the lower classes' ability to function as responsible political agents
and, hence, to deny them the right to vote.[6]

But what if belief in individuality wavered? What if individuality could
no longer credibly serve as the foundation of social order, decision mak-
ing, and moral behavior? In the 1890s, the jargon of mass psychology
often served to exclude those who supposedly had not raised themselves
to the civilized level of the cultured bourgeois and thus had no chance of

becoming autonomous individuals. In the 1920s, by contrast, the jargon about the masses voiced a deeper anxiety about a future *without* individuals and the values and qualities associated to individuality. In his famous cultural diagnosis of 1931, *Die geistige Situation der Zeit*, Karl Jasper identified "the mass" as a foundational feature of the contemporary world, in the sense that individual will was everywhere canceled by the qualities of the majority. "The basic problem of our time," he concluded, "is whether an independent human being in his self-comprehended destiny is still possible."[7]

11. GEORG SIMMEL'S MASSES

How to describe the slow transformation of French mass psychology into the twilight discussion on mass society and cultural decline in Weimar Germany and Austria's first republic? Georg Simmel's career bridges the years between the codifications of mass psychology around 1890 and the end of World War I. Simmel was also the first to introduce French and Italian mass psychology in Germany and Austria, presenting the two books that exerted the greatest influence on late-nineteenth century discussion on crowds and masses. Already in November 1895 he reviewed Le Bon's *La psychologie des foules*, published in France the same year.[8] Two years later he also reviewed the German translation of Scipio Sighele's *La folla delinquente*.[9]

Simmel is rarely mentioned in historical accounts of crowd theory. It is true that he never devoted a specific book or essay to the topic. In order to understand his theory of the masses we need to extract it from the general sociological writings in which it is embedded. In Simmel's work we see a German thinker approaching the category of "the masses" as it was elaborated in French crowd psychology, but only in order to open it up, extending its reference and finally applying it to the social field in its entirety. To be sure, Simmel's concept of the masses remains remarkably constant throughout this transformation, but he places it in a different theoretical and historical context. After an initial dialogue with the positivist crowd psychology of Tarde, Le Bon, and Sighele, Simmel's notion of the masses embeds itself in a different philosophical environment. The new landscape is shaped by influences from Bergson and Nietzsche, among others. Its name is vitalism, or *Lebensphilosophie*—both *lieu commun* and doxa of German thought at the beginning of the twentieth century.[10] In this way,

Simmel adjusts the conceptual machinery of mass psychology to the tradition of German social philosophy, at the same time retooling it for durability in the political terrain that emerged after World War I.

In his article on Le Bon, Simmel immediately problematizes the notion of the individual as the foundation of society and knowledge. Is it not true, he asks, that the historical method of the *Geisteswissenschaften* and the heredity theory of the natural sciences (i.e., Darwinism) have demonstrated that the individual is a mere cross-section (*Schnittpunkt*) of social tendencies? "Thus, society is everything, and what the individual can add to its properties is a *quantité négligeable*." Yet this proposition, too, is problematized. For is it not also true, Simmel asks, that all things that we value in life, everything exceptional and elevated, are "the products of individuals who have raised themselves above the social average?"[11]

It is impossible, Simmel concludes, to determine whether society is prior to the individual, or vice versa.[12] Intellectual paradigms have sometimes privileged the individualistic viewpoint, sometimes the social, Simmel observes. In contemporary France, most intellectuals lean toward the individualistic view, he argues, mentioning as evidence the enormous French interest in Nietzsche, as well as Le Bon's "ferocious charge against all kinds of democracy and socialism."[13]

Having thus refused to privilege either "individual" or "society," Simmel goes on to refute many of the assumptions of both Le Bon and Sighele. Both had defined the crowd as a single being governed by a "mass soul." Simmel objects that this definition stems from a confusion of cause and effect. Collective action often results in one massive effect—the destruction of a building, the roar emerging as if from one throat. This is where the confusion sets in, Simmel explains: "The unified external event resulting from many subjective mental processes is interpreted as an event resulting from a unified mental process—a process, namely, of the collective soul."[14]

Simmel also rejects the idea that the crowd can be defined by suggestibility. In Simmel's view, the psychological processes of an individual within a crowd are not different from those of an individual by himself. The emotional impact of a mountain view is not qualitatively different from the impact of a surrounding crowd.[15]

In refuting the idea of a mass soul and that of suggestibility, Simmel in fact rejects two major criteria that until then had been used to define the crowd, to the effect that he dissolves the foundation of French and Italian

crowd psychology and removes the frightening qualities that it attributed to "the masses." Yet in limiting the substance of the definition of the masses, Simmel at the same time extends the concept's applicability. No longer an entity following its own psychological laws, and no longer a simple ideological projection of the bourgeoisie, the mass is retained as a category for a certain type of sociation, or *Vergesellschaftung*, that encompasses modern society in its totality.

In one stroke, Simmel thus turns "the mass" into a sociological category. In his view, the aim of sociological inquiry was precisely the examination of various forms of sociation. Sociology should not conceptualize the contents of human activity, but the *social forms* under which this activity is pursued. Basically, this entailed the formal study of human interaction, including the ways in which this interaction generates institutions, hierarchies, and structures of subjectivity, in a word, various forms of sociation. Like Max Weber and Ferdinand Tönnies, the other two great founders of German sociology, Simmel inserted these forms of sociation in a historical trajectory whose guiding thread is rationalization, differentiation, and individualization. These processes spell the doom of one kind of society— Tönnies's *Gemeinschaft*, Weber's world of enchantment and charisma, and Simmel's small-town life with its homogeneous mindset and personalized exchange. In their wake, a new society emerges. For the human subject, these processes appear to be liberating. Yet the emancipatory thrust ends in unprecedented forms of unfreedom as the subject becomes entangled in a network of functions and abstractions that deprives it of individuality. If we follow Tönnies's analysis, we encounter, at history's end, the instrumentalized aggregate that he called *Gesellschaft*. If we follow Weber's analysis, we encounter a person locked inside the infamous iron cage. If we follow Simmel, we are faced with the mass, now being posited as the dominant form of sociation in modern society.

In my view, Simmel's definition of the mass may be summarized as follows: "the mass" is the concrete form in which the relation of human subject and society is made manifest in modern society. This relation can be analyzed historically or formally. Let me explain its historical meaning first.

On the very first page of his *Soziologie* (1908), Simmel states that it was the emergence of the masses that made scholars discover the relation of individual and society.[16] As the lower classes ascended during the nineteenth century, they also advanced into the view of the upper classes,

making these realize that the world is not just made up by individuals situated by providence in different stations and ranks, but that there is a phenomenon called society that conditions which class an individual will be part of. Each human subject now appeared as socially conditioned, impossible to conceive of in abstraction from society. Historically speaking, therefore, the presence of the masses for the first time made manifest the relation of human subject to society.

It follows from this, Simmel argues, that the masses, in fact, are the historical origin of sociology itself because the task of sociology is precisely to examine the relation between subject and society that the masses have exposed. Incidentally, and as evidence of Simmel's originality, this notion of the masses is very different from that of his colleague Ferdinand Tönnies. Whereas Simmel analyzed the masses as a historical formation typical of modernity, Tönnies subscribed to the more common idea that the mass was simply another name for the ordinary people, whom he regarded as the uneventful but timeless agency behind social change—the grass of history, on which society stood.[17]

Let me now turn to Simmel's formal analysis of the masses as a concrete representation of the relation between human subject and society. Simmel here repeats one crucial element of Le Bon's and Sighele's analyses, although he casts it in a theoretical frame that he developed already in *Über soziale Differenzierung* of 1890. The element concerns the leveling impact of the masses. A crowd, Simmel argues, must base its actions on desires and qualities that all its members have in common, and "what everyone has in common can only be the property of the one with the least property."[18] What Simmel argues, in short, is that a crowd is never more intelligent than its least intelligent member, never better than its worst part, never richer in possibilities than its poorest member. As he puts it in "Massenpsychologie": "It is always possible for the one who is up to step down, since the one who has more also possesses what is less; but the one who is down cannot ever step up."[19]

Simmel founds this argument on a theory about the relation between "the individual level" and "the social level" that is central to his sociology.[20] He argues that the smaller and more homogeneous a society is, the lesser the difference between the level of the individual and the level of the social group. As society grows larger and more heterogeneous, the individual has greater possibilities to differentiate himself. The diversification

of labor allows anyone to perfect his or her mastery of a limited task. As a consequence, however, the common ground shared with others is greatly reduced; it can consist only of the simple needs and generic traits of the entire species. Whenever a human being wants to interact with others or wants to influence them, he or she must descend to this level, for this is the only ground that he or she shares with those fellow humans.[21] The form of sociation in modernity thus allows everyone to become a genius in his own *Gebiet*, but at the cost of becoming an idiot in everything else. Simmel calls it a "sociological tragedy."[22]

The consequences of the sociological tragedy are manifested in the mass, Simmel argues. An individual who attempts to assert his or her individuality socially finds that he or she can effectively do this only by descending to the lowest common denominator of the members of his society. It is in this context that Simmel produces a clear definition of "the mass." He discusses the questionable virtue of journalists, actors, and demagogues who "seek the favour of the masses." This would not be so bad, he states, if these people really served the mass as a sum of individuals. Yet the mass they serve is no such sum:

> It is a new phenomenon made up, not of the total individualities of its members, but only of those fragments of each of them in which he coincides with all others. These fragments, therefore, can be nothing but the lowest and most primitive. It is this *mass*, and the level that must always remain accessible to each of its members that these intellectually and morally endangered persons serve—and not each of its members in its entirety.[23]

The sociological tragedy is accentuated by a closely related dilemma, what Simmel calls "the tragedy of culture." For Simmel, human life is an ongoing attempt to express one's inner being in external forms, cultural products, identities, and institutions. These forms constitute what Simmel calls "objective culture," in contradistinction to "subjective culture," the ineffable life process itself, what Henri Bergson called *élan vital*, which constantly urges for expression and for form.[24] As layer after layer of objective culture accumulates, these petrified sediments will gradually prevent the life process from reaching full expression.[25] Modern culture is more tormented than any other era by the conflict between individuals urging to

express their individuality more strongly than ever and a life world grown so dense, rigid, and intrusive that it effectively prevents everyone from expressing his or her individuality. In his famous essay "The Metropolis and Mental Life" (1903), Simmel contends that the growing division of labor reduces the individual "to a *quantité négligeable*, to a grain of dust as against the vast overwhelming organization of things and forces which gradually take out of his hands all progress, spirituality and value."[26]

As we have seen, in his article on Le Bon's mass psychology Simmel stated that the mass reduces the individual to a negligible quantity. Here, using the same figure of speech, he claims that modern society as such reduces the individual to a negligible quantity. Evidently, the same form of sociation is at work in both cases. Simmel argues, in short, that in modern society, the mass constitutes the relation—the point of mediation—between the human subject and society. The mass is the objective culture, and the structure of sociation, in opposition to which the subject tries to express his or her individuality. In Simmel's theory, everything external to the mass is also external to the social; it is individual. The mass is the social essence of the human subject.

Let's return to Simmel's historical examination of the forms of sociation prevailing in modern society. As I have mentioned, Simmel argues that it was the emergence of the masses that forced scholars to discover "society." The truly dialectical moment in Simmel's analysis arrives when he explains that the emergence of the mass as a dominant form of sociation, is, in its turn, a result of individualism.[27] The individualism of equality and the rights of man emancipated individuals from those premodern social bonds that previously circumscribed their being, setting them free to realize their universal human essence. Yet this emancipation of everybody's human qualities has tragically led to its opposite, Simmel claims. The human essence that someone can realize consists only of the primitive parts of his or her being that he or she shares with everyone else. In a word, universal human being is a mass being.

But there is also a different individualism, Simmel stresses. There is the individualism of romanticism, according to which each subject strives to express not a universal essence but his or her particular essence or individuality. This project also founders, however, but for different reasons. The weight of "objective culture" is in modern society so great that there is no room for anyone's expression of his or her "subjective culture."

Ultimately, then, what emerges in Simmel's analysis are two notions of individualism, which prevent each other's realization. There is an individualism of equality that flattens everyone to the common level of the masses—the sociological tragedy. There is an individualism of difference that throws up such an excess of petrified objective culture that all efforts to express one's individuality are crushed—the tragedy of culture. In both cases, the result is the same: a society of masses.

When Simmel speaks of the mass, then, he does not speak about a concrete social phenomenon as the French crowd psychologists did. The crowd is for him a sociological structure, always construed in dialectical tension with another abstract structure, individuality. In Simmel's *Lebensphilosophie*, these structures are eventually assimilated into a metaphysics as two forms of appearance of the eternal dialectic between life and form. Just as life seeks to appear in its naked immediacy but can do so only by producing forms that betray this immediacy, so does individuality seek to realize itself by raising above the common level of the masses but only to find itself pulled down to the baseline from which the project of self-realization must begin anew. This is what Hegel would have called a bad dialectic because it has no telos or synthesis. This is also related to what philosopher Max Scheler, in a famous address of 1927, defined as a process of equalization or evening out (*Ausgleich*).[28] Scheler saw this as the dominant tendency of modernity, and he argued that it could usher in an era of democracy and tolerance, erasing national boundaries and defusing the conflict between masses and elites, provided it received an adequate political response. However, Simmel does not recognize any possibilities of that kind. For him, the problem is not so much that the dialectic is infinite because as long as it continues, the rejuvenating process of life is an end in itself. The problem is rather that in modernity, the dialectical process has reached a standstill as the poles have been equalized. The institutional forms that once kept individuality elevated above the dull level of normality have been dismantled. Therefore, the dialectical tension between individuality and mass has collapsed. The two will henceforth ceaselessly pass over into each other.

Simmel devoted one of his most brilliant essays to a cultural phenomenon that epitomizes this rapid oscillation between individual and mass, uniqueness and conformity: fashion. Fashion satisfies the demand for social adaptation and makes the subject conform to the mass. At the same time, fashion allows everyone to feel like a unique individual. The human subject

becomes unique by participating in a mass phenomenon, and he or she adapts to the mass by expressing his or her individuality.[29] Fashion allows the human subject to be a part of the mass and an individual at one and the same time. Fashion thus signifies the destruction of those embankments that once separated the dry ground of individuality from the fluid element of the masses.

I mentioned that Simmel saw the emergence of this form of sociation, the mass, as a result of individualism. If we place Simmel's major work, *The Philosophy of Money*, alongside his long chapter on power in *Soziologie*, we see that his work also provides a materialist foundation for this argument. In *Soziologie*, he describes the mechanisms of "Superordination and Subordination" that stabilize and stratify any given society. *The Philosophy of Money*, for its part, describes how the money economy, the great leveler, dissolves institutional arrangements and makes all personal values and individual identities fluid and interchangeable.[30] These processes thus erode those mechanisms of "Superordination and Subordination" that once stratified society by erecting a hierarchy of representatives and represented, individuals and masses. A society without a firm framework for the organization of power and the stratification of the social field is a society where individuals and masses are inseparable. Simmel's theory articulates the form of sociation that prevails in such a society, a society in which everybody moves from triumphant individuality to absolute anonymity in an instant. When distinguishing this form of sociation from others, Simmel always employed the notion of the mass.

12. IN METROPOLIS

"My legacy," Georg Simmel wrote shortly before his death, "will be like cash, distributed to many heirs, each transforming his part into use according to *his* nature."[31] I believe Simmel's theory provides such a supreme articulation of the ideological dilemmas in postwar Germany and Austria that it fuses with the general cultural discourse of the era. As Simmel himself predicted, the dilemmas that he examined were inherited by many and resolved in vastly different ways.

At one extreme, the traditional principle of individuality was reinforced and magnified as the only solution to the deplorable alienation and

leveling of the human condition that, supposedly, characterized modernity, and postwar Germany and Austria in particular. By the 1920s, writes the intellectual historian Fritz Ringer, "no German professor doubted that a profound 'crisis of culture' was at hand."[32] One result of this tendency was a constant rehashing of Simmel's antinomy of individuality and massification.[33] However, the mass was rarely seen as a general form of sociation in modernity, as Simmel had taught, but was transformed into a social issue and content in its own right, and often it became another name for the lower classes. "The contempt for the masses is a typical characteristic of most intellectuals of the Weimar Republic," Helmuth Berking observes. Their contempt for "the masses" was a defensive reaction, he asserts.[34] Werner Sombart, a colleague of Simmel and highly influential in early German sociology, provides another illustration. Summarizing the state of the masses, to which he counted the lower classes in general, Sombart found three distinguishing traits:

1. The masses are mentally limited, not just stupid; that is, they only have practical understanding: their intelligence measures up to the concrete and the technical, not to the abstract and general, to what is practical rather than theoretical. . . . 2. The masses do not let themselves be guided by rational grounds in their behavior, but either by custom or by compulsive impulses, feelings, moods: they have an 'irrational', feminine predisposition. 3. The masses are in their emotional life at a very low level: the average of their scale of values is very low: values of pleasure and utility are predominant. Their sensations and feelings are primitive, 'natural', crude, undifferentiated.[35]

Sombart was pained by a postwar situation in which the privileges of the intellectual elite were undermined by media technology, urban forms of life, and ideas of democracy. For German mandarins whose worldviews were organized in terms of "*Bildung*," "*Geist*," "*Kultur*," "*Persönlichkeit*," "*Seele*," "*Innerlichkeit*," and "*Individualität*," the masses could only appear as a symptom of decline; hence the frequent appeals to the necessity of personal cultivation and aesthetic education of all citizens, hence the calls for *Führung*, and hence the reminders of the responsibility of the elite in the life of the nation. Another writer, having described the 1918 November Revolution

as a product of "feminine, primitive, fickle, moody, barbaric, and monstrous" masses, ended a 1919 book on *Die Massenseele* (The mass soul) with an exhortation: "Let us hope that a German leader with brazen heart and ironclad chest will arise from our people."[36] This is the Weimar discourse on the masses that is best known, an "aristocratic" criticism of mass society, and the one that has been the focus of scholarly studies.[37] It is also the one that was ultimately realized in the fascist enthronement of the *Führer* as the embodiment of society. Sombart is representative in this sense as well; in the early 1930s, he came to support the Nazis.[38]

Theoretically, this version is as sterile as it is simple: given the definition of the masses as opposed to individuality, and given the view of individuality as the support of culture and knowledge, the conclusion follows automatically: a representation of the masses as disorderly and destructive, as an agent of leveling passions in need of discipline and guidance.

As we shall see in the rest of this chapter, however, even this seemingly simple discourse was articulated in a variety of contexts and genres and with various degrees of originality. Georg Simmel's disciples and colleagues in sociology no doubt provided the most serious treatment of the topic, albeit never really challenging the binary framework that posited the mass as a deviation from a norm.

But before investigating the sociological contributions to the analysis of the masses in the interwar period it is important to get an idea of how it was played out in the general culture of the era. What did the mass look like? What did it feel like? How was it expressed in the broader cultural arena? If we were to choose one cultural document to embody the spirit of Weimar culture, Fritz Lang's *Metropolis* from 1927 would surely be a predictable candidate: Not only because of its dystopian narrative about a future civilization where the companionship of machine and capital has reduced humanity to a toiling herd. And not only because of its experimental form in which futurism and science fiction were fused with social commentary and gothic expressionism into a vexing imagery of special effects and stage craft that surpassed everything else in its era. And also not only because it was the biggest and most expensive motion picture made in the period, a true mass mobilization of the productive capacity of Weimar's cultural industry. But also because of its typical portrayal of the crowd, which in Lang's film is a character in its own right. To measure the extent to which Lang's portrait of the masses is saturated by the cultural and political fantasies of its time it suffices to repeat some general

observations on the film, most of which were made already at its appearance, and the dominant ideology of the masses comes into view.

The masses in *Metropolis* are anonymous and dressed in uniform. They are placed at the lowest level of the capital city, working in underground power plants and factories and holding meetings in the catacombs. Lang's masses are not only untouched by civilization and light. They also lack cognitive ability and individuality. Two forces control them: either the hard discipline that impels them to show up every day for their shift in the various plants where they work themselves to death or the ideological manipulation that excites their passions to the point where they erupt in rebellions in which they destroy the machinery and cause the lower levels of Metropolis to be flooded, almost killing their own wives and children (see figures 2.1 and 2.2).

If the masses thus signify body and instincts, Joh Fredersen, the individual that rules Metropolis, signifies mind and intelligence. The film thus posits masses and individual as opposites, and it lets this opposition unfold in any number of related binaries: body against brain, hand against mind, depth against surface, earth against sky, darkness against and light, passion against reason, ignorance against science, primitivity against civilization, femininity against masculinity. The spectacular visual scenery as well as the filmic action is driven by these tensions and the attempt to mediate between them.

Interestingly, the main mediator and catalyst of these tensions is a woman, Maria. At the beginning, she soothes the hapless masses, encouraging their righteous instincts to help them endure. In the science-fiction scenario of the film, Maria is then cloned. Her double is identical to the authentic Maria but her opposite in terms of character. The artificial Maria usurps her position as spiritual leader of the workers and agitates them to revolt. The rivaling Marias—one virgin, one vamp—not only illustrate the ambiguously deceptive nature of femininity, which was another cultural stereotype of the era, but also display the alleged fickleness of the masses as they impulsively react to any stimuli they receive. According to Lang's scenario, the masses must be guided by somebody capable of directing their passions toward constructive aims, as the real Maria strives to do. Otherwise, the masses become a force of destruction, as the artificial Maria is there to show.

The happy ending of Lang's film consists not in undoing any of the oppositions generated by its social fantasy but in mending the social divide. This

FIGURE 2.1 Obedient masses: shift workers in Metropolis meet at the factory gate. Still from Fritz Lang's *Metropolis*, 1927. *Source:* © Friedrich-Wilhelm-Murnau-Stiftung. Distributor: Transit Film GmbH.

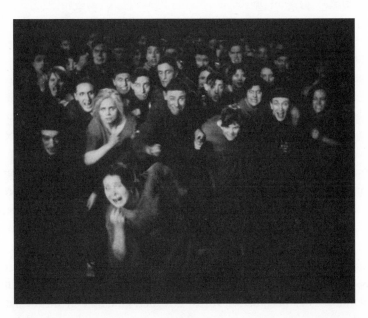

FIGURE 2.2 Rioting masses: workers of Metropolis are being aroused to strike and destroy. Still from Fritz Lang's *Metropolis*, 1927. *Source:* © Friedrich-Wilhelm-Murnau-Stiftung. Distributor: Transit Film GmbH.

is accomplished through the ritual purging of the female desire embodied by Maria, whose destructive aspect is displayed by the robot vamp that arouses the workers' lust to revolt, and at the same time through the symbolic castration of the workers, whose inability to maintain the high-tech infrastructure of Metropolis serves to justify that they be held in servitude by their capitalist master. Sexual and political passions are thus thoroughly vilified and eliminated as female desire is visually translated into self-defeating mass violence. As Andreas Huyssen has pointed out, the seductive character of the film stems from its capacity to ignite a sexual and political desire, which is then trimmed and adapted to the technological and economic demands of the existing order.[39] Anton Kaes is also on the mark, showing how the film systematically associates collective political organization with feminine hysteria and mad violence: "The very idea of a revolt is delegitimized."[40] Instead of challenging the idea that most people are masses and live in the dark, *Metropolis* teaches that the majority needs firm and fair supervision by rational individuals. And instead of challenging the idea that only some are rational individuals, it teaches those happy few that they depend on the services of the masses.

Metropolis is thus a film that opted for social compromise, at the same time calling for compassion with those who were suffering the consequences of status quo. The film rushed to endorse the crumbling compact between capital and labor, codified in the Stinnes-Legien agreement of November 1918, in which the employers offered social policy in exchange for the workers' renouncing socialization, at the very time when support for the agreement had started to erode.[41]

For my purposes, what is most important is the film's function as a "sponge," to use an expression of Thomas Elsaesser, which sucks up all the ingredients in the dominant social and political imaginary of Weimar Germany.[42] In this imaginary, the masses loomed large as an unstable and potentially dangerous agent at the depth of the social world. It is as though Fritz Lang tapped into all the period's fears and fantasies of the masses and invented the visuals that matched them. The fame of *Metropolis* is in no small part attributable to its innovative experiments with film's ability to render masses in motion. It set the standard for cinematographic depictions of crowds, showing how the rhythms and physiognomies of the collective vary depending on its location in street, church, factory, dance hall, political meeting, or the like. According to many commentators, however, Lang's

experiments with perspective, superimposition, projection speed, editing, and special effects only tended to confirm established ideas of the masses as the underbelly of humanity.[43] The Spanish filmmaker Luis Buñuel remarked in his review of the film that Lang had in fact forgotten one actor, "full of novelty and possibilities: the crowd." For despite the omnipresence of crowd scenes in *Metropolis*, the mass seemed present not for its own sake, nor to demonstrate some more specific social condition, but as a vindication of an authoritarian perspective according to which reason and agency were wholly on the side of the individual mastermind. As Buñuel stated, the multitudes of *Metropolis* "seem to fill a decorative role, that of a huge ballet; they aim to impress us by their beautifully choreographed and balanced movement rather than allow us to see their soul, their subordination to more human, more objective agencies."[44] The same point was later elaborated by Siegfried Kracauer, who regarded *Metropolis* as a dress rehearsal for fascism, in which the masses were patterned into ornaments according to the directions of the leader. The workers' "rebellion results in the establishment of totalitarian authority, and the rebels consider this result a victory."[45] In this way, *Metropolis* illustrates how the main ideological problem in Weimar culture was most typically resolved. The masses were everywhere. And wherever they were, authority was called for.

13. THE ARCHITECTURE OF SOCIETY

The generation of sociologists and social scientists writing after the foundational moment of Georg Simmel, Ferdinand Tönnies, and Max Weber often took issue with the predominant view of the masses in Weimar Germany that I discussed in the previous section. They tried to purge the notion of the mass of its ideological and psychologistic traits and turn it into a rigorously scientific concept. This was true for Alfred Vierkandt and Leopold von Wiese, influential thinkers in the nascent discipline of academic sociology, and even more so for a younger generation of scholars who began their academic careers right after World War I, among whom we find von Wiese's student Wilhelm Vleugels, and brilliant intellectuals like Theodor Geiger and Gerhard Colm. They all identified the masses as an urgent area of research, and they soon discovered that the terrain was overgrown with half truths and vulgarizations.

In a major attempt at theoretical clarification in 1924, Gerhard Colm remarked that "the mass" and "the masses" showed up everywhere in contemporary literature, but the terms carried so many different meanings that they had become a source of confusion.[46] Social scientists of the period despaired at the ambiguous meanings attributed to "the mass" in ordinary language. Their frustration only increased as they realized that scholarly usage was equally messed up. "It is not only the case that different authors tie different concepts to the word 'mass'; even in the same author the word often refers to different concepts," wrote Wilhelm Vleugels in one effort to determine the precise meaning of the "mass."[47] Theodor Geiger also lamented the fuzzy terminology,[48] and Leopold von Wiese, professor of sociology in Cologne, went so far as to ask if social scientists should not simply drop the word and invent new terms for the social formations under analysis. In order to avoid the dubious connotations evoked by "the mass," perhaps the sociologist would better employ Greek letters and simply speak of "delta-formations" or the like, he said.[49]

Sociology nonetheless retained the mass as a principal category. It is not hard to see why. The word reeked of confusion and prejudice, to be sure. Yet it asserted itself as the inevitable rubric for investigations of a social issue that was fundamentally important, to the extent that many saw it as the cardinal feature of modern society. Were sociology to avoid "the mass" and instead opt for the clinical language of science, the public would continue to be misled, these sociologists feared, by the questionable explanations offered by mass psychology, notably Gustave Le Bon and Sigmund Freud, or by the deceptive ideas on "the age of the crowd" and "the rebellion of the masses" promoted by cultural philosophers like Oswald Spengler, José Ortega y Gasset, and Max Scheler, or else it would fall prey to demagogues of even worse brands. The mass, therefore, was a word and a subject not to be ignored. Objecting to the minority of social scientists who excluded "the mass" from their list of relevant topics, Wilhelm Vleugels simply proscribed that the mass was "an important object of sociological knowledge."[50]

German sociologists thus shouldered a tough job of terminological laundry. Seeking to obtain a supposedly scientific conception of the mass, they exposed the term to two cycles of clarification. First, an inventory of the meanings of the mass in ordinary language was drawn up. Even after excluding all references not pertaining to social phenomena, these sociologists still

had their hands full of contradictory and partly overlapping categories. We have already in the previous chapter encountered Alfred Vierkandt's list. According to him, "the masses" referred to all of the below: followers as opposed to leaders; average people as opposed to those above the average; lower strata as opposed to higher strata; uneducated people as opposed to educated people; temporary aggregates of people as opposed to groups; professional associations, classes, social strata, races, or the like; and, finally, temporary associations of people in states of strong emotional excitement.[51]

In a more rigorous effort to disentangle the use of the term, Theodor Geiger argued that despite the word's ambiguity, a semantic core persisted. The mass evoked "the image of an undifferentiated complex of uncountable, or at any rate uncounted, similar part-units."[52] For the purpose of sociological analysis, Geiger went on to abstract four main inflections of the general idea of the mass in contemporary discourse about society. Its first meaning was neutral: great numbers and quantity, any amassment of objects and people. This is how we still today speak of mass communication, mass meetings, or the like. The second meaning referred to human groups and collectives held together by common sentiments or emotions. The mass here emerged as a psychological phenomenon, and it was in this sense that it had caught the interest of mass psychology. In order to examine how the emotional life of an individual is transformed when he or she becomes part of a crowd, mass psychology had construed an antithesis between individual and mass which has been a "source of many misunderstandings," Geiger maintained.[53] He then identified a third meaning of the mass, since long ingrained in ordinary language. In thousands of figures of speech "the mass" was negatively colored as a designation for those lacking the refinement, cultivation, wisdom, genius, skill, or courage by which putatively superior men and women distinguished themselves. Geiger defined this conception of the mass by describing it as a human average residual ("Auslese-Überbleibsel" or "Auslese-Rückstand"): the mass were the human leftovers or left-outs who remained once the more valuable members of the population had been selected for their tasks and positions in society.[54]

But the mass also carried a fourth meaning that had been neglected, Geiger submitted. The activity of the revolutionary masses and their relation to their political leaders demanded to be studied as a sociohistorical phenomenon in its own right.

Geiger then went on to argue that these four distinct ways of speaking about the mass had been mixed up. For the most part, the negative associations ascribed to the mass in the second and third case—the mass as acting in emotional excitement or as constituting a human residual—had immersed social commentary and sociology in an atmosphere of anxiety and fear. Geiger was probably the first sociologist to expose the hidden assumption behind this manner of speaking about crowds. Since everyone took the sovereign individual as a firm point of reference, the mass had to appear as a force of decline, corrupting whatever qualities people had in their allegedly natural state as autonomous individuals. Most statements on the mass, Geiger asserted, presume that a person who joins a mass has his or her true ancestry and authentic being outside it, or, as he put it in German, they postulate "die außermassische Herkunft der im einzelnen Fall vermassten Individuen."[55]

How to gain a clearer view of the matter? Geiger argued that the mass must be posited as a social *Gestalt* in its own right, rather than being judged as a deviation from some unquestioned idea of individuality: "A sociological investigation of the mass must grasp the mass as a specific kind of social association of objective character."[56] Here we enter the second cycle of clarification proposed by German social scientists. Once the misconceptions of common language had been purged, the mass must be repositioned as an objective social entity. But how? According to Weimar sociology, knowing something sociologically amounted to finding its right place within a "general sociology," "pure sociology," or "formal sociology" (*allgemeine Soziologie, reine Soziologie, formale Soziologie*). For this enterprise, *the social relation* was the primary object of scientific inquiry. Analyzing the social relation entailed a radical abstraction of the elementary forms of interhuman life from their geographical, cultural, historical, and political embeddings.[57] As in Simmel's concept of sociation, the *forms* of social interaction were separated from whatever content they held, and these forms were conceptualized as theoretical entities in their own right, pinned to a conceptual grid made up by so many allegedly transhistorical modes of human interaction.

The great system builders of Weimar sociology would thus analyze various aspects of human interaction, as it could be studied as an ongoing "process," as a "relation" between social agents or as resulting in some more or less stable "formation." The mass was typically analyzed as a phenomenon of

this kind, for which the Germans used names such as *Gebilde* (formation), *Verband* (association), *Körperschaft* (body), or, indeed, *Gestalt*.

This is to say that Weimar sociology put great emphasis on the correct way of classifying social units. To begin, Theodor Geiger saw the "group" as the principal form of social association, with "the couple" and "the mass" at opposite ends of a wide spectrum. Leopold von Wiese, for his part, identified three principal "formations": groups, masses, and abstract collectives (*Gruppen, Massen,* and *Körperschaften/abstrakte Kollektiva*), each of which, in turn, contained a number of types. In von Wiese's system, groups were thus divided into couples, trios, small groups, and large groups. Masses were divided into abstract masses and concrete masses. Abstract collectives (*Körperschaften*), in turn, were classified according to an impressive taxonomy, consisting of social bodies of primary order: family, clan, tribe, people, state, church, estate, class, economic associations, and intellectual and artistic communities; in addition to a number of social bodies derived from the primary ones and hence constituting collectives of secondary rank: army and navy; associations of industry and technique, political parties, schools, and so on.[58]

Gerhard Colm proposed a less complicated system as it fell on him to codify the authoritative definition of the mass in interwar German sociology.[59] He spoke of "group formations" (*Gruppengebilde*) and presented a typology divided into four categories. These four types never exist in pure forms, Colm stressed. But depending on the historical situation, social formations would be more or less patterned on one of them. The first group type was defined by its communal way of living. People were here organic parts of a social totality, their values and identity determined by life and work shared with one another; Colm linked this type to Tönnies's concept of *Gemeinschaft*. The second type was characterized by communal aims, values, or interests, and the group existed in order to fulfill, realize, or embody these. For Colm, this conformed to Tönnies's *Gesellschaft*. A third type was simply called "*Bund*," defined as a union involving one's entire being and exemplified by groups founded on enduring relations of love. The fourth and final category in Colm's system was "the mass," constituted by the shared emotions or sentiments of its members.

It is easy to imagine extending these different typologies until all conceivable forms of social activity are exhausted. Similar inventories were compiled by Vierkandt, Sombart, Geiger, the Swiss sociologist Hans Töndury, and others, with variations in terminological and classificatory

procedure.[60] Many sociologists also added transitional or intermediary social bodies, thus accounting for social change. For instance, Wiese described how loose masses became bounded groups via intermediary formations such as "troops," "bands," and "gatherings."[61]

To put all this differently, Weimar sociology aimed to establish the very architecture of the social world. Its starting point was society as it actually existed; its methodological tools were devised for observation, analysis, and abstraction; and its goal was a conceptual system with a set of elementary sociological categories fit to describe any society. Gerhard Colm and Alfred Vierkandt emphasized that the concepts discovered by sociology constituted purely theoretical possibilities never truly realized in history since actually existing societies were always mixtures of the ideal types that analytic science described in pure form.[62] Their point is an interesting one, for it implies that Weimar sociology produced a theoretical system from which it could derive a full inventory of all theoretically possible societies.

This stunning feature of Weimar sociology—the search for a theory accounting for virtually all possible social formations—offers unexpected insights into Elias Canetti's enigmatic work on the mass. Once we reinsert Canetti's *Crowds and Power* into its original proximity with this now largely forgotten corpus of formal sociology, today treated as dead weight in the history of science, the reasons for Canetti's comprehensive ambition and peculiar method are partly clarified. Excelling in detailed enumerations of various kinds of masses and different phases of crowd behavior (*Hetzmassen, Festmassen, Fluchtmassen, Umkehrungsmassen*, etc.), and listing a great number of "mass symbols" ("*Massensymbole*"), Canetti betrays an affinity with the sociological syntheses—Vierkandt's *Gesellschaftslehre*, Leopold von Wiese's *System der Allgemeinen Soziologie*, Theodor Geiger's *Soziologie*, and perhaps also Max Weber's uncompleted *Economy and Society*—that were eventually dwarfed by his own giant undertaking. These works aimed straight at the essentials of society, seeking to calculate the combinations of various modes and forms of human interaction, the crucial difference being that Canetti's conception of the mass usurped the sovereign concept of sociation (*Vergesellschaftung*) around which the Weimar sociologists built their systems. What for interwar sociology were social processes, social relations, and forms of sociation became for Canetti modalities of the mass drive or crowd instinct (*der Massentrieb*). Conversely, whereas Canetti viewed all social formations as subspecies of the universal

phenomenon of the mass, Weimar sociologists held on to the view that the mass was one social formation among others.

Or was it? A closer look at the matter demonstrates that the mass lay close to the heart of Weimar sociology, if it was not itself that heart.

14. STEAK TARTARE

When "the mass" was established as an object of knowledge at the end of the nineteenth century, the question arose as to which scientific branch it belonged to. Psychiatrists and psychologists claimed the masses as their territory, and the founders of sociology addressed the mass as a form of social interaction that could not be accounted for by psychic mechanisms. The debate continued throughout the interwar era, as is evidenced by the animated engagement of Weimar sociologists with French mass psychology or their disputes with Sigmund Freud's *Massenpsychologie und Ich-Analyse*.[63] For the sociologists, "the mass" constituted a field of research where they could assert the superiority of their own approach over against psychological explanations of social behavior.

I have already discussed one strategy through which Weimar sociologists challenged the "psychology of the masses." Instead of taking the idea of the masses at face value, they retreated to semantic analysis, arguing that mass psychology had mixed up a number of contradictory conceptions of the mass. The only common denominator of these conceptions was that they all referred to "process-complexes" involving a great quantity of human beings, as Leopold von Wiese dryly put it.

Rather than taking the mass as an a priori psychological category, sociological inquiry defined it, as we have seen, in relation to other social formations—group, organization, or the like. In this context, the mass was almost always a chosen denomination for social formations lacking the internal organization and differentiation typical of other collective units, and whose cohesion could therefore be attributed only to the emotional investments of its members, for instance, the sense of sharing a common predicament or adversary. This general conception of the mass was in turn split into two. The first component was the mass in action, an agent of unrest, protest, and rebellion. Leopold von Wiese referred to it as "the concrete mass"; Vleugels called it "the active mass" ("*die wirksame Masse*"); and

Theodor Geiger spoke of "the actual mass" ("*die aktuelle Masse*"). In order to understand how the active mass emerged as a collective agent guided by shared emotions, social scientists then postulated the existence of a complementary modality of the mass. They spoke of the "latent," "abstract," or "passive" mass, indicating human collectives consisting of atomized individuals detached from traditions and without organization, internal differentiation, and discipline. The absence of organization gave the emotions all the more freedom to influence the lives and ignite the spirits of the members of the abstract mass. In certain circumstances the influence would be strong enough to turn them into a raging, active crowd.

Explaining the mass in action, Weimar sociologists pretty much agreed that it was a proper object for psychological analysis since it was mainly constituted by emotional bonds. Leopold von Wiese's definition of the concrete mass is representative: "A loose inter-human structure or formation of relations . . . , which for short duration, and if the circumstances trigger the appropriate and more or less dominating affects in all participants, transforms itself from a multitude into a unified chain of collective actions."[64] Such definitions salvaged key elements from the doctrine of mass psychology: the masses were seen as acting in affect; the affects expressed by its members were those that everybody shared with his or her fellows; in the explosive movement of mass action, collectively shared emotions therefore occlude the individual personality and govern the behavior of each member of the mass. Interwar sociological theories thus revisited the territory claimed by Scipio Sighele and Gustave Le Bon, critically reviewing all the familiar topics discussed by them: the existence of a collective soul, the importance for the masses of a leader, the primitive character of the masses, the leveling of intelligence and morality in a crowd, the heightening of emotions, and the criminal leanings of the masses. With the crucial exception of Theodor Geiger, Weimar sociologists confirmed that mass psychology gave a fairly accurate idea of the emotional mechanisms within the *active* mass.[65]

For all other purposes, however, mass psychology gave an insufficient picture, Weimar sociologists argued. Where, when, how, and why do mass actions occur? What are the historical causes and social consequences of crowd behavior? Addressing such questions, these sociologists claimed that answers be provided by sociology alone. Many followed Georg Simmel's example as they maintained that the mass was a particular form of sociation and that the active mass—all the crowds flooding streets, public spaces, and

political discourse of interwar Germany and Austria—was an expression of a more abstract social phenomenon: great numbers of loosely connected human atoms sharing roughly the same emotions, habits, sensations, loyalties, and social positions. In stipulating the existence of *abstract* masses, sociology confirmed that society was increasingly transformed by human collectives far too shapeless and anonymous to be classified as organizations, groups, classes, associations, parties, or the like.

The abstract mass thus obtained its identity only in relation to social formations of firmer identity. "The ideal type of the abstract mass is related to the group as Chaos to Cosmos," Leopold von Wiese stated. He continued: "It is characterized by seething and undifferentiated forces. . . . The major aspirations of the humans of the mass are as yet too undecided and unshaped; the unconscious and the vegetative stand in the foreground." In less pejorative language, Wiese defined the abstract mass as "a disorganized, vague, interhuman formation of long duration, which is held together by the unclear fantasy of its members of being united in fate or feeling."[66]

It is sometimes hard to decipher what social phenomena the sociology of the mass actually addressed. Who was implicated by its discourse? On the surface, the sociological analyses of the mass of the interwar period seem preoccupied with theoretical clarification and conceptual analysis. The abstract mass is always defined as a transhistorical social formation or as an ideal type. However, in illustrations of the abstract mass a certain segment of society always comes to the fore: the working classes. On the one hand, then, Weimar sociologists argued that the abstract mass was a formal category, a social *Gebilde*, as abstract and timeless as, say, the group, the couple, the clan, and the organization. On the other hand, the mass seemed to be a theoretical category containing only one item, for when exemplifying the abstract mass, sociological language was always invaded by well-worn metaphors that had been in use since the French revolution to describe what nineteenth–century discourse knew as "the dangerous and laboring classes [*les classes dangereuses et laborieuses*]."

Theoretically, the distinction was thus clear. The mass named a specific type of sociation or social formation, not to be mixed up with any empirically identifiable social phenomena. Leopold von Wiese went as far as stating that no fundamental difference pertained between the community of feeling of the proletariat and certain other collectives such as the high bourgeoisie. "Good society," too, constituted an "abstract mass" because

of the shared habits of the ladies and gentlemen constituting it. The same applied to a "community" of moviegoers or a sports audience. In defining the abstract mass, Wiese evoked a range of faceless and boundless human collectives, loosely brought together by a shared experience of the culture of modernity.[67]

The question as to whether the proletariat was identical with the mass was thus usually answered in the negative. Rather, the proletariat was taken to be an example of the mass. However, this was a question of secondary importance that concerned only the historical application of the concept whereas the primary issue always was the proper definition and systematization of all forms of sociation. Among Weimar social scientists, there was a strong tendency to avoid discussing the social and political implications of their theory or to disregard the conflicts that pressed hard onto the walls of their academic enclaves. When the German Association of Sociology reconvened for the first time after the war, in Jena in September 1922 under the direction of Ferdinand Tönnies, the subject for the two-day conference seemed to invite reflection on the immediate past and contemporary politics. Just three to four years before, Germany and Austria had experienced revolutionary upheavals. Parts of the population of both countries were still engaged in political violence and revolutionary movements. And now sociologists from both states gathered to discuss nothing less than "the nature of revolution [das Wesen der Revolution]." As elsewhere in the social sciences, however, impartiality reigned supreme in Jena, banning all historical, political, and ethical considerations. What the members of the sociological association were discussing in Jena was thus neither the recent past nor the revolutionary situation of the time. As the rubric made clear, they were interested neither in the causes nor in the consequences of the German revolution but in its "essence" (Wesen). There was general agreement that sociology's main task was to provide a general definition of what a revolution was.

In his keynote address, Leopold von Wiese maintained that the crucial problem was to find a pure concept of the revolution, that is, to determine the specific relation between social differentiation and social integration, thus enabling the sociologist to assess a revolution's function in the larger schema of social entities.[68] Explicit references to the recently crushed revolution in Germany were absent also in the second keynote address, by Ludo Moritz Hartmann. In the ensuing discussion, the Austrian sociologist Max

Adler intervened from the floor, confessing how odd it felt sitting through an entire day of discussions about the revolution without anyone even mentioning the name of Karl Marx, and he added that this confession would probably be received as an expression of party politics and cost him his scientific reputation. Adler then went on to reject Wiese's and Hartmann's numerous remarks about the role of masses in the revolutionary process: "With this objection, the sociologically useless concept of 'the mass' completely disappears from sociology and what is revealed instead is the new concept of a community of interests [*Interessengemeinschaft*], the specificity of which remains to be examined more closely and which in regard to the history of revolution turns out to be that of class."[69] Adler thus identified a peculiar trait of Weimar sociology. Among all social formations contained in its seemingly exhaustive list of classifications, "class" was conspicuously absent, or at best thrown in as a subspecies under major formations such as group, mass, and abstract collective.

Another example of sociology's phobic relation to contemporary affairs is Vilhelm Vleugels's *Die Masse*, completed in the fall of 1927. Vleugels signaled the urgency of his book by vague hints of the recent uprisings in Vienna (the burning of the Palace of Justice on July 15, which I discussed in chapter 1). But precisely because of this urgency he then retreated from contemporary matters, explaining that for the sake of scientific credibility one must avoid being affected by "one's own political passions." Instead of testing his theory of the mass against the contentious reality of his present, he collected evidence from accounts of the slave revolts in ancient Rome.[70]

The conflict between history and theory in Weimar sociology never comes to full expression but is detectable in gestures of closure—the striving for scientific rigor, the credo of impartiality, the commitment to formal analysis—that mark the Jena discussion on the revolution as well as Vleugel's remark on the Vienna uprisings. This makes clear that the sociological concept of the mass was not primarily shaped through an empirical encounter with the surrounding social world but through a critical encounter with mass psychology, on the one hand, and through a theoretical derivation of social formations, on the other. Following Ferdinand Tönnies's narrative about the slow change from tradition to modernity, from *Gemeinschaft* to *Gesellschaft*, German social theory of the period was organized around an axis stretching from social cohesion and homogeneity to atomization and heterogeneity. The sociological concept of the mass would be determined

by its allotted place in that framework. It was a residual category, associated with decline, decadence, and pathology and defined by the *absence* of the organization, cohesion, duration, differentiation, or rationality that pertained in comparable social formations. No longer the antithesis of the qualities associated with individuality, the mass became the antithesis of the qualities ascribed to complex social formations.[71]

The irony, of course, was that those actually existing mass movements that sociology dared not approach, for fear that it would lose in objectivity if venturing too close to history, would in the next step be invited to illustrate the lack of rationality, organization, and differentiation that sociology imputed to its concept of the mass. The sociological description of the "real" mass of laboring people was thus largely deduced from the theoretical concept of "the mass." Consequently, the habits, mentality, and ways of living of the proletariat and the lower classes' masses were painted in gloomy colors: they all emerged as an embodiment of the lack, absence, emptiness, and mediocrity that sociology attributed to their theoretical concept of the mass. An abstract and scattered collective consisting of countless people identifying with one another on the basis of their shared emotions toward society—such was the "latent mass," which seemingly corresponded to the situation of the proletariat. As it was loosely organized and poorly anchored in established associations, the latent mass was easily mobilized by the pressure of external events or powerful leaders so as to be transformed into a concrete and active crowd, united by common motifs, hatred, or resentment—and on this point, too, the rebellious segments of the proletariat provided the main example.

That Weimar sociology kept looking at the working classes to verify its theoretical concept of the mass is hardly surprising. There was no other social formation at hand to exhibit the stipulated connection between the abstract mass united by common sentiments and the concrete mass translating these sentiments into violent demands. But if the working classes were the only empirical phenomenon conforming to the sociological concept of the mass, why not simply identify the two with each other? And why not simply speak of the working classes instead of the mass? On this point, as we have seen, most sociologists stood firm: for scientific reasons their concept of the mass must not be historical but formal and objective, describing a general modality of sociation that could be used to describe many particular social formations throughout human history.

Ultimately, it is therefore the formalist intention of Weimar sociology, rather than simple political prejudice or ideological bias, that explains why the mass remained such a mysterious term in its systems—an empty signifier introduced for whatever social agents and events that threatened to escape the vast system of social representations that sociology threw out as it tried to tabulate the proper name and place of every social grouping and relation. As Helmut Berking observes, the more painstakingly mass sociology sought to delineate the analytical contours of its founding concept, the more these contours became diffuse since the mass could be determined only as a deviation from this or that other class or group of more structured composition.[72]

The mass became a sociological denomination covering everybody not sufficiently organized by hall-marked social associations and everybody not represented by established political institutions. Leopold von Wiese captured this by saying that the mass is not "*vergeistigt*," thus literally casting the mass as matter not yet mastered by mind, untouched, as it were, by the power of logos. The mass lacks a guiding idea. It is not pulled by tradition, nor is it motored by ideology, Wiese submitted. This accounts for the difficulty of describing the mass in positive terms. It seems to resist cultural representation and scientific conceptualization; the mass is "far too difficult to circumscribe, far too disorganized, and far too difficult to grasp through legal statutes and official protocol."[73]

Contrary to many other accounts that described the mass as incendiary or explosive, Leopold von Wiese emphasized the inertia of the mass. Having positioned the mass as the opposite of intellect or consciousness (*Geist*), it is only logical that he ended up positing the mass as materiality, animality, and, indeed, flesh. "The mass is always primarily flesh. It forces the noble ones to make compromises, or else it exterminates them. . . . [I]t has the task of tearing down the superhuman to the level of the human, all too human. . . . It supports a creaturely and earthbound life, and resignation to what is transient and ephemeral; it defends muscles, spine, and belly against brain."[74]

Belly is to brain as the mass is to the national elite, just as hand is to mind in Fritz Lang's *Metropolis*. Perhaps we need not ask to which camp Leopold von Wiese counted himself. For all the scientific rigor that he summoned to support his general sociology, it obviously could not keep the stereotypes from rolling in, drowning his scientific theory of the masses in jargon typical of his time. No wonder that later scholars have concluded that, in

practice, German mass sociology worked "like one great effort to prevent the masses and the anxieties fed by them from getting at one's throat."[75] For if we were to believe Wiese's account, we must also take seriously its suggestions that large sections of the German people and humanity in general were equivalent to meat.

Of course, the tragedy is that such suggestions *were* taken seriously, although few dared spell out what political consequences they could have. The art of the Weimar Republic was an exception to this rule. What was only insinuated in academic discourse on the masses, or shrouded in silence, comes into view at the theater or in the visual arts, usually through the revelatory force of caricature or with a pitch of the grotesque. In *The Three-penny Opera* Bertolt Brecht unintentionally picked up Leopold von Wiese's idea and took it all the way. The broad masses as meat? This is exactly what is echoed in the "Cannon Song," where the two war veterans revel in sweet memories of their careers in the service of the Queen's empire, fighting the colonized peoples all across the earth:

What soldiers live on
Is heavy cannon
From the Cape to Cooch Behar.
If it should rain one night
And they should chance to sight
Pallid or swarthy faces
Of uncongenial races
They'll maybe chop them up to make
some beefsteak tartare.[76]

15. DELTA FORMATIONS

According to Georg Simmel, the masses offered to nineteenth-century scholars and intellectuals the occasion to discover society. As the lower classes started to intrude upon the political arena, thinkers became aware of the bonds of interdependence among classes and estates. From this awareness sprang the idea of "society" as a totality of interhuman relations.

In German sociology of the 1920s, too, the masses guide the scholarly gaze toward the secret origins of communal life and social organization.

Leopold von Wiese made a bizarre impression, to be sure, when he suggested that scholars cease speaking about the mass and instead invent some neutral term, like delta formations, to designate the phenomena under study. However, the intuition behind his suggestion was rational, for what shines through sociology's copious attempts to cut out a neutral definition for "the mass," with all the semantic disputes that ensued, is a nagging sense that this object constitutes the undetermined and undeterminable factor X, or formation Δ, of history, asserting its presence outside the more intelligible social formations in which sociology anchored its theoretical systems.

Sociological assessments converged on this point: the mass is a border phenomenon clouded in uncertainty. For some, the mass meant not just the border of the social world but the end of it. To approach the mass was to experience the dissolution of social order, morality, and culture. Abandoned by spirit and by God: that was the predicament of the mass, according to Werner Sombart, who went on to define it as a "dead multitude of mere particles . . . a disorganized and amorphous population heap."[77] Is the mass always a symptom of decline? Wilhelm Vleugels asked at the end of his long investigation. He responded, predictably, that it all depends on which mass we are speaking about.[78] However, if some scholars argued that the mass spelled the end of the social world, others remarked that it was the origin of society.[79] Thus, the mass spelled both doom and rebirth, it was apocalyptic and at the same time a source of rejuvenation: a wellspring of society.

Were the masses the beginning of society or its collapse? The question signals the extent to which the "the mass" functioned as a liminal concept, a terminological placeholder for social matter that sociology reached for but could not fully grasp. Leopold von Wiese observed that the institutions making up the core of a nation—political organs, judiciary, business, institutions of culture and learning, arts and sciences—had barely taken notice of the abstract mass. The abstract mass is so shapeless and latent that it may appear as if it was not really there at all, he stated.[80] Sociology, by contrast, did take notice of the mass. Yet for all the discourse it produced, the mass remained at the threshold of visibility, a flickering image of social substance resisting sociological classification and representation, not so much an image of something perceived in external reality but a mirror image of formal sociology and its failure to account for social processes and change.

We have already seen that the objectivist spirit of Weimar sociology prevented it from approaching this forbidden territory. What would have

been the result, had sociology proceeded in the opposite way? What if it had developed its concept of the mass by actually studying the collective movements in the Weimar era rather than ascribing to these movements a lack of qualities that it deduced from its theoretical concept of the mass? The question would be purely hypothetical were it not for Gerhard Colm's and Theodor Geiger's efforts to actually test the sociological concept of the mass against the brute facts of history. Their books—Colm's *Beitrag zur Geschichte und Soziologie des Ruhraufstandes vom März–April 1920*, published in 1920, and Geiger's *Die Masse und ihre Aktion* of 1927 as well as *Die soziale Sichtung des deutschen Volkes* of 1926—are remarkable for what they reveal about interwar mass sociology.

Only weeks before his death, Max Weber inspired Colm to embark on a sociological interpretation of the proletarian uprisings in the Ruhr area in March 1920.[81] Colm's book is a rare test case involving a young, talented social scientist using contemporary theories of crowd behavior to shed light on social and political conflicts in his present. Given Colm's adherence to Weber's ideal of impartiality, or *Wertfreiheit*—nicely summed up in the epigraph from Spinoza, "*non ridere, non flere, sed intelligere*" (not to laugh, not to weep, but to understand)—his initial reservations about using the crude category of "the mass" is hardly surprising. One conclusion emerging from his analysis is that "the mass" loses its analytic value if used in isolation or defined as the opposite of individuality. In Colm's work we thus find the same progressive thrust as in the general social sciences of the period: the semantic ambiguities and ideological bias infiltrating most accounts of the masses is checked by defining the word in relation to other social formations rather than seeing it as a simple negation of normative individuality.

Colm investigates how in March 1920 workers' militias battled openly against the regular German army and won control of industrial centers of the Ruhr area. The background of the insurrection was the so-called Kapp-Lüttwitz putsch, an attempt by high-ranking officers and nobility to liquidate the young republic and seize control of the state. After the coup, military garrisons in the Ruhr area raised the flag of the fallen empire, symbolizing support for the coup. Fearing that the army would betray the democratically elected government, left-wing unions and other groups of labor then rose to defend themselves and the democratic republic. Armed workers carried sweeping victories, forcing the Reichswehr to retreat and leaving villages, towns, and cities of central Ruhr under the partial command of a

newly constituted Red Army. Colm's book chronicles these events in great detail, informing the reader about the insurrection's key battles, movements, meetings, facts, figures, and protagonists, thus providing a wealth of detail that contributes to making his book a history of current affairs with a pow-erful streak of investigative journalism.

However, as Colm ventures to explain the Ruhr uprisings he shifts to a different register. Instead of subjecting the empirical documentation to proper historical analysis, sorting out the causes and factors contributing to the insurrection, he treats the event as a case study to prove a sociological theory of the masses. What results is a rather speculative explanation. Colm notes that in response to the coup, the unions across Germany declared a general strike. He asserts that this sealed the unity among the workers: from now on they constituted "a unified mass, animated by a single will and emotion. In everybody lived the same hatred for the Reichswehr and the will to annihilate it."[82] Colm goes on to explain how this volatile situation offered an opportunity for unscrupulous individuals. The war and its dire aftermath had prevented such characters from making conventional careers in established economic, political, or religious institutions. In the Ruhr rebellion, however, they could now realize their desire for recognition, their need for distinction, or their hunger for influence and power by stepping forth as spokesmen translating the furious passions of the masses into revolutionary action.[83]

According to Gerhard Colm, this was the Ruhr insurrection: a mass united by shared hatred for a common enemy, giving rise to demagogic leaders knowing how to transform emotions into actions. Put differently, his interpretation is patterned on standard ideas of mass psychology. But this analysis is then framed by a *sociology* of the mass, and in this context the Ruhr rebellions come across as an example of "the mass" as a social formation arising when alternative social formations are either weak or absent. The mass, defined as a community of affect, is thus the result of circumstances under which human agency is socially mobilized, but without being bounded by more stable social forms, or what Weber would call "organizations." This is Colm's sociological explanation in a nutshell: where organizations fail, the mass erupts. He does not see the mass as a negation of individuality, yet he still defines it as a negative phenomenon: the mass comes to designate social formations deviating from the examples of normality set up by institutionalized social bodies. Relying largely on Le

Bon, Colm concludes by making a comparison between the mass and the organization: "The foundation of the 'mass,' and thus also of the demagogic leader, is affect; in the 'organization,' by contrast, deliberation rules."[84]

Gerhard Colm's early study of the Ruhr insurrections thus speaks of both the insight and the blindness typical of Weimar mass sociology. The active mass is analyzed on the model inherited from mass psychology, but it is no longer seen as a negation of individuality but as a social formation in its own right. As a social formation, however, it emerges only in situations where the more regular apparatuses of sociation fail. Set loose from the integrating powers of communities, associations, and organizations, the human subject will feel connected to his or her fellows only through whatever emotions they share, and these emotions are at once so vague and unpredictable that they escape organized means of political representation while they at the same time lend fuel to any leader who might give them a proper expression and target. This is why, in Weimar sociology, the mass would be posited as a symptom of historical crisis and social instability. Codifying this view in a 1931 dictionary of sociology, Colm asserted that "the action of the mass is an alarm bell of history."[85]

16. ALARM BELLS OF HISTORY

Theodor Geiger also asserted that the mass must not be understood in abstraction but as a response to conflicts arising in given historical and social circumstances. We have already seen that he distinguished between four ways of speaking about the mass. First, the mass was simply a great and undifferentiated quantity of apparently similar things or people. Second, the mass was any group unified by shared emotions. Third, the mass was a name for a social residual, consisting of all who had not distinguished themselves as "great individuals." Geiger asserted that these three meanings of the mass were questionable. In no case was the mass discerned in its sociological and historical specificity, that is, as a particular social formation. On the contrary, these three designations were only the result of a certain way of perceiving any human collective: either visually, in which case one could speak of "an optical mass," or in terms of its inner dynamics, in which case one could speak of the mass as a psychic entity, or, finally, from a position of superiority, in which case one could speak of the broad masses in

the same sense as Edmund Burke once spoke of "the swinish multitude."[86] One's view of the mass and one's idea of whom to include in it were in all three cases wholly determined by one's perspective vis-à-vis society.[87]

In its fourth sense, however, the mass did in fact count as a specific and objective social formation, Geiger argued. He here spoke of the revolutionary mass, devoting to it an original analysis that still stands out as the most advanced attempt in Weimar sociology to conceptualize the mass as a historical phenomenon with its own proper value and function.

Unlike other mass sociologists and mass psychologists who were satisfied to dwell on the general nature of crowd behavior, Geiger asked why "the mass" had become a sensitive topic. The reason, he stated, was of course that collective movements filled the streets and squares of Weimar Germany, usually appearing as agents of unrest, challenging the status quo and the political system. For Geiger, it was this mass that deserved sociological inquiry: "Let us thus call 'mass' that social entity, which is driven by the destructive-revolutionary and mobile multitude [*Vielheit*], and for which there is as yet no name."[88]

Geiger went on to firmly link the mass to the proletariat. What characterizes the proletariat? he asked. He argued that the proletariat was the product of what he called a destruction of value in modern society. A universal value, granting social cohesion by insuring that everybody felt part of the national community, was missing, and the proletariat was the social stratum in which this absence of shared values was made manifest.

In relating the emergence of the mass and of the proletariat to the transformation of values, Geiger relied on an influential mode of thought developed by Max Scheler and Heinrich Rickert that was also highly relevant for Max Weber. Diluted versions of this "philosophy of value" (*Wertphilosophie*) circulated throughout literature and public discourse. In this view, communities and cultures crystallize around the values shared by their members, which also explains why it is difficult for an outsider to understand and appreciate any society but his own. Values were here taken as objective phenomena, and since they were accessible primarily through emotional experiences, they served as the organizing nodes of human action and feeling. In any given society there is thus a set of core values, usually objectified in certain ideas, artifacts, and texts, that makes sense for all its people and that gives sense to social life in general. In its strongest form, this theory implied that the whole vast network of human relations, traditions,

symbols, and experiences that shape social life eventually derives its meaning from a structure of values, of which all concrete social phenomena constitute so many objectivations.

In a stable and harmonious society, Geiger went on, social formations tend to correspond to a dominant value. This dominant value is represented or embodied by a ruling group in such a way that most members of the community are able to experience it as a source of meaning for their activities.[89] Periods of conflict and stress, by contrast, are typically caused by a mismatch between values and social institutions. It may be the case, for instance, that the elite or ruling classes have established political policies, hierarchies, and cultural habits that suppress the values of the majority. Or it may be the case that, because of social upheavals, great parts of the population simply lose belief in the values upheld by society's dominant classes. Periods of revolution are illustrations of this, Geiger argued. A revolution entails the destruction of a social formation that has lost its social legitimacy and is now blocking the realization of emergent values, and the revolution also brings with it new formations that structure society around values adequate to new historical conditions.[90]

This implies that revolutions are motored by social forces that are in touch with emergent values and that precisely for this reason find themselves in an antagonistic position vis-à-vis the social system that prevents their realization. In modern society, or at least in Geiger's own present, this is the proletariat's position. It stands in a negative relation both to the nation as idea and to those groups that uphold the ever more hollow values around which it is organized. Geiger thus derives his definition of the proletariat and the mass from his analytics of value: "As long as the lower strata appear as carriers of the national union of value [*nationale Werteinheit*], the term proletariat has no meaning. It gets that meaning only with the decomposition of the national community of value [*nationale Wertgemeinschaft*], that is, with the shattering of the validity of the national value contents [*nationale Wertgehalten*]."[91]

In Geiger's theory, the proletariat consists of those who are excluded from experiencing and influencing the values around which society is organized. He asserts that the proletariat can be divided into three distinct forms: "(1) the proletariat as such—as an oppressed class—; (2) the organized proletariat; and (3) the proletarian mass. The oppressed proletariat stands in passive opposition to ruling social formations, the organized

proletariat struggles constructively against them, while the mass, by contrast, terroristically-destructively rejects them."[92]

Why is "the mass" necessarily destructive? This follows from Geiger's idea of the revolutionary function of the proletariat. It has a dual task: to destroy existing social formations and to erect new ones that embody the emergent values around which a future community may be organized. Geiger's definition of the organized proletariat, on the one hand, and the mass, on the other, is thus a reflection not of reality or of empirically observed political events but rather of a preconceived concept of the revolutionary process as its dual modality of value destruction and value construction makes him assume that there must be a corresponding two-faced agent behind it.

Of course, it is not self-evident that "the mass" must be restricted to the dirty work of demolition; why could it not also have a constructive function? However, given Geiger's intellectual context, with its broad agreement on the minimum definition of "the mass" as a temporary social formation held together by emotions and manifesting itself through spontaneous action rather than organized political deliberation, the destructive task was really the only one that could come into question.

Previous analysts of the masses had identified crowd behavior as such. They had tried to disentangle the psychic mechanisms involved and to explore what caused them. Geiger's decisive contribution was to identify the specific historical and sociological meaning of crowd behavior, demonstrating that "the mass" never emerges without reason but because social circumstances call it into being to fulfill its task in the revolutionary drama: "Its revolutionary function is destructive, its spirit is a spirit of annihilation." Or again: "The mass, through the collective 'no' by which it objects to existing formations—be it only in the form of non-cooperation—is the destructive factor of the revolution." Indeed, "the mass means eternal struggle, an eternal No to all social reality."[93]

Geiger thus recognizes the historical necessity and social inevitability of the mass while at the same time depriving it of political intentionality. Or rather, it owns an intentionality, but one that is entirely negative. "Every mass is anarchistic," he states:

> The mass does not ask about the new forms and formations to come. It senses the task belonging to it: to tear down what exists; to clear ◊ the table. . . . As explosive mass, it does not see, and cannot see, that

tearing down must be followed by building up; that being human means 'having form'; that being human means providing naked and untamed being with Gestalt. That a return to a condition of social nakedness, an unconditional new beginning, simply does not belong to what is humanly possible, since it would ignore what being human is. The organized proletariat knows this.[94]

Despite the differences between Geiger's and Colm's efforts to relate the theory of the masses to the revolutionary present of Weimar Germany, they eventually reach the same conclusion. "The spirit of the masses is a great No," says Geiger.[95] The mass signals emergency, says Colm. To both, the mass is, above all, absence of organization. At the outset amorphous and unknown, the mass remains what it always was: a social phenomenon impossible to define in other than negative terms. A figure of otherness, the mass as seen by Weimar sociology is thus comparable to the otherness examined by sociology's sister discipline of anthropology, which sought to shed light and impose structure on the cultural Other. The critique of early-twentieth-century anthropology here applies to mass sociology as well. Both are, as the philosopher V. Y. Mudimbe argues, "prisoners of [their] epistemological frames," and they "only unfold the consequences of their own postulates."[96]

In interwar Germany, the "mass" was therefore a word without denotation. The function of the term was predominantly indexical: it named and it pointed. It named a savage part of humanity, and it pointed toward the wilderness, territory uncharted by the social scientist. To shift metaphors, the mass was a matter constantly out of focus, and once it was brought into focus, it ceased to be a mass and became a group or formation like any other in the table of formal sociology. Geiger spoke of "optical masses," calling to mind those situations where one is led to speak about masses only because one is too far away to discern people individually; they appear as masses in the field of vision. Yet he never ventured to ask whether the mass as such, that entity on which Weimar social theory spent so much research and reflection, was not in itself an optical illusion, a product not so much of history and society as of a certain manner of doing social analysis, which presupposed a perspective too far removed from the realities of the present.

Interestingly, Geiger also made a completely different attempt to approach the broad masses of the new German republic. In a pioneering effort of statistical sociology, what today is called sociometrics, he broke down the

adult population of Germany into its constituent parts according to criteria of income, education, sex, profession, class, and the like.[97] No investigation of the masses can match the sense of detail and rigor that Geiger displayed in this effort to seek out each human unit in the population and insert his or her data in a tabulation that eventually provided a picture of the people as such. Surprisingly, the concept of "the mass" is never mentioned in this work. Despite this, or perhaps we should say, because of this, this work gives a far more nuanced and complex image of the so-called masses than any other sociological account of this period. The lesson is a paradoxical one. The most successful attempt to gather knowledge of the masses is found in a work of sociology in which the concept of "the mass" is absent. The best way to know the masses, it turns out, is to stop knowing them *as* masses—and this may at least partly explain why Geiger's early sociometrics is one of the few works of Weimar sociology that continues to be read and studied in our own day, as a classic of interwar sociology.

Geiger's study of the stratification of the German people is in this sense isomorphic with another path-breaking work of Weimar culture in a completely different genre, August Sander's photographic atlas *Menschen des 20. Jahrhunderts*. In this project, by now well known and often exhibited, Sander attempted to document all the professions, classes, and groups of the German people. He photographed individual human beings, on their own or in small groups, each placed against the background of his or her class, profession, ethnicity, or place of origin (see figures 2.3, 2.4 and 2.5). The different portraits were then sorted into types, and each portfolio of types was ascribed a particular place in a general table that was supposed to give a general overview of all groups and subgroups of Germany's population. As Sander explained, the project "moves from earthbound men to the highest peaks of culture in finest differentiation, and then downwards to the idiots."[98] Sander's encyclopedic project was more ethnological than sociological and more inventorying than analytic. Perhaps precisely because of his organic and somewhat premodern approach, however, he shed light on the inevitable imprecision of sociology's attempt to classify the rich and variegated collectives of modernity into a limited number of predetermined slots.

From Sander's example we learn that the greatest strength of the sociological approach to the mass was also its decisive weakness. In line with the legacy of Simmel, sociology saw the mass as a particular form of sociation that should be understood as a social entity in its own right. This was a step

FIGURE 2.3 August Sander, *Unem-ployed*, 1928. *Source:* The J. Paul Getty Museum, Los Angeles. © J. Paul Getty Trust and the Photograph. Samml./ SK Stiftung Kultur —A. Sander Archiv, Cologne/Artists Rights Society (ARS), New York/BUS Sweden 2012.

forward from the mass psychologists, who tended to see masses wherever people gathered in groups and who always regarded such gatherings as a danger to the psychic sanity of the individual. However, when describing the mass as a specific form of sociation, sociology nonetheless tended to see it as a symptom of crisis, a social formation consisting of all who had been disconnected from more established social formations, or had never

FIGURE 2.4 August Sander, Untitled (Members of the Piscator Theater), 1929. *Source:* The J. Paul Getty Museum, Los Angeles. © J. Paul Getty Trust and the Photograph. Samml./SK Stiftung Kultur —A. Sander Archiv, Cologne/Artists Rights Society (ARS), New York/BUS Sweden 2012.

FIGURE 2.5 August Sander, Untitled (National Socialists at Cologne Central Train Station), 1937. *Source:* The J. Paul Getty Museum, Los Angeles. © J. Paul Getty Trust and the Photograph. Samml./SK Stiftung Kultur —A. Sander Archiv, Cologne/Artists Rights Society (ARS), New York/BUS Sweden 2012.

been successfully socialized by the ruling systems of values. Mass sociology thus failed to account for its object in other than negative terms. As Leon Bramson has argued, it was preoccupied with ideas of "social disorganization" and "social disintegration," and the mass was the predictable outcome of such stories of atomization and decline.[99] Moreover, but with the exception of Gerhard Colm and Theodor Geiger, mass sociology also failed to account for its object as a historical agent. Rather, the mass was typically seen as a reservoir of people left behind, usually at the bottom of society, or as the broad segments of the population who took no active part in political and cultural life. Ultimately, the academic social sciences used the mass as a term for social life as it was lived at the margins of society. Since this life apparently threatened to disrupt or to evade the political system and its established ways of representing the interest of the nation, the mass was associated with social disintegration. To be more precise, the mass was not just *associated* with social disintegration; frequently, the mass was simply another name for chaos.

17. SLEEPWALKERS

In the arts and literature of interwar Germany and Austria the masses were as dominating a concern as they were in sociology, psychology, and cultural philosophy. What writers and artists found so challenging, or even attractive, were the two aspects of the masses that sociology was unable to handle: the mass as an agent of social rejuvenation and of social collapse—or in a word, the mass as an agent of transformation. As we have seen, this phenomenon was beyond the reach of formal sociology and hence conceived of as the opposite of social rationality.

Literature kept exploring this borderland. In most aesthetic representations we find largely the same idea of the mass as a negative and destructive element as was typical of mass sociology, and they resonate with the apocalyptic overtones found elsewhere in Weimar culture. At the same time, however, they are counterpoints of sociology, for they bring us face to face with the groups and collectives that sociology kept at a distance. Here I will look at two highly influential literary accounts of masses and mass action, the first one by Hermann Broch, the second by Ernst Toller. Both deal with the German revolution of November 1918. As we have seen, sociologists

like Wiese, Vleugels, Cohn, and Geiger approached the German revolution through figures of evasion and abstraction. Broch and Toller, by contrast, post themselves in its midst in order to diagnose the concrete experiences that it spawned.

If fire is the main "crowd symbol," as Elias Canetti argued in *Crowds and Power*, Broch's *The Sleepwalkers* is a truly awesome manifestation of the crowd. In the climactic chapter of the novel, four buildings are set ablaze. Just as Canetti watched the burning Palace of Justice in Vienna on 15 July 1927, Broch's protagonists are spellbound by the sight of the collapsing dome of the medieval city hall as the building founders in a sea of fire. Sensing the sharp smell of smoke and turning his gaze toward the burning townscape, one character starts hallucinating about the last verdict. The title of the chapter—"'Nobody sees the other in the darkness.' Events of 3rd, 4th and 5th November 1918"—is an exact historical reference to the German Revolution, which was the breakthrough of democracy in Germany.[100] Broch, by contrast, regarded the revolution as the collapse of European civilization. The crisis had been in the making for a long time, in fact, ever since the Renaissance, at which point the erosion of social and existential values set in that subsequently accompanied the process of modernization and ended in the "mass insanity" of the interwar period, according to the Austrian novelist and critic.

In order to understand what Broch had in mind when analyzing the turmoil of 1918 and why he blamed the masses for it, it is instructive to relate his work to Simmel's sociology, especially to Simmel's analysis of how urban modernity had transformed mental life. The German sociologist detected a growing gap between what he called the individual level and the social level. A process of social rationalization gradually stripped the human subject of his or her traditional ways of relating to the surrounding community. The specialization of life and work tended to rob the individual of "all progress, spirituality and value," Simmel contended, to the extent that the human being was ultimately reduced "to a grain of dust as against the vast overwhelming organization of things and forces."[101]

The undoing of the relation of individual and society was Broch's major topic, too, but his analysis differed from Simmel's. In order to clarify the causes of the disintegration Broch developed not a sociology but an idealist philosophy of value, or *Wertphilosophie*, that is distinctive of *The Sleepwalkers*, the trilogy of novels that he published from 1930 through 1932, and

that he then continued to develop in a long academic treatise throughout the 1930s and the 1940s, posthumously published as *Massenwahntheorie* (Theory of mass insanity). In this work, the decomposition of values in modern society is directly linked to the rise of the masses and the emergence of fascism. However, when tracing Broch's ideas of the masses back in time, we discover that they were triggered by the revolutionary events in the fall of 1918. His first text on mass insanity was an open letter published in December that year. Entitled "Die Straße" (The street), it expressed deep disgust not only for the mass manifestations that by then were a dominating factor in German and Austrian social life but also for the organized workers' movement as such.[102]

In *The Sleepwalkers*, Broch's theory is presented by one of the minor characters, Bertrand Müller, a philosopher who delivers an essay on "the disintegration of values" that serves as a running commentary on the historical events related in the narrative. The remaining characters embody the existential and social consequences of this process of erosion. We can easily relate these consequences to the historical paralysis that, in Broch's view, characterized modern European society and that he saw as the first signs of mass insanity, and he endorsed such an interpretation of his work. However, the novel depicts and symbolizes the everyday signs and acts of civilizational change and psychic deterioration in such richness and intensity that the narrative by far exceeds the theory of value that it was supposed to illustrate. *The Sleepwalkers* thus presents a story of decline and fall, and it does so from several points of view and in a variety of genres—philosophical discourse, historical chronicle, bildungsroman, psychological introspection, lyrical ballad, drama, small-town farce, and journalism. Each genre offers a different perspective on the cultural collapse culminating in 1918. But the different strands of the story never fall into line. What results is a heterogeneous narrative that mirrors the incoherence of modern life, its fragmentation into several different value spheres without any organizing value that would bring unity to the world and meaning to existence.

Simmel and his heirs had put their trust in conceptual clarification and sociological inquiry. Broch, by contrast, shunned sociological explanations of historical events and human actions. He looked to the arts, especially the novel, as the sole remaining hope of integrating the chaotic elements of the present so that they could be understood, their causes clarified, and their consequences avoided. Moreover, Simmel and the sociologists of

Weimar Germany had investigated various forms of sociation, recognizing that modernity entailed new forms of social interaction that they all associated with the masses; Broch, for his part, invented a literary language able to register what happens inside a mind that is slowly disconnected from communal horizons of meaning and left to its private ruses, until it finally succumbs to the plague of mass insanity.

According to Broch, religious, ethical, and aesthetic values constitute the bonds among humans, and these values are also the means by which people make themselves at home in the universe. To say that there is a community is to assert the presence of shared ideas, which, precisely by virtue of being shared, emerge as values reigning in a sphere of their own, partly abstracted from the communal life whose members they serve as ethical ideals or as guides of conduct. True communal life thus depends on the ability of each person to relate his or her existence to a central system of values that helps everybody to master the irrational forces that keep intruding on it. In so far as these values find expression in ethical doctrines or works of art, they function as symbols in which the community may contemplate the image of its own unity and coherence. Expressed as ethical commandments, practiced in religious rituals, or visualized as aesthetic symbols, values are thus indispensable for the individual's ability to feel connected to society, integrated into its communal dealings, and responsible for its progress.

Broch went so far as to state that a culture or epoch proved its vitality by its capacity to express itself in a certain symbol, aesthetic style or manner of ornamentation. Only in this way could the people of an epoch establish the inner coherence of their value system, demonstrating that each being and object belonged to a totality, for which the single ornament—the detail sealing the formal unity of a building, a poem, or a painting—served as the ultimate symbol. Sometimes, this idealism led Broch to remarkable conclusions, as when he argued that the power of the Habsburg Empire was entirely dependent on the symbolic power of the crown.[103] That modern European culture was incapable of creating a persuasive aesthetic style, or that the modernist architects of Austria and Germany rejected the ornament as empty decoration, was a sure sign of the disintegration of values, according to Broch. He established a firm link between the aesthetic level and the political level, arguing that an epoch "that can no longer give birth to ornament" is also one that is "completely under dominion of death and hell."[104]

It appears that Broch, when writing these lines at the beginning of the 1930s, never recognized the possibility that the modern epoch had perhaps already created its own art of ornament. Siegfried Kracauer had argued as much in his landmark essay of 1927, "The Mass Ornament," in which he showed that the mass itself gave rise to a new kind of ornament. As I will discuss in a later chapter, Kracauer described how at great gatherings human bodies could be turned into ornamental patterns that could be manipulated and viewed from a distance, in ways that corresponded to how people where drilled and rearranged according to the needs of the capitalist economy and the modern state. There is nothing in Broch's work, however, to suggest that he had digested Kracauer's argument. While it is true that Broch proclaimed that people without connection to values became particles in a great human mass, he did not follow Kracauer's hint that these mass particles may well be reorganized into some new pattern. Broch insisted on the sheer formlessness and lack of expressivity of the mass.

Explaining the intentions behind his novel, Hermann Broch stated: "What we experience is the destruction of the great rational systems of value. And the catastrophe of humanity that we experience is most likely nothing but this destruction. A catastrophe of muteness."[105] *The Sleepwalkers* is conceived as a novel about the catastrophe and the forces causing it. It begins in the 1880s among the aging nobility in the Prussian heartland, and it ends with the November revolution of 1918, in which the old ruling class is defeated and the working classes assert their power, although the only ones gaining from the upheaval are ruthless individualists like Wilhelm Huguenau, the main character of the third part of the trilogy, who participates in the social and political events only to reap individual profit. As Broch's narrative takes us through four decades of history from the booming 1880s to the chaotic postwar period we come to share the characters' anxiety as they experience the unmaking of their social fabric. Among the members of the older generation, personified by Pasenow, the protagonist of the first novel, values are internalized and function as a source of motivation. In the turn-of-the-century generation, represented by Esch, the bookkeeper turned newspaper editor at the center of the second part, the same values are seen as oppressive conventions that one must break or escape from in order to realize one's own millennial ideals in Nietzschean fashion. As for the members of the postwar generation, they learn from their experiences in the trenches that they better adapt to a world without any values other than those serving their own needs.

As told by Broch, the history of European culture thus inevitably approaches a stage where men and women lose touch with all systems of value. Gradually and imperceptibly, they are deprived of that inner sense of orientation that had previously enabled judgment and behavior in accord with ethical standards and social norms. Instead, human action is increasingly guided by primary impulses of self-preservation. The rationale for action and communication becomes, in Broch's language, "individualistic." Wilhelm Huguenau, the antihero of the last part of the trilogy, personifies this spirit. He is immune to ethical and political values yet prepared to support any value that can be converted to private riches, and hence happy to benefit from the misery of others. Broch presents Huguenau as the archetype of individualism.

What makes Huguenau important for our purposes, however, is not that he embodies individualism but that he is also, and because of his individualism, a man of the masses. Huguenau's triumphal moment arrives in November 1918, which unleashes his individualistic character. The novel describes him as "the passive revolutionary," indifferent to the revolution's political goals yet actively taking advantage of the moment to further his own interests.[106] Eternal *deserteur* from collective efforts and model entrepreneur of his own future, Huguenau is a personification of the Weimar zeitgeist. Had Weimar sociologists looked for an example of their notion of the latent mass, none would have suited them better than he.

Of course, it seems paradoxical that the moment of individualism is also that of the masses and that both coincide with the revolutionary turning point of German history. For Broch, a firm logic underlies this process. "The final indivisible unit in the disintegration of values is the human individual," states Bertrand Müller as he sums up the action of 1918. He goes on to spell out the ominous consequences of this triumph of the individual:

The less [the] individual partakes in some authoritative system, and the more he is left to his own empiric autonomy—in that respect, too, the heir of the Renaissance and of the individualism that it heralded—the narrower and more modest does his 'private theology' become, the more incapable is it of comprehending any values beyond its immediate and most personal environment: whatever comes from beyond the limits of its narrow circle can be accepted only in a crude and undigested state, in other words as dogma, . . . The man who is thus

outside the confines of every value-combination, and has become the exclusive representative of an individual value, is metaphysically an outcast, for his autonomy presupposes the resolution and disintegration of all systems into its individual elements; such a man is liberated from values and from style, and can be influenced only by the irrational.[107]

The final product of the historical process chronicled by Broch is a human being "liberated" from all communal values, "der wertfreie Mensch," who accepts no gods except those endorsed by his or her "private theology." In short, it is the individual. At the same time, however, the final product is the mass. For in Broch's theory, the mass is the sum total of all those who truly have become individuals, a social aggregate made up by everybody who has been disconnected from the value systems that once regulated human life and who must now live according to their own instincts. Hence, the masses are defined by an immunity to rational values and a willingness to act irrationally.[108]

"The mass" served Broch as an objective designation of the condition of *Wertfreiheit*. A social world structured by transcendental values assigning to each being a specific position and function within the whole was now replaced by a world of disconnected singularities existing in a state of immanence without organizing pattern. Society turned into its opposite: that is what the mass was about. Broch's notion of the mass was thus not devised as a historical or social concept. Although his conception was influenced by observations of postwar conditions—unemployment, starvation, social conflict, demobilization of armies, mobilization of militias, the rise of populist demagogues—he was careful to point out that the mass was the result of processes affecting the human condition in general. In his theory, then, the mass is a metaphysical notion, designating a thoroughly atomized world, the end product of the decomposition of the value systems that once provided for community. Although people without material and social security are the first ones to be swallowed by the mass, the mass is not restricted to the proletarian condition. It consists of all people, no matter what their social rank, who are placed at an existential *Nullpunkt* characterized by anxiety and fear.

Anxiety and fear? Yes, because without connection to any system of values, people have no ability to make sense of the irrational side of human

existence. The world appears as hostile, silent, and devoid of meaning—
sinnlos. Everybody stands face to face with his or her own lonely being.
All are turned into strangers to one another and into outcasts vis-à-vis the
social world they once knew.

Now we see why Huguenau, the triumphant individualist, is also a crea-
ture of the masses and why he comes into his own in the destructive phase
of the revolution, where he is free to commit any act without sensing the
consequences. In the midst of revolutionary turmoil, Huguenau first pays
visit to the wife of his antagonist, Esch, and violates her on the living-room
sofa. "Save my husband," she cries as he is leaving. Huguenau shouts back,
to comfort her, "I'll look after him." Soon enough he finds Esch and follows
him down an alley, only to stab him in the back with his bayonet. A few days
later, he swindles the widow, whom he has just raped, of the inheritance
from her husband, whom he has just killed. Having committed these atroci-
ties, Huguenau concludes, like the Lord on the seventh day of creation: "All
was well [Es war alles gut]." The narrator adds: "Huguenau had committed
a murder. He forgot it afterwards; it never came into his mind again."[109]

Broch renders the November revolution of 1918 as a monstrous event.
Revolutions, he asserts, are "insurrections of evil against evil, insurrections
of the irrational against the rational, insurrections of the irrational mas-
querading as extreme logical reasoning against rational institutions com-
placently defending themselves by an appeal to irrational sentiment."[110] The
agent of the revolution, or rather, the tool that revolution uses, is not the
masses as a collective agent but the masses as atomized and agonized indi-
viduals. As Broch explains in *The Sleepwalkers*, the instrument of the revo-
lution is "the isolated human being, stripped of values, [der einsam wert-
freie Mensch] . . . and on the day when the trumpets of judgment sound it
is the man released from all values [der wertfreie Mensch] who becomes the
executioner of a world that has pronounced its own sentence."[111]

In this sense, the revolution is the social form—or formlessness—ade-
quate to great numbers of people placed at the zero-degree level where all
values are voided. It is their only remaining way of mastering the world,
so as to force everybody and everything to comply with their own irratio-
nal instincts. The revolution is ultimately an event marked by destruction,
aggression, and violence, for it stems from an inability to see self and oth-
ers as subjected to one overarching ideal and instead posits the self as the
only remaining value. In Broch's diagnosis, the revolution was thus akin

to the new spirit of objectivity that characterized the culture of Weimar Germany, "die neue Sachlichkeit." It was a culture that rejected values in the name of sobriety, concreteness, and objectivity. It implied a mechanical attitude to the world and an instrumental treatment of fellow human beings. Everything and everybody had value only insofar as they contributed to the individual's self-preservation and self-assertion. At least, this is what Broch claimed, as he let Huguenau, a man liberated from all values, occupy center stage of the third and final part of his novel, entitled "Huguenau, oder die Sachlichkeit."

Broch's notion of the mass was no less negative or apocalyptic than any other mass theory in interwar culture; in fact, it was more so as it anticipated the end of the Weimar Republic, the collapse of German culture, and the decline of the West. The mass, according to Broch, had nothing to do with community, cohesion, collectivity, or social bonds; the mass, rather, was social structures falling apart and societies set ablaze and, in the smoking ruins, millions of scattered souls fighting it out among themselves or crying out for a savior.

In his theory of mass behavior, Broch coined a word for this predicament: *Dämmerzustand*. It was a condition of twilight in which the light of reason was extinguished. The condition is evoked by the title of the culminating chapter, "Nobody sees the other in the darkness," and also by the title of the novel itself: *Sleepwalkers*. Darkness has fallen; men and women are alive but live as though they were asleep, groping their way without light to guide their actions, reacting on instinct to preserve themselves in a world filled with hostile powers, and fearing every signal from the external world. Marguerite, one of the characters, is an example: "The sleepwalking of the infinite has seized upon her and never more will let her go."[112]

Broch attributed great explanatory value to his notion of *Dämmerzustand*.[113] The term has the advantage of evoking the dozy state of an individual on the verge of succumbing to delusions while at the same time it conjures up a twilight atmosphere of some more epochal doom, as Oswald Spengler had prophesized in his best-selling work *The Decline of the West*. In this condition, people sink into a dreamlike state where unconscious instincts dominate their behavior and social norms lose validity. The ego, or the *I*, disintegrates along with the values that are supposed to keep it in place as an organizing center of control and rationality. The person becomes "ego-less" (*ichlos*), as one commentator puts it.[114] In this condition

of "sleepwalking," people are prone to be afflicted by "mass insanity" as they easily come under the spell of irrational value systems.[115]

Broch spent the greater part of his later career developing an analysis of this collective disorder. It was an urgent task, he insisted. In their twilight predicament, masses of disconnected human atoms desperately sought to escape their atomization and the ensuing disorientation by intoxicating themselves with any consoling idea that was offered or by subjecting themselves to authorities showing a way out of their misery and loneliness. "Remember how gloriously drunk we all were in August 1914," says an old military physician in *The Sleepwalkers*, alluding to the nationalist enthusiasm released at the outbreak of the war. "It seems to me as though that was the first and the last time that people felt a real sense of fellowship." The doctor longs for "some new drunkenness, . . . morphia or patriotism or communism or anything else that makes a man drunk . . . give me something to make me feel we're all comrades again."[116]

Elaborating his theory of the destruction of values and the rise of the masses into ever finer detail and greater complexity, Broch came to develop a political theory of fascism. He looked upon the Nazi government and World War II with wide-eyed terror, observing how the 1930s turned into a far more powerful illustration of mass insanity than the situation of 1918 that he had rendered in his novel. In the mid-1930s he set to work on a new novel in which he told the same story about ethical and social disintegration as he had done in *The Sleepwalkers*, but this time with explicit references to Hitler and fascist mass hysteria.[117] The novel was not completed, partly because Broch despaired about literature's possibilities to capture the historical situation. By the end of the 1930s he turned away from fiction and devoted himself to an ambitious study on the psychology of politics. Unlike Weimar sociologists, Broch never disavowed the critical relation of theory and history. On the contrary, every fiber of his oeuvre—and especially *Massenwahntheorie*, which he was never able to complete—is marked by a sense of political responsibility that turned his career into an act of defiance against the totalitarian regimes of his time.

On Hermann Broch's own account, his major achievements belonged to the areas of ethics and political psychology, and he placed his novels in the service of his ethical convictions. He construed an idealist discourse about the disintegration of values in which he never ceased believing; in addition, he developed a theory of the mass and mass hysteria by which he sought to

account for the consequences of that disintegration. An idealist, Broch had no other cure for mass insanity than powerful ideals. If the masses longed for guidance and had been spellbound by false authorities, they should be offered true and rational ones instead. Whence would they come? Broch first placed his hopes in the wisdom of poets and writers; then in the League of Nations, which he sought to provide with a new resolution that would revitalize its mandate; and finally in the liberal ideas of the United States. He demanded that these powers deliver "global peace" and "total democracy" according to numerous proposals that he drafted toward the end of his career. These drafts remained utopian blueprints, disconnected from the brute realities of power and economy.[118]

The main weakness of Broch's theory is this idealist foundation, the Platonic conviction that social order presupposes the existence of universal values to which all citizens pledge allegiance by second nature. Did such an order ever exist? Broch regarded medieval Christianity as a golden age in which compelling religious values along with the scholastic system of rational deduction offered men and women a centralized system of value (*Zentralwertsysteme*), which enabled a "harmonious cultural development where the individual was given the attainable maximum of material and psychic security."[119] Like many other thinkers of interwar Europe, Broch regarded the contemporary situation as one of steep decline, the greatest symptom being the emergence of fascist mass delusions. Broch understood these delusions as collective somnambulism and explained it as the consequence of the disappearance of a central value system. Being the end product of a process that had destroyed all universals, the mass now emerged as a new universal condition of valuelessness.

Having identified the mass as the universal human condition in modernity, Broch went on to examine its psychological, ethical, aesthetic, and political consequences. In this effort, he relied heavily on existing mass psychology, copying into his own theory most of the weaknesses and prejudices of the discourse founded by Gustave Le Bon.

Broch's theory of the mass is thus based on a philosophy of history that was fairly common among intellectuals of his period. They posited modernity as a protracted period of decline and human alienation, and to prove that their story was right they pointed at the catastrophe of World War I, the mechanization and instrumentalization of capitalist society, and the depravity of modern life in general. Among conservative thinkers this view led to a

nostalgic longing for the old times. Among radical thinkers, it bred a utopian urge to reestablish social harmony by inventing a socialist system, or what Michael Löwy has termed a revolutionary romanticism.[120] The revolutionary right, for its part, hailed Hitler as a leader able to reestablish political authority and guide the Germans toward a future beyond social strife.

Broch no doubt belonged to the utopian flank, and he worked harder than most for an international community based on justice. What set him apart from ordinary liberals and leftists, however, was his Platonic faith, according to which history and human action were meaningful only insofar as they were enveloped by a horizon of fixed values. To him, it was indisputable that the basic problem of modernity was the disintegration of values, which had reduced men and women to mere particles in a crowd. It was just as indisputable, therefore, that the right solution was to construe a new system of values, which would restore a sense of coherence and belonging to the disintegrating polities of Europe.

Broch's postulation of the mass as a universal predicament proved more original and fruitful in the aesthetic area than in the ethical and political domains. By bringing ideas of the mass and mass insanity in proximity with narrative writing, Broch attained two goals. First, on the formal level, the suggestion of the *Dämmerzustand* as the pervasive mood of German society allowed him to bring unity to his complicated narrative, integrating all the discrepant parts of the historical panorama into a comprehensive narrative totality. The organizing mechanisms of this totality were the notions of the *Dämmerzustand* and mass insanity, which allowed Broch to construe every mind, action, or person as a particular instance of the same historical condition. In order to probe deeper into history, Broch's novel could keep inventing new situations and characters, without the narrative ever losing the panoramic feature that ensured that its events and characters would refract the same catastrophic light, in which all objects and beings stood revealed as members of one single species doomed for extinction. If Broch's mass theory failed as *theory*, it proved all the more fruitful as *narrative*, that is, as an aesthetic device making disclosed layers of the psyche available for literary representation.

For the second and more important goal that Broch attained was the discovery of a mode of writing able to adequately render how each human being experiences "mass insanity" in his or her own particular way. This could not be done by bringing in psychological models and general

categories, for that would have turned the novel into a mere illustration of theory. In order to compellingly show how the disintegration of values and the onset of mass insanity had transformed the human condition, Broch had to stay within the bounds of individual experience and perception. He resolved this problem by positing a new object of aesthetic exploration and by inventing a prose to capture it. The object in question is the state of being that he called "sleepwalking" and, later on, in his theoretical work, "*Dämmerzustand.*" Both terms name an area of interference between the human psyche and politics, a juncture of history and psychology. In the words of Ernestine Schlant, "Sleepwalking can be viewed as an individual psychodrama on an unconscious level played against the social and historical background. It is a state of openness in which the desires and fears of the protagonists are enacted without inhibition. Due to its sheer irrationalism, sleepwalking can never become the basis for a new integration of values. Unless it can be channeled into rational structures and larger systems, it remains an unbound, value-free, anarchic force."[121]

In Broch's view, the novelistic rendering of these unconscious yet historically conditioned states of being served the purpose of elucidating the more general phenomenon of mass insanity. Sleepwalking and *Dämmerzustand* were the proper mode of existence for humans that had turned into mass. However, once these modes of existence were given literary form, they exceeded the ideological or theoretical figure of the mass, which now appeared as a mere pretext for a far more rewarding enterprise. Broch's theory of mass insanity should thus be recognized less as systematic doctrine or theory than as narrated mass psychology, in which transformations of human subjectivity and affect are registered and conveyed and explained as effects of social stress and historical danger.[122] No theory of the mass can contain the infinite variations in which Broch explores the psychology of sleepwalking. At the same time, he would perhaps never have felt compelled to probe the psychic reactions on German history with such precision, had he not been convinced that his exploration served a more general purpose, the establishment of the laws and qualities of mass behavior.

Interestingly, Broch's metaphors of *Schlafwandel* and *Dämmerzustand* resonate with terms Walter Benjamin chose to account for the same historical predicament. In his *Arcades Project* from the 1930s, Benjamin compared the human predicament under capitalism, especially after its totalitarian turn in Europe of the 1920s and 1930s, to the state of sleeping and dreaming.

His theory of history, as well as his critical writing more generally, aimed to serve as an alarm clock for this collective, or society of sleepwalkers. With Broch's picture of how historical events actuate a sensory deprivation, which sends everyone into a twilight world where they lose sense of time, place, and direction, we should juxtapose Benjamin's concept of "Awakening" as the only proper way of emancipating oneself from an oppressive history. Yet the similarity of metaphors also demonstrates the points at which their interpretations of the interwar period diverged: where Broch saw an unleashing of irrational political passions that would eventually explode in the night of fascism, Benjamin observed political passions capable of igniting a revolution.

Like no other novel of the Weimar era, Broch's *Sleepwalkers* was able to record how historical processes and collective events affected human consciousness, generating a wide variety of psychic responses depending on the specific situation of the individual. Broch therefore occupies a particular place in the development of the psychological novel. For a long time, the novel of emotions had kept to the private sphere, registering the subject's emotional investments in intimate and familiar settings. With Broch, the psyche opened itself to historical and social influences of a more general kind. He belongs to the discoverers of the political constitution of subjective passions. Hidden behind Broch's theory of the masses there is a more interesting text, which invented a way of representing human passions at a moment when they were critically charged by great collective events.

18. I AM MASS

In Hermann Broch: social destruction and death. In other writers: social destruction and rebirth. In all literature of the Weimar era, the mass is an image of society's border zone, whence ominous signs of social change emerge. A strange phenomenon, this mass—neither included in society nor fully excluded from it, it elicits deep anxiety among interwar European intellectuals, who yet fail to describe it except through negations. If we want to understand the position of the mass in mainstream culture and discourse of the 1920s, Ernst Toller's drama *Masse Mensch* offers a final lesson.[123]

In this masterpiece of politically committed expressionism, Toller attempted to sort out the reasons for the defeat of the socialist republic

that governed Munich and Bavaria for some months in 1918 and 1919, part of that time under Toller's own leadership. He drafted the first version of his play in October 1919, at the beginning of his five-year term in the Nieder-schönenfeld prison to which he was condemned for high treason because of his involvement in the government of the red republic. He did not seek only to show the reasons for the failure of the revolution. His self-proclaimed aim was to work through his lingering sense of guilt for having engaged in an armed struggle that had proved unfruitful and had caused the death of innocents.

Immediately after its successful staging at the Volksbühne in Berlin in the fall of 1921, *Masse Mensch* stirred controversy. Many saw it as a power-ful example of an emerging socialist theater. Everybody also recognized that under Jürgen Fehling's directorship the play inaugurated a new tone on the German stage. The Berlin premiere counts as the birth of Ger-man stage expressionism.[124] Meanwhile, Toller's left-wing and communist admirers were skeptical. Did not *Masse Mensch* exalt the virtues of indi-vidual conscience and spirituality over collective forms of political organi-zation and action? The play showed that Toller was lost for Moscow, these critics argued.[125]

To be sure, *Masses Man*, as the title is translated into English, dwells on none of the obvious historical circumstances that doomed Munich's peas-ant, worker, and soldier republic from its first morning. A glance at the real historical situation would reveal a frustrated and exhausted population divided between a nervous bourgeoisie and an impatient working class, all of them suffering from a severe shortage of food and supplies and many of them distrustful of their new leadership, which harbored conflicting views as to the aims of the revolution and was never able to organize a proper defense, and which was therefore fated to be crushed by the enemy's over-powering military might. *Masses Man* disregards these facts, however, as it seeks the reason for defeat in a metaphysical conflict between two protago-nists: man and mass, *Mensch* and *Masse*. The revolution fails because these two are at odds.

As Toller's drama depicts human history as a struggle between Man and the Masses, it cannot but conclude that human history is an unnerving and tragic affair. The individual cannot take part in mass politics without betraying his or her ethical standards, and as the suffering masses seek to realize their vision of peace, justice, and community they must first undo its

oppressors in a violent struggle that undermines those very aims. Putatively a play about "the social revolution of the twentieth century," *Masses Man* thus transforms the concrete events and agents of German history into an agonistic struggle between opposing ethical principles.

This abstract view was in line with Toller's conception of expressionist drama. In 1929, looking back at the situation after the war, Toller discussed the expressionist form of his first plays, *Die Wandlung* (*Transformation*, completed in 1918) and *Masse Mensch*. Expressionism, he argued, wanted "to change the surrounding world by giving it a more just and luminous face. Reality should be reconceived and reborn in light of the idea."[126] This is why expressionist theater had to discard realistic characters, seeking instead to depict universal human beings in all their nakedness. Expressionist theater presented types, not individuals.

True to the ideas of expressionism, *Masses Man* avoids particularity and identity. The roles contain no lifelike people but characters such as "Woman," "Man," "Worker," "Soldier," "Banker," "Priest," "Guard," and "Prisoner" (131/66). Toller's depersonalization of history goes even further as he also populates the stage with "shadows" and, above all, that supremely paradoxical personification of anonymity who is the mouthpiece of the masses, "The Nameless." Furthermore, the drama is set in a dreamland of abstraction where each situation and statement is pressed for some timeless truth. We are faced not so much with a specific description of the social revolution, much less with an account of the Munich events, but with a dramatization of *la condition humaine*. The air of universality is heightened by a series of expressionist special effects, masterfully developed in Fehling's production. In the rotation of scenes, dream pictures interrupt the scenes of the main action, which themselves have the atmosphere of a nightmare. Most scenes are set in late evening or at night, eliciting the impression that the spaces where the workers prepare to strike are oppressive and impenetrable by daylight. In one of the dream pictures, stage directions instruct that the room be "boundless" ("*unbegrenzt*"), stressing the transcendent thrust of the story (172/99).

Toller creates what Hermann Broch called a *Dämmerzustand*. In *Masse Mensch* action takes place in a twilight world without firm boundaries or contours, where no one discerns the right course of action or the true motifs and identities of the agents seeking charge of the revolution. The decisive actions and turning points of the drama take place off-stage and are often

reported third-hand by messengers who enter and exit at high pace, leaving the main protagonists to argue about the meaning of the history that unfolds around them, but beyond their control. Gradually, two alternatives emerge, one embodied by The Woman, the other by The Nameless. Neither one is a human being of flesh and blood. Both personify principles and both remain nameless throughout the drama. True, The Woman is also listed as Irene Sonja L in the list of roles, but not in the script's main text.[127] The wife of a government official and from a bourgeois family, The Woman crosses the class divide to join in the spontaneous protests of the proletariat. After six years of war we have had enough, she declares. While The Woman dismisses both capitalism and communism, she also hesitates to support the revolution as it inevitably implies violence. A humanitarian and pacifist, her preferred path to progress is one of social reform and education. The Nameless, for his part, thinks her naive and calls for armed struggle against the ruling classes.

Who is the agent of the revolution? Which values emerge from the struggle? What are the legitimate means through which these values may be furthered? These questions, raised in the dialogue between the antagonists, ultimately converge in one enigma: Who are the masses, and what do they want? The conflict between The Woman and The Nameless, which first appears as a conflict between ethics and politics, is ultimately translated into a conflict between the human and the mass.

According to The Nameless, "Masses are revenge for the injustice of centuries. Masses are revenge!" To which The Woman responds: "Halt, you're crazy from the struggle. I have to make you stop. Masses should be a people bound by love. Masses should be community" (167/95). The Nameless is of a different meaning:

> THE NAMELESS: How far you are from the truth!
> Masses are leader!
> Masses are strength! . . .
> Masses are action!
>
> (155–56/86)

For "the masses" to unite in love and form a true community, they must first remove the obstacles preventing them from realizing their program, argues The Nameless. Liberation is won not through a prior commitment

to ideals but through action. Before the masses can attain their humanity, oppression must first cease. And for oppression to cease, the masses must defeat the ruling classes.

The Woman cannot accept this view. Ethical commands ought not be sacrificed for political demands, violence may not be justified in the name of some future peace. To prove her point, she sacrifices her life to save a handful of enemy soldiers who have been taken prisoners and are awaiting execution:

THE WOMAN: Hear: no Man may kill another Man
For the sake of a cause.
Unholy the cause which makes that demand.
Whoever demands human blood for the sake of a cause
is Moloch:
God was Moloch.
State was Moloch.
Masses were Moloch.

(184–85/110)

The Nameless takes an opposite view. It is delusive to believe, as The Woman does, that oppressed and oppressors could form a common "Family of Man," recognizing one another as fellow human beings, only by pledging allegiance to the same set of ideals. Indeed, "There is no 'Man'. / Only men of the Masses here! / And men of the State over there!" (182/107). According to The Nameless, "Man" can be born only when "the Masses" have completed their work of liberation. As for now, "Only the Masses count, not Man" (184/109). To this The Woman responds that the oppressed masses are weak, enslaved by their oppressors and motivated only by despair, hatred, aggression, and resistance. Such emotions are a poor support for a human community of love and freedom:

THE WOMAN: Masses are not holy.
Violence made the Masses.
Dispossession made the Masses.
Masses are instinct born from need,
Devout submissiveness . . .
Brutal revenge . . .

Blinded slavery . . .
Pious will . . .
Masses are a trampled field,
Masses are a trapped and buried people.

(182/107)

Throughout these exchanges, a peculiar instability pertains between the level of discourse and the level of action. For while The Woman and The Nameless debate the nature and aspirations of "the Masses," producing an endless series of incoherent and opposing descriptions, the masses themselves act in the wings of the drama, where they are striking, arming themselves, marching off to defend the railway station, until they are finally defeated and destroyed. Jürgen Fehling's Berlin staging depicted the culmination of the struggle in a shattering scene, in which a workers' choir was gradually surrounded by the enemy troops, the triumphant voices singing "The International" being gradually drowned out by a crescendo of machine-gun fire that mows down the insurrectionary workers.

Largely, but not completely, the opinions voiced by The Woman conform to those of Toller, who rejected violence as a political tool and embraced a humanitarian and pacifist program of social improvement, while the ideas expressed by The Nameless correspond fairly well to the Bolshevik leader Eugen Leviné, who competed with Toller for the leadership of the central council of the red republic.[128] A member of the Independent Socialist Party (USPD), Toller had agreed to join the central council in the hope that all elements of the progressive majority could be brought together to peacefully collaborate toward a socialist commune. However, when it became clear that the social democrats in Bavaria's regional assembly and Berlin's central government disproved of red communes—or "soviets," as they were often called—the republic had no real prospect of survival as sections of the regular army approached Munich, along with private militias paid to crush the rebels. Having entered the revolution as a socialist pacifist, Ernst Toller ended up as commander in a ferocious military combat.[129] His memoirs, *Eine Jugend in Deutschland* (*I Was a German*), recount his involvement in the republic all the way to its defeat in May 1919. "I felt at odds with myself. I had always believed that Socialists, despising force, should never employ it for their own ends. And now I myself had used force and appealed to force. I who hated bloodshed had caused blood to be shed."[130]

According to Toller, then, what demanded aesthetic depiction and analysis was not the historical and political crisis as such but rather the upsetting ethical dilemma into which the crisis threw him: "What awaits a person, I ask myself, who wants to intervene in the course of the world, who thus becomes politically active, if he wants to realize the moral idea which he considers just in the struggle of the masses?"[131] Was Max Weber correct, he asks, in saying that those who are unprepared to meet evil with violent resistance must live like Francis of Assisi and withdraw from the world into the realm of the divine? Toller's self-questioning brings him to address the nature of the masses:

Must the man of action always be dogged by guilt? Always? Or, if he does not wish to be guilt-ridden, must he be destroyed? Are the masses impelled by moral ideas, are they not rather driven by distress and hunger? Would they still be able to win if they renounce force for the sake of an idea? Is the human being not individual and mass at one and the same time? Does the struggle between individual and mass take place in society only, and not inside the human being as well? As an individual, he acts according to the moral idea that he finds just. He will serve that idea, even as the world is wrecked. As a mass he will be driven by social impulses, and he wants to reach the goal, even if he must renounce the moral idea. This contradiction appeared irresolveable to me, as I had been experiencing it as a man of action and was attempting to shape it. This is how my drama *Masse Mensch* came into being.[132]

What is remarkable here is not primarily the ethical dilemma outlined in the passage, which is real enough. In a famous address by Max Weber in 1919, the sociologist had argued that the man of politics must carefully weigh "an ethics of intention" against " an ethics of responsibility" and must be prepared to use both compromise and—when judgment proscribed—violence, although this would "endanger the salvation of the soul."[133] Toller found it hard to accept Weber's position and sought for a line of political action in harmony with the Kantian command—always do in such a way that your act may be upheld as universal law—which, however, ran up against its limits as soon as the question of violence was posed.

Yet what is even more remarkable is that this ethical dilemma so overwhelmed Toller that it came to structure his entire view of "the social

revolution of the twentieth century." As some critics immediately remarked, this tendency to transform the political struggle into an ethical dilemma distorts the historical process, to the extent that *Masses Man* takes a reactionary turn, discarding political strategy of any kind and instead celebrating the martyrdom of The Woman, who sacrifices her life in order not to compromise her ideal.[134]

More remarkable still is that Toller's depiction of the mass radiates the same anxiety and terror that pervaded most other representations of the masses in Weimar culture. The masses are rendered as amorphous, boundless, impulsive, and violent. The masses assault the ethical qualities that the drama poses as its ideal. They are thus explicitly posited as the negation of everything that the drama associates with humanity, *der Mensch*. At once unhuman, nonhuman, ahuman, and prehuman, Toller's masses may be posited as an agent of destruction but also as a source of becoming or as a depository of the will to power. Fuel and engine of the revolution, the masses may move in any direction, crushing any obstacle in their way. Needless to say, they therefore need someone to guide, steer, and lead—a chairman, a *comandante*, a *Führer*.

Should we be surprised to find such a negative view of the masses in a prominent left-wing writer and revolutionary activist who is often seen as the very model of politically committed literature?[135] Perhaps. But it also demonstrates the omnipresence of the fantasy of the irrational crowd in this period. Yet precisely through its aesthetic transformation of the real historical event, including all its particular groups, personalities, events and controversies, into an abstract conflict involving a fixed set of "types" and "ideas" battling one another on the dream stage of expressionism, until they all eventually line up for a great showdown between the principle of humanity and the principle of the mass, we begin to see *what the masses ultimately were* in Weimar culture. The masses were an allegory, in the strong sense of the word: an allegory or screen image evoked by the need to mark powers of change that appeared to govern the world of modernity and that at the same time resisted both symbolic and political representation.

Put differently, the masses connoted a dimension of social existence that caused fear and anxiety precisely because it disrupted the horizon of values and meanings through which class and gender identities had until then been affirmed, cultural hierarchies secured, and social order constituted. In this sense, "the mass" could be taken as a term for what in Weimar society

was experienced as *the real* in some Lacanian sense. The mass referred to phenomena that could not be assimilated into the symbolic order. An even better explanation of the function of the mass allegory in Weimar culture is perhaps provided by the theory of allegory that Walter Benjamin, of the same generation as Toller, developed toward the end of World War I. In his work on the German play of lamentation, or *Trauerspiel*, Benjamin claimed that all elements of baroque theater ultimately could be posited as signs in a metaphysical text, to which poets and playwrights appealed as they tried to make sense of a historical period marked by instability and warfare, the seventeenth-century Europe of the Thirty Years' War. As Benjamin argued, the death emblem and other elements of baroque theater, including the court feuds and savage wars of succession that dominate its intrigues, should all be read as a message concerning the vanity of worldly fame. No matter what signs of success, and no matter what aspirations and achievements the tragic drama put on stage, they would soon disclose their rotten core, thus displaying death and decay as the ultimate telos of human history. Behind each living being, a rattling skeleton and an empty skull; behind each dwelling, palace, or castle, a desolate ruin or a gravestone, sunk down in the mud and covered with vine. The more the baroque drama seemed to exalt a life of action, the more it proved the power of death to undo all worldly achievements.[136]

In Benjamin's view, this traffic of meaning was regulated by baroque allegory, which converted all signs of life and growth into implacable proofs of decomposition. The skull was an allegorical representation of death, but so was the battling chevalier as he eventually served to remind the audience of the brevity of human conquests. But Benjamin's main point was not that the baroque allegory showed the futility of worldly action. Precisely in showing a world under the spell of *vanitas*, baroque allegory proved the necessity of the divine as the sole redeeming power. As Benjamin wrote, the allegorical "intention does not faithfully rest in the contemplation of bones, but faithlessly leaps forward to the idea of resurrection."[137] Allegory said: if human history has any meaning, this meaning is granted only by the divine because human history in itself has but the meaning given unto it by death.

If the function of baroque allegory was to support belief in divine resurrection in a world that piled corpse upon corpse, we should ask what meaning to attribute to the mass as the preeminent allegory of interwar modernity. Benjamin's dialectical approach offers an insight into this process as

well. For if baroque allegory portrayed life as death in order to prove the possibility of heavenly redemption, so it may be argued that the mass allegory portrays society as ruled by the masses in order to prove the necessity of some authoritarian intervention, which would reinstitute organization and discipline in social life.

Weimar social and cultural discourse remained fixated at this point, witnessing emergent social processes and political agents that it could not fully comprehend, for which no language of representation was yet invented, but that nonetheless seemed to require a firm response. Wherever the mass was evoked, we may be sure that discourse lagged behind, as it fell back on the simple mechanism of allegory to approach levels of reality resistant or inaccessible to symbolization.

All this is clarified by Ernst Toller's *Masse Mensch*, in which the masses are continually defined and redefined, their essence repeatedly asserted and reasserted in so many ways that we must finally conclude that the mass itself is an allegory whose meaning forever remains in suspense, generating as many interpretations as the historical process itself. Toller's drama suggests one definition of the masses, which is then denied by a different one, which, in turn, is contested by a third. The result is an infinite chain of signification: "masses are fate," "masses are us," "masses are you," "masses are me," "masses are not me," "masses are powerless," "masses are strong," "masses are weak," "masses are force," "masses are leader," "masses are blind slaves," "masses rule," "masses obey," "masses are anger," "masses are love," "masses are community," "masses are scattered people," "masses are faceless," "masses are nameless," "masses are guilty," "masses are innocent," "masses are need," "masses are deed," and so on.

These descriptions, jammed into the simple, denominative clauses typical of Toller's expressionist style, imply that "the masses" allow for virtually any kind of definition and interpretation. It is logical, then, that the only interpretation of the identity of the masses that remains stable throughout *Masse Mensch* is the one that posits the mass as a negation of identity. "Foules sans nom!"—"Masses without name!"—exclaimed Charles Baudelaire and, after him, Victor Hugo, in different poems.[138] Its echo resounds in Toller's drama: "Masse ist Namenlos!" (88). The only true representative of the masses is therefore that figure of namelessness who serves as mouthpiece for the revolutionary uprising and as the antagonist of "The Human." A peculiar figure, The Nameless is both a character acting in the play and a representative of others whose lives he enacts. He is both singular and

plural, both mass and its representative, both an individual "I" and at the same time a "we" or "they." The culminating point, where these incompatible modalities fuse, comes as The Nameless exclaims: "I am Masses!" ["*Ich bin Masse!*"]. A linguistic form used to profess an identity ("I am . . . so and so") is inverted into a confession of the absence of identity. In saying "I am masses," The Nameless actually says that he is "a nameless namelessness." A singular collectivity, or a plural individuality? The point is that both he and the mass prefigure social formations for which no terminology or categories exist. The Nameless is the allegorical personification of the mass, but this mass is in its turn the great allegory of the Weimar republic.

In sorting out the logic of Ernst Toller's drama we begin to understand how dense and mobile the semantics of the mass was in Weimar culture. Yet although the semantics was complex, the logic was as simple as the logic of allegory, which allowed the mass to be interpreted in many ways while still retaining its ability to signify some terrifying "truth" about society and history as it was lived in this epoch. This also explains the common conviction that the person who was able to interpret the mass allegory, who was in touch with the deeper sentiments of the masses, would also know the right way of representing, organizing, or even mobilizing the social body. Solving the riddle of the masses was no less than solving the riddle of society. "The masses" thus come across as the dominant signifier for the political as such, and the person able to understand the masses would be seen as somebody possessing authority to speak for society as a whole.

For Weimar intellectuals, politicians, and artists, the meaning of the masses was indeed as variegated as in Toller's drama—as open and indeterminate as change itself. The masses were the empty signifier of revolution, of times a-changing, of old powers falling and new ones rising. Anyone embracing revolutionary change would then affirm, along with The Nameless, "I am masses!" The far greater number who feared instability would draw the opposite conclusion, thinking that the masses were always the others. Or, as it is also written in Toller's drama, "They are masses!"

19. RILKE IN THE REVOLUTION

The ideas and images of the masses that I have dealt with so far have one thing in common. They were inadequate to their task and merely continued

describing the masses as out of reach for established systems of representation. In Broch's novel and Toller's drama, the masses also remained an allegory for unknown and unconquered subaltern forces, which caused every attempt to explain or represent them to run up against its own limits. At the opposite end of Weimar's intellectual spectrum, the sociologist Leopold von Wiese vented similar frustrations every time he addressed the notion of the mass, claiming that all conceptions seemed to share an idea of the mass as "shapeless, undifferentiated, unorganized, and of unclear boundaries," whereas the revolution shone as "something unknown, unpredictable, irrational . . . not to be grasped by human understanding."[139]

How come the detached sociologist and the committed writer ended up with almost identical depictions of the masses? Perhaps because the tangible presence of the masses reminded intellectuals and theorists of their inability to grasp the social totality and direct its history, thus forcing them to confront the limitation of their powers of representation. Who were the masses? In dominant Weimar culture they usually remained hidden behind the very models that sought to conceptualize their essential features, or they were covered by the images that wanted to delineate their contours. In rare instances, however, they suddenly leapt into view. Rainer Maria Rilke also visited the revolution, mixing with the masses that alarmed Weimar sociologists and influential intellectuals like Toller and Broch. In a letter to Clara Westhoff-Rilke, his former wife and lifelong confidante, he reported from the Bavarian revolution. His impressions of the first days of November 1918 deserve to be quoted at length. They throw the flaws of dominant mass theory into relief:

Everywhere gatherings in the beer-halls, almost every evening, everywhere speakers, among whom professor Jaffé is of first prominence, and where the halls are not big enough, gatherings of thousands out of doors. I too was among thousands Monday evening in the Hotel Wagner; Professor Max Weber of Heidelberg, national economist, spoke, after him in the discussion the anarchistically overstrained Mühsam, and then students, men who had been four years at the front,—all so simple and frank and of-the-people. And although they sat around the beer-tables and between the tables so that the waitresses only ate their way through the human structure like wood-worms,—it wasn't at all stifling, not even for breathing; the fumes of beer and smoke and

people did not affect one uncomfortably, one hardly noticed them, so important was it and above all immediately clear that the things could be said whose turn has come at last, and that the simplest and most valuable of these things, in so far as they were to some extent made easily accessible, were grasped by the enormous multitude with a heavy massive approval. Suddenly a pale young worker stood up, spoke quite simply: 'Did you, or you, or you, any of you,' he said, 'make the armistice offer? And yet *we* ought to do that, not those gentlemen up there; if we take possession of a radio station and speak, we common people to the common people yonder, there will be peace at once.' I can't repeat it half as well as he expressed it; suddenly, when he had said that, a difficulty assailed him, and with a moving gesture towards Weber, Quidde and the other professors who stood by him at the platform, he continued: 'Here, these professor gentlemen know French, they will help us say it right, the way we mean it . . .' Such moments are wonderful, and how we have had to do without them in this very Germany.[140]

In a radio address relayed to the American Office of War Information in early 1945 with the proposition to have it broadcast to the German population, Hermann Broch delivered his opinion on recent European history: "The German people were as blind as sleepwalkers."[141]

True or not—but who were the German people, and were not their political and cultural representatives just as blind? In a culture where most writers and scholars behaved like sleepwalkers, perceiving contemporary events only through the specter of the masses, Rilke's eye-witness report about everyday discussions and interactions during the Bavarian revolution flares up as a rare moment of alertness.

3

The Revolving Nature of the Social

PRIMAL HORDES AND CROWDS

WITHOUT QUALITIES

20. SIGMUND FREUD BETWEEN INDIVIDUAL AND SOCIETY

When people gather in great numbers, their moral qualities disappear. People stop thinking, act contrary to their interests, forget all sense of reason, and are guided solely by their emotions. At least, this is the conclusion that Sigmund Freud drew from his observations of the first few months of global war. In 1915, when he published his "Thoughts for the Times on War and Death" ("Zeitgemäßes über Krieg und Tod") in the psychoanalytic journal *Imago*, there was no sign that the thunder would abate. Daily, death harvested thousands on the Eastern and Western Fronts. Although the battles had gone on for just a few months, Freud knew the war had already crushed all faith, be it ever so brittle, in human progress.[1]

Just a year earlier many had believed that culture and enlightenment could free the human race from its lower instincts. What illusions, Freud now exclaimed. The war had shown how quickly Europeans could descend

from civilization to barbarism. Judged by our unconscious wishes, we are just like the primal humans who lived before the dawn of history: a band of murderers, indifferent to the death of others and all too ready to assist in the killing. Freud was horrified by this discovery. Even the best minds of the continent, about whom one had had reason to think that they would be immune to such bloody passions, participated in the hideous spectacle. Even philosophers, writers, intellectuals behaved like fanatics, impervious to reason and logic but instead disseminating foolish propaganda, inciting hatred, and egging their countrymen to beat up neighbors with whom they had traded peacefully less than a year before.

Freud was horrified, but he was not surprised. The war and the patriotism that fueled it proved what he had always argued: that logical arguments are powerless against affective interests and that the efforts to turn these affective interests toward social and ethical purposes may rapidly be undone if political leadership and social organization fail. The war was a tragic case of such ills, Freud asserted. How could the European states expect their citizens to follow ethical norms and obey the law, if these states themselves ignored morality and violated universal codes of conduct? It is a mystery, Freud contended, why states and nations (Freud spoke of "collective individuals," or *Völkerindividuen*) should despise and detest one another—every nation against every other. "It is just as though when it becomes a question of a number of people, not to say millions, all individual moral acquisitions are obliterated, and only the most primitive, the oldest, the crudest mental attitudes are left."[2]

World War I seemed to prove a point that had been made in theories of crowd psychology since the 1890s: when swallowed by a mass, people act irrationally; when people crowd together their rational and ethical qualities are leveled. "I cannot tell why this is so," Freud stated in 1915. Six years later, in 1921, he returned to the issue, trying to explain what had taken place in World War I. The result was his book *Massenpsychologie und Ich-Analyse*, soon translated into English as *Group Psychology and the Analysis of the Ego*, and more recently as *Mass Psychology and Analysis of the 'I.'*

This is one of Freud's most contentious works. Because of its enormous ambition, its effort to explain both the development of the individual and the formation of society within one single theory, it has caused disagreement as regards its ultimate meaning and importance. While few social theorists and political philosophers have been interested in the psychoanalytic

theory that Freud presented in this work, psychoanalysts have usually been unwilling to discuss its sociological and political dimensions. *Massenpsychologie und Ich-Analyse* is one of these works that through their effort to connect several branches of knowledge runs the risk of being disregarded by all of them. Even today, the validity of Freud's synthesis of individual psychology, social theory and anthropology remains an open question. This uncertainty about the theoretical significance of Freud's book probably reflects the ambiguity of the notion of "the mass."

From a historical perspective, however, there is no doubt that Freud's book crossed a threshold as it presented a theory that sheds light on all the new ways in which masses and collectives were represented and analyzed in interwar European culture. An inherited notion of the masses, formulated in the late-nineteenth-century discourse of crowd psychology, was here replaced by a different conception of society, which this chapter will explore.

If *Massenpsychologie und Ich-Analyse* is a transitional text, connecting late-nineteenth-century crowd psychology with the discourse on mass society of the 1920s, Freud's place in the history of crowd theory is comparable to that of Georg Simmel. As the first German intellectual to write about French crowd psychology, Simmel transformed the theory: before World War I, it primarily addressed the urgent but limited concern posed by the so-called dangerous classes; after the war, it claimed to explain contemporary society in its entirety. Simmel ended up formulating a theory in which "the mass" signifies the dominant form of sociation (*Vergesellschaftung*) in modern society. The mass, for Simmel, denominates the social essence of the subject of modernity. Something similar is going on in Freud's text. As Freud explained in a letter to Romain Rolland, the book "shows a way from the analysis of the individual to an understanding of society."[3] From the individual to society, then—but Freud's argument also moves in the opposite direction: from society to the individual. In his hands, mass psychology turns into a theory about the origins of social power and how humans inevitably fall under its spell.

Freud's influence on the interwar discussion of the masses is as indisputable as is Simmel's. Many took Freud's book as their point of departure for their own explorations of the nature of society. It is clear, for instance, that Elias Canetti, Hermann Broch, Robert Musil, Theodor Adorno, Erich Fromm, Wilhelm Reich, Arnold Zweig, and Herbert Marcuse all wrote in dialogue with Freud, or sought to outdo him, as they developed their own respective theories of social cohesion, crowd behavior, and mass society.

An understanding of Freud's *Massenpsychologie und Ich-Analyse* and the historical influences that shaped it is therefore indispensable if we want to know what was meant by "the masses" in the interwar era.

This is to say that Freud deviates from the dominant German sociologists of the 1920s, who held on to the widespread idea that "the mass" was a bad and dangerous phenomenon or, in any case, a cause for worry and alarm, which emerged in social spheres that were unruly, disorganized, and mentally and materially impoverished. Freud also splits away from the nationalist and national-socialist ideologies, which saw "the mass" as an unordered and explosive matter that had to be tamed by strong authorities. It is true that some of these features of the mass are preserved in Freud's book—I will return to some of them—but his explanation of crowd behavior also transforms "the mass" so that it comes to signify a far more global, productive, and dynamic agency that cannot be confined within the narrow definitions and functions that the science of sociology or the ideology of national socialism had ascribed to it. Freud attempts to posit the mass as a fundamental epistemological category that serves to explain what holds societies together and what causes them to fall apart. This theory reaches far beyond the sociological discourse and the nationalist ideology of the era and takes us into unmapped social terrain.

21. MASSES INSIDE

There are crucial differences among the theories and ideologies of the masses that had been formulated before Freud's book. However, they usually agreed on one point. They defined the mass as the antithesis of individuality. Whereas the individual remained unquestioned as the seat of responsibility, rationality, consciousness, creativity, and identity, the mass was described as a force that destroyed or dissolved this position of authority. Where the mass was, the individual was not, and vice versa.

As we have seen, sociologists of the Weimar 1920s found a different way of defining the mass. The mass was no longer the opposite of individuality but a residual category that designated social formations lacking organization and inner differentiation. This definition had its own limitations, however, as the mass still remained a category without positive content and was seen as a sheer negation of established social forms. Freud had a completely different understanding of individuality. For him, individuality resulted

from the repression, sublimation, and inhibition of psychic drives. Through this process, which for Freud was a process of cultivation and civilization, the subject's desires were shaped by external influences, which guided it toward a place in the social world. In psychoanalytic theory, society is present within the subject from the outset, and it is society that enables the subject to become a conscious individual. "We are 'peopled' by others," writes Jacqueline Rose of Freud's *Mass Psychology*. "Our 'psyche' is a social space."[4]

The intrinsic relation of the social and the subject is the point of departure in *Massenpsychologie und Ich-Analyse*. Freud spells this out on page one: "In the mental life of the individual, the other comes very regularly into consideration as model, object, aid and antagonist; at the same time, therefore, and from the outset, the psychology of the individual is also social psychology in this extended but wholly justifiable sense."[5]

Freud took issue with previous mass psychologists who regarded the individual subject as an autonomous unit, modeled on the Cartesian consciousness, and thus ignored that social relations shaped every human being from the start. It was only because of their disregard of these relations, Freud asserted, that they were able to posit the "influencing of an individual by a large number of people" as a "separate object of investigation" (18; 34). This was the fatal mistake of mass psychology, Freud charged. It studied the individual "as member of a tribe, people, caste, class institution, or as one element in an assemblage of human beings [*Menschenhaufen*] who at a particular time, for a specific purpose, have organized themselves into a mass" (18; 34).

The neglect of the immediate social nature of the human subject had lead the mass psychologists to exaggerate the influence exerted on the subject by large collectives, and this, in turn, explained why these mass psychologists erroneously ascribed a specific property to such masses. Freud clarified:

Following this rupture of a natural context, the obvious next step was to regard the phenomena that emerge in such special conditions as manifestations of a special drive not susceptible of being traced back further, the social drive (or *herd instinct*, or *group mind*), which does not come out in other situations. However, we may well object that we find it difficult to attribute such great importance to the numerical factor as to make it possible for number alone to rouse a new and otherwise unactivated drive in the life of the human mind.

(18/34)

Freud thus spells out the essentials of his approach. He will agree with previous crowd psychologists that men in a crowd act more on instinct than according to reason and that they descend to a more primitive stage of evolution. But contrary to previous crowd psychologists, he will argue that this was caused by psychic processes within each individual, not by any collective psyche. Like Simmel, he will thus reject the central assumption of conventional crowd psychology: that masses posses a collective soul, a mass mind, or a mob mentality. The cause of mass behavior is thus to be sought in the individual psyche. In order to understand the mass we must analyze the "I." Halfway into his argument, Freud will then turn this causality inside out, stating that in order to understand the "I," we must analyze the mass. And at the end of the book, the mass and the ego, *die Masse* und *das Ich*, stand out as two internally related phenomena, the one holding the secret of the other.

What I have said so far also clarifies the title, *Massenpsychologie und Ich-Analyse*. It also suggests that we may choose to study the link between the "I" and the mass from either of the two perspectives that the title suggests. In the reception of Freud's book, it is easy to see how some have chosen to deal with its implications for mass psychology while others have discussed the book as a phase in Freud's exploration of the structure of the individual psyche. This pattern of reception seems to have been officially endorsed by Freud and his colleagues and followers in the psychoanalytic movement. Early in 1922 the official journal of the psychoanalytic community, *Internationale Zeitschrift für Psychoanalyse*, carried two different reviews of Freud's book under the same rubric. Géza Róheim dealt with the political, social, and anthropological aspects of *Massenpsychologie und Ich-Analyse*,[6] while another Hungarian psychoanalyst, Sandor Ferenczi, focused on the book's contribution to individual psychology. According to Ferenczi, Freud's accomplishment in this book was his discovery of the ego-ideal (*das Ichideal*), a new developmental phase of the "I" and the libido.[7] The importance of the book would thus be the theoretical clarification of this controlling agency, later rephrased as the superego. In the history of psychoanalysis, *Massenpsychologie und Ich-Analyse* thus connects Freud's essay on melancholia from 1917, in which he first stipulated the existence of such a punishing agency within the ego, and *The Ego and the Id* from 1923, in which he finalized his metapsychological theory, according to which the mind is a dynamic tripartite structure: the id or unconscious, the ego, and the superego.

For those interested in mass psychology, Freud's book brought a different set of questions to the fore. These are the same three questions that Freud asks at the beginning and sets out to resolve: "What is a 'mass', how does it acquire the ability so decisively to influence the mental life of the individual, and in what does the mental change it imposes on the individual consist?" (20; 35). In raising these issues, *Massenpsychologie und Ich-Analyse* is a key text in a group of speculative works where Freud deals with the nature and meaning of society. On this shelf belong *Totem und Tabu* (*Totem and Taboo*) from 1913 and later works such as *Die Zukunft einer Illusion* (*The Future of an Illusion*) from 1927, *Das Unbehagen in der Kultur* (*Civilization and Its Discontents*) from 1930, and *Der Mann Moses und die monotheistische Religion* (*Moses and Monotheism*) from 1937.

According to Freud, "the task facing theoretical mass psychology" is to answer these three questions. He adds that "the best way to tackle them is by starting with the third," after which he intends to work his way up the list (20; 35). First, then, question three: "In what does the mental change [which the mass] imposes on the individual consist?" Freud here follows closely in the footsteps of Gustave Le Bon, stating that his description of the individual's behavior in a mass is largely correct. But he objects to Le Bon's explanations of crowd behavior and thus gives a new answer to his second question: "How does [the mass] acquire the ability so decisively to influence the mental life of the individual?" Whereas Le Bon and others believed that crowd behavior was caused by "suggestion" and "mental contagion," and in the last instance by the mass soul itself, Freud proposes his own theory of *identification* and the "I-ideal" as a superior explanation.

What about the first and decisive question on Freud's list, "What is a mass?" After reading *Massenpsychologie und Ich-analyse* one has a disappointing feeling that the author never really answers it. The reason, plausibly, is that his answer is present throughout the book, although it cannot be made explicit. When Freud says he will postpone the first question and instead start with the third, he is playing a trick. For his ability to answer questions two and three—how does the mass acquire the capacity for exercising such a decisive influence over the mental life of the individual? And what is the nature of the mental changes which the mass forces upon the individual?—presupposes that he already *knows* what a mass is. Yet it cannot be defined. It is true that Freud offers his theory of identification as a definition of the mass. But this theory cannot fulfill that purpose for it has

such a wide applicability that it virtually covers any form of social behavior, to the effect that "the mass" seems to lose both its reference and its definition. Yet Freud insists on the importance of the term. His account of the mass consequently takes on the properties of the thing defined. Like the mass, the definition of it becomes malleable, formless, and oblique.

This is the reason why *Massenpsychologie und Ich-analyse*, despite its brevity and apparent clarity, is more difficult and perplexing than commentators have been willing to admit. What is at stake is an epistemological dilemma: how to claim knowledge about a phenomenon that defies definition and cannot be circumscribed. As Céline Surprenant remarks in her book on Freud, there is only one other phenomenon in Freud that is as elusive as the mass: the unconscious itself, intimately known and yet beyond the reach of language.[8]

22. IN LOVE WITH MANY

Most of Freud's works before 1921 were occasioned sometimes by individual cases (Dora, Little Hans, The Wolfman), sometimes by mental phenomena actualized in psychoanalytic practice (dreams, jokes, slips of tongue), and sometimes by theoretical problems that he needed to resolve in order to assure the diagnostic validity of his theory. By contrast, *Massenpsychologie und Ich-analyse* departs from an already existing body of theoretical works. There are few studies by Freud where he discusses the views of other scholars in such detail as he does here. Long sections of the text summarize what others have already pronounced on the topic of crowds and Freud quotes extensively from Gustave Le Bon, Walter McDougall, and Wilfred Trotter.[9] Less visibly, he also relies on two little-known works by Ludwig Kraškovič and Walther Moede for his account of crowd behavior throughout history.[10] As we know, Freud frequently wandered into history, literature, art, archaeology, anthropology, and political theory, and he frequently gave the impression that he was the first one there, expressing lofty disregard for the specialists who had already long labored in the same fields. "I am not really a man of science, not an observer, not an experimenter, and not a thinker," he once wrote to Wilhelm Fliess, "I am nothing but by temperament a *conquistador*."[11] Setting foot on the territory of crowd psychology, however, Freud is eager to gather up support from the

most representative theories, as though sensing that there is something in this corpus that touches the kernel of his own enterprise.

Commentators have launched competing views.[12] Let me mention the most important ones. I have already discussed a general reason for Freud's interest in the masses. It has frequently been argued that he turned to the topic because of his experience of irrational nationalist sentiments during World War I.[13] Others say he was led to the topic by the pitiful state of Vienna and Austria, a once cosmopolitan metropolis in a once multinational empire, which after the war experienced a complete collapse of political and social authority that pushed the country to the brink of civil war.[14] A third factor may have been Freud's reaction to the upsurge of anti-Semitism. The immediate postwar years saw a new generation of intellectual leaders and authoritarian politicians who dispensed racist hatred to their audiences.[15] Others claim that Freud entered mass psychology to counter conflicts within the psychoanalytic community. As Paul Roazen points out, the circle around Freud had the air of a royal court.[16] The 1910s was a time of growing dissent among Freud's disciples, some of whom expressed their dissatisfaction with Freud's authority, and this made it necessary for him to clarify the underlying principles of group formation and collective collaboration.[17] A fifth category of writers argues that it was the intrinsic evolution of Freud's psychoanalytic theory that led him to the topic of the masses. As already mentioned, *Massenpsychologie und Ich-Analyse* is an important step in the development of Freud's metapsychological theory. Analyzing melancholia in 1917, Freud had discovered an agency within the psyche that split the ego in two parts, with one part forcing the other into submission; the reason he turned to mass psychology, with its theories of hypnosis and authoritarian leadership, may then have been a wish to explain the origins of this prohibitive and disciplinary aspect of the psyche.[18]

Yet another reason is hinted at in the text. Freud highlights that mass psychology has its roots in the experiments in hypnotic suggestion that took place at Hippolyte Bernheim's clinic in Strasbourg, later moved to Nancy, and at Jean-Martin Charcot's Salpetrière school in Paris in the late 1880s (40–41; 52–53.).[19] As a young man, Freud himself had observed these sessions, but he drew a different conclusion from them than the crowd psychologists who also followed them closely, such as Fournial, Sighele, and Le Bon.[20] When Freud returned to this scene of origin of both crowd psychology and psychoanalysis, he was eager to refute the theory that masses are

held together by emotional suggestion and wanted to assert the superiority of his own theory against his rivals.

There are thus at least six possible—and plausible—reasons that Freud set out to put the existing observations of crowd behavior on a firmer theoretical basis. Presumably, *Massenpsychologie und Ich-analyse* is overdetermined by several of these, and we will return to them later. For now, suffice it to say that an assessment of the book will to a certain extent depend on which of these motivations is seen as the primary interest behind Freud's theory.

Entering the field of mass psychology, Freud reasons like a detached scientist, surveying the state of the discipline and evaluating what previous scholars have contributed to it. Yet the sources Freud chooses to discuss reveal an additional intention. Freud makes his exploration easier than it ought to be. Or should I say that he makes it more difficult? Interestingly, he seeks support neither in Gabriel Tarde's theory of imitation (*Les lois de l'imitation*, 1890) nor in Émile Durkheim's *Les formes élémentaires de la vie religieuse* (1912), two equally compelling theories of social passions and collective behavior that were readily available in Freud's time and that in fact enjoyed a far wider acceptance among sociologists and psychologists than either Le Bon, Trotter, or, but to a lesser extent, McDougall. It is also significant that Freud neglects Simmel's theory of the masses.[21] It is not hard to see the reason for this bias. For there is in fact one crucial difference between the constellation of sources that Freud chooses to rely on and the constellation he neglects. Le Bon, Trotter, and McDougall all embrace the idea of emotional suggestion. Durkheim, Tarde, and Simmel regard suggestion as an unscientific idea. As we shall see, Freud, too, will dismiss the idea that suggestion is the crowd's cohesive force, and he will replace it with his own theory of identification. The fact that Freud chooses to deal only with crowd psychologists who emphasize suggestion, and that he bases his own theory of the mass on a concept of identification that explicitly serves to replace "suggestion," indicates that this is indeed a central interest that governs his essay.

Does this mean that "the mass" serves as the mere occasion, as a launching ground for Freud's attempt to clarify his idea of identification? Such a view would probably be going too far. However, once we realize that Freud is primarily interested in processes of identification, it also becomes clear why he would focus on the army and the church as his main examples of the mass. This is indeed a peculiar feature of Freud's book. Few readers

of Gustave Le Bon's *Psychologie des foules* could fail to see that the author primarily had the insurrectionary urban underclass and the labor movement in mind. As Freud seeks to clarify the notion of the mass, he looks toward the absolute opposite end of the social spectrum. A discourse that was developed to dismiss the aspirations of the Paris commune mutates into a discourse about the Austrian Catholic church and the recently collapsed Austro-Hungarian army.

Many commentators have pointed out the awkwardness of classifying the army and the church as masses. Does Freud mean that they are phenomenon of the same order as the licentious, criminal, and irrational crowds that for long had been the favored object of all crowd psychologists? Indeed, this is what Freud invites us to think. Moreover, if Freud's main interest is to clarify the process of identification, it makes sense to study the army and the church, for these are social organizations in which the members' identifications with a leader or leading idea may be studied under the most favorable conditions of stability and constancy.

Identification is thus the link, the social tie (*die Massenbindung*), which connects the subject with society, the "I" with the mass. The clarification of this link is the great and enduring accomplishment of *Massenpsychologie und Ich-Analyse*, which has inspired and benefited an immeasurable number of later theories of cultural identity and ideological interpellation, including figures such as Wilhelm Reich, Erich Fromm, Theodor Adorno, Herbert Marcuse, Jacques Lacan, Louis Althusser, Cornelius Castoriadis, Kaja Silverman, Chantal Mouffe, Etienne Balibar, Serge Moscovici, Klaus Theweleit, and Elias Canetti, to mention just a few.

How does Freud conceive of the "social tie"? And in what way does this help us to understand "the masses"? As already mentioned, Freud returns to the experiments with hypnotic suggestion that prompted crowd psychologists to posit suggestion as the emotional bond that characterizes crowd behavior. His first analytic move is to demonstrate that "suggestion" is a manifestation of libidinal drives, that is, "those drives having to do with everything that can be brought together under the heading of love" (41; 54). In one stroke, Freud has thus repositioned the discipline of crowd psychology. He firmly connects it to his own concept of libido, and crowd behavior will from now on be understood as a manifestation of the ways in which the psyche manages its libidinal energy. In other words, Freud has transformed the mass into a psychoanalytic object. The "essence of the mass mind [*das*

Wesen der Massenseele]," Freud stipulates, is constituted by love relationships: "the mass is obviously held together by some kind of power. But to what power could such an achievement be better ascribed than to Eros, which holds together everything in the world" (31*; 45).

Freud then goes on to show that the libidinal ties that constitute a mass are of a certain kind. According to him, there are two libidinal tendencies in the subject. One is ego-directed, self-loving or narcissistic, consolidating the ego as an independent unit. The other tendency is oriented toward external "objects," expressing a desire for the other. Enter now Oedipus, or a force of repression, which prevents these love relationships from being realized. Because of this inhibition, the libidinal tie transforms itself into a more enduring or even permanent emotional bond to the object. Since the subject cannot attain the loved object, it will continue to invest its libido in it and form a firm bond with it. Freud calls such permanent libidinal fixations identifications and idealizations. He then goes through a few case histories from the past, finding that identification comes in three kinds:

> Firstly, identification is the most original form of emotional attachment to an object; secondly, through regressive channels, it becomes a substitute for a libidinal object-attachment, as it were by introjection of the object into the 'I'; and thirdly, it may arise in connection with every newly perceived instance of having something in common [*Gemeinsamkeit*] with a person who is not an object of the sex drives. The more significant that 'having something in common' [*Gemeinsamkeit*], the more successful this partial identification must be capable of becoming, so corresponding to the beginning of a new attachment.
>
> (59–60*; 69)

Freud then adds that the mutual tie between members of a mass consists of an identification of this third kind, constituted by "their having a great deal in common emotionally, and we may assume that what they have in common consists in the manner of their attachment to the leader" (60; 70).

What remains for Freud now is to clarify the tie that binds the subject to the leader. Here, too, Freud goes back to his stock of case histories, finding that the identification with an object may sometimes be unusually strong. The object absorbs so much of the psyche's libidinal energy that it prevents the ego from functioning in its own narcissistic self-interest. A crack, or

differentiation, has emerged in the "I": the loved object is internalized and comes to control the rest of the ego as its conscience or ego-ideal. Usually, this ego-ideal is produced through several libidinal attachments to others, starting in early childhood with the identification with the parents. Usually, the ego-ideal is therefore a composite, a superimposition of several "objects" that the subject has internalized as its internal authority.

What happens in a mass, however, is that there is a particular loved and idealized object, which usurps the place of the previously developed ego-ideal. Thus, a new object is put in the place of the ego-ideal. This accounts for the hierarchical relationships in a mass. Hence Freud's succinct definition of the mass: "Such a primary mass is a number of individuals who have set one and the same object in place of their 'I'-ideal and who have consequently identified with one another in terms of their 'I'" (69; 78). According to Freud, this is the first form of every society, but it is also the original libidinal pattern that determines the psychological life of every subject. The subject is first subject to a figure of authority. It is only later, by becoming conscious of and resisting the authority of the leader, that he or she is able to become an individual. This is why the mass is also the secret of individual psychology.

Freud has thus given an analytical definition of the mass, based on his theory of identification. But we still do not know what empirical content or social phenomena would fit Freud's definition.

23. PRIMAL HORDES

We have seen that some have read *Massenpsychologie und Ich-Analyse* as a book about the individual, others, as a book about society. As for those who have read it as a book about the masses and society, a second bewildering question appears. Does the book provide an account of totalitarianism, the mass cult of the political superego? Or is it a book about the ties that constitute society as such, any kind of collective; is it thus a book about what we refer to as "the social"? At first, it seems impossible to tell because Freud's use of the concept of the mass is notoriously vague. As Helmut König has pointed out, "mass" is synonymous with "community" and "social" throughout the book.[22]

A book about totalitarianism or about society? Good arguments have been proposed in favor of both alternatives, which, however, seem

incompatible with one another. In an essay that appeared in *Imago* in 1922, Hans Kelsen argued that what Freud describes is actually the propensity of individual subjects to hypostatize their social community. Through a process of ideological doubling, the members of a social unit project their already acquired historical unity into the realm of ideals and symbols, thus creating among themselves the impression that they are in some sense a chosen people and that their community conforms to some divine or at least superior intention.[23] In Kelsen's view, the cult of the leader-object is thus a secondary effect of an already existing union, and its function is to externalize this unity into the sphere of ideals so that the members become conscious of it. Kelsen portrays Freud's project as comparable to that of Durkheim or materialist thinkers such as David Strauss, Ludwig Feuerbach, and Karl Marx, who showed that political and religious ideals are collective representations by which the members of a community fabricate a community and a destiny for themselves.[24]

Kelsen's redemptive reading does not square with Freud's argument, however. Indeed, Freud insists that we see the social process in the opposite way: it is only with the emergence of a leader or leading idea that the mass comes into existence. The leader is the constituting power of the mass, and this is for two reasons. First, it is the presence of the leader alone that can explain why crowds and masses are so submissive, primitive, and quick to obey. Though we may argue that it may not necessarily be the case that masses behave in this way, for Freud this was a given, as it was for Le Bon. Moreover, it is only the agent of the leader that can direct us toward a final explanation of the crowd. According to Freud, the willingness of the human subject to submit to the mass expresses a return to a prehistoric phase or state of nature, in which humankind was organized into small hordes, each ruled by a strong male leader:

> The mass thus appears to us as a resurgence of the primal horde. In the same way as primeval man is preserved virtually in every individual, the primal horde can recreate itself out of any crowd of people; in so far as mass formation habitually dominates people's lives, we recognize in it the continued existence of the primal horde. We must conclude that the psychology of the mass is the oldest human psychology; what we, by disregarding all the residues of the mass, have isolated as individual psychology emerged only

subsequently, gradually, and, as it were, still only partially from the old mass psychology.

(77–78*; 85)

According to Freud, the "uncanny, compulsive nature of mass formation" should thus be "traced to the fact that it has its origin in the primal horde." Through a set of analogies, he explains why the mass and the primal horde are at bottom one and the same: "The leader of the mass is still the feared primal father; the mass still wishes to be dominated by absolute power; it is in the highest degree addicted to authority (in Le Bon's expression, it has a thirst for subordination). The primal father is the mass ideal that dominates the 'I' in place of the 'I'-ideal" (81–82; 90).

Freud's depictions of the primal horde, with its grisly images of parricide, absolute rule, and violent suppression, explain why many commentators soon read *Massenpsychologie und Ich-Analyse* as a book about fascism.[25] After World War II, Theodor Adorno summarized this type of reception in his essay "Freudian Theory and the Pattern of Fascist Propaganda." He stated that Freud "clearly foresaw the rise and nature of fascist mass movements."[26] Indeed, he went further, stating that Freud's definition of the mass "corresponds exactly to the fascist *community of the people*" (*Volksgemeinschaft*).[27]

Was Adorno right? Is *Massenpsychologie und Ich-Analyse* a theory of fascism? Or was Hans Kelsen right in saying that the book provides a general theory of social cohesion and the relation between community and ideology? What is disturbing with these interpretations is not each of them per se but the vast difference between them. How is it that Freud's definition of the mass can appear to some as a definition of society, of any society, held together by love or Eros, and to others as a definition of totalitarianism, held together by the cult of the leader and by mutual fear? What are we to conclude about Freud's book and the European notion of the masses around 1920 from the fact that this term—"the mass"—could function as a signifier for such contradictory images of society?

If Adorno was right, we must apparently renounce Freud's larger claim, that his book provides a general explanation of "the social tie." Conversely, if we accept Freud's general claim for his book, we must dismiss Adorno's view that this is a book about fascism. Because these two views are compatible only on condition that we accept an even stronger and more disturbing claim: that there is something inherently fascist in society itself.

As we know, Adorno and Horkheimer moved toward this view. In *The Dialectic of Enlightenment*, they drafted a theory of anti-Semitism arguing that capitalism and the bourgeois family structure breed docile human subjects that succumb to all forms of prejudice and irrationality. Together with colleagues in New York and Los Angeles, they initiated empirical research on the relation between the psychological structure of the individual, authoritarian ideologies, and social discrimination, an effort that resulted in the book series Studies in Prejudice. As Horkheimer acknowledged in his preface to *The Authoritarian Personality*, which is the most well known of these publications, this research depended in no small part on Freud's assumption concerning the close relation between a child's upbringing and its social and political views as an adult.[28] The authors of the volume concluded that their empirical results seemed to support Freud: "a basically hierarchical, authoritarian, exploitive parent-child relationship is apt to carry over into a power-oriented, exploitively dependent attitude toward one's sexual partner and one's God and may well culminate in a political philosophy and social outlook which has no room for anything but a desperate clinging to what appears to be strong and a disdainful rejection of whatever is relegated to the bottom."[29] Many researchers of the exiled Institute for Social Research articulated similar ideas. They extracted the political dimension of Freud's mass psychology, which thus became a theory of fascism and authoritarianism. These ideologies were in turn seen as dominant features of contemporary Western society.

Similarly, Wilhelm Reich, once a disciple of Freud, claimed that fascism was not exclusively a German or Italian affair, but latent in every society in his period. Fascism, he wrote in *The Mass Psychology of Fascism*, is "the basic emotional attitude of the suppressed man of our authoritarian machine civilization."[30] This was also the reason for what Reich called the "Hitler psychosis," which he detected everywhere around him in the early 1930s as he was writing his book.[31] The primary cause of the "disease" was not the authoritarian leaders per se, nor delusive propaganda, but the fact that people had learned all too well to repress their desire for freedom. In order to understand the politics of modernity, this psychological disposition had to be taken into account, and since it was so generally spread throughout society it had to be seen as a genuine mass phenomenon. Hence, according to Reich, the study of contemporary politics necessitated a theoretical base in mass psychology.

Mass psychology, as Reich saw it, started from the Freudian theory of primary repression of the sexual instincts in early childhood. At this stage, the child learns to submit to family authority. It evolves an obedient character structure that prohibits every impulse to revolt, no matter how rational and justified such a revolt may seem from an objective point of view.[32] Just as a child learns to suppress its libido by internalizing a punishing superego, so will this superego, once it has become an integral part of the psychic apparatus, continue to punish and suppress the adult's desire to live according to his or her own wishes. As compensation for a successful suppression of this drive for freedom, the individual also obtains something in return. He or she is able to identify with a model ego, an authority or a leader, who channels and directs the libido toward ideologically validated objects of affection or aggression, in relation to which the frustrated desire may be safely released, the loved object usually being the leader himself and the object of hatred being this or that discriminated category of human beings. Along these lines, which I cannot follow at length here, Reich claimed to have resolved the central political problem of the period: "Why do the masses allow themselves to be politically swindled?"[33] That is, why did the Weimar "masses" not just tolerate but welcome or even desire fascism, though it should have been clear to them from listening to speeches or reading party programs that this was against their own interest? Reich's mass psychology thus claimed to explain the power of the ideologies of patriarchy, capitalism, and fascism, which all derived from the same primary repression that caused the masses to glorify those in power and loathe the powerless, and all this despite the fact that they themselves belonged in the latter category. "This identification with authority, firm, state, nation, etc., which can be formulated 'I am the state, the authority, the firm, the nation,' constitutes a psychic reality and is one of the best illustrations of an ideology that has become a material force."[34] Since fascism had its basis in the personality structure of the masses, it could be fought only through a revolution of all social relationships, Reich argued. On this point he was in agreement with the authors of *The Authoritarian Personality*, who concluded that mass delusions "are products of the total organization of society and are to be changed only as that society is changed."[35]

The influence of Freud's mass psychology is evident and explicit in all these writings on fascism and authoritarianism, and the same is true of the

socio-psychological studies of Erich Fromm and Herbert Marcuse, which also saw the authoritarian character as a manifestation of social conditions.[36] Still, it may be asked whether Freud's writing on the masses in 1921 actually contains a theory of fascism and authoritarian ideology, which brings us back to the question as to the actual motivations behind his book. That fascism was not on the list of problems that the book addressed is proved not only by the date of its composition: in 1921 fascism was starting to dominate Italy and Hungary, to be sure, but it was still outside the agenda of the public intellectual debate. It is also indicated by an off-hand remark where Freud speculates about what social ties may replace those bonds that were once upheld by the church. Freud here warns against the "socialistic tie [*die sozialistische Massenbindung*]," which he sees as the most likely source of renewed fanaticism and intolerance (50; 62). This is an indication as good as any that the fascist possibility did not yet register on Freud's political horizon. It lay in the shadow of the "bolshevist" threat.

The contrast between Kelsen's reading, on the one hand, and Adorno's and Reich's, on the other, indicates a peculiar feature of Freud's text. For each example of a mass that we find in this book, we would in the same book be able to pick out a different example that seems to be its opposite but that in Freud's view also qualifies as a mass. The army is a mass, but so is the spontaneous rebellion. The Catholic Church is a mass, but so is the labor union. A hypnotic session is a mass—*eine Masse zu zweit* (a mass for two), says Freud—but so is a scientific community like the Psychoanalytic Association. The peasants toiling under their lords are a mass, but so are the peasants rebelling against their lords during Carnival.

Though this ambiguity accounts for one's impression that Freud's terminology is imprecise, and that it is hard to follow his main line of argument, this objection is hardly justified. For this is clearly the way Freud wants it. Loyal commentators have attempted to bring order into Freud's perplexing use of the term "mass," and they have imposed definitions on the text that are not there. Such efforts to dress up the text often obscure its radical nature. This is a text that goes to the root, and we must follow Freud all the way. It may be impermissible not to distinguish among a popular uprising, a scientific organization, and systems of authoritarian rule, but Freud nonetheless refuses to obey such distinctions. He wants to detect the similarities or, better, the fundamental identity among them all. To mark this identity by saying that all three are masses does not take us far. But to say that all

are made up of one and the same structure of emotions and that all are revivals of the primal horde—that is something else. For this is what Freud is arguing. And this is why *Massenpsychologie und Ich-Analyse* is a work of breathtaking reductionism, just as it is a work of striking radicalism. This should be understood in a purely descriptive sense. Freud cuts down society to its roots so that we can perceive the ground on which it stands. According to him, every social interaction is founded on the mass dynamics of the primal horde.

This is not the place to judge the theoretical truth or correctness of Freud's analysis. It makes little sense to say that his view is simplistic, reductive, or wrong—or that he should have defined the mass in some better way—because there is no way you can get the problem of the masses right once you have set it up the way Freud did. It is more interesting to examine Freud's book as a symptomatic text: what must be presumed about the social imagination of a given era for a text like this—or a discourse like mass psychology—to make sense? As soon as the problem is posed in this way, we can start to relate Freud's text to its historical context.

Indeed, if Freud chose the army and the church as exhibits of how "the social tie" develops in a mass, it speaks to a specific historical situation in which these two institutions could present themselves as credible generalizations of the social field as a whole. It has been said that psychoanalysis could come into being only in a society dominated by authoritarian institutions and ideologies in which the subject's development depended on its ability to come to terms with real or imaginary fathers and leaders. Freud's choice of the army and church as models of the mass would seem to expose a situation in which the idea of society necessarily presupposed ideas of hierarchy and patriarchy.

But if this is true, it also becomes clear why Freud's book may be read both as a general social theory and as a theory of totalitarianism, and it turns out that Adorno may have been right after all–not in the sense that there is anything inherently fascist in society but that there was something inherently authoritarian in the society of Sigmund Freud. Georg Lukács hit exactly at this sensitive point in Freud's theory when he remarked, in his review of *Massenpsychologie und Ich-Analyse*, that the argument was profoundly anachronistic in the sense that it turned the situation of the bourgeois individual caught in the patriarchal structures of an authoritarian order into a timeless model for all societies from prehistory to the present.[37]

One of the sources for *Massenpsychologie und Ich-Analyse* is Paul Federn's *Die vaterlose Gesellschaft* about the revolutions in Germany and Central Europe in the fall 1918.[38] To Federn's more optimistic view of the possibility of a society without fathers, Freud countered with his argument that society would fall apart without someone shouldering the role of the primal father.

This is not to say that Freud's book mirrors the state of central Europe after the war; the picture is more complex. Both the Weimar Republic and Austria's first republic were societies in which the effort to develop a legitimate system of democratic representation eventually failed. In the end, no enduring consensus could be established about how sovereignty should be delegated from the bottom to the top, from the people to the government. As we have seen several times already, the notion of "the masses" usually comes to the fore under such historical conditions, where large parts of society distrust or reject the official mechanisms of political representation.

Within this horizon, Freud's idea of "the mass" begins to make sense. Since it can be used to describe any social formation, "the mass" will serve as a signifier for society in its most elementary sense, regardless of its political form. The mass is a relevant signifier for society as long as it remains in a liquid or libidinal phase, as it were, as long as it lacks the institutions and political bodies that could stabilize and represent popular emotions. This also explains why the mass cannot function as an empirical designation for any given group of people. Indeed, it can have no representational function whatsoever because its main function is to point out that which as yet remains beyond representation: society in raw state, before it has been subjected to any political ordering or has taken on any definite political form.

This appears to be the last answer to Freud's question: what is a mass? Or rather, this unrepresentable aspect of society explains the function that "the mass" performs in his text. The almost infinite range of signification of the term allows it to name any grouping or constellation that arises from this zero level of society.

This is also the sense in which we can retain the truth in Hans Kelsen's essay on Freud's mass psychology. According to him, this discourse amounted to a description of how society viewed its own unity in the hypostatized figure of the leader. What was hypostatized in interwar Europe, however, was more often the notion of the mass itself, which became the enigmatic allegory, or the formless form, in which society encountered its

true nature and toward which its members projected their fears or dreams of future political actions.

24. MASSES AND MYTHS

If we take a closer look at art, literature, film, photography, and thinking in interwar Austrian and German culture, we encounter many other instances in which the mass was used in a way that is similar to what Freud proposed in *Massenpsychologie und Ich-Analyse*. The mass served to record the existence of those areas of the social world that defied representation. Often, these areas were also zones of defiance against the systems of political and ideological representation that claimed to speak on their behalf.

But *Massenpsychologie und Ich-Analyse* can also help us clarify two more specific features of the interwar image of the masses. I am thinking of the two methods through which Freud approaches and represents the social tie, or *die Massenbindung*. The first method is libidinal analysis; the second is mythological interpretation. It is no exaggeration to say that artists and writers in German and Austrian culture of the 1920s show a preference for both in their effort to visualize or narrate society. If this was a society with weak institutions and political structures, the emotions were bound to appear as the real social bond that kept nations and communities together. As we shall see shortly, Freud's focus on libidinal energies as the basis of the social tie and mass behavior was shared by many throughout the Weimar period.

As for the method of mythological interpretation, this also points to one of the dominant ways of narrating and visualizing society in Weimar culture, though in a less dynamic mode. The historians Jost Hermand and Frank Trommler speak of an increasing tendency in this period to actualize myths and mythical themes as a means to come to grips with the present.[39] The complexities of the modernity—urbanism, mediated communication, technological innovation, political mass movements, consumerism, and entertainment—ignited a number of neomythical counter-reactions, some of which took the form of complete philosophical or aesthetic worldviews, as in the case of Stefan George and Ludwig Klages. According to Peter Sloterdijk, most of these amounted to intellectual attempts to escape the realities of modernity by way of simplifications.[40] Instead of inventing new modes of analysis, intellectuals typically reduced "the new" to archaic

schemas and mythological patterns in which the mass became a mythic being, heroic or vilified, and dressed up in national, racial, or proletarian costumes. For instance, as Ernst Osterkamp demonstrates, "the gap between the great individual and the collective—the multitude, the mass, the people—is a staple in George's world of thinking," and he adds that Stefan George's struggle against degraded collectives always amounted to defending mythic essence against modernity.[41]

Examples of such treatments of the mass are found not only among conservative intellectuals from Spengler and onward. In fact, two of the most substantial works on the masses, Canetti's *Crowds and Power* and Broch's *Massenwahntheorie*, rely heavily on mythological interpretations and interpretations of myths, and both were written in dialogue with Freud. The determination with which Freud assimilates "the mass" with the mythic figure of the primal horde testifies to a strong conviction that myths explain society, and that they do so better than many other interpretations and representations. By explaining the mass as a recurrence of the primal horde, Freud locked it into an ideology that mythologizes the political field.

Freud's book thus appears to firmly situate the mass in a land of myth, far removed from the real domain of social conflicts, urban congestion, and the laboring classes that we tend to think of when speaking about the masses. Stripped of its political and social reference, Freud's notion of the mass becomes a fantasmatic image of the origins of society. Like all fantasms, this one, too, is eventually assimilated with the unconscious itself. Because if "the mass is a revival of the primal horde," as Freud states, it means that mass behavior is governed by those inherited memory traces that in Freud's view are contained in the unconscious of each subject. We saw that the mass in Freud's book is often rendered in terms analogous with his description of the unconscious, something intimately known and yet beyond representation. It is a general tendency of Freud's to conceive of human society and the individual human being as analogous or isomorphic in terms of evolution and structure. In his essay on the war from 1915, for instance, he stated that a state or nation is an individual—or, rather, *ein Großindividuum*. What role does the mass play in these social and collective individuals? Obviously, the mass occupies the same place and function in society as the unconscious does in human individuals.

The point is clarified by a remarkable passage from his 1932 text "My Contact with Josef Popper-Lynkeus."

> Our mind, that precious instrument by whose means we maintain ourselves in life, is no peacefully self-contained unit. It is rather to be compared with a modern State in which a mob, eager for enjoyment and destruction [*in dem eine genuß- und zerstörungssüchtige Masse*], has to be held down forcibly by a prudent superior class. The whole flux of our mental life and everything that finds expression in our thoughts are derivations and representatives of the multifarious instincts that are innate in our physical constitution.[42]

Here, the unconscious is likened to a rebellious mass. In *Massenpsychologie und Ich-Analyse*, on the other hand, the mass is compared to the unconscious and explained as an emanation of the unconscious. Now, it could be objected that the mass was always just a *fantasy* that informed the social views of those that constituted what Freud calls the "prudent superior class." Yet, as it was activated throughout the nineteenth century, that fantasy always referred, however distortedly, to some actually existing social phenomena, usually the so-called dangerous working classes. Freud's mass has no such social or historical reference. On the contrary, he defines the mass as a representation of the unconscious, that is, as a representation of the buried memory of the primal horde. Drained of its reference to the concrete political world, Freud's mass will from now on be a name for the social unconscious itself. An aesthetic and ideological fabrication of interwar Germany and Austria, this social unconscious points to the deepest layer of the social, a sediment inaccessible to social theory and political policy but all the more present in the period's literature, visual arts, and cinema, where we can see it emerge and disappear at the horizon of the intelligible world, as a spiritual condition in Jaspers, as an epoch in Spengler, as a dream-image or *Traumbild* in expressionist drama and poetry, always illuminated by the twilight or *Dämmerlicht* so typical of the social narratives of the 1920s. The mass: now a promise of redemption, now a portent of destruction, a figure of change and flux, an allegory of the revolution in the original sense of the term, an element exposing the brutally revolving nature of the social.

25. THE DESTRUCTION OF THE PERSON

Elias Canetti saw his investigation as a conquest, describing the mass as an "untouched mountain," which he was the first to climb.[43] Sigmund Freud, for his part, confessed to being an intellectual conquistador, the first discoverer of the terra incognita of the mass and the unconscious.[44] Both thinkers dismissed the general idea behind Gustave Le Bon's influential account of mass psychology, but they salvaged some of his insights. Among the things retained was the idea that individual identities are unimportant in the crowd. However, Freud and Canetti shifted the emphasis. While they believed that the mass deprives the subject of individual identity, they did not regard this as a degeneration but underlined that the mass constitutes a *situation* in which the subject reenacts the formation of his or her identity through new identifications. Unlike most other thinkers of their period, Freud and Canetti dared to approach this zone of indistinction in which the social substance appeared in naked shapelessness.

Freud maintained that the process of "massification" was wholly mediated by a leader, a group ego who served as the ego ideal of each person and who was thus able to shape an otherwise boundless world of inchoate social interaction. Canetti, for his part, argued that the mass needs no leader as it consists of drives intrinsic to each human subject.[45] Notwithstanding this difference, Freud's and Canetti's reconceptualizations of mass psychology shared one fundamental presupposition. Neither construed the masses as a negation or antithesis of individual rationality. It simply was not true, they argued, that a person as individual and a person in a crowd are qualitatively different from each other.

Why did they discard individual rationality as normative for human behavior and as axiomatic for social analysis? One explanation is obviously the experience of World War I and the enthusiasm with which most Europeans greeted it. Having witnessed the nationalist frenzy of August 1914 and the chaos of the immediate postwar years and now, in the 1920s, being confronted with the mass mobilization of fascism, numerous intellectuals began to explore whether the passions were not as constitutive of social life as rationally acting individuals. As Freud, Canetti, and a minority of other thinkers came to argue, the mass gives a glimpse of society at a stage where human passions are not stabilized by institutions or authorities, a stage, therefore, where power does not yet exist, society

degree zero, constituted by human subjects whose identities are momentarily suspended and rebuilt.

Freud and Canetti thus deviated from the dominant attitude of their era. The main discourse on the masses in the Weimar period was the authoritarian one. In this version, the masses were defined by negation, as the opposite of individuality. However, once the notion of the mass is uncoupled from idealized individuality, it takes on more interesting meanings. It is well known that modernist culture, and Weimar modernism in particular, articulates radically new ideas about the human subject.[46] In early-twentieth-century art, we witness a decomposition and asymmetric reconstruction of the human face and body. In architecture, the idea of the interior as the padded case of the individual's essence gives way to the utopian living spaces of Walter Gropius or Ludwig Mies van der Rohe, in which the person became a variable function of his or her environment. Numerous novels chronicle how the space of individuality, materialized in the *intérieur* and set apart from public life, is invaded by external forces, to the extent that the self appears as a random mass of impersonal elements. To paraphrase Judith Ryan's book on this process, we witness a vanishing of the subject.[47] Where there was once a sovereign individual, there is now, as Robert Musil stated, "a big, vacuous, round O."[48] The outcome of this process was not only a post-individualistic idea of human subjectivity but also a post-individualistic notion of the masses. If previous theories had sought to "explain the masses on the basis of the individual," as Georg Lukács had argued in his rebuttal of crowd psychology, that basis had now disappeared.[49]

In the individualistic conception the mass appeared as a cluttered background in the field of vision of a perceiving subject, which, when trying to bring the masses into focus, experienced disorientation and dizziness. In the post-individualistic conception, the opposition of subject and object dissolves into a heterogeneous social continuum where the boundary between individual and mass is shifting, constantly reasserted only to be contested and undone. What we find, on the one hand, is a human subjectivity that is often described as embedded in the mass, invaded by the mass, or even constituted as a mass. Only the masses allow the individual to flourish, as Klaus Theweleit puts it.[50] On the other hand, the mass is often seen as a new form of subjectivity, whose principles of formation and action becomes an object of study and fascination in its own right.

Helmuth Lethen provides an interesting interpretation of this predicament, asserting that the belief in a self-centered individuality acting in accord with an internalized disposition was largely exhausted by 1918. He goes on to demonstrate how different modes of subjectivity came into being in Weimar modernity, the most important being what he calls "the cool persona."[51] Lacking inner cohesion and conviction, the cool persona cultivated an art of social maneuvering. Having lost his inner certainty and sense of direction, that core of values that Hermann Broch saw disintegrating before his eyes, he found it more important than ever to raise a shield, a reinforced ego, so as to not be invaded and ruined by the pressures exerted on him by his surrounding society. Yet, as Lethen observes, the boundaries of the cool persona were fragile and incomplete.[52] Borrowing a term from *The Lonely Crowd* (David Riesman, 1950) he defines the cool persona as the "radar type" or the "other-directed character." He contrasts it to the "inner-directed" subject, typified by the person whose life seems to be guided by a core of values or an "internal compass." In an urban environment characterized by intensification of sensory stimuli and increased mobility, by multiplicity and heterogeneity, the interior compass provides insufficient guidance, Lethen argues. "The new means of mass communication surround both figures; the inner-directed type attempts to unify the welter of news through a single lens, in order to judge it in moral terms, while the outer-directed type uses information to orient behavioral patterns, in order to determine the appropriate habitus, learn, and consume—and, when it is functional, to maintain an attitude of indifference."[53]

Already in an early essay on popular reactions to the outbreak of the war, Siegfried Kracauer made a distinction similar to Lethen's. On the one hand, there was an older generation firmly believing in guiding ideals, which in their view were sadly waning in modern society. The younger generation, on the other hand, was marked by a consciousness that was chaotic and confused, lacking a central value system. Kracauer's point was that both groups greeted the war with enthusiasm, but for different reasons. For the first group, the war confirmed long-held beliefs that many had started to doubt; it resurrected the values of nation and community. As for the second group, the war helped them discover a value that brought order to their existence and connected them, as if for the first time, to a community that they had never believed in before and toward which they had felt like strangers.[54]

Perhaps we may identify the first group with Hermann Broch's character Pasenow, while the second group or the radar type is clearly parallel to Hugenau, the spirit of *die neue Sachlichkeit*. The radar type is the man in the crowd or the passerby in the street who drew so much contempt from intellectuals and moralists precisely because he or she appeared to lack personality, firmness of character, and other qualities that had been highly valorized in German culture. From the point of view of the political right, the radar type was a symptom of disintegration: the democratization and feminization of the Reich. From the point of view of the left, the radar type was susceptible to the attractions of the entertainment industry and other populist fascinations and therefore an easy prey for collective enthusiasms, including fascism. In short, the radar type was a sure sign of cultural decline, a psychopathological figure always exposed to the dangers of mass insanity, who apparently confirmed all the pessimistic axioms of crowd psychology itself.

Yet what if this post-individualistic subject owned capacities of resiliency and adaptation that could provide the basis for a new human autonomy in its own right—an autonomy that was able to resist authoritarian appeals and that, moreover, was not necessarily seen as the antithesis of collective life but as an integral part of it? This is the proposition of Lethen and, before him, Riesman. There is certainly much to say in its favor, especially if we want to avoid the anachronism according to which the majority of Germans, as they entered the era of modernity and sought out new ways of representing themselves, were predestined to fail because some inherent character weakness prevented them from organizing in any other forms than those provided by fascism.

According to Lethen, Weimar thought and literature were defined by a generation schooled in old habits that presupposed the inner-directed type as the indispensible foundation of society and culture. In this intellectual community of "German mandarins," as Fritz Ringer calls it, the radar type was not given chance to have his views and attitudes discussed in intellectually valorized medias. And if his voice and views did manage to come across, they were dismissed as vulgar echoes from the new and despicable arena of popular entertainment and mass media. The radar type therefore escaped literature's grasp, Lethen argues: "As writers, sociologists, politicians, and cultural theorists observed the phenomenon of the radar type, they reacted. And they reacted like individuals who feel—as events take a

sudden leap forward—that they are being run over. The substance of their dilemma was that none of them understood the new phenomenon as something possessed of its own right and worthiness."[55] How, then, do we define this new form of subjectivity, the radar type? As a "character still in search of a genre and an appropriate technical medium," Lethen responds.[56]

This is a simplification, however. The radar type was portrayed as more than a contemptible character, exemplified by Broch's Hugenau. As we shall see in a moment, this type was also the subject, or even the hero, of novels like Robert Musil's *The Man Without Qualities* (1930–1932) and Alfred Döblin's *Berlin Alexanderplatz* (1929). Even more interesting, there was a literary genre devoted to the radar type, namely, so-called flâneur literature. Contrary to Lethen's suggestion, there was also a set of technical media calibrated to reproduce flâneur experience—the new documentary photography and cinema of the 1920s. This point is brought out by Anke Gleber, who, echoing Lethen's words on the radar type ("an apparatus receiving signals from near and far"), establishes the flâneur as "the registering medium of Weimar modernity."[57]

26. THE FLÂNEUR—MEDIUM OF MODERNITY

The flâneur was a journalist, writer, photographer, or artist who was passionately devoted to experiencing everyday life in the great city, recording it in word or picture, and presenting its essence in a constellation of signs and images that could capture its mobility and motion, the diversity of its population and the variety of its appearances, often by focusing on its neglected spaces and hidden histories. The model is Franz Hessel, whose 1929 collection *Spazieren in Berlin* has become canonical of Weimar flâneur experience. Equally important are Siegfried Kracauer and, perhaps, as Anke Gleber suggests, women writers such as Charlotte Wolf and Irmgard Keun, although the flâneur is heavily coded as a masculine subject position, enjoying privileges of roaming the city and its outskirts that were rarely accessible to women of the same period. Moreover, the vision of the flâneur attained its monumental expression in a different art form. Films such as Walter Ruttman's *Berlin: The Symphony of the City* (1927) stand out today as great celebrations of urban life in Weimar modernity and also as remarkable experiments in how to represent collective life without succumbing to

any of the stereotypical ideas of elites contra masses which informed, for instance, Fritz Lang's *Metropolis*.

Walter Benjamin is also part of this constellation. He practiced his own mode of flâneur writing, for instance, in *One-Way Street* (1928). His 1929 essay "The Return of the Flâneur" dealt with Franz Hessel's essays. In speaking about the *return* of the flâneur, Benjamin underlined that this figure certainly was no invention of Weimar culture. *Flânerie* emerged in nineteenth-century travel writing and descriptions of city life, predominantly so in renderings of Paris, which already by the mid-1800s confronted writers, artists, and intellectuals with a new world populated by crowds and saturated by a commercial and political culture that other European cities were to repeat within the coming decades.[58] This was the historical panorama that animated Benjamin's own major undertaking, the unfinished *Arcades Project*, in which he developed a theory of the masses that I will explore in the next chapter.

In speaking about a return of flânerie in German literature of the 1920s, Benjamin also implied that Weimar culture displayed features comparable to those that had conditioned flâneur literature in nineteenth-century Paris. It was a rapidly expanding urban environment with increasing contacts but also sharp conflicts among professions, groups, and classes. Add to this a palpable lack of consensus and concord, combined with a sense of economic and political volatility, and all in an urban world that saw the demolition of the old city structure and the construction of railways, boulevards, highways, roundabouts, office towers, public buildings, and shopping areas. In Berlin, this development came to a head only after World War I, when the feudal system gave way to urban capitalism and monarchy was replaced by democratic parliamentarism. The German capital became a magnet for everything modern, and hundreds of thousands of new inhabitants came searching for jobs and a future in an environment that was expanding under previously untried political and economic conditions.

Anke Gleber discusses how this development was treated in German flâneur literature, photography, and film of the 1920s. Characteristic of the flâneur was a specific sensory apparatus adapted to the increasing amount of sensory stimulus emanating from the depths and surfaces of the urban milieu, typically captured in the form of long inventories, as here by Siegfried Kracauer: "Cafés, window displays, women, vending machines, headlines, light advertisements, bobbies, busses, variety photographs, beggars."[59]

In flâneur writing of the 1920s the flâneur does not master the city, nor does he survey it, but he lets himself get lost in it. Rather than following a definite line, his course resembles, as Robert Musil noted, "the path of a man sauntering through the streets, turned aside by a shadow here, a crowd there, an unusual architectural outcrop, until at last he arrives at a place he never knew or meant to go to."[60]

The flâneur was thus engaged in a conquest very different from that of Canetti and Freud. This conquest operated not through surveys and analyses, nor by classifications and general laws. Rather, it was the city itself that conquered the individual, and the flâneur surrendered by becoming one with the crowd while at the same time recording its changeable rhythm, velocity, and intensity.

Gleber associates the flâneur's sensorium with an attitude of existential precarity, manifesting itself in a strange mix of alertness and indifference, detectable in people who lived without strong guidance of internalized values and who at the same time protected their vulnerable selves by refusing to identify with any social collective. An attitude of alienation? Perhaps, but in that case just as alienated from old notions of how an individual should behave and act as from the new icons generated by the politics and culture of the 1920s. The flâneur attitude matches well with what Lethen describes as a "culture of distance." It also contained a wide range of new modes of describing and narrating the modern world. The flâneur, Gleber argues, "represents a perspective on modernity that is particularly partial to the visual registration of its multiple phenomena. A medium embodied in a human sensitivity, he specializes in the perception and formulation of the city's heterogeneous mental life."[61]

The conditions of possibility for the emergence of this "registering medium" or "perspective" were, on the one hand, the loss of the "inner compass" or the sense of individuality so often lamented in Weimar culture, and, on the other hand, the rapid emergence of urban spaces flooded by vehicles, bodies, goods, signs, and messages, which put the human senses on alert and called out for interpretation. In this predicament, a subjectivity emerged that combined a certain openness of mind toward the external world with the lived encounter with a society that incited new attempts at decoding the environment. The post-individualistic subjectivity that Lethen associates with the radar type and that Gleber links to the Weimar flâneur may thus be seen as a new phenomenological

configuration, based on a specific relation between consciousness and world: the encounter of a psyche deprived of cohesive values with a social space that was increasingly incoherent. Psyche and society were both marked, so to speak, by a certain fragmentation, which generated an increased sensitivity and necessitated strong defense mechanisms and efforts of reorientation.

Put differently, the flâneur affirmed what Rimbaud had once called the "disorganization of the senses," and he or she practiced an open way of seeing. When defining the mindset of the flâneur, Franz Hessel described it as a well-nigh unconscious activity. No filter should intervene between world and mind, and the recording psyche should move about in a "hypnotic," "intoxicated," "somnambulatory," or trancelike state of mind, uncontrolled by superego and ego.[62]

Anke Gleber describes the flâneur as a "walking medium": "The visual kaleidoscope of the city changes in accordance with the development of a new constellation of modern images: new forms of traffic and light, displays and signs, department stores and railroad travel, glass constructions and many other visual phenomena." In this milieu, the flâneur "is as much a product of modernity as a producer of its images. His sensitivity to the objects and obsessions of this modernity renders him a significant kaleidoscope of his time."[63]

A product of modernity and a producer of its images? This definition fits not only the flâneur's sensorium but also a technical innovation usually seen as the very emblem of cultural and aesthetic modernity. Gleber stresses the affinity between the gaze of the flâneur and the camera. The flâneur's movement through the city in search of "images" is similar to the moving pictures. The sensorium of the radar type parallels the camera's optical eye. Flânerie and photography appear as analogous dispositions. The former may even appear as a metaphorical extension of the latter.[64] Indeed, this analogy was established already by the first practitioners of flânerie and photography. Gleber quotes Christopher Isherwood's rendition of himself standing in the street—"I am a camera with its shutter open, quite passive, recording, not thinking. . . . Some day, all this will have to be developed, carefully printed, fixed"—as well as Louis Aragon—"I see them move by as if I was one of these slow-motion cameras filming the gracious unfolding of plants"—and finally Dziga Vertov—"I am kino-eye, I am a mechanical eye. I, a machine, show you the world as only I can see it. Now and forever,

I free myself from human immobility, I am in constant motion, I draw near, then away from objects."[65]

The gaze of the flâneur and the radar type are, to be sure, proto-theoretical and proto-sociological dispositions as they construe impromptu taxonomies and instinctive analyses of all the contents and forms of the urban environment. Like the camera, this subjectivity proceeds inductively. It must disregard the general laws, political dogmas, and ethical norms by which people and phenomena are usually ordered and explained—or it has simply lost faith in such categorizations. In order to reveal the secrets of modern society, Siegfried Kracauer asserted, "one must therefore to no small degree rely on indirect methods, on indices of the most various kinds."[66]

The post-individualistic subject takes pride in recording people and phenomena without prejudice. Forms and contents of modern life are deposited into his notebook, onto his film negative, or into his unconscious without previous censorship or validation. For this subject, anything may be central or significant, depending on the context in which it appears and the constellation to which it is linked. He or she does not scrutinize the world in order to confirm established "truths" but embraces the world in its plurality and looks for new "truths" concealed below its surface. This accounts for the spirit of cool objectivity—*die neue Sachlichkeit*—that gave this period its name. Nothing was too small not to deserve attention. On his strolls through Paris, Kracauer went so far as to decipher the differences between seemingly identical blocks of coal displayed in a fuel depot in Rue de Vaugirard.[67] Variety and detail were discovered even in areas that seemed monotonous and insignificant. Occurrences that others would have found ordinary—"an ordinary evening . . . in a modest dance hall not far from Place de la République . . . about which there is nothing to report"—could strike the flâneur as miraculous revelations.[68] Susan Sontag once stressed this aspect: "The flâneur is not attracted to the city's official realities but to its dark seamy corners, its neglected populations."[69]

The flâneur is thus able to provide a new view of modern society because his perspective is wholly constituted by modernity. The sensorium and consciousness of the post-individualistic subject are not external to the urban world it describes but placed in its midst. He is constantly moving in and out of situations and events, traversing several urban milieus, linking impression to impression, phenomenon to phenomenon, sign to sign, and body to body. Kracauer took note of the result: "The worlds change in

kaleidoscopic fashion, with each new step a new one is opened up."[70] The product of this connective work is a collective that is observed from several points at once and that changes its shape, as in a kaleidoscope, depending on the movement of the observer. In this sense, the urban crowd constitutes the precondition of post-individualistic subjectivity and hence also, as Gleber writes, of the modern scopophilia and cult of distraction promoted by the flâneur.[71] Indeed, for Kracauer in Paris, crowds made up "the vegetation" through which everyone moved while before a similar scene in Berlin he suggested that the street crowds are merely an additional layer of organic matter, deposited on top of the asphalt.[72]

There is thus a family likeness between the post-individualistic subject, the radar type, and the flâneur, each of whom comes across as a "registering medium" or "cultural sensorium" able to bring the realities of urban modernity into aesthetic and cultural expression. It should be clear that this medium or sensorium also corresponds to a new vision of the masses. In this view, the masses are at once the constitutive force behind the new subject, the object of its aesthetic and cultural representations, and the audience to which it offers its documentation. In his article on Franz Hessel, Walter Benjamin remarked that the flâneur "lives together with the masses." Indeed, this social type would be unthinkable without the presence and pressure of urban crowds and mass movements; at the same time, these crowds and movements are able to present themselves properly for the first time only through the moving perspective of the flâneur. Perhaps, I may suggest, then, that this new mode of subjectivity *is* the subjectivity of the masses.

Yet this is at best a half-truth, for it is also clear that this registering medium of modernity is, principally, a masculine medium. As Musil stated, the experience recorded by the flâneur is "the path of a *man* sauntering through the streets." As though commenting on Musil's phrase, Anke Gleber contends that "the female flaneur has been an absent figure in the public sphere of modernity, in its media and texts, in its literatures and cities. From the very first step she takes, her experience is marginal, limited, and circumscribed."[73] This observation has crucial implications for our understanding of the masses. If the perspective of the flâneur is a post-individualistic one, and if this perspective approaches the perspective of the masses themselves, it must be added that such a post-individual vantage point is available only to somebody who still has some sense of individuality, if only as a fallen ideal, half-lost memory, or past mode of experience. A woman writer would

find it difficult to assume the post-individual flâneur attitude because she would rarely have been able to relate to the autonomous and secure individuality whose fragmentation and disorientation is recorded and affirmed through the agile senses of the flâneur.

A feminine subjectivity assuming the gaze and perspective of the masses is therefore difficult to discern in Weimar modernity. Yet her very absence is in itself an articulation of prevailing power structures that, in Weimar and elsewhere, determined the distribution of access to leisure time and public space and to positions of authority traditionally associated with male individuality. When a woman would aspire to the position of the flâneur, she would either be dismissed as *flâneuse*, a term with belittling and derogatory overtones, or she would be seen as an example of a male-posing or cross-dressing attitude. Still, such subjectivity seems to be more organically related to the experience of the masses than any male subjectivity could possibly be. It is not the flâneur, then, but rather the *flâneuse*, who "lives together with the masses."

Meanwhile, the idea of female subjectivity as being more organically linked to the masses is obviously problematic, too, since it repeats the idea of individuality as a masculine phenomenon and masses as a feminine one, which had been a stock item of mass psychology since the discovery of the notion of the crowd. The gendered aspect of the masses turns out to be a notoriously difficult issue. Or, perhaps it is a *false* issue—in the same sense that the issue of "the masses," when presented in broad and general terms, is in itself a false one.

27. ORNAMENTS OF THE PEOPLE

It is a simple fact but worth noting: Siegfried Kracauer published most of his cultural analyses in *Frankfurter Zeitung*. This tells us that Kracauer wrote about the life of the masses in a major mass medium. The newspaper was a publishing venue that academic intellectuals of the period sometimes met with scorn. It also tells us that Kracauer was not just an idling flâneur taking pleasure in the adventures of the city. Scanning the surfaces of public spaces and diagnosing objects, signs, events, and individuals, Kracauer identified patterns that made everything hang together as a whole. He was trained as an architect and had received his doctorate on a study of wrought

ironwork in German architecture.[74] Having changed careers, he retained the architect's eye for spaces and volumes and his expertise in architectural styles. He often compared the social forms that he detected in the city to ornamental patterns.[75]

On reading Kracauer's articles one contrast strikes the eye. His descriptions of Paris's crowds and Berlin's masses in the 1920s are cut out in different designs. In the French capital, Kracauer encounters people who "possess a body, a soul, and a spirit that maintain a profound relation with one another."[76] Such "organic" collectives are extinct in Germany, he argues. People crowding Berlin's Kurfürstendamm "have hardly anything in common with each other," except for the air they breathe and the asphalt under their feet.[77] Kracauer explains the difference by the social and political cultures of the two countries. In the land of the revolution, it was taken for granted that society consists of crowds, masses, and communities of various kinds. Being internal to society, the mass could not be perceived as a threat to society as such but only to other collectives or groups within it. In Germany, devoted to the cult of individuality, the mass appears as a something external to the social world and often as a source of terror. Kracauer notes that the masses make German intellectuals nervous.[78]

German society would thus seem to lack the cohesion found among Paris's lower classes. If French politics was guided by consensus-driven pragmatism, German politics was dominated by high-principled party programs that sought to mobilize as many followers as possible, which inevitably resulted in intolerance toward those rallying behind opposing principles. Kracauer deplored that public life in Germany appeared to be organized around an abstract opposition between individual and mass. Once political problems were framed by this abstract binary, proposed solutions tended to become simplistic and divisive. An imaginary political problem—the rise of the masses—had given rise to imaginary political solutions.[79]

In articles and essays of the late 1920s and early 1930s Kracauer analyzed several authoritarian blueprints, such as Ernst Jünger's *Der Arbeiter* (1932), which called for an "organic construction" of the national community and sought to impose discipline upon the allegedly disorganized masses. Kracauer resented such proposals because they presupposed an organization of the masses from above, in the case of Jünger by hoarding them into a predetermined "Gestalt" of the heroic yet obedient "Worker."[80] Faced with such right-wing manipulations, Kracauer developed his own theory of the mass

and the people. He treated both categories as concepts but also as designations of real men and women whom he encountered in streets, squares, and movie theaters. Coupled to Kracauer's journalistic and literary reports of the habits of the Paris and Berlin crowds, there is thus also his theoretical investigation of the masses as a specific collective formation in interwar Europe.[81]

Kracauer saw the interwar discourse on the masses as a symptom of at least three developments. Like Freud, Reich, and others, he struggled to understand the collective enthusiasm of August 1914, at the outbreak of World War I. How come so many had sacrificed their personal well-being in the name of the nation and the people? In the same year that Freud published his "Thoughts for the Times on War and Death," Kracauer authored an insightful analysis of the collective sentiments released by the war.[82] Second, there was the rapid rationalization of work, in factory and office alike, along with the general increase of capitalist relations of production, which created new forms of human interaction and class relationships. The third and most pressing problem was the political instability in the wake of World War I and the Versailles treaty, a situation marked by political violence and wavering support for Germany's newly instituted democratic organization.

In Kracauer's view, the problem with the German situation was precisely that "the people" did not exist as a lived reality. But what did German society consist of, if there were no "people" in the political sense of the word? Kracauer's answer was similar to that of others: Germany consisted of masses. However, he rarely described the masses as disorganized or anti-individual. Their existence arose from the simple fact that the population had not yet found the proper means of representing itself collectively. The public sphere was occupied by clashing parties and movements, all of them claiming to speak on behalf of the German people and most of them vilifying their antagonists as dangerous mobs. One's membership in the German people or, indeed, one's belonging to the human race thus depended on one's adherence to this or that party's definition of what it meant to be German or human. "It is not the case that a mass of humans are organized in parties, but rather the other way around: it is the criteria of party-membership that allows the organized ones to see for the first time that they also are human. . . . The party doctrine rules unrestricted, at the cost of the persons supporting it, and even imposes itself above and beyond social reality."[83]

Against this background, Kracauer found it urgent to investigate the relation of the individual and the collective. He developed his analysis in a handful of key essays on mass psychology and collective representation through which we also may trace the transformation and ultimate demise of Weimar's experiment in democracy. In his early essay "The Group as Bearer of Ideas" ("Die Gruppe als Ideenträger," 1922), he followed Georg Simmel and standard crowd psychology as he listed the characteristics of the individual that becomes part of a group. Such a person undergoes a leveling process: "The subject's unique totality is thus banned from the newly emerging group-self, and only those traits common to all the various subjects belonging to the group can contribute to the construction of a group individuality."[84]

Kracauer argued that "the full individual" ("*das Vollindividuum*") disappears in the group. What emerges instead is a reduced being, fixated only on the narrow goal that the group members have in common. Like Simmel, Kracauer spoke of "fragments of individuals":

> The people united in a group are no longer full individuals [*sind keine Vollindividuen mehr*], but only fragments of individuals whose very right to exist is exclusively a function of the group's goal. The subject as an individual self [*Einzel-Ich*] linked to other individual selves [*Einzel-Ichen*]: a being whose resources must be conceived as endless and who, incapable of being completely ruled by the idea, still lives in realms located outside the idea's sphere of influence. The subject as a group member: a *partial self* [*Teil-Ich*] that is cut off from its full being and cannot stray from the path which the idea prescribes for it.[85]

Outside the collective, Kracauer stated, there exists something called *das Vollindividuum*; within the collective, this being becomes a partial self, a *Teil-Ich*.[86] The mass was thus defined as a transformation of authentic individuality, or as its deformation.

Compare this analysis to the more canonical one in "The Mass Ornament" of 1927. In the analytic framework that Kracauer employed in this essay, the masses were not measured against an idealized notion of individuality. A notion such as *das Vollindividuum* has no role to play. As Kracauer made clear, the complete individual is conceivable only in the fully mythologized world, where each being is independently meaningful as a

natural sign of the divine creation or the perfected community, or in the fully enlightened world, where each being is independently meaningful by virtue of a reason that has liberated humankind from the constraints of myth and nature. In the historical existence proper to men and women, however, they are always entangled in various kinds of collectives. The real human being is never more than a partial self, a *Teil-Ich*. Rather than accepting the false alternatives of individual or mass, one should distinguish between various forms of collectives and the degree of freedom or oppression that they entail.

Kracauer's idea of the mass as an ornament seems to have entered his thinking as he was reviewing performances of touring American dance companies known as Tiller Girls. As one scholar describes these popular revues, they consisted of "kick-lines of 'girls' . . . in various states of undress."[87] The dance companies featured dancers with long legs and shiny costumes whose coordinated steps and gestures formed rhythmic patterns in which the single performer had no meaning except as part of the greater constellation she formed together with her companions. The shows were often large in scale, filling auditoriums and sports arenas, where hundreds of performers would form colorful patterns before excited audiences.

Kracauer realized that the secret behind these spectacles was organization: "Like the pattern in the stadium, the organization stands above the masses, a monstrous figure whose creator withdraws it from the eyes of its bearers, and barely even observes it himself."[88] He went on to suggest that the subjection of the dancer to the mass ornament mirrored the human condition under capitalism. "The hands in the factory correspond to the legs of the Tiller Girls. . . . The mass ornament is the aesthetic reflex of the rationality to which the prevailing economic system aspires."[89] Like the mass ornament, the capitalist division of labor had liberated human activity from older forms of bondage. And as in the case of the mass ornament, the liberation offered by the capitalist system failed to encompass the human subject and served to subordinate him or her under the reign of an abstract organization hidden from those who toil within it. What Kracauer called *the mass*, then, was precisely the effect of this social contradiction: people had been liberated from old oppressive communities but at the same time enslaved under a new set of abstract social relationships. He painted the reality of the new system in vivid metaphors:

When they formed themselves into an undulating snake, they delivered a radiant illustration of the virtues of the conveyor belt; when they stepped to a rapid beat, it sounded like "business, business"; when they raised their legs with mathematic precision above their heads, they joyfully affirmed the progress of rationalization; and when they continually repeated the same maneuver, never breaking ranks, one had visions of an unbroken chain of automobiles gliding from the factory into the world and the feeling of knowing that there was no end to prosperity.[90]

As already stated, Kracauer, in "The Mass Ornament," rejected the presupposition of individuality—the *Vollindividuum*—that made "The Group as Bearer of Ideas" a somewhat predictable sociological exercise in the wake of Simmel and Tönnies. As a result, he was able to paint a more intriguing picture of the social drama. The choreographed ornaments were, on the one hand, a result of a reorganization of human relationships according to rational principles. Human activity was asserted as independent of nature and tradition. On the other hand, the end to which the activity was directed bore no relationship to the persons who actually participated in the mass ornament. The patterns they formed in stadium or on stage were not offered to *their* senses but could be seen only from afar or from above, like an aerial photograph. The mass ornament thus represented an unprecedented rationalization and coordination of human activity, but this did not serve those who literally built the ornament with their own bodies and movements. On the contrary, they found themselves subjected to a new mythological totality. As a cultural expression, the mass ornament was therefore typical of an intermediary stage. Along with capitalism itself, it emerged as a transient way of representing society. This society was no longer a society of individuals but of partial selves—swinging legs, hands, and heads, independently executing their assignments. No longer a simple sign of cultural decline, the masses here signified a reservoir of ambiguous social, political, and aesthetic energies and elements. They had been liberated from the old order and were set free to represent themselves differently, but they also risked becoming fixed in an even more monstrous order of power.

The Tiller Girls and other American dance shows that entertained Weimar audiences thus belonged in the same category as athletic mass spectacles and manifestations of right-wing movements with singing youth in

uniform. Such was the collective ornament in which Kracauer deciphered ominous signs of the future: "The bearers of the ornament is the *mass* and not the people, for whenever the people form figures, the latter do not hover in midair but arise out of a community."[91]

This was a crucial distinction. On the one hand, there was the ornament built up by one mass (of performers) for the enjoyment of another mass (of spectators). On the other hand, there was the kind of ornament associated with the people and organically expressing their community, without recognizing any separation between participants and viewers. In making this distinction, Kracauer reasoned in the same way as when he identified the difference between the Paris masses and those of Berlin. The former were organic and popular, the latter mechanical and remote-controlled.

Kracauer believed in the self-organizing ability of human collectives. He was a theorist of mass formations but, as Miriam Hansen underlines, he also cherished the open and candid encounter with the crowds. "His nonphobic relation to the modern mass made him a seismograph, . . . attuned to the historical and political mutability of the phenomenon as much as its conceptualization."[92] As a flâneur, Karcauer's expeditions into the modern city turned into an exploration of collectives less rigidly patterned than the Tiller Girls and the German youth movements. As I have mentioned, it was above all in Paris but also in Marseille and other port towns along the Mediterranean coast that he found illustrations of peoples' capability of self-representation:

This people has created for itself a city landscape in which it can persist, an indivisible cell fabric, which is hardly damaged by the architectural perspectives of the kings and the enlightened bourgeoisie. The smallness of the cells corresponds to the smallness of human proportions and needs. Paris is a small town, if this is not misunderstood as meaning provincial mediocrity. The people are as incalculable as the web of streets. . . . Bourgeois society seeks to insure its own existence beyond the moment and moves within a system of lines running as straight as avenues. (Of course, this system has no permanence.) The image in which the small people present themselves is an improvised mosaic. There are plenty of free and empty places.[93]

Opposed to the power apparatus of the upper classes that sought to organize the city according to straight principles of discipline and profitability,

there was thus the improvised mosaic of the popular classes. Opposed to the ornament of power, there were the ornaments of the people. Again, what Kracauer called "the mass ornament" should be seen as an intermediary form between these two. What was missing in the mass ornament, he argued, was the participants' ability to see for themselves the marvels and beauty they performed.

Correspondingly, what was lacking in contemporary Germany was the awareness among the people of the social creativeness and collective intelligence inherent in their everyday activities. If that awareness were to spread, people would soon reject the powers that organized them from above into armies, factory workers, or other kinds of mass ornaments. In the early 1930s, as right-wing assaults on the Weimar Republic multiplied, Kracauer became increasingly vocal in his critique of the rationalizing logic of fascism and capital, both of which prevented people from becoming the self-representing collective that was democracy's promise.

Insofar as Kracauer's articles record moments of happiness, they deal with the unexpected encounter with a collective utopia. These moments often take place in taverns and dance halls where the wanderer sits down to rest. One evening in Paris he notes that the faces on the dance floor radiate a soft reddish glow. The impression is faint, yet he treasures it all the more. What he has rediscovered this ordinary evening in a modest dance hall not far from Place de la République is nothing less than the enchanted mood of *The Thousand and One Nights*.[94] In the view of Kracauer and other radical writers who mixed with the crowds and wrote for the masses in interwar Germany and Europe, the flâneur's recording of such moments was a first step in the process whereby the masses would become aware of their ability to narrate their own lives, organize their own affairs, and represent themselves collectively. If that happened, society would change, Kracauer wrote. "Then, too, the mass ornament will fade away and human life itself will adopt the traits of that ornament into which it develops, through its confrontation with truth, in fairy tales."[95]

28. BEYOND THE BOURGEOISIE

"Our concept of the mass is derived from the standpoint of the individual," Bertolt Brecht wrote in the late 1920s. "The bourgeoisie has no understanding

of the mass. It always just separates the individual and the mass."[96] The section of Brecht's notes that was published as "Marxistische Studien" contains not only a critique of the individualistic definition of the masses that dominated Weimar culture but also an attempt to conceptualize the relation of mass and individual that took Kracauer's analysis one step forward. According to Brecht, the individual is a "dividual," a being that can be divided into smaller components. The reason for the dividable nature of the individual is that he or she is part of different collectives, each of which offers the subject a different identity. The term *individual* is thus an abstraction, concealing the fact that the human subject really is a superimposition of many different characters or, as our contemporary vocabulary would say, subject positions. As Brecht stated concisely, "What should be stressed about the individual is precisely his divisibility (as he belongs to several collectives)."[97]

Brecht's perspective has wide-ranging consequences. First, the individual, in his or her dividable nature, appears as a mass: "The individual appears to us ever more as a contradictory complex in continuous development, similar to the mass."[98] Second, the individual now emerges as a secondary phenomenon in relation to a more basic social reality consisting of masses, collectives, communities, and groups. Instead of seeing the mass as an eclipse of individuality, Brecht regards the mass as the condition of possibility for the emergence of individuality. "Man does not become man again by stepping forth from the masses but by sinking deeper into them," he once stated.[99] To be sure, Brecht acknowledges that a society dominated by large collectives entails the destruction of what he calls "the person" ("*die Zertrümmerung der Person*"). But this destruction only reveals that the person was never but a social construction in the first place. The fundamental and originary element of humanity, culture, or society is not, to use Kracauer's terms, *das Vollindividuum*, but rather *das Teil-Ich*. Or as Brecht states:

> The expanding collectives entail the destruction of the person. The suspicions of the old philosophers concerning the fragmentation of the human being are realized: thought and being are mirrored in the person as a terrible disease. He falls apart, he loses his breath. He turns into something else, he is nameless, he no longer has any face, he escapes from his overstretched state into his smallest proportion—from his dispensability into nothingness—yet having made the

passage into his smallest proportion he recognizes, deeply breathing, his new and true indispensability within the whole.[100]

The mass thus comes across as a social medium in which a false notion of individuality is first decomposed into its constituent parts, after which these subindividual components rearrange themselves, as it were, constituting new subjects according to available mechanisms of collective identifications. What Brecht had in mind when developing his constructivist aesthetics and his ideas about the epic theater was precisely such a reconstitution of humanity. "We will start from the mass-character to seek the individual and thus construct him," he stated in his notebook. The same objective was frequently announced in his writings on theater or in the plays themselves, the canonical statement being the "intermission speech" in *Mann ist Mann*: "Here tonight, a man will be reassembled like a car / Without losing anything in the process."[101]

What Brecht called "the destruction of the person," after which the subject is rebuilt, organized a number of remarkable aesthetic projects in Weimar culture. I have already mentioned Alfred Döblin's *Berlin Alexanderplatz* and Robert Musil's *The Man Without Qualities*. In both novels, we encounter a hero, Franz Biberkopf and Ulrich, respectively, who at the beginning tries rather desperately to establish a firm sense of self. In both cases, the effort fails, and the hero descends to a state of insanity. Ernst Toller's drama *Hoppla, We're Alive!* (*Hoppla, wir leben!*) from 1927 depicts a similar destruction of a person as the hero Karl Thomas is driven into madness and suicide by an inhospitable environment. Brecht's description of the fate of the person may be read as a note on Döblin's, Musil's and Toller's heroes: they fall apart; they lose their breath. They go over into something else, they are nameless, they no longer have any faces, they escape from a situation in which they are superfluous by becoming mad and by confronting their own nothingness—just as Kafka's heroes, incidentally, escape from their tormenting human condition by becoming animals. At the same time, Döblin's and Musil's novels, like Brecht, affirm this descent into nothingness as a step toward a more truthful relationship to the social totality. And in both novels, this process of individual decomposition and rebirth is mediated by the experience of the masses. Ulrich's experiences of the urban crowd are thus rendered as epiphanies that dilute individuality in an ocean of sensory stimuli. Note the affinity between the following passage and Kracauer's description of the mass ornament:

For whenever his travels took him to cities to which he was not connected by business of any kind, he particularly enjoyed the feeling of solitude this gave him, and he rarely felt this so keenly as he did now. He noticed the colors of the streetcars, the automobiles, shop windows, and archways, the shapes of church towers, the faces and the facades. . . . Such aimless, purposeless strolling through a town vitally absorbed in itself, the keenness of perception increasing in proportion as the strangeness of the surroundings intensifies, heightened still further by the connection that it is not oneself that matters but only this mass of faces, these movements wrenched loose from the body to become armies of arms, legs, or teeth, to all of which the future belongs—all this can evoke the feeling that being a whole and inviolate strolling human being is positively antisocial and criminal. But if one lets oneself go even further in this fashion, this feeling may also unexpectedly produce a physical well-being and irresponsibility amounting to folly, as if the body were no longer part of a world where the sensual self is enclosed in strands of nerves and blood vessels but belongs to a world bathed in somnolent sweetness.[102]

The last pages of *Berlin Alexanderplatz*, on the other hand, evoke what Brecht would have called the rebuilding of the subject through his or her communion with the collective. Döblin's final lesson is not that a subject that is embedded in the collective is diminished or fragmented, but, on the contrary, that his or her powers are multiplied:

One is stronger than I. If there are two of us, it grows harder to be stronger than I. If there are ten of us, it's harder still. And if there are a thousand of us and a million, then it's very hard, indeed.

But it is also nicer and better to be with others. Then I feel and I know everything twice as well. A ship cannot lie in safety without a big anchor, and a human being cannot exist without many other human beings.[103]

Döblin was no unreserved supporter of the masses, however. "You have to protect yourself from the masses," he warns his readers in a 1932 article. "They are the calamity of the day and the genuine obstacle to being really human. They are arrogant troublemakers, and more than anything they are

indestructible despots and absolutists. Whether they openly call themselves emperor or secretively, the public or the collective, do not let yourself be fooled. They all have the same thing in mind; they want to swallow you up."[104] In this and other texts, Döblin describes the mass as an antihuman phenomenon. It is a force that rationalizes life to the extent that it absorbs whatever is left of individuality. It is an inert, second nature of petrified urban forms, delusive commercial messages, and manipulative political slogans. The masses are also the leaders, companies, and organizations benefiting from the standardization of culture and the rationalization of life. In *Berlin Alexanderplatz* , the mass may even be seen as the totality of the modern city itself, determining the movements and daily lives of its inhabitants.[105]

In other words, Döblin's mass is sometimes an oppressive materiality, comparable to what Georg Simmel called objective culture, and so vast and overwhelming that the human subject often struggles in vain not to get crushed by it. However, in order to resist this abstract mass, or just survive its cruel treatment, a lonely soul like Franz Biberkopf has but one rescue— to join with others. Thus, if Döblin depicts the mass as the enemy of individuality, this is because he regards the mass as the opposite of humanity. But this also means that the mass is no more the antithesis of human individuality than of the human collective, and since the collective is stronger and more resilient than the individual, people are bound to one another in struggle against the hostile and alienating environment that surrounds them, the masses.

The weaker the individual, the stronger the mass—and vice versa. Such is, in simple terms, the logic of Alfred Döblin's social imagination. However, as the mass gets stronger, it also becomes clear that individual life itself and even the very idea of individual autonomy were always inescapably bound up in collective life, or what Weimar intellectuals referred to as the masses. That the individual was a product of the masses may be a too strong way of putting it, but it certainly became increasingly difficult to sustain the idea of individuality as a mode of existence independent of the masses. Weimar society consisted of masses. Most people sensed their identity as being an interconnected part of mass society, and some of them affirmed this situation and explored the possibilities it entailed. In another context, Döblin stressed this point, describing the masses as the most important "species of humanity [*Menschenschlag*]": "overwhelming and formless, they constitute

the most conspicuous and enormous fact of the present."[106] These masses should not be discussed in the abstract, as intellectuals, academics, politicians, and bourgeois people in general tended to do, Döblin argued. Rather, one must approach the masses, enter into their midst, and get to know their way of living. Collecting facts is necessary, as are statistics and comparisons, Döblin wrote. He also advised everybody who wanted to know the masses to join the workers' movement. "Much would also be achieved by taking up residency in working-class district or getting factory jobs." If this strategy was employed the "masses" would soon be discarded from serious intellectual discourse, and intellectuals and other "Kopfarbeiter" would discover nothing less than "another Germany," unknown and unexplored.[107]

The process described so far in this chapter may perhaps be conceptualized as a transformation of the social imaginary, in which the ideologically charged opposition of mass and individual is slowly replaced by what I have called a post-individualistic understanding of the masses and the human subject. Freud, Kracauer, Brecht, Döblin, and Musil are inscribed in this transformation; others could be added. They all agreed that the mass negates individuality, but the work of negativity is for them a work of reason that discloses a layer of social life deeper than the individual. It is this substance of sociality that they attempt to represent, as they seek new ways of conceptualizing, narrating, or depicting the masses.

It remains to see how other Weimar intellectuals conceptualized this social substance as an entity or force in its own right. Here, too, art and aesthetics led the way, one step ahead of political discourse and theoretical reflection. While politicians and scholars struggled to understand Weimar's modernity by trying to make it fit inherited categories, artists, filmmakers, and writers were more successful as they invented new modes of narrating or visualizing the emerging society and culture.

Georg Grosz's work is a case in point. His famous portfolios of drawings, such as *The Face of the Ruling Class* (1921) and *Ecce Homo* (1922), are characterized by a formal boldness that may be seen as an expression of a ruthless social gaze (figure 3.1). The unity of the pictorial plane is exploded by a dissonant play of horizontal, vertical, or diagonal lines that appear to extend beyond the frames of the image. No individual is so autonomous that he or she may be set apart from others by means of an unbroken line of contour. Instead, the outlines of one person intersect with those of his or her neighbor, and both of them are dissected by or

FIGURE 3.1 Georg Grosz, *Ecce Homo* (1922), plate 68. *Source:* © Georg Grosz/Artists Rights Society (ARS), New York/BUS Sweden 2012.

merge with the jagged lines of the tilting cityscape. Shapes are superimposed. Forms interconnect in one great social chain. Neither individuals nor masses: what Grosz presents is an agglomeration of subindividuals—*Teil-Ichen*—in the process of splitting away from or fusing with other similar subjects.

Grosz's work presents a grotesque diagram of the dividable nature of the human subject and the agglomerative nature of the collective. No

wonder that Grosz is often identified with the very spirit of Weimar culture. What we see in his drawings is not the mass as ornament but the multitude as moveable montage: a society in permanent crisis that continually reconstitutes itself without reference to any stable positions of sovereignty. Discursive attempts to render "the masses" and categorize their various forms appear as flat simplifications when compared to the visual detail and nuance of Grosz's human bestiarium.

Recall the description of the flâneur as a "registering medium" or "cultural sensorium," able to bring the realities of urban modernity into aesthetic expression. Grosz, too, is equipped with such a sensorium, and his images are a visual record of its activity. And recall Kracauer's description of his impressions of a Paris street: "The worlds change in kaleidoscopic fashion, with each new step a new one is opened up."[108] Such accounts appear as mere abstracts of the metropolitan universe opened up by Grosz, whose perspective is kaleidoscopic and, indeed, mobile. His images may be seen as superimpositions of several impressions, collected by someone observing the city from different angles and at different moments, and now reassembling these impressions into one composite picture. The result is an image of the city as perceived by some collective being. This is what the world looks like when seen by someone who has fully acquired the optics of the mass.

29. SHAPELESS LIVES

In 1938, Robert Musil wrote about the mass in one of his black notebooks:

> The 'mass' was something that I despised as a beginner; later, I considered that to be a youthful error; now I'm probably moving back a little toward the original position? But probably more in the direction of an object of study? (For example, wild outbursts of enthusiasm at major festivals.) What kind of thoughts may these most skilful manipulators of the mass have about such things?[109]

The brief statement is interesting in two ways. First of all because it confirms that Musil, too, was among the writers who were intrigued by the masses, a fact largely ignored in the secondary literature on this modernist

innovator and critic of interwar European society.[110] The second striking aspect is Musil's confession that his attitude toward the masses underwent a change. At first he held the masses in contempt. Then he found that his contempt was wrong. Then he changed again, now positing the masses as an object of investigation. In Musil's work we would thus find at least three different representations of the mass, or perhaps three different masses. There is no doubt that Musil's second position—the realization that his contempt for the masses was an error—is the more interesting one. The other attitudes are fairly predictable, given Musil's life and times. It is hardly surprising that a young writer of the early twentieth century, coming from the upper bourgeoisie, trained at military academies and a devoted reader of Nietzsche, despised the masses. It is also to be expected that Musil would see the mass and its manipulators as an urgent object of study after Hitler's rise to power. What is not typical in the career of such a writer, however, is that there would be a period in which he would "correct" his previous view of the mass and begin to view it in some different way.

Different in what way? The long passage I cited above about Ulrich's well-nigh mystical experience when strolling in unfamiliar cities comes from the beginning of the third part of *The Man Without Qualities*. In this part of the novel Musil's protagonist lays out his ideas about the so-called "other condition [*der andere Zustand*]." This was Musil's designation of a utopian state of living, the dream of another way of being, knowing, and perceiving. Obviously, the practice of *flânerie* is for Musil one way of illustrating what this alternative way of living and being would amount to. As Ulrich explains to his sister Agathe in the novel, his sweet experience of being lost in a city and surrounded by anonymous crowds equals the experience of the mystics.[111] In other instances as well, the blessed experience of the other condition is sparked by Ulrich's encounter with the modern city, the sense "that it is not oneself that matters but only this mass of faces," only these "armies of arms, legs, or teeth." Thus, what Ulrich experiences as "the other condition" is strongly related to an archetypical modernist euphoria, perhaps first registered by Baudelaire: "The pleasure of being in a crowd is a mysterious expression of sensual joy in the multiplication of number."[112]

Ulrich explains that all concepts and experiences are of two kinds—"one based on a sense of being enveloped by the content of one's experiences, the other on one's enveloping them"; he also describes it as a contrast between

"'being on the inside' and 'looking at something from the outside.'" What Ulrich calls the other condition is related to this sense of "being enveloped" or of "being on the inside." He is no longer an individual subject seeking to master the world, looking at it from the outside. Rather, he is "inside" society, enveloped by the world. In *The Man Without Qualities*, this condition is frequently illustrated by Ulrich's experiences of urban masses and urban spaces, by his being enveloped by them and feeling the distance to others falling away.[113]

Already in the first two chapters of the novel, we find a couple of powerful images of this kind. The first comes as a general description of the metropolis:

> Like all big cities, it consisted of irregularity, change, things and affairs sliding forward, not keeping in step, colliding, with fathomless points of silence in between, of paved ways and waywardness, of one great rhythmic throb and the perpetual discord and dislocation of all opposing rhythms, and as a whole resembled a boiling fluid in a vessel consisting of the solid material of buildings, laws, regulations and historical remnants.[114]

As many commentators have pointed out about the first chapter of Musil's novel, the implicit reader is offered a choice between a narrative register of objectivism, which observes this reality from a distance, and another register that records the experience of being inside this boiling liquid mass.[115] The next image of the mass is presented in chapter 2, where Ulrich appears for the first time. We see him looking out on the street, positioned in front of this "container" of boiling fluid, the city, and we are told that "for the last ten minutes he had been ticking off on his stopwatch the passing cars, trucks, trolleys, and pedestrians, whose faces were washed out by the distance, timing everything whirling past that he could catch in the net of his eye. He was gauging their speeds, their angles, all the living forces of mass hurtling past."[116]

From the beginning, then, Ulrich is introduced as an observer of the masses. The centrality of this theme is proved by the fact that it goes back to the oldest sediment of the novel. Musil's earliest drafts relate the hero's dream of getting lost in an imaginary metropolis. The dreaming subject is overwhelmed by an urban space of crowds and vehicles—"this tube of

streets with a dizzying stream of life"—and his impressions are explicitly compared to a film rushing through his mind.[117]

Ulrich continues to be an observer of masses throughout the novel, without interruption, although his methods of investigation change. Moreover, his commitment to the mission deepens to the extent that it transforms his being and sense of self. At first, we see him shrugging his shoulders at the spectacle of the street. Soon, he again finds himself before the masses, as he accepts the position of secretary of the so-called Parallel Campaign. The campaign is launched in 1913 and commissioned to arrange a great manifestation of imperial unity, rallying all the peoples and citizens of the Austro-Hungarian Empire around the emperor's throne. As secretary of the campaign, Ulrich thus faces the tough task of organizing all the peoples of the Dual Monarchy. He must crack the riddle of the masses and invent the formula that will pacify class struggles as well as interethnic conflicts in order to secure domestic harmony and external peace.

Needless to say, the effort fails. Instead of supporting the campaign, the population of Austria-Hungary turns against it. What is achieved is not peace but war, not internal concord but escalating conflict. Such is the ironic gesture of *The Man Without Qualities*. Interestingly, the first sign that the campaign is bound for a catastrophic ending is a gigantic mass manifestation, not unlike what Canetti experienced in July 1927, which Musil renders through a series of carefully crafted crowd scenes. The title of this chapter speaks for itself: The Parallel Campaign causes an uprising ("*Die Parallelaktion erregt Aufruhr*"). As Ulrich looks out on "the threatening open-mouthed faces" in the square below his office windows, he first spews out his contempt on the protesting masses. He recalls his training at the military academy: "It would take only one company to make a clean sweep of the square. . . . His imagination transformed the menacing black crowd into a flock of hens scattering before a dog rushing into their midst." After this initial reaction, the scenario is reversed, however, and now it is Ulrich who is swept clean by the masses:

> He was undergoing a strange transformation. 'I can't go on with this life, and I can't keep rebelling against it any longer, either!' was what he felt, but he also felt, behind him, the room with the large paintings on the wall, the long Empire desk, the stiff perpendicular lines of draperies and bell ropes. And this now seemed like a small stage, with

him standing up front on the apron, outside of which the events on the larger stage were passing by, and both these stages had their own peculiar way of fusing into one without regard for the fact that he was standing between them.[118]

Through this transformation, Ulrich leaves his position of mastery vis-à-vis the masses and feels as though he was being enveloped or invaded by them. At the same time, the room behind him appears to contract and turn inside out, as though the room itself was "flowing through him or around him like something that was very soft":

"A strange spatial inversion!" Ulrich thought. The people passed by behind him, he had gone through them and had reached a Nothing-ness; perhaps they passed by both before him and beyond him, and he would be washed over by them like a rock is washed over by the same but everchanging ripples of a stream. It was an experience half beyond understanding, and what struck Ulrich in particular was the glasiness, emptiness, and tranquility of the state in which he found himself.[119]

The presence and pressures of the masses transforms the observer into a participant in a social and existential drama that he cannot control, although he is fully aware of its taking place. Ulrich is washed over by the people like a rock is washed over by a stream. The masses transport him into that cherished other condition, where it is no longer him against society. There are many instances like these in Musil's novel. A normative position of individuality is emptied by forces of negativity that emanate from love, religion, strong sensory impressions, or urban space with dense masses of people, movements, and objects. In these situations, "the mass" negates a normative individuality, but the result is not disorder and destruction but the discovery of new possibilities for representing the self and the disclosure of a deeper substance of sociality.

Musil sought a formula for this social substance. The foremost example is what he called his "Theory of Human Shapelessness" ("*Theorem der Gestalt-losigkeit*"), which stipulates the initial shapelessness of all things human and social.[120] In trying to reach this level of reality, Musil experimented with various ways of conceptualizing, narrating, or depicting the masses. But of course, "the masses" is not the correct term to employ here.[121] Instead, we

would need to invent a new term that would refer to the social body before it crystallizes into individuals, classes, groups, or whatever other designation we may choose. What we see in the post-individualistic conceptualizations of the masses, of which Weimar literature and arts offer a number of brilliant examples, is thus neither individuals nor masses. What we see, rather, is the social in the most elementary sense, as it exists before being interrupted by those forms of sociation, or *Vergesellschaftung*, and those acts of representation that divide society into individuals and masses.[122]

If we continue to use "the masses" as a term to describe these post-individualistic images of society, we must thus qualify the usage. The importance of the masses represented here is not that they destroy a person's individual identity but that they offer a social space where the human subject undergoes a concurrent socialization and individuation, sensing both what it is like to lose one's individuality by merging with the collective and what it is like to shape one's individual identity by adapting to, or deviating from, the norms and forms that the collective makes available. In this view, the masses signify not a fall from social organization to disorder, but an ongoing reorganization of social passions.

30. ORGANIZING THE PASSIONS

The passions? When Freud approached the discourse of mass psychology he immediately dismissed the idea that masses were characterized by their "suggestibility" and by processes of "mental contagion." These ideas had been formulated in French crowd psychology at the end of the nineteenth century and had since then become dogmas. What the old crowd psychology had designated as suggestion and explained as an expression of a mass soul was in Freud's view a manifestation of general libidinal instincts. Freud thus repositioned the discipline of mass psychology. The mass would from now on be understood as a manifestation of the ways in which the psyche manages its libidinal energy. The essence of the masses, Freud said, is constituted by "those drives having to do with everything that can be brought together under the heading of love."[123]

Interwar Germany and Austria were societies in which all institutions and political structures were under severe stress. Under such conditions, the emotions were bound to appear as the real social fabric that prevented

nations and communities from falling apart. As we have seen, many shared Freud's conviction that libidinal energies were the real basis of society. This is also the reality behind Helmut Lethen's observation that Austrian and German culture of the 1920s excelled in various manuals and handbooks that taught the individual to keep his or her libido in check, controlling, concealing, disguising, or expressing the emotions, all in order to successfully adapt to a social and political terrain that was liquid and changeable.

The Man Without Qualities is a prime example of this tendency. The novel's historical meaning cannot be separated from its investigation of the social passions. Analyzing the cultural and political situation of the interwar period, Robert Musil confronted the enigma of the masses, and just like Freud he came to believe that society was held together by emotions. Thus, as Ulrich observes the chaotic last session of the Parallel Campaign, he concludes "that the emotional life of mankind slops back and forth like water in an unsteady tub."[124] In a desperate effort to prevent the complete failure of the Parallel Campaign, Ulrich suggests that it should institute a "World Secretariat for Precision and Soul." Such a secretariat, he imagines, would be a kind of negotiating body able to prevent open conflict between all movements and parties that claim to be the truthful voice of the people. In proposing the World Secretariat, Ulrich commits to a top-down agenda as a way of resolving the problem he has been struggling with ever since we met him, stopwatch in hand, trying to calculate the dynamic force of the mass. The task of the World Secretariat would be to investigate the unknown laws of human affections and passions. This investigation, in turn, would be the basis of an ideological engineering that would encourage the intellectual and erotic possibilities of humanity, rather than the monstrosity realized in the war.

Musil's emphasis on the passions as the substance of society and the key to political transformation also explains why *The Man Without Qualities* almost comes to a full stop, as Ulrich, in the projected continuation of the novel, embarks on an attempt to construe nothing less than a philosophy of emotions. The novel here turns from narration to discourse—and according to many critics from excitement to tediousness—but what remains constant is Musil's ongoing exploration of the existential, political, and ideological dimensions of passions and emotions. These final drafts for the end of the novel have most often been seen as an exercise in mysticism.[125] However, what motivates the exercise seems to be the same problem

that motivated Freud's analysis of libidinal identifications. Musil sought to account for the social ties that bind subjects together, what Freud called "*die Massenbindung*."

As early as 1914 Musil compared the collective energy released by the war to the experience reported by mystics, the exhilarating sense of being emptied and enveloped by a larger reality.[126] Because such borderline sensations of utopian dimensions would continue to attract people, it was necessary to examine how this kind of desire and affectation were produced and to see if their utopian content could be salvaged and managed in more constructive ways. Hence Ulrich's interest in the seemingly esoteric topics evoked by the titles of these chapters: "Historical synopsis of the psychology of emotions," "Naïve description of how an emotion originates," "Feeling and behavior. The precariousness of emotion," "Truth and ecstasy," "Ulrich and the two worlds of emotion." These rubrics mark the stages in Musil's libidinal analysis, which, on closer inspection, turns out to be a parallel to Freud's study of the emotional fabric of collective formations.

And hence Ulrich's fascination for the masses. Robert Musil had once participated in the quasi-religious mass celebration of a people mobilizing for war, and he had come to know the results.[127] His interest in political affectation and human emotion was conditioned by this experience, which also was a central element in Freud's and Kracauer's turn to crowd psychology. As he contended in his essay "Helpless Europe" (1922): "We do not have too much intellect and too little soul, but too little intellect in matters of the soul."[128] As long as the phenomenon of affection remained unknown, there was a risk that it again would result in a flight from peace into the ecstasies of the tribe. Of all the elements in Musil's project, this part is perhaps most difficult to grasp: at the projected end of *The Man Without Qualities*, the intrinsic connection between the nationalist passion released by the war and the mysticist experience of "the other condition" should stand revealed: "The religious element in the outbreak of war. Deed, emotion, and Other condition fall together."[129] It is difficult to think through these scandalous lines, in which mass violence somehow comes to equal love and collective solidarity: "War is the same as the other condition."[130] What the lines say, however, is exactly what Freud had suggested: all human collectives, even of the most monstrous kind, are ultimately constituted by love.

From this perspective, Musil's novel belongs to a group of projects that, partly in the wake of Freud's *Massenpsychologie und Ich-Analyse*, sought to

explain the political role of affections and the libidinal appeal of mass movements. Canetti's *Crowds and Power*, Adorno and Horkheimer's *Dialectic of Enlightenment*, Reich's *Mass Psychology of Fascism*, Arnold Zweig's *Caliban, oder Politik und Leidenschaft*, Broch's *Sleepwalkers* and *Massenwahntheorie*, and Musil's *The Man Without Qualities* all examined the at once inevitable and deceptive appeal of collective ideologies and the origins of political passions. After the burning of the German parliament in 1933, Musil noted in his journals that he wanted to write an essay on "Reason and Affects in Politics" ("*Vernunft und Affekt in der Politik*").[131] Right after, he started writing the chapters where Ulrich analyzes the emotions. Musil's aim was often explicitly stated in his notes: to separate the utopian and productive aspects of affective bonding from its destructive aspects. This is why he wanted to bring more precision into questions of the soul. His investigation into collective behavior amounts to a mass theory in its own right, a diagnosis of mass movements, which in his time changed Europe's political and cultural landscape.

It should now be clear what Musil hinted at when he stated in his black notebook that his attitude to the masses had changed over the years. The three phases that he mentioned may be summed up: first, unreflected contempt of the masses and an affirmation of the mass psychological theories of Le Bon and others. This was a common ingredient of the rank-and-file intellectual of the era.

Then came a realization that the mass is the base of society and individual, always present as the passions that constitute the social bond and hence also the constituting element of individual and collective behavior. In this stage, Musil affirmed what I have called the post-individualistic mass, and his novel became a registering medium of the social energies in interwar society and culture, providing new ways of representing collective life.

Finally, he came to believe that these social passions should form the novelist's main object of investigation, for it was only through the precise knowledge of the passions that one would be able to understand World War I and Nazism. At one point in *The Man Without Qualities*, Ulrich explains that he tends to see society as "a vast experimental station for trying out the best ways of being a human being and discovering new ones."[132] For the hero and his author, who labored at this station, the primary object of experimentation was "the mass," the social passions that hold societies and communities together. The aim of their experiment was to clarify the conditions for the intelligent collective.

4

Collective Vision

A MATRIX FOR NEW ART AND POLITICS

31. MASS PSYCHOSIS AND PHOTOPLASTICS

The same year as Vienna's crowds set the Palace of Justice on fire, in 1927, Hungarian artist László Moholy-Nagy offered a graphic illustration of the idea of the masses that many Europeans subscribed to in this period. The image has come down with two alternative titles: *Massenpsychose* (Mass Psychosis) and *In the Name of the Law*. It is one of Moholy-Nagy's photoplastics, a mixed-media form he developed while he was teaching at the Bauhaus school of architecture and design (figure 4.1).[1]

Moholy-Nagy emphasized that the photoplastic image portrays "concentrated situations" that can be developed instantaneously through associations.[2] An Eskimo would be unable to understand a photoplastic sheet, he claimed, because the image speaks to viewers accustomed to an urban world characterized by the compression and simultaneity of objects and events.[3] The photoplastic image teaches such viewers to perceive the relationships

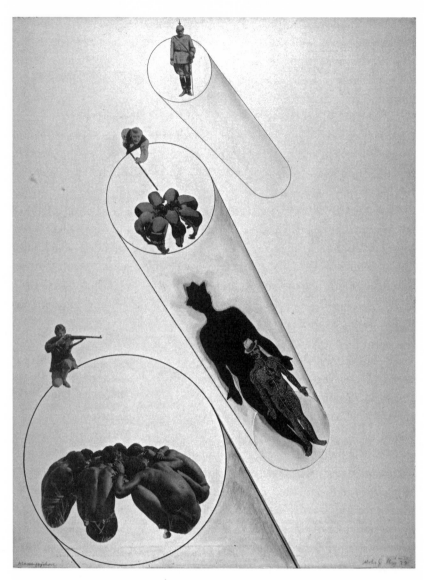

FIGURE 4.1 László Moholy-Nagy, *Massenpsychose* (Mass Psychosis) /*In the Name of the Law*, 1927. Photoplastic montage. *Source:* George Eastman House, International Museum of Photography and Film. © László Moholy-Nagy/Artists Rights Society (ARS), New York/Artists Rights Society (ARS), New York/BUS Sweden 2012.

structuring their world. The image, Moholy-Nagy said, "is directed towards a target: the representation of ideas." To this end, the title is crucial. "By means of a good title a picture's grotesque or absurd entirety may become a sensible, 'persuasive truth.'"[4]

What's then the truth revealed by the title of this image, *Massenpsychose* or *In the Name of the Law*? Moholy-Nagy stated that the photoplastic scene is a condensation of an idea. He asserted that whole acts of theater or film could be compressed into a photoplastic scene.[5] Following his hint, we may see *Massenpsychose* as a diagram of the influential theory of mass psychology. By implication, the image also addresses the general discourse on "the masses."

The relationships in *Massenpsychose* are hierarchical. The pool player masters the female swimmers. The female gunslinger controls the Africans in her own cylinder and the male figure in the adjacent one. The general stands at the peak of the pyramidal structure, governing the field as a whole. The positions of dominance are thus occupied by individuals with recognizable faces. The positions of subordination, by contrast, are held by faceless females and Africans. Moholy-Nagy portrays the latter in accordance with the principles of mass psychology: human subjects who form a crowd lose their individual identities, claimed the founders of mass psychology, Gustave Le Bon and Gabriel Tarde, as well as Georg Simmel, Sigmund Freud, and their followers in the interwar period. This is because people in a crowd are eager to conform, obeying the laws of "imitation," as Tarde argued, or "contagion," which was Le Bon's term for the same concept. What results from this psychic chain reaction is a collective agent behaving like a "decapitated animal," as Henry Fournial argued, or a "wild beast without a name," which was Gabriel Tarde's expression.[6]

Moreover, we see that the individuals occupying the positions of dominance are carrying phallic objects. These objects signify the traits that characterize a leader. Metonymically linked to the king's scepter and the magic wand, the cue, the sword, and the rifle are signs of the leader's charismatic power, the instrument of suggestion with which he manipulates the sentiments of the masses. "A crowd is at the mercy of all external exciting causes," Le Bon stated. The crowd is "the slave of the impulses it receives" or "a servile flock that is incapable of ever doing without a master."[7] Apparently, *Massenpsychose* offers a view of a social world split between ruling leaders and subjugated collectives. The image also shows the manipulatory nature of the relation obtaining between the two.

The bonds that bind persons to a crowd are always emotional in character, argued the theoreticians of crowd behavior. The affects that govern a crowd scrape off the individual's layer of cultivation and reason, making him or her conform to the lowest common denominator of the group, the base instincts of the unconscious. This process is also captured by Moholy-Nagy's photoplastic. Consider the man with the giant shadow at the bottom of the second cylinder, locked at the intersection of the trajectories of the bullet, the billiard ball, and the thrust of the sword. What remains of his civilized being is just the hat. The rest—his entire body—has lost the skin of cultivation that shelters individuality. A shadow is a conventional symbol of the subject's unconscious passions. This may be the accurate reading here, for it conforms to the central thesis of mass psychology: in the crowd, the subject is subdued by his impersonal instincts. His individual identity is overshadowed, and he merges with the faceless *bête humaine* represented by the females and the Africans, who would thus correspond to Freud's primal horde.

Finally, the transparent cylinders, resembling test tubes of a chemical laboratory, suggest that *Massenpsychose* also portrays the methodology of mass psychology.[8] Gustave Le Bon stated that the transformation occurring in a crowd is comparable to what happens in chemistry as certain elements such as bases and acids are brought into contact and combine to form a new compound.[9] The French historians and sociologists who inaugurated the analysis of the crowd modeled their studies on the natural sciences, branding their newly parceled out domains with names such as "social physics," "social statics," and "social dynamics." They understood the social field in terms of psychological charges of interacting social atoms that could be measured by a neutral scientist. Hippolyte Taine, the first true historian of the crowd, wanted to explain the evolution of French society through such a chemistry of passions. Just as the chemist analyzed the contents of his test tubes, so Taine examined society. In this spirit he concluded, famously, that the psychological forces manifested in history are comparable to chemical compounds: "Vice and virtue are products like vitriol and sugar."[10]

With just a few carefully organized images and lines, Moholy-Nagy's work thus captures the idea of the masses underpinning the disciplines of mass psychology and mass sociology. By revealing the nature of this idea, Moholy-Nagy's image asks the viewer to take a closer look at it. In representing the way in which the discourse of mass psychology represents

society, *Massenpsychose* thus exhibits the ideological message of this discourse and invites the observer to pass judgment on it. By extension, the image discloses the oppressive agency operating "in the name of the law," being, of course, the same oppressive agency that operates in the name of "mass psychology." It would therefore be wrong to call Moholy-Nagy's *Massenpsychose* a representation of the psychology of the masses. Rather, it is a representation of mass psychology as a discipline of knowledge and power.

From the 1890s onward, mass psychology and mass sociology had turned the masses into an object of investigation. Now, in 1927, Laszló Moholy-Nagy reverses the perspective and turns mass psychology into an object of examination, evincing the ideological character of its view of society.

If a certain discourse that once structured the prevailing perception of society is transformed into an object of perception or is revealed as an ideology, this seems to indicate that the legitimacy of that discourse has diminished, or else it would not be possible to think outside it, much less post it onto a board for public display. Evidently, Moholy-Nagy's image records such a transformation in the dominant conception of the masses. As I have stated, the meaning of "the mass" changed profoundly between the inaugural moment of French crowd psychology in the 1890s and Germany and Austria of the 1920s. The transformation did not entail that there was less talk about the masses nor that there was more clarity on the issue of the masses. On the contrary: more talk, less clarity. To enter the cultural landscape of interwar Germany and Austria is to encounter competing views, theories, and images of crowds.

32. JOHANNA IN THE REVOLUTION

How should we understand that Moholy-Nagy's *Massenpsychose* features a rifle-woman taking aim and a group of women in swimsuits? Portraits and narratives of collectives in the 1920s entailed a reshuffling of the gendered categorizations of the crowd, a topic I have so far only evoked but now must elaborate in some detail as it partly explains the emergence of what I have called the post-individualistic notion of the masses. In its early versions, for example, in Le Bon, mass psychology asserted that the masses are of feminine nature, a subservient and malleable matter, in relation to which the leader exercises his powers.[11] Similarly, Werner Sombart stated in 1924

that the masses "have an 'irrational,' feminine predisposition."[12] By rejecting the conception of individuality as a subject position that is external to the masses, many of the writers I have discussed also refuted the sexual ontology that ascribed masculine qualities to the leader-individual and feminine ones to the masses. This transformation may be related to the conferral of suffrage to women in November 1918 and the general consolidation of the women's movements in the interwar period as *die neue Frau* (the new woman) became symbol of a constituency that was not reducible to any of the conflicting classes in the social struggle.[13]

The women's movements pressed for a more multilayered interpretation of society than conventional class analysis could offer. In this context, the figure of femininity was often evoked as a political subject or an ideological and aesthetic fantasy able to transcend the dualistic framework that split the social body in individual citizens and proletarian masses. Interestingly, two emblematic Weimar dramas, Ernst Toller's *Masse-Mensch* (1919), which I discussed in chapter 2 (section 18), and Bertolt Brecht's *Die heilige Johanna der Schlachthöfe* (1927; translated as *Saint Joan of the Stockyards*), follow this pattern, and it applies to the heroine in Fritz Lang's *Metropolis* as well (also discussed in chapter 2, section 12). All three stage a violent antagonism between the anonymous masses and a group of capitalist individuals. All posit a female hero as a mediatory figure in this struggle: in Toller's play she is called *Die Frau* (The Woman); in Brecht, Johanna; and in Lang, Maria. These heroines are personifications of the dehumanized collective. Their solidarity is without limits. In her prophetic dream, Johanna sees herself at the head of all the protest marches and uprisings of human history.[14]

Mediating between the dehumanized masses and not yet existent institutions of political representation and citizenship, these female leaders seem to be symbolic manifestations of the real dilemma of constituting the gendered female subject as a citizen of the democratic republics of interwar Germany and Austria. As the women's movement triangulated the political struggle, it constituted a force that was assimilable neither with the disenfranchised proletarian masses, nor with the stereotypical individual *Burgher*. Johanna, Maria, and The Woman thus reflect a collectivity that becomes visible if we attend to the gender dimensions of the opposition between the figure of the masses struggling to attain citizenship and the figure of the individual citizen struggling to retain his power to represent society. Always partly occluded and suppressed by this dominant axis in

the social and political struggle, female agency as embodied by these hero-
ines offers a third alternative of representing the social body, one that we
must not identify either with the proletarian revolution as envisioned by the
communist parties nor with right-wing authoritarianism.

Yet Johanna and The Woman—and the alternative they bring to life—
are somehow too good for this world, as Brecht would have said. They are
utopian figures, symbols of a social-democratic reformism, egalitarian
republicanism, or humanist universalism that bears no relation to the frac-
tured political reality of Weimar Germany. This lack of firm anchorage in
the real political sphere may explain why both dramas have recourse to
the nineteenth-century practice of allegorizing the nation and the people
as a feminine figure. Like Marianne, the allegory of the French people, or
Germania, her German equivalent, Johanna and The Woman appear as the
corpus mysticum of the people, redeeming the antagonisms that destroy the
corpus politicum of male society. On a structural level, then, Lang's, Brecht's,
and Toller's heroines, notwithstanding their socialist convictions, are akin
to "the great German mother," the allegorical mother of the nation through
whom conservative segments of the women's movement and fascism itself
sought to represent the German tribe. This is by far most evident in the case
of Lang's Maria. Explicitly identified as the "heart" mediating between the
"hands" of the working masses and the "brains" of the elite, she comes across
as a hyper-idealization of this figure of femininity—while her bad double,
the robot-Maria, comes across as a caricature of the female rabblerouser.[15]

Unlike the fascist figure of femininity, however, these heroines fail to repre-
sent the collective. By foregrounding these failures, Brecht's and Toller's plays
problematize the inherited principle of representation, according to which
the masses is a force of potentiality that must be mobilized by the leader or
the vanguard party. While Maria, as we have seen, is split in two, embody-
ing the dual nature of political passions, or what Theodor Geiger saw as the
destructive-constructive couplet of the proletariat, Brecht's Johanna and Toll-
er's Woman shift positions as the revolution unfolds—now assuming the role
of the individualized leader, now embracing the anonymity of the movement,
now emerging as negotiators between the struggling classes. Yet they always
end up betraying the collective they wish to serve, which is also the case as the
evil Maria usurps the leadership of her good double and destroys what she has
accomplished. Such is also the tragic kernel of Toller's and Brecht's dramas:
although The Woman and Johanna are initially situated as mouthpieces of the

people, neither dispose of the forms—that is, the rhetoric, the organization, the revolutionary strategy, the institution—by which they could represent the people politically. If we read these texts as efforts to address the critical problem that haunted Weimar society—how to represent society politically and culturally—we must conclude that they fail to project an image of democracy, that is, a form of representation that does not define itself in opposition to an excluded majority branded as "the masses." However, it is precisely through this failure that they disclose their truth as political dramas, in the sense once summarized by Heiner Müller: the task of political theater is not to invent new possibilities but to demonstrate the impossibility of reality.[16] The political truth that they express is precisely what Kathleen Canning has identified as the real predicament of women's problematic and incomplete accession to citizenship in Weimar Germany. Political reality—notably, the articles on marriage and property in the new Weimar Constitution—made it impossible for them to acquire citizenship on the same terms as men.[17]

However, what turned out to be politically impossible was at the same time aesthetically productive and revealing. *Masse-Mensch* and *Die heilige Johanna der Schlachthöfe* each stages a collective that blurs the distinction between individual and mass, at the same time questioning the gendering of society in terms of masculine and feminine qualities. Placing a woman at the head of the revolution, the dramas illustrate the post-individualistic figuration of the masses that characterized a crucial part of Weimar culture. This figuration entailed a conception of political and cultural representation that went beyond the sterile opposition of individual and collective, as well as the false political alternatives of authority and anarchy, issuing instead in a republican egalitarianism in terms of both class and gender and a public sphere consisting of neither (feminine) masses nor (masculine) authority.

The Weimar artist Marianne Brandt also visualized a woman placed at a vantage point of historical insight and vision. Brandt was a coworker of László Moholo-Nagy at the Bauhaus school, where she enrolled as a student in 1923 and four years later was hired as leader of the metals workshop, and in the art of photomontage she showed exceptional compositional skills. One of her montages, made in 1928, is called *Es wird marschiert* (*On the March*) (figure 4.2). It depicts a mundane, modern, and emancipated young woman—an allusion to the stereotype of the urban *Garçonne*—who is leaning her head in her hands while the whole world appears to be spread out on the café table on which she is resting her elbows. This world is represented

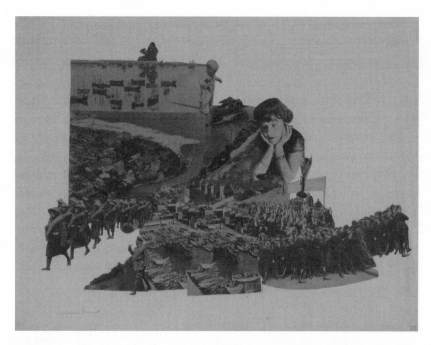

FIGURE 4.2 Marianne Brandt, *Es wird marschiert*, 1928. Photomontage. *Source:* Militärhistorisches Museum der Bundeswehr, Dresden. © Marianne Brandt/Artists Rights Society (ARS), New York/BUS Sweden 2012. Photo: Ingrid Meier.

by press photographs of masses, carefully cropped and crammed together or piled on top of one another in the picture—masses of boats, masses of buildings, and masses of human bodies, most of which are marching and demonstrating left and right across a cut-up panorama containing elements from Europe and Asia. The woman is poised above this bustling historical momentum and is contemplating the mass movements that occupy the social space she surveys. Her gaze appears at once analytical and melancholic, and the composition of the montage turns this gaze into an extension or representative of a public gaze, which is able to survey and critically assess contemporary world affairs. The title, *On the March*, indicates the content of her assessment: everything in the world that she contemplates from her elevated position suggests that politics and history are increasingly dominated by uniformed masses and militarism.[18]

Brandt invites her viewers to behold the world through the eyes of a personification of the new woman. These eyes see a world dominated by

crowds, a world that is comparable to what was put on display in the image by Brandt's colleague László Moholy-Nagy, *Massenpsychose*, to which we may now return. Using Brandt's montage as interpretative key, we understand how Moholy-Nagy's photoplastic also draws on and subverts a preexisting coding of masses as female and social authority as masculine. Curiously, *Massenpsychose* places the figure of femininity at both sides of this opposition: it is linked both to the subdued masses (the faceless female swimmers huddling together in their circular collective) and to the sovereign leader (the armed woman is a picture as good as any of dictatorial potency). Needless to say, these figures do not add up to one coherent feminine ideal but rather belong to contradictory registers.

Importantly, Brandt's photomontage also provides an additional perspective on the masses, which is illustrated by Moholy-Nagy's image as well. Offered by *Es wird marschiert* is a representation not just of mass society but also of a subject—the *Garçonne* at the center of the image—who is observing mass society and forming an opinion about it, thus serving as a representative of an implied public. Hence, she is not so much a *flâneuse* as a wholly new kind of authority. In Moholy-Nagy's image, the position and perspective of this subject is not present in the visual material as such but only in the image's mode of address. Like Brandt's *Es wird marschiert*, Moholy-Nagy's *Massenspychose* allows us to see the discourse on "the masses" from two different historical perspectives at once. On the one hand, we stare at the content of the images: a social hierarchy with firm boundaries between individual leaders and masses. To be sure, such was the image of society presented by mass psychology and mass sociology, from Tarde to Freud and from Le Bon to Hitler, and deeply entrenched in European society of the period. On the other hand, we may reflect upon the images' public mode of address. The implied spectator of these photoplastic pictures has acquired such a high level of "literacy" in mass-psychological matters that he or she—like Brandt's new woman—could be counted on to decode, almost instinctively, the meaning of the photoplastic constellation. The images invite this public to reflect on mechanisms of power, on the relation between leaders and subjects, between male and female genders, and between individuals and masses. That is, they invite a perspective of precisely the kind that Brandt offers by inserting the female figure at the center and endowing her with panoptical vision.

By consistently employing such a dual focus, Moholy-Nagy's image thus turns into a condensation of the entire discourse on the masses, from its

inception in France in the 1880s and 1890s to the transformations it under-
went in the Weimar Republic. His image contains the trajectory traversed
in this book, from the view proposed by mass psychology, that the mass was
the opposite of individuality, organization, *Bildung*, masculinity, reason, and
other laudable human qualities, to a variety of views according to which
the mass possessed its own internal dynamics and rationality. If there had
once been a relative consensus as to what the mass was, how masses were
shaped, and why masses dominated society, it had disappeared by the 1920s.

Moholy-Nagy also argued that photoplastic images constituted a new
visual language, suitable for all kinds of public uses, from commercial
advertising to radical propaganda. From this perspective, *Massenpsychose*
as well as Brandt's *Es wird marschiert* become critiques of the dominant,
individualistic notion of "the masses," and they suggest an alternative, post-
individualistic way of representing society. In sum, the public—or the com-
mon public sense, the *sensus communis*—that these two images address is
a negation of the society depicted in the images themselves. Activating a
social contradiction, Moholy-Nagy and Brandt provide visual representa-
tions of a society divided between leaders and masses while, at the same
time, through their mode of interpellation, they institute a public culture
without either individuals or masses.

What such culture entails may be roughly gauged in another interesting
image by Moholy-Nagy from the late 1920s (figure 4.3). It is provisionally
named *Up with the United Front* (*Hoch die Einheitsfront*), a title borrowed
from one of the banners carried by the people in the crowd that is shown in
the photograph. Unlike the carefully calculated compositions of *Massenpsy-
chose* and *Es wird marschiert*, this picture gives an impression of rawness and
incompletion: it comes across as a snapshot taken from within the crowd.
Are there any individuals in this photograph? Are there any masses? The
image depicts something else, a many-headed social agency that cannot be
reduced to any of the two categories and which is neither disorganized, nor
fully organized. Rather, this collective agent is abiding in a state of frozen
mobility. The title evoking a united front is paradoxical, for if there is any-
thing missing from the depicted crowd, it is unity. A disunited unity? What
Moholy-Nagy shows are people conquering the public square and the social
stage, instituting, as for the first time, a vocal and multifarious public culture.

In this way, the visual works of Moholy-Nagy and Brandt trust the view-
ers' ability to undo the dichotomy of individuals and masses and to project

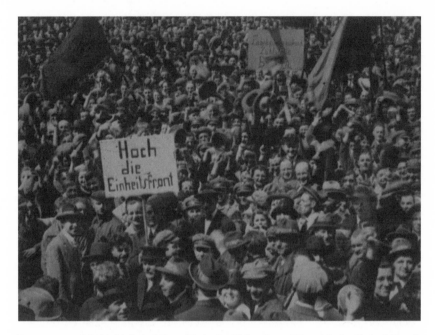

FIGURE 4.3 László Moholy-Nagy, *Hoch die Einhetsfront* (*Up with the United Front*), 1925–1930. *Source:* The J. Paul Getty Museum, Los Angeles. © Estate of László Moholy-Nagy/ Artists Rights Society (ARS), New York/BUS Sweden 2012.

themselves in a utopian direction, beyond those mechanisms of power that split the social field into a set of individual leaders and a faceless mass. They thus help outline the contours of a new public sphere of political and cultural representation while at the same time conjuring up the collective subjects and the subject of collectivity that are needed to make this arena a truly democratic one. This is also why Moholy-Nagy's and Brandt's works, along with the photoplastic technique they illustrate, are exemplary cases of Moholy-Nagy's general constructivist program. As he argued in his article "Constructivism and the Proletariat," constructivism "is the socialism of vision—the common property of all men."[19]

33. A SOCIALIST EYE

Walter Benjamin, too, promoted a socialism of vision. In major writings from the late 1920s and throughout the 1930s he explored how contem-

porary modes of aesthetic representation and visual perception referred to "the collective," just like the culture of an earlier era expressed a social life organized around "the individual." In Benjamin's view, the bourgeois interior of the late nineteenth century was the emblem of individuality, a sheltered place in which bourgeois man experienced himself as a creative and autonomous subject, striving for self-fulfillment and aesthetic enjoyment through the objects arranged in his dwelling. The social and economic upheaval after World War I, along with new mass media, enabled different forms of cultural production and aesthetic innovation that could be confined neither to the interior nor to any aims of individual self-expression. Cultural forms proper to the twentieth century ushered in a "liquidation of the interior," Benjamin claimed.[20] The function of art was no longer to create individuals but to affirm collective modes of life. The topos of the interior as a space of individuation was replaced by the topos of the street as a space of collectivity. An entry in Benjamin's *Arcades Project* describes the transformation:

> Streets are the dwelling place of the collective. The collective is an eternally unquiet, eternally agitated being that—in the space between the building fronts—experiences, learns, understands, and invents as much as individuals do within the privacy of their own four walls. For this collective, glossy enameled shop signs are a wall decoration as good as, if not better than, an oil painting in the drawing room of a bourgeois; walls with their "Post No Bills" are its writing desk, newspaper stands its libraries, mailboxes its bronze busts, benches its bedroom furniture, and the café terrace is the balcony from which it looks down on its household. . . . More than anywhere else, the street reveals itself in the arcade as the furnished and familiar interior of the masses.[21]

The public spaces of the city serve as *interieur* for the masses, and the exterior walls are their writing desks. The same idea motivated Marianne Brandt's and László Moholy-Nagy's theory of the photoplastic image, launched as a visual language addressed to urban crowds who would find enjoyment in this new public art while at the same time digesting the messages posted onto walls and façades. Benjamin, Brandt, Moholy-Nagy, and a number of other intellectuals of the interwar period sought to define spaces

for cultural and political representation through which the masses could appropriate the productive forces that so far had served to control them. How to turn these instruments of oppression into means of liberation? In answering this question, they attributed great importance to two phenomena: first, the architecture and technology that made up the material infrastructure of the modern life world; second, new media technologies such as photography, film, radio broadcasting, the newspaper, and the illustrated magazine, which circulated in these new channels. These phenomena were considered as constitutive of urban modernity, reflecting the rapid development of the productive forces of capitalism and, at the same time, generating new modes of private and public life, along with corresponding forms of sociation, both individual and collective.

Whereas most thinkers of the Weimar era argued that the masses heralded the destruction of culture, the intellectuals highlighted in this final chapter argued that the masses prefigured progressive forms of art and cultural production. Sometimes, the masses were even seen as the covenant for a more advanced community that would turn human labor and technology into means for achieving truly human ends. Primary among these new forms of cultural production were the new visual media. Reviewing a photography book by Karl Blossfeldt, Walter Benjamin argued that photography provides the language of the future: it allows people to look deeper into the material realm and to uncover its underlying patterns, thus "altering our image of the world in as yet unforeseen ways." Benjamin also quoted Moholy-Nagy, whom he called "the pioneer of the new light-image": "The limits of photography cannot be determined. Everything is so new here that even the search leads to creative results. Technology is, of course, the pathbreaker here. It is not the person ignorant of writing but the one ignorant of photography who will be the illiterate of the future."[22]

Benjamin argued that the camera provides for collective vision as its lens detects images and forms indecipherable to a pair of individual eyes: "unfathomable forms of the creative, on the variant that was always, above all others, the form of genius, of the great collective, and of nature."[23] Seeing beneath appearance, seeing differently, seeing deeper, the camera takes stock of organizational designs stored in the oldest sediments of the human collective. In a later essay, Benjamin would describe it as the "optical unconscious." Making these designs conscious amounted to a renewal of the political imagination. Camera pictures could therefore serve political emancipation.

Of course, they might just as well serve purposes of objectification, oppression, and manipulation. Cases in point are what Siegfried Kracauer described as the mass ornament and what Theodor Geiger called the optical mass, in which the lens is so far removed from social reality that people inevitably appear as compact and anonymous masses. Most images, ideas, and theories of the masses in interwar Europe employed this strategy, either literally or figuratively, thereby making human beings comparable to ants. "And what can we say about an ant-heap?" Alfred Döblin asked in 1929, characterizing the remote viewpoint of historians, sociologists, and economists. "There may be some five hundred ants moving across a path, coming from a root, or from a pile of stones, in a fast and conspicuous movement. A hundred yards away there is an even larger crowd of them at work." As with ants, so also with humans, Döblin concluded: "Viewed from a certain distance, distinctions vanish; from a certain distance, the individual ceases to be."[24]

The major question emerging from this context was whether the masses were best comprehended from afar or from nearby, from the outside or from the inside. What if the photographer's camera, the sociologist's gaze, or the writer's vision ceased to distance itself from the crowd and instead planted itself in its midst? No longer seen as colored dots against the pavement or as a black wall on the horizon, the social body would then appear as faces and bodies in motion surrounding the sociological gaze or seeping through it, just as the subject in Robert Musil's novel was transformed into a rock washed over by a stream. Walter Benjamin's theory of modernity hinges on a reversal of this kind, which in his view amounted to no less than a cultural revolution. No longer separated from society, no longer surveying the masses from above or from afar, the aesthetic work would "be absorbed by the masses," as Benjamin put it in his essay "The Work of Art in the Age of Its Technological Reproducibility."[25] Once the aesthetic work, or the medium of representation, disappeared into the crowd, the image of the mass was inverted and turned into a collective imagination in its own right. Benjamin speculated about a dialectical reversal of the subject and object of representation. Where there was once an unknown "Delta formation," an object of fear hovering at society's outermost border, there would now be a self-conscious subject of history occupying the central square. Where there was once an objectifying representation of the mass as inert human matter, there would now be a self-performing collective.

34. THE SECRET CODE OF THE NINETEENTH CENTURY

The crowd was the subject most worthy of attention for nineteenth-century writers, Walter Benjamin asserted in his last essay on Charles Baudelaire. Through the spread of literacy, the masses were taking shape as a reading public. They became customers of culture and wanted to be portrayed in the novel. Victor Hugo, according to Benjamin the most successful writer of the century, went so far as to acknowledge the demands of the masses in the very titles of his novels: *Les misérables, Les travailleurs de la mer*. Even in an esoteric poet like Baudelaire, Benjamin detected urban crowds swarming inside the sonnet stanzas and prose poems: "In *Tableaux parisiens* the secret presence of a crowd is demonstrable almost everywhere."[26]

Judging from Benjamin's essays of the 1930s, the crowd was an even more adequate topic for the early-twentieth-century intellectual and one that, with the emergence of fascism, was of utmost political importance. When Benjamin corresponded with Theodor W. Adorno about his work on Baudelaire, Adorno described "the notion of the mass as a secret code," the deciphering of which would afford fundamental insights into the historical relation of art and politics.[27]

Benjamin's *Arcades Project* is usually seen as an investigation of the emergence of modernity and the cultural forms corresponding to it. Central to this project is Karl Marx's notion of commodity fetishism, which Benjamin extracted from Marx's analysis of capitalism and redefined as the determining factor of the culture of modernity.[28] Benjamin approached nineteenth-century France by studying the nodes and hubs in the system of circulation and consumption of commodities: shopping arcades, boulevards, railway stations, factories, world exhibitions, and department stores, among others. In these locations Benjamin detected the formation of a new kind of collective: aggregations of men and women acting as vendors or buyers of things and services and thereby instituting a social life organized by the elementary yet mysterious reality of exchange value. When referring to this new collective, Benjamin spoke of the masses.

Benjamin did not summarize his theory of the mass in a single essay or book, although there is much to suggest that the *Arcades Project* would have contained a comprehensive treatment of the masses had it been completed. In order to reconstruct Benjamin's notion of the mass we must therefore stitch together his main essays and drafts of the mid- to late 1930s: "The

Paris of the Second Empire in Baudelaire" (1938), "On Some Motifs in Baudelaire" (1940), "Central Park" (1939), "The Work of Art in the Age of Its Technological Reproducibility" (1936), "The Author as Producer" (1934), "On the Concept of History" (1940), as well as the *Arcades Project*, which furnished a reservoir of ideas and motifs that was later tapped and refined in the essays.

Allusions to crowds, masses, and collective behavior and action abound in these writings, to such an extent that it is safe to say that this is one of their main concerns. Miriam Hansen goes as far as stating that Benjamin, in "The Work of Art in the Age of Its Technological Reproducibility," posited the masses as "*the* problem of modern politics."[29] However, the immense literature on Walter Benjamin does not contain any consistent attempt to reconstruct his theory of the masses. The notion of the masses is also virtually absent from the standard reference books on his work.[30] Hansen's work is an exception, yet she, too, fails to seize the content and intention of Benjamin's notion of the masses as she concludes that it "ultimately remains a philosophical, if not aesthetic, abstraction."[31] As I will demonstrate, it is more plausible to see in Benjamin's analysis of the masses his discovery of the concrete mediation between culture and economy in nineteenth- and early-twentieth-century capitalist society. He traced the transformation of this mediation up until the 1930s, at which point he would identify the masses as the key political problem that had to be resolved in order to create a democratic, which for Benjamin translated into communist, society.

One reason that no one has bothered with this exegesis is that it is hard to decipher what Benjamin actually means by terms such as mass (*Masse*), crowd (*Menge*), collective (*Kollektive*), people (*Volk*), class (*Klasse*), proletariat, petty bourgeoisie, and bourgeoisie.[32] This conceptual obscurity derives mainly from the fact that Benjamin uses these terms in three different ways: either colloquially, as in everyday speech, or as theoretical concepts or, again, as dialectical images elucidating the social function of art and culture. This being said, there is no doubt that the terms form a coherent conceptual structure. A sentence in "Central Park" proves Benjamin's awareness of the terminological choices involved: "On the concept of the *multitude* and the relationship between 'crowd' and 'mass' [Über den Begriff der Multitude und das (Verhältnis) von 'Menge' und 'Masse']."[33] As we shall see, Benjamin's theory of modernity hinges on careful distinctions between "crowd," "mass," "proletariat," "petty bourgeoisie," and "people."

Once we look closer at Benjamin's analysis of these categories we notice that his first impulse is often to treat the mass as a simple matter of fact. His twin essays on Baudelaire and Paris immediately establish the crowd as the most conspicuous feature of urban modernity and take it as a point of departure for a diagnosis of the arts, literature, and culture of modernity. What do we mean by "the masses" that put their stamp on Baudelaire's lyric poetry, Benjamin asks? These masses, he contends, "do not stand for classes or any sort of collective; rather, they are nothing but the amorphous crowd of passers-by, the people in the street."[34]

Benjamin here uses "the mass" as a descriptive term designating the urban crowd as it appeared to nineteenth-century metropolitan writers, and for this purpose he usually employs the word "*Menge*." The amorphous city crowd was a new and overwhelming phenomenon, a creation of mid-nineteenth-century industrial society, which caused concern among writers and painters who would seek to render this new aspect of their city in words and images. Benjamin's main examples are Edgar Allen Poe's short story "The Man of the Crowd" and Friedrich Engels's report *The Condition of the Working Class in England*, but he mentions a whole range of other books, artworks, and genres that took the crowd as their primary object. Charles Mercier's city panoramas, Balzac's catalogs of urban physiognomies, and Daumier's and Grandville's caricatures are all to be seen as different attempts to describe and decipher the urban masses. According to Benjamin, they introduced new metaphors and topics as the expanding city was compared now to wild forests, now to terra incognita, while the crowds inhabiting it were portrayed as internal savages and barbarians. The crowd was described as a milieu in which all sorts of promiscuous and criminal behavior were not just concealed but also actively cultivated. Crowds became objects of fear and suspicion, sheltering crime, conspiracy, and depravity. The detective story was a product of this environment. It invented a new kind of hero endowed with the eyes and ears needed to track down criminals and *conspirateurs* who used the dense and changeable crowd as a protective veil or hiding place. Dwelling on the origins of the detective story, Benjamin shows how the crowd offered a space that allowed a person to disguise his identity but also to protect it or to liberate himself from it. As Benjamin then moves on to discuss Baudelaire's poetry, he shows that although Baudelaire rarely depicts the crowd *en face*, it remains the

medium and external force that give meaning to the poet's characteristic oscillation between self-celebration and self-effacement.

Walter Benjamin thrives as a cultural historian mining the archives for items related to Paris's crowds. Why does he devote so much attention to the masses? According to him, the masses were closely linked to the emergence of an economy centered on the mass production of commodities. Here's an example from the notes covering "Arcades, Magasins de Nouveautés, Sales Clerks": "For the first time in history, with the establishment of department stores, consumers begin to consider themselves a mass. (Earlier it was only scarcity which taught them that.)"[35] Another instance is found in his file on "Saint-Simon, railroads": "The historical signature of the railroad may be found in the fact that it represents the first means of transport—and, until the big ocean liners, no doubt also the last—to form masses."[36]

In these remarks the mass is no longer a colloquial description of "people in the street" but a theoretical category designating a new collective that corresponds to a particular economic and technological domain. If the city of modernity invented urban and architectural technologies geared to optimize manufacture, transportation, and marketing of commodities, and if this architecture amounted to a new environment for the urban population, it also created forms of sociation and individuation adequate to the new milieu: "The most characteristic building projects of the nineteenth century—railroad stations, exhibition halls, departments stores . . .—all have matters of collective importance as their object. . . . In these constructions, the appearance of the great masses on the stage of history was already foreseen."[37]

A stage prepared for the arrival of the masses: such is Benjamin's congenial description of the modern city and its commercial infrastructure. This also explains why he argues that the mass is a secondary phenomenon, a symptom of historical change rather than its cause:

Its secondary [social] significance depends on the ensemble of relations through which it is constituted at any one time and place. A theater audience, an army, the population of a city comprise masses which in themselves belong to no particular class. The free market multiplies these masses, rapidly and on a colossal scale, insofar as each commodity now gathers around it the mass of its potential buyers.[38]

As a theoretical concept, then, the mass is the social expression of the capitalist logic, which constitutes the essence of the urban crowds gathering in arcades, galleries, and department stores designed for the new cult of the commodity. In addition, and precisely by virtue of being the dominant social form of cultural modernity, the mass constitutes the visible social context of human experience and artistic and literary production in nineteenth-century France. In other words, the mass is a category of mediation: it allows Benjamin to link his economic analysis of the commodity form to his analysis of Baudelaire's poetry, Hugo's novels, or other great crowd scenes found in nineteenth-century culture, and also to a vast number of nineteenth-century social types (collector, flâneur, bohemian, prostitute, gambler, idler), architectural inventions (arcade, boulevard, winter garden, railway station), political movements (Fourier, Saint-Simon, the June insurrection of 1848, the commune of 1871), visual technologies (photography, panorama), cultural institutions, notions, styles, objects, and genres (museum, *interieur*, mirror, automaton), all of which are indexed in the convolutes of the uncompleted *Arcades Project*. Most if not all of these phenomena derive their ultimate importance as either producers of masses or as reaction-formations vis-à-vis the masses.

Benjamin's conception of the mass thus differs from most others we have encountered so far, except, possibly, from those of Bertolt Brecht and Siegfried Kracauer. He does not approach the mass deductively, as did sociologists and cultural philosophers of Weimar Germany, who defined the mass by negation as a social aggregate lacking organization, individuality, and rationality, and hence as an agent of disorder. He also does not approach the mass as a psychological category, as did Freud and the mass psychologists preceding him, who defined the mass as a temporary or permanent gathering of people whose psychic identifications and passions are turned toward the same external stimulus. Benjamin also branches off from most post-individualistic accounts of the mass, according to which the mass was made up by people lacking means to represent themselves coherently as individuals with firm identities and positions. Deviating from these theories, Benjamin defined the mass by identifying its material condition of possibility, which he located at the economic level, in a system of production that put out saleable goods in great quantities and in a system of marketing that attracted customers in large numbers. In "Central

Park," he stated the matter straightforwardly: "The masses came into being at the same time as mass production."[39]

However, the definition of the mass as a social effect caused by the city's accelerating circulation of commodities is only the first element in Benjamin's theory of modernity. For the metropolis does not only form masses as a by-product of an economy centered on commodity production. It also supplies these masses with compensatory environments, allowing them to escape the commodification of their existence and to fantasize about themselves as authentic individuals and independent agents of civilization: "As soon as the production process began to draw large masses of people into the field, those who 'had the time' came to feel a need to distinguish themselves en masse from laborers. It was to this need that the entertainment industry answered."[40]

We may extrapolate Benjamin's argument: the masses are not just consumers of mass-produced and mass-marketed goods but also a collective whose members fulfill their dreams of social harmony and existential wholeness through the historically new activity of consuming mass-produced stories and images. In this sense, the mass is what Benjamin called a "dreaming collective," which attributes powers of magic and healing to the commodity. This mass lives and moves in an urban environment constructed so as to prolong this dreaming: "All collective architecture of the nineteenth century constitutes the house of the dreaming collective," Benjamin writes.[41] He draws up a list of some of these "dream houses of the collective: arcades, winter gardens, panoramas, factories, wax museums, casinos, railroad stations."[42] Had Benjamin written about the 1920s and 1930s, he would have added the movie theater to his list. In such spaces, the newly emergent urban crowds contemplate images of themselves as masters of nature and history. Benjamin's notion of the mass thus has at least two sides. On the one hand, the mass is a social formation instituted by the capitalist commodity economy and shaped by the architectural and commercial infrastructure corresponding to that economy. On the other hand, the mass is a vehicle for a new culture—patterns of social interaction that ignite sensations, fantasies, and dreams, thus becoming a source of what Benjamin calls collective phantasmagorias: dream images of the past, present, and future that are constantly rekindled by the circulation and display of commodities. In both senses, Benjamin's masses show strong traits of what he and other Marxists called the petty bourgeoisie.

35. SPEAKING COMMODITIES

It is easy to see why the mass served Benjamin so well as a dialectical image. At one stroke, his notion of the mass reveals two faces of the historical process: the relation of commodity and culture or of economy and experience. To put it simply, the mass is a social phenomenon that reveals how base and superstructure are connected in high-capitalist modernity.

However, it is not as simple as that. By examining how the relation of economy and experience was expressed in the masses, Benjamin was also able to account for the emergence of a social idea that remained dominant in his own era: "the individual," which he regarded as the supreme phantasmagoria of the nineteenth century.

Benjamin explained that the individual was an effect of the mass by analyzing two phenomena typical of early urban culture, the flâneur and the *interieur*. Both emerge as figurations of the nineteenth-century conviction that the individual is the basic unit of reality. In Benjamin's analysis, however, both the *interieur* and the flâneur are products of the mass, in the sense that the urban crowds constitute the raison d'être of both. The bourgeois interior, for its part, is in Benjamin's view a sheltered space where the individual seeks refuge from a society that is becoming increasingly compartmentalized into specialized professions and activities. It is a compensatory realm, where "man," estranged from the world of commodities that he has produced and that now begin to produce him, can preserve an "authentic" relationship to the world and continue to believe in his own unique individuality.

As for the flâneur, we saw already in the previous chapter how for Siegfried Kracauer the flâneur was equal to a new mode of apprehending society that could be approximated to the very subjectivity of the masses. The main theorist and historian of the flâneur, Benjamin explores the history and political potential of this new collective subjectivity. He starts by showing that the flâneur is the very opposite of the bourgeois subject cultivating his individuality in the interior. For the flâneur it is the street itself that that serves as a living room. The flâneur's arrival on the historical stage is anticipated by a number of other historical figures, all of them moving at the margins of urban life and ranging from the *conspirateurs* of early revolutionary sects, to radical students and all kinds of bohemians, all the way to the artists and writers who are forced to make a living on the

marketplace. People without strong class affiliations and as yet without strong ties to the bourgeoisie, the flâneurs are free-floating intellectuals: eyes, ears, pens, and painters of public life, of streets, taverns, and cafés. In short, they are those who wrest a living by recording their impressions of public life in the growing public mass media such as the newspaper feuilleton and the serialized novel.

The city's dense concentrations of people constitute the medium through which the flâneur perceives reality, writes Benjamin. For the flâneur, the masses fulfill several functions: "They stretch before the flâneur as a veil: they are the newest drug for the solitary.—Second, they efface all traces of the individual: they are the newest asylum for the reprobate and the proscript.—Finally, within the labyrinth of the city, the masses are the newest and most inscrutable labyrinth."[43] What characterize the flâneur's perception are sensations of movement, density, quantity, anonymity, collisions, and adventure, and these sensations are all generated by the crowd. Like Kracauer, Benjamin argues that the flâneur represents a historically new way of apprehending reality, one that is marked by quick sensations rather than enduring experiences and by a vulnerability of self that forces him to continuously reinvent his identity and redefine his position vis-à-vis others. Richly orchestrated by writers and artists of the period, the flâneur's experience of crowds is marked by a tension between the observer's wish to master the masses with his gaze and mind, thus providing a heightened sense of self, and his simultaneous temptation to lose himself in the collective. The flâneur turns this tension into his *modus vivendi*.

As I already stated, however, the presence of the masses was not always explicit in the art and literature of the nineteenth century. Writers and artists were far more preoccupied by the individual, narrating or depicting his path of personal cultivation, the education of his feelings, or the disillusion he suffered as he ran up against the powers of the establishment. Still, the individual's attitudes and actions were nonetheless conditioned by the subject's proximity to the urban crowds, Benjamin argued. In a crucial passage he asserts that the increasing valorization of individuality was the result of the increasing dominance of the masses. "Individuality, as such, takes on heroic outlines as the masses step more decisively into the picture."[44]

Therefore, the paradigmatic emotions of modernist art, solitude and ennui, which are experienced by virtually all literary heroes of the period, from the protagonists of Gustave Flaubert (*L'éducation sentimentale*) to those

of Knut Hamsun (*Sult*), only make sense once we picture these heroes uneasily rubbing themselves against city crowds. Baudelaire is Benjamin's primary example: "The mass has become so much an internal part of Baudelaire that one seeks in vain for any descriptions of it in his work."[45] A page or so further down, Benjamin remarks about Baudelaire's sonnet "À une passante" that "the crowd is nowhere named in either word or phrase. Yet all the action hinges on it, just as the progress of a sail-boat depends on the wind."[46] This was Benjamin's discovery: the mass, nowhere named or described, yet omnipresent, to the extent that it could be posited as the first obsession and primary content of the culture of modernity. Or, to put it differently, this was Benjamin's discovery of the critical relation of nineteenth-century experience to its exterior. Crucially, it was a dialectical relation, insofar as what appeared to be a relation to an external phenomenon—the crowd— was also an internal tension within the individual subject and the work of art itself.

Benjamin uses Baudelaire's sonnet "À une passante" as an object lesson on the dialectics between individual and mass (which Baudelaire, remaining firmly inside the patriarchal order of his era, depicts as an encounter between male gaze and female body). The poem relates how the flâneur sees a woman coming toward him, their eyes meeting for a moment, after which she again disappears. Baudelaire mentions that the woman is dressed in mourning, "en grand deuil," and Benjamin seizes on this detail. The veiled woman appears like a revelation, her figure emerging from the crowd in the same way as a face comes unveiled. Benjamin uses the image of the veil innumerable times. Things and objects are unexpectedly "unveiled" as they detach themselves from their embeddings to excite the senses of the flâneur. The veil is a source of fascination, and so is the secret it hides. "The masses [*die Masse*] were an agitated veil, and Baudelaire viewed Paris through this veil," Benjamin explains.[47] In a different context, he states that "the crowd [*die Menge*] is the veil through which the familiar city is transformed for the flâneur into a phantasmagoria."[48] In yet a different entry, already quoted above, he remarks that the masses (*die Masse*) "stretch before the flâneur as a veil."[49]

In the above quotations, crowd and mass (*Menge* and *Masse*) are obviously synonymous; both refer to the impression of people moving in the street, the anonymous and unknown inhabitants of the metropolis. However, a fourth entry increases the complexity of the image: "For the flâneur,

the 'crowd' is a veil hiding 'the masses' [Die 'Menge' ist ein Schleier, der dem flaneur die 'Masse' verbirgt]."[50] Whereas the mass previously was likened to a veil, it is now, strangely enough, described as reality hidden by the veil of the crowd. How to understand this sudden shift of meaning? What remains constant, throughout these entries, at least, is the image of *the crowd (Menge) as a veil*. To see the city and its inhabitants as through a veil obviously implies that reality is partly concealed: the city crowd appears as a phantasmagoria filled with secrets. But the veil does not just entice and agitate. It also puts a filter on reality and prevents something from coming into view. "The 'crowd' is a veil hiding the 'masses.'" Remove the veil, remove the spectacle of the urban crowds, remove its fascinating heterogeneity and variegation, its endless stream of shimmering appearances, and what comes into view is "the mass" (*Masse*) in the more theoretical sense of the term: a world ruled by a quantitative and repetitive accumulation of exchange value, that is, by a capitalist logic piling humans and things onto one another as commodities while turning the people that are exposed to this logic into a new class of petty bourgeois retailers, shopkeepers, and consumers whose life, work, and thinking are objectively delimited by their position vis-à-vis the production, marketing, and consumption of commodities.

In this more theoretical sense, Benjamin clearly states that the individual flâneur is himself an embodiment of the logic of the commodity that turns all things and all humans into replaceable units in a mass. The flâneur, he explains, is someone abandoned in the crowd. This places him in the same situation as the commodity, for it, too, appears on the store shelf without trace of its origins or of the hands that produced it. "The intoxication to which the flâneur surrenders is the intoxication of the commodity immersed in a surging stream of customers."[51]

Individual and commodity here turns out to be made of one piece; both are creations of the implacable laws of the market. Separate, unique, independent, sovereign—these qualities attributed to the hero of modernity, the individual, are also characteristics of the commodity as it is perceived as a fetish with a soul of its own.[52] The individual feels himself or herself as the very opposite of the mass—and most nineteenth-century culture helped tailor that feeling into a firm conviction. As Benjamin argues, however, individualism and massification are governed by the same historical logic through which the human being is atomized, turned into the isolated

monad celebrated by individualism and then joined to other such human units into the great aggregate of the mass. Massification, individualization, commodification: all are facets of one single process.

If the mass functions as a secret code in nineteenth-century culture, and if it was Benjamin's great discovery to establish the presence of that code *inside* virtually every piece of art, literature, architecture, and popular culture created in that period, it remains to be seen what this code ultimately meant. As a dialectical image, the mass expressed an undividable constellation of economic life and mental life, of commodity production and collective dreaming. The mass revealed that the commodity is the soul of the culture of modernity, in which social life and historical progress are identical to the process by which everything and everyone are transformed into commodities and subjected to the logic of capital. The mass, in Benjamin's analysis, represents the reduction of history, society, nature, and life itself to an eternal sameness produced on the conveyor belt.

As a cultural phenomenon, then, the mass is a collective of petty-bourgeois character organized around the cult of the commodity. The social relations within the mass are constituted by the participants' position in the circulation of exchange values. As commodity circulation assumes fetishistic qualities, however, it is perceived as a source of historical, cultural, and aesthetic values, through which the members of the collective construe a sense of authenticity and individuality. Such is the phantasmagoric quality of the mass, preventing the members of the collective from apprehending the impersonal, economic powers governing their world while at the same time convincing them that they are themselves independent individuals living and acting in accord with their own free will.

Benjamin saw the similarity between the sleeping collective of the nineteenth century and the fascist communities of the 1930s. In both cases, the collective was held in spell by alluring utopias, which prevented it from perceiving its actual enslavement. The mass was thus not just the secret code with which Benjamin unlocked the relation of nineteenth-century culture to the realities of industrial capitalism. In addition, it was a code that offered an understanding of Benjamin's present, which had fallen under the rule of fascism's successful mobilization of the masses and their subsequent transformation into a nationalistic people's community, or *Volksgemeinschaft*. This is the moment to look at the continuation of a passage that I quoted above:

The free market multiplies these masses, rapidly and on a colossal scale, insofar as each commodity now gathers around it the mass of its potential buyers. The totalitarian states have taken this mass as their model. The *Volksgemeinschaft* aims to root out from single individuals everything that stands in the way of their wholesale fusion into a mass of consumers. The one implacable adversary still confronting the state, which in this ravenous action becomes the agent of monopoly capital, is the revolutionary proletariat. This latter dispels the illusion of the mass with the reality of class.[53]

The appearance of the mass yields to the reality of class. Yet in order for this to occur, the proletariat must "dispel the illusion" that prevents people from seeing the true origin of the commodity without distortions. The phantasmagorias emitted by the commercial and cultural institutions of bourgeois society would then dissolve. The inhabitants of the metropolis would realize that their position in society is not primarily determined by their role as consumers but by their position in a system of production that divides humanity between those who are forced to become commodities, selling their labor, and those who can buy that labor and extract a surplus from it. According to Walter Benjamin, this is the "undistorted reality" that, once the veil is torn, underlies the exhilarating panorama of the urban crowd.

36. DEUS EX MACHINA

I suggested that Benjamin's theory of modernity could be glimpsed in his distinctions among crowd, mass, proletariat, petty bourgeois, and people (*Menge, Masse, Proletariat, Kleinbürgertum, Volk*). As we have seen, Benjamin evokes the crowd as an object of visual pleasure and existential adventure, sometimes likened to a labyrinth, sometimes to a shimmering veil. Benjamin's crowd (*Menge*) is thus a phantasmagoric appearance behind which the critic detects the deeper reality of the mass (*Masse*). The mass, in turn, is also a secondary phenomenon brought into being by the commodity economy as each commodity and each site of commodity exchange, such as the arcade or the department store, effectively *forms* the mass that is appropriate to it. Deeper still, there awaits a third kind of collective

formation, the class. It constitutes itself at the moment when the mass becomes conscious of its subordination to the rule of the commodity or revolts against that rule.

Yet the superstructure of culture and knowledge erected by the victorious bourgeoisie prevents the mass from becoming conscious of the rule of the commodity. This culture presents itself as a phantasmagoric universe promising satisfaction of all desires and fulfillment of all dreams. This is why the dreaming collective of the nineteenth century prefigures the fascist collective of the twentieth. Fascism completes the process of dehumanization and de-individuation at the heart of the commodity economy; at the same time it invents a social form, the racialized *Volksgemeinschaft*, in which the individual's absolute subjection is a prerequisite for his or her existential fulfillment and social recognition. A long footnote to the second version of "The Work of Art in the Age of Its Technological Reproducibility" in which Benjamin directly addresses "the ambiguous concept of the masses" seems to confirm this view. He speaks of fascism's cunning use of the laws of mass psychology as it seeks to form "compact masses" infused by "the counterrevolutionary instincts of the petty bourgeoisie." In conjunction to this he sketches a history of the masses:

> The mass as an impenetrable, compact entity, which Le Bon and others have made the subject of their "mass psychology," is that of the petty bourgeoisie. The petty bourgeoisie is not a class; it is in fact only a mass. And the greater the pressure acting on it between the two antagonistic classes of the bourgeoisie and the proletariat, the more compact it becomes. In *this* mass the emotional element described in mass psychology is indeed a determining factor. But for that very reason this compact mass forms the antithesis of the proletarian cadre, which obeys a collective *ratio*.[54]

As Benjamin judged the historical drama: whereas fascism obtained the ideal community according to the conventional prescriptions of mass-psychological doctrine, that is, through obedience and aesthetic glorification of the leader, socialism would achieve *its* ideal community through human liberation and political self-representation of the collective, enabled by a leader whose "great achievement lies not in drawing the masses after him, but in constantly incorporating himself into the masses, in order to be, for them, always one among hundreds of thousands."[55]

Benjamin's analysis thus moves from the crowd (as the collective expression of cultural and visual phantasmagorias offered by urban life), to the mass (as the collective expression of the commodity economy, and often identified with the petty bourgeoisie), and onward to the proletariat (as the collective expression of capitalist exploitation and of revolutionary resistance), which "is preparing for a society in which neither the objective nor the subjective conditions for the formation of masses will exist any longer."[56] These three analytical steps also mark the progression of the gradual awakening of the collective. Benjamin's objective for the *Arcades Project* was thus to extract from the dreaming collective of the masses, which he identified with the petty-bourgeois collective, the awake and self-conscious proletarian collective. "Wouldn't it be possible," he states in an early entry, "to show how the whole set of issues with which this project is concerned is illuminated in the process of the proletariat's becoming conscious of itself?"[57]

Benjamin never investigated the concrete historical preconditions for the emergence of the proletariat as a revolutionary agent. It is clear, however, that he perceived such a scenario as the only alternative to fascist mass politics. As the Second World War continued, his belief in revolutionary change became increasingly militant—and, one should add, increasingly abstract and utopian. In his last piece of writing, the theses "On the Concept of History," the revolution flares up as the universal solution and sole hope in times of darkness. The proletariat, we are told, is capable of "a tiger's leap" into the future: this "leap in the open air of history is the dialectical leap Marx understood as revolution." The proletariat figuring in Benjamin's theses on history is the virtual equivalent of the Messiah. "What characterizes revolutionary classes at their moment of action is the awareness that they are about to make the continuum of history explode."[58]

Adorno criticized Benjamin for giving the proletariat the role of deus ex machina in the historical drama.[59] His objection was to the point. Benjamin's texts are not the place to look for sociological arguments concerning the actual motivations of the working classes to become the subject of history. Rather, the proletariat's revolutionary calling was in his view an ontological idea. A self-proclaimed "constructivist," Benjamin believed that the truth of history is accessible only to those who actually construct the historical world with their own labor.[60] In his diary, he approvingly noted a conviction of Brecht's: "The sense of reality of the proletarian is incorruptible."[61] Thus, rather than examining the proletariat's sense of reality, Benjamin took it as pregiven.[62]

But are there any workers at all in the arcades? asks Jacques Rancière in an article on Benjamin's philosophy of history. He observes the striking disparity between Benjamin's rich commentary on the arcade as the embodiment of petty-bourgeois modernity and the rare notes, most of them raw excerpts, that he devoted to laboring people of nineteenth-century Paris.[63] One entry in the *Arcades Project* seems to admit as much. "It is a very specific experience that the proletariat has in the big city—one in many respects similar to that which the immigrant has there."[64] Apparently, the working classes do not belong in the crystal palace of bourgeois modernity. Still, Benjamin is convinced that they hold the key to progress. The social function of this class is thus the opposite to that of the masses. Masses were formed by the capitalist market and the circulation of exchange values. The proletariat was brought into being by capitalist *production*. To step from the appearance of the mass to the reality of class was thus to step from the sphere of consumption to the sphere of production—in a way corresponding to Karl Marx's analytical move in the first volume of *Capital*, where the reader, having just been taught everything he should know about the circulation of money and value, is suddenly invited to enter "the secret workshop of production, above the gates of which is posted a board saying: No admittance except on business."[65]

Marx actually entered the capitalist sweatshop, carefully analyzing the power relations, business organizations, capital investments, factory work, and wage systems at the basis of European capitalism. Benjamin's step toward the sources of production ends up elsewhere, in a materialist cosmogony, or a myth of creation. The secret of production may be beheld not by describing the relation between worker and owner in the capitalist system but by studying the timeless relation between the human organism and nature, especially the skill and vision with which somebody transforms matter. In other words, Benjamin's model of production is based on an idea of nonalienated labor, where working ideally involves play, creativity, self-expression, existential fulfillment, and community building. In utopia, work would be conducted on the model of children's play, Benjamin states: "All places are worked by human hands, made useful and beautiful thereby; all, however, stand, like a roadside inn, open to all."[66]

Benjamin always paid particular attention to the world makers—peasants, artisans, children, and workers—who know how to make the world inhabitable by transforming matter with hands and minds. His recurring references to the world of artisan labor and craftsmanship and his keen

interest in toys and children's theater are all part of his notion of authentic production as the foundation of human experience and its various cultural expressions.[67] To make the world is thus to know the world, and in capitalist modernity the proletariat is the class that makes the world.

For the system of capitalist production does not bring into being only "masses" of people ready to buy and consume what the factories deliver, and not just the immaterial know-how and technology needed for the production of these commodities. Crucially, capitalism also brings into being a social class whose sensory apparatus is profoundly shaped by these new technological forces of production. And this is why Benjamin can claim that the worker's hands are somehow better adapted to handling the world of modernity, just as the eyes and ears of the working classes are superior to the dulled senses of the bourgeoisie when it comes to understanding modern society.

For instance, the worker's eye is thus on a par with the technical eye of the camera, Benjamin argues. Both see beneath appearance, both see differently, and both see deeper. There is also a parallel between the proletariat and cinema because film is produced, edited, and narrated according to a cutting technique similar to what obtains in factory work. Moreover, both cinema and factory work rely on a rational division of labor. In the production of an automobile or a film, no single individual is skilled enough to run the production process as a whole, in the way an individual craftsman controlled the manufacturing of an object. Rather, the manufacture of commodities as well as the creation of artworks takes on a *collective* character, which makes the idea of the autonomous individual and the artistic genius obsolete. However, manual work and spiritual work do not just become collective. They are also increasingly determined by a common logic or a common mode of production characterized by a strong reliance on machinery and technological devices. Benjamin's designated this logic as one of "technical reproducibility," arguing that it radically changes the function of art, the nature of political representation, and the properties of knowledge.

Benjamin stressed that large-scale dissemination of images enabled by camera and reproduction techniques had for the first time in history given common people access to reproductions of artworks as well as images of distant places and unknown parts of nature. Moreover, new techniques of reproduction had given these people a possibility to represent themselves for what they were—as the true producers of history. The collective itself, or even *work* itself, was thereby given a voice.[68] Having previously been

forced to rely on a class of sages who protected their own privileges of seeing and describing, people had now attained the means to present and represent themselves by using the camera. The transformation was already under way in Soviet Russia, Benjamin wrote: "Some of the actors taking part in Russian films are not actors in our sense but people who portray *themselves*—and primarily in their own work process. In Western Europe today, the capitalist exploitation of film obstructs the human being's legitimate claim to being reproduced."[69]

Benjamin concluded that technology would be rationally employed at its highest potential only if placed under the control of the masses. Of course, this is standard Marxism: the full realization of society's productive forces requires the abolishment of private ownership. Benjamin's contribution to the Marxist doctrine was to develop a corresponding analysis concerning the forces of *cultural* production. Just as machine technology served as a way of exploiting factory workers, so was media technology used to subject the masses by disseminating phantasmagoric messages and images naturalizing their subordination. Fascism raised this use of media technology to a new level.

Technical development had brought the masses into being and turned them into consumers of the phantasmagorias made available by mass media. But the same technical development also offered the masses an opportunity to place themselves at the center of the historical stage and to present themselves as the conscious subjects of history. This is a decisive step in Benjamin's analysis of the collective. As many commentators have pointed out, it is also a questionable, if not doubtful, move—the utopian tiger's leap into the future.[70] By using new media technology to represent themselves and to fabricate themselves in their own image, people would put an end to their own existence as masses at the margins of the polity, transforming themselves into the constituent subject of society. The very principle of "technical reproducibility" that instituted the masses—as consumers and obedient political subjects—would thus "dispel the illusion of the masses with the reality of class."

This self-transformation of the masses into a historical subject would also entail a profound change of the function of the artist and the writer. Adapting to new modes of cultural and aesthetic production that were collective in nature, they would relinquish their status as individual or autonomous creators placed at a distance from society. Instead, they would engage

in collective production, as facilitators and experts in the effort to bring all parts of a variegated and heterogeneous society into representation and expression, a task entailing no less than the awakening of the collective.

Ultimately, it is this whole process of social and cultural transformation that Benjamin encapsulates in the first sentence of the final section of his artwork essay: "The Masses are a matrix from which all customary behavior toward works of art is today emerging newborn."[71] Art is no longer placed above the masses as an object cherished for its cult value. Instead, it is valorized for what Benjamin calls its "exhibition value." No longer founded on ritual, the social function of art becomes based in politics: the artwork serves to *display* the social community. Benjamin contrasts the old relation to art to the new one by comparing the attitude of the connoisseur of master painting with that of the distracted film spectator: "A person who concentrates before a work of art is absorbed by it [*versenkt sich darin*]; he enters into the work, just as, according to legend, a Chinese painter entered his completed painting while beholding it. By contrast, the distracted masses absorb the work of art into themselves [*die zerstreute Masse dagagen versenkt das Kunstwerk in sich*]."[72]

But—how can the masses "absorb" the work of art? Benjamin put great faith in the combined effect of new technologies of reproduction and representation, new forms of collective self-organization, and new forms of communal or communist ownership. The result would be what Bertolt Brecht called an *Umfunktionierung* or functional transformation of all art forms in accordance with emerging socialist forms of production.[73] In his writings from the late 1930s, Benjamin always contrasted this ideal, to his great disappointment already partly betrayed in the Soviet Union, with that in fascist Europe. For fascism, too, allowed the masses a space within the field of representation, but only for the purpose of consolidating the hierarchy between rulers and ruled. The only way to avoid this development was to transfer the new means for cinematic and photographic production into the hands of the masses. If in traditional bourgeois culture the beholder was absorbed by the work of art, and if in fascist culture the masses were absorbed by a society turned into an artwork painted by the leader, then in Benjamin's ideal communist society a third possibility was realized, in which the work of art was absorbed by social life itself.

The work of art being absorbed by the masses—and the "functional transformation" of the very conception of art: this is precisely the role

that Brandt and Moholy-Nagy attributed to the photoplastic image. It was designed to be placed at the center of the public square, in the midst of the city crowds, the members of which would all be counted on to decipher its visual language and be enlightened by its message. As the work of art was thus absorbed by the masses, it provided these masses with a new medium in which their own experience was at once reflected and represented. This program presupposed aesthetic media that were able to view the masses from within and also to see society with the very eyes of these masses. The aim of the program was to transport the lens through which the social body represented itself closer to the ground; to enable these masses to represent themselves politically, culturally, and aesthetically without intermediaries; and to turn arts and culture into a genuinely democratic enterprise. In Moholy-Nagy's and Brandt's photoplastic posters the mass is therefore no longer an object of fear hovering at the margins of the social world but the subject of its own means of representation. The mass is no longer seen from the outside but from the inside, at which point it ceases to be a mass and turns out to be a collective that is far more heterogeneous and differentiated than what is evoked by that word. Benjamin speaks of the "loosening" of the proletarian masses, which occurs "when it becomes conscious of its social position and political role and takes up the struggle for liberation." He continues: "The loosening of the proletarian masses is the work of solidarity. In the solidarity of the proletarian class struggle, the dead, undialectical opposition between individual and mass is abolished."[74]

In this sense, Moholy-Nagy's and Brandt's aesthetic inventions and Benjamin's theory also indicated a more general feature of Weimar modernism. For it seems that the deconstruction of the dichotomy of individuals and masses presupposes a cultural or aesthetic medium that would dissolve the opposition between aesthetics and politics or aesthetics and public culture. In Brandt's and Moholy-Nagy's case, this new medium was the photoplastic technique itself, which is hard to locate in any conventional system of aesthetic genres. In the case of Bertolt Brecht, epic theater served the same function, as the newspaper feuilleton did for Kracauer and, as we shall see, the documentary drama for Erwin Piscator, to mention just a few examples. Also, we may recall that Döblin's *Berlin Alexanderplatz* appeared not only as a novel in 1929 but also as a *Hörspiel* in 1930 and a year later as film; or that Brecht's *Three-Penny Opera* was produced as opera, novel, film, and then as a book documentation that addressed precisely the

tensions among these media. In these cases, the presence and pressure of the masses determined the very forms of artistic and intellectual labor, eroding the distinction between high and low. The negation of the distinction between individual and mass lead to an interrogation or transgression of the distinction between art and its other—whether we call it mass culture, primitive culture, folk culture, propaganda, *proletkult*, or constructivism. For a long time, all dominant views of art had presupposed a conception of the authentic and creative individual. By thinking through the phenomenon of "the masses," Moholy-Nagy and Brandt followed Benjamin as they eventually undercut the individualist foundation of aesthetics and robbed art of its conceptual and institutional autonomy. No longer anchored in the private sphere or the bourgeois interior, art and literature were "absorbed by the masses" and subsequently redefined as forms of social production, with the artist and author as producers. When Walter Benjamin in the last sentence of his essay on the work of art calls for the politicization of art, it was a process of this kind that he probably had in mind.

37. DEMOCRACY'S VEIL

The problem of the masses turns out to be a veil hiding the problem of democracy. This is to say, then, that my investigation of the interwar discourse on masses has now reached a different level, at which the object of the discourse disappears into the historical landscape, and all we encounter are numberless ordinary people of various kinds. In the late 1970s, Jean Baudrillard called them silent majorities, though they could not be called silent in the rebellious 1920s. Siegfried Kracauer called them "those who wait" ("*Die Wartenden*").[75] What were they waiting for? To file their "legitimate claim to being reproduced," as Benjamin argued? To become recognized as human beings, rights-bearing political agents, and citizens? To see themselves truthfully reflected in the representations of people and community offered by the politicians?

In the preface to this book I mentioned Kracauer's contention that Weimar imagination was caught by a false dilemma. Political debate was set up as a choice between tyranny and anarchy. The dominant discourse on the masses in interwar culture reflected this dilemma, and most ideas, theories, and images of the masses served to amplify the fear that the population in general and the lower classes in particular were a dangerous force that had to

be confined and controlled by some unyielding authority. Tragically, the political and business elites of Weimar ended up resolving the weaknesses of the newly instituted democratic republic by abolishing democracy, opting instead for fascist authoritarianism. The promise of fair and equal representation to all stayed unfulfilled, largely because Germany's elites abhorred the prospect of letting everybody into the political and cultural arena. In their view, that prospect amounted to the tyranny of the majority, as Tocqueville once called it, or what the Spanish philosopher Ortega y Gasset termed the rebellion of the masses or, again, what Joseph Goebbels derided as "asphalt democracy."

As we have seen, though, a number of intellectuals argued that the discourse about the masses, rather than denoting anarchic forces and instinctual depths, addressed fundamental issues at the heart of any democratic politics: how to make a people speak, how to organize, exhibit, promote, and represent the social whole? Trying to resolve this problem, Walter Benjamin ended up outlining the fundamentals of a democratic cultural politics, while at the same time examining the possibilities enabled by emerging media technology for new modes of political participation and collective representation. In Benjamin's writings, we see before us how the discourse on the masses was transformed into something that had little resemblance to its antecedents. He historicized the backward-looking fear of the masses that had dominated European imagination ever since the early French nineteenth century. He explained that the masses were a result of the capitalist system of commodity production. He also prophesized that they would soon emerge in a completely different shape—a people awakening to their task of bringing the system of exploitation to an end—and would achieve this by gearing all the technological forces of production toward the common good. Benjamin himself envisioned a public sphere in which people would finally recognize themselves as self-conscious producers of history. If the masses had once symbolized the destruction of civilization, Benjamin plotted how they could transform themselves into superior forms of collective life. Having once been discussed as an omen of metaphysical doom, they now posed the more quotidian question as to how to organize arts and culture in a democratic society.

Throughout this book I have been suggesting that the idea and image of the masses in interwar Europe is most adequately interpreted as actualizing the crucial problem of representation. The thinkers that developed the theories of mass psychology and mass sociology had a different understanding of their project, as do present-day social psychologists toiling with their

conceptual tools. According to them, mass psychology remains a quasi-universal theory about the emotional substance of collective life, and mass sociology is a theory about explaining and directing collective life. The point, however, is to rethink the problem posed by the masses according to the following formula: wherever masses are, there is also a crisis of representation.

With Benjamin's concern for everybody's "legitimate claim to being reproduced," we finally start to see how the discourse on the masses, once it is viewed not from the perspective of the elite, the sociologists, or the armchair thinker but from the perspective of producing artists and so-called new mass media, slowly turns out to be a discourse precisely about aesthetic and political representation. To speak of the masses in interwar Europe was to take a stand as to the legitimacy or illegitimacy of *everybody's* claim to being reproduced. Recognition of that claim implied the masses' ability to become self-conscious political and aesthetic subjects. Rejection, by contrast, implied that some people were masses and had to remain so.

38. THE FACE OF THE MASSES

"Power struggle has entered new forms," Ernst Jünger wrote in his introduction to a book of photographs published in 1933 by Edmund Schultz. Through an impressive selection of thematically arranged photographs accompanied by striking captions, Schultz groped for the zeitgeist. "The transformed world: a picture album of our time," he called the book (*Die veränderte Welt: Eine Bilderfibel unserer Zeit*). Why was the world transformed? Because photography and mass media provided a new matrix to which politics and society now had to adapt. And politics, according to Jünger's introduction, was always about power struggle.[76]

Or as one caption in the book announced: "Intensification of optical and acoustic means provides the political will with unexpected possibilities."[77] Underlying the statement was a conviction that current realities would soon be outdone by new "means." Jünger argued that the advent of photography made a certain kind of politics obsolete. "Today, a reasonable objection against a politician is that he looks ugly on photo."[78] He also implied that the parliamentary system was outdated because its reality could not be captured in a snapshot or because extended negotiations in the house's subcommittees made for boring cinema.

Photographic media favored a different set of political forms. The pictures chosen by Jünger and Schultz left no room for doubt as to the kind of politics that harmonized best with optical and acoustic innovations. The captions, too, were unequivocal. One of them stated: "Disarmament? What the prophets of liberalism have not predicted: the voluntary entry into uniform." This caption referred to two images, one featuring a "workers' parade in Moscow," the other one showing SA-militia hailing the swastika (figure 4.4).[79]

Such were the new forms of mass power nourished by mass media. For Jünger and Schultz, there was an obvious relation between the media through which society was visually represented and the forms in which society was politically organized. Insofar as photography was a mass medium, it was also a medium that prompted the masses to emerge as the visible substance of society. According to Jünger, the camera reveals that history has already left individuality behind, and what emerges instead are new human types that have put on the masks of various kinds of masses. Their subjective action and facial and bodily appearance are wholly subordinated to a larger collective aim and perspective.

Die veränderte Welt is just one among many similar publications describing interwar society as dominated by the masses.[80] As I have suggested, the masses that we encounter in these works should be seen as fantasms or allegories expressing the difficulty of a coherent representation—scholarly, theoretical, political, narrative, visual, or other—of society in a situation of disintegration and conflict. Jünger and Schultz's book is instructive precisely because it suggests how this difficulty could be resolved in two opposing ways, each corresponding to a certain social image or metaphor. In the case of Jünger and Schultz, the metaphor in question is simply "the face of the mass," indicating that the mass appears as an object in the field of vision of someone perceiving it from a distance, which corresponds to what Theodor Geiger called the "optical mass." In other texts or works of art, equally preoccupied with the masses, a different idea prevails, according to which the masses are endowed with a perceptual apparatus and subjectivity of its own, which was sometimes metaphorically expressed as the masses having vision, eye, and gaze.

One section of Jünger and Schultz's album is thus entitled "The changing face of the mass [*Das Veränderte Gesicht der Masse*]." Photos display marching masses and working masses, masses in combat, in the factory, and on the beach, as well as sporting, playing, mourning, and parading masses (figure 4.5).[81] In short, they show different types of human mass formations,

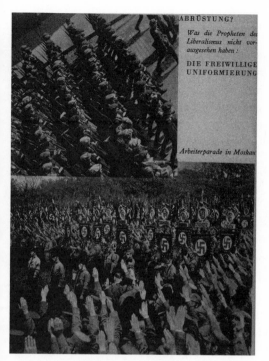

FIGURE 4.4 *(left)* "The Voluntary Entry Into Uniform." Page from Edmund Schultz and Ernst Jünger, *Die veränderte Welt: Eine Bilderfibel unserer Zeit*, 1933. *Source:* Copyright 1933: Wilhelm Gottl. Korn Verlag, Breslau. Unidentified photographer. Photo: David Torell.

FIGURE 4.5 *(below)*Mourning masses and celebrating masses. Pages from Edmund Schultz and Ernst Jünger, *Die veränderte Welt: Eine Bilderfibel unserer Zeit*, 1933. *Source:* Copyright 1933: Wilhelm Gottl. Korn Verlag, Breslau. Photo: Stefan Jonsson.

each with its own pattern of appearance, its own facial traits. But the images also reveal how the camera is here far from a neutral medium and rather an active force in front of which people form themselves into new designs. What Kracauer called the mass ornament comes across as a product of the camera and related regimes of specular manipulation and expansion. Describing the relation between the camera and the crowd in the interwar period, Jeffrey Schnapp shows how illustrated mass media excelled in so-called mass panoramas. The photographer's angle choreographed the crowd and made it fit "the frame, the grid, the geometry of the page, the edit and cut. Politically disciplined by the leader, the crowd [was] pictorially disciplined through photomontage."[82] The point was often to render the crowd as an oceanic force of nature, yet one that was dammed and controlled, and for this purpose traces of individuality and internal difference were erased. Through the distant camera lens, individual faces vanished, and the bodies of those now faceless individuals merged into a new composite face.

That the mass had a face and that that face changed as you moved from marching columns of soldiers, to workers lined up along the conveyor belt, to the passersby on Kurfürstendamm, or to spectators in a sports arena was a discovery of the 1920s. The faces of the masses seen in Jünger and Schultz's collection vary from the amorphous multitude to the uniformed army. The face of the mass may thus be swarming, anarchic, and uncontrollable. But it may also be obedient and ordered, constituting a social resource prepared to follow any command issued by leaders who are cunning and competent enough to direct them. Two different faces, one firmly unified, the other with fuzzy contours—yet both are observed from, if not constituted by, a point of view far away from the men and women in the crowd. Thus, when Jünger and Schultz point at "the face of the mass," they refer least of all to the faces of the individuals in the mass but rather to the greater collective face in which the face of the single human being is but a small component.

In a previous era, between, say, the French Revolution and World War I, the masses were usually described as faceless and anonymous or as a changeable horde, herd, or swarm. The most characteristic trait of the mass was its very lack of traits. Since the mass was described as a phenomenon produced by common affects, governed by passions and instincts, it was also seen as acting without volition or rationality. For the same reason, it was typically described as passive and reactive, owning no inherent principle of

formation, no firm definition or identity. Jünger and Schultz affirmed the idea that the mass as such lacks form, but at the same time they emphasized that it could be *given* any form. Because of its reactive character, the mass was a perfect object of leadership and visionary guidance. That is to say, the masses attain form, their face is developed, their identity clarified, once they are viewed and organized by some external agent. In speaking of "the changing face of the mass," Jünger and Schultz emphasized that the mass looks different depending on the regime that commands it and the optical means through which it appears.

Two years earlier, Edmund Schultz had published a similar book of documentary photographs. Interestingly, it was called "The face of democracy": *Das Gesicht der Demokratie: Ein Bildwerk zur Geschichte der deutschen Nachkriegszeit.* The villain in Schultz's book is liberalism and the system of parliamentary democracy, that is, the Weimar Republic as a political project. The hero is the German spirit, embodied above all by the so-called *Kampfbünde*, militias and paramilitary groups operating in uniform at the fringes of legality and organizing an extensive part of the nonunionized male population. A long introductory essay, this one written by Ernst Jünger's younger brother Friedrich Georg, describes Weimar as an interregnum, a time of "*Kaiserlosigkeit.*"[83] Parliamentary democracy had resulted only in anarchy, Jünger claims. He and Schultz instead promote what they call "directed democracy," by which they understand a form of quasi-mystical sovereignty invested in the nation and its leader or, in German: *Führerdemokratie.* In their view, the face of democracy is of two kinds. The first entails the politicization of the masses and the organization of the people into parties and voters, which is said to have weakened the state and the nation in Germany. The second one is *Führerdemokratie*, that is, the unmediated transubstantiation of nation and people into the authority of the state. Photos of chaotic crowd scenes and portraits of individual "betrayers" symbolize the first face of democracy, according to Jünger and Schultz. Photos of armed militiamen in columns—groups called *Stahlheim*, *Wehrwolf*, and *Reichsflagge*—show the second face of democracy.[84]

It may seem strange that Schultz and the Jüngers, devoting so many pictures and pages to the "face of the masses" and "the face of democracy," never once asked whether this face also had eyes to see with. Considering that all three endorsed a fascist worldview, however, it is hardly surprising. Those who trusted the mass to have perceptual capacities of its own were

usually artists and intellectuals accustomed to viewing society from a point of view level with the asphalt. They recognized that the mass had vision and gaze. Consequently, the mass was able to assume its own perspective on the world and to judge and act as a political subject.

To look at the face of the mass—or to assume the gaze of the mass? These are merely metaphors that simplify the issue. Yet if one were to unpack the contents of these metaphors, one would also get a measure of the stakes involved in the struggle for a fitting political and aesthetic representation of Weimar's culture of crowds. To clarify the difference between the two metaphors is to identify the extreme poles between which the discourse of the masses was suspended. Between these options, indeed, the drama of the Weimar Republic played itself out.

39. LEARNING TO HOLD A CAMERA

Can we picture a seeing collective? A mass equipped with optical gaze, perhaps even a complete apparatus of perception? A vast laboratory for aesthetic and ideological experiments, the Weimar Republic also fabricated complex designs of the perceptual machinery of the collective. Two historical conditions were necessary for this idea to emerge. The first had to do with the process of production and the division of labor: the factory system had taught people how to organize many individuals according to a common logic so that they all contributed to the same end. The second had to do with the new media situation, which made it possible to produce messages and images on a mass scale and to disseminate them to a mass audience whose members received and experienced them simultaneously. The first is a case of collective production of material things, the second a case of collective reception of signs and images.

If these two processes were connected, the outcome would be a comprehensive process of social representation, as envisioned by those who acknowledged that the masses had their own perspective and perceptual apparatus. The result, that is, would be a process in which the collective was author of the media and its contents and at the same time its recipient or addressee. In this process we encounter a collective representing itself in a form adapted to its own senses. Whatever the medium employed, it would be configured so as to record and transmit the contents perceived by the

gaze of the masses and to do this in such a way that the masses would apprehend these contents as a truthful representation of their situation. Or, more simply put: society represents itself to itself.

It is therefore appropriate to conclude this chapter by examining two cultural projects that demonstrate in almost graphic fashion how the masses and the anxiety they evoked relate to the problem of representing society. The first one is the magazine *Der Arbeiter-Fotograf*, which beginning in 1926 sought to train workers in photography by teaching them to reproduce and represent themselves and their milieu in accord with their own senses. The second one is Erwin Piscator and Walter Gropius's project for what they called the Total Theater, launched in 1927. Recognizing that the masses were the great issue of interwar culture, both these projects posited *self-representation* as a solution. Their aesthetic elaborations also reveal the blind spots in the sociological and philosophical discourse on the mass and the ambiguity of the young republic's system of political representation. What these examples disclose, in other words, are the narrow limits within which Weimar's democratic project was confined. By expanding or even exploding the aesthetic arena, *Der Arbeiter-Fotograf* and Piscator and Gropius's *Totaltheater* momentarily transgressed these limits, showing what a less restricted form of democratic representation would intend.

How did the masses get eyes, and what could be meant by such a proposition? A key person in this context was Willi Münzenberg, the greatest media genius of the German labor movement, and perhaps in all Weimar Germany. In 1924, Münzenberg founded a weekly magazine, *Arbeiter-Illustrierte Zeitung* (AIZ). It aimed to break the indoctrination of the labor movement by the bourgeois press. Like all popular media of the period, AIZ featured the photographic image, which was believed to possess unique and advantageous properties for instruction and propaganda, all the more so if one wanted to reach an audience with poor education and literacy. AIZ encountered serious problems, however. The editors had to rely on existing commercial photo agencies. The photographs provided by these agencies rarely touched upon the realities of working-class life that AIZ sought to cover. There was also the risk that agencies would boycott or refuse to do business with AIZ as the workers' magazine deprived commercial magazines of a segment of the market. AIZ was a successful project—at the end of the 1920s its circulation surpassed half a million—and a serious challenger of the hegemony of the bourgeois illustrated press.

The solution to these problems, Münzenberg gathered, was to create a pool of photographers supplying the magazine with the pictures it needed. In March 1926 AIZ arranged a competition among its readers for the best photographic depictions of working-class life:

The illustrated magazine is the paper of the future . . . today the biggest bourgeois publishers announce that in a few months time there will be no German newspapers without illustrations, that the illustrated papers will soon achieve the circulation of existing dailies. A whole organization of press agencies for photographers has already appeared. Just as the capitalist news agencies shower the dailies with tendentious news about the world, so the bourgeois press photographic agencies create a wealth of pictures to influence the masses with capitalist and bourgeois viewpoints. Pictures from the life of the proletariat are unknown and aren't produced. . . . This gap has to be filled. The workers have to keep abreast of new developments. The big expansion of the *Arbeiter-Illustrierte Zeitung* shows the importance of reporting political, social and cultural life with text *and* pictures. But we openly admit that the *AIZ* has not always been able to achieve its self-imposed aim, because we found it impossible to obtain the necessary picture material. The Neuer deutscher Verlag [the publishers of *AIZ*] has therefore decided to call upon its readership, the whole of the working population, to help it achieve this aim.[85]

The editors called for five categories of motifs: "1. Photographs typifying the workers' revolutionary movement; 2. Photographs typifying the workers' social conditions; 3. So-called genre-motifs, which provide good insight into all phases of the workers' everyday life; 4. Photographs from work places which clearly reveal the conditions of labor and its environment; 5. Photographs demonstrating modern technology and its ways of functioning; industrial buildings and their construction." AIZ concluded the instructions for its competition: "The task is not easy and not to be underestimated. You must courageously capture the beauty in your own work, as well as the terrifying aspects of social misery."[86]

The response was overwhelming—so much so, in fact, that in the fall of the same year the magazine founded an amateur organization for the

camera-owning part of the working class, Vereinigung der Arbeiter Foto-
grafen Deutschlands, the German Association of Worker Photographers.
Already in January 1927, Münzenberg reported that more than thirty local
associations of worker photographers had been founded throughout Ger-
many, and the initiative had spread to Switzerland, Czechoslovakia, Norway,
and Russia.[87] At its peak in 1931 the German organization counted 2,412
members divided into some 100 local branches. The association launched its
own printed forum, which soon developed into an ambitious magazine in
its own right, with the untiring support of Münzenberg.[88] It is in this maga-
zine, *Der Arbeiter-Fotograf*, that we may follow, issue by issue, how the mass
grows eyes of its own, equipping itself with an apparatus of perception and
photographic recording, which brings into being hitherto unexplored ways
of representing society, as well as representations of social spaces until then
unexplored (figures 4.6 and 4.7). The magazine amounts to no less than a new
aesthetic education of its readers, who start to develop their own aesthetics
of representation in order to transgress the boundaries of the public arena.

The process may be observed on several levels. First, as regarded basic
practical skills, *Der Arbeiter-Fotograf* offered education and advice on the
technique and equipment needed in order to produce photographs. The
association negotiated discounts with camera and film manufacturers for
the benefit of its members, and the magazine provided recommendations
on which cameras to choose: Leica, Foth-Derby, Korelle, Mentor Drei-Vier,
Pupille, or Kolibri?[89] The magazine also gave hands-on counseling on how
to take pictures, develop film, and make copies, as well as on how to repair
damaged negatives, retouch prints, and store developed film. It provided
theoretical learning on the refraction of light waves, the laws of optics, and
the use of chemicals in the dark room. It gave lessons on reproduction
techniques, graphics, and printing (figure 4.8).

On a second level, *Der Arbeiter-Fotograf* provided its readers with a *soci-
ological* inventory, naming the obscured parts of society that the worker-
photographer should approach and capture. Most important were motifs
and topics from the life of the working class for the simple reason that these
realities were absent from the worldview of the bourgeois press, and the
magazine did not fail to mention seemingly trivial topics such as the potato
harvest and the playground. In February 1927, the magazine published har-
rowing photos of slums and shantytowns around the country, all of which
had been sent in by local worker-photographers.[90] Of course, this ambition

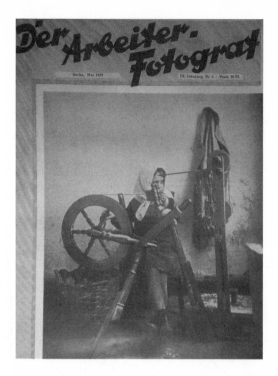

FIGURE 4.6 Unidentified photographer, girl with spinning wheel. Cover of *Der Arbeiter-Fotograf*. May 1929. *Source:* Photo: Stefan Jonsson.

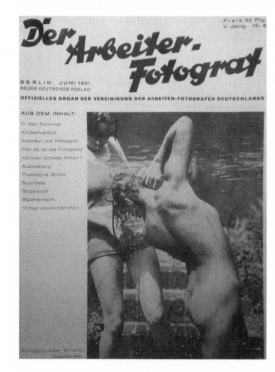

FIGURE 4.7 Unidentified photographer, "A Refreshing Shower." Cover of *Der Arbeiter-Fotograf*. June 1931. *Source:* Photo: Stefan Jonsson.

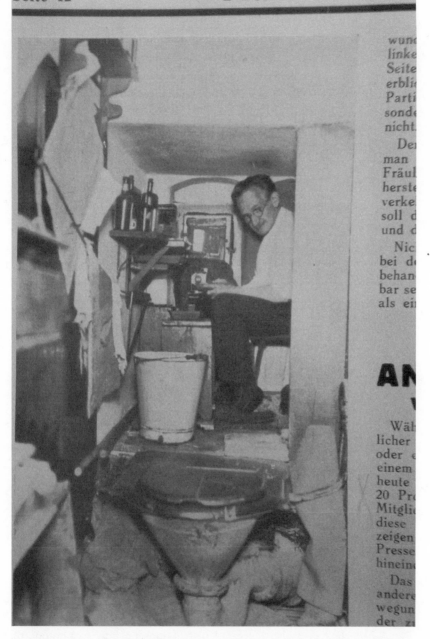

wun<
linke
Seite
erbli<
Parti
sond<
nicht.

De
man
Fräul
herst<
verke
soll d
und d

Nic
bei d<
behan
bar se
als ei

AN
V

Wäl
licher
oder <
einem
heute
20 Pr<
Mitgli<
diese
zeigen
Presse
hinein<
Das
andere
wegun
der z

FIGURE 4.8 Unidentified photographer, proletarian darkroom. Clipping from *Der Arbeiter-Fotograf.* September 1930. *Source:* Photo: Stefan Jonsson.

✓ also demonstrated a *political* tendency: to show the unseen; and to depict what had for long been pushed outside the frame.

Der Arbeiter-Fotograf also contained articles on how proletarian photographers should try to influence politics in a more direct sense, for instance, by documenting police violence and the actions of right-wing militias. "The police must be policed," wrote Walter Nettelbeck in an article that outlined the principles for a new journalism.[91] Nettelbeck explained how worker photographers should establish proper reporter teams and news organizations in order to get out the latest news before anyone else. Such an organization should consist of four groups, he maintained: Group One: a mobile troupe of carefully positioned photographers able to follow a demonstration or some other political event from beginning to end; Group Two: posted on the first floor in houses along the demonstration's itinerary, making sure to occupy windows with a free view onto the street; Group Three: well-trained darkroom personnel; Group Four: bicycle couriers delivering film rolls from photographers to darkroom and developed prints from darkroom to the press. And all this in accordance with the slogan: "You are telling well, only by telling fast!" (figure 4.9).[92]

On yet another level, *Der Arbeiter-Fotograf* also expressed an *ethical* thrust. An intention to humanize the worker by emphasizing his or her righteousness, beauty, and dignity was explicit on almost every page. Finally, the magazine contained an *aesthetic* didactic, most pertinently revealed in gallery sections featuring photographs taken by famous professionals such as László Moholy-Nagy, Tina Modotti, and John Heartfield, and exhibited as so many models to be emulated. Heartfield, it should be added, also did most of the covers for the parent magazine *Arbeiter-Illustrierte Zeitung*. In addition, the magazine included articles on the principles of photomontage and photograms and the relation between photography and painting, thereby seeking to explain how modernist techniques should be "functionally transformed" into weapons in the class struggle while also warning that technical experimentation could divert into futile aestheticism.[93]

A recurring section was called "Picture criticism" (*Bilderkritik*) and consisted of illustrated analyses of good and bad photographs. In this context, *Der Arbeiter-Fotograf* also delivered instructions on how to photograph crowds and mass manifestations so as to avoid reducing the participants to anonymous bodies and swarming ants. The worker-photographers were encouraged to choose the camera angle, distance, and cropping techniques

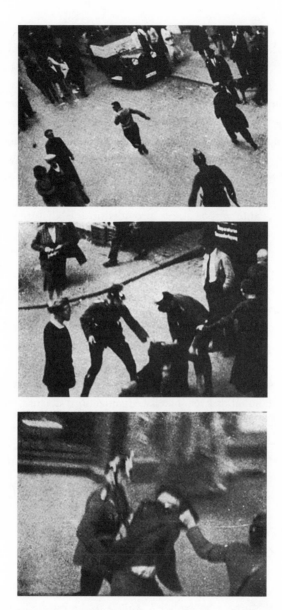

FIGURE 4.9 Unidentified photographer. "Pursued—Beaten—Detained." Page from *Der Arbeiter-Fotograf* documenting police violence against demonstrating workers in Frankfurt am Main. August 1928. *Source:* Photo: David Torell.

that reproduced the event and the protesting people in ways that were true to their own perspective. The photographer, the magazine stated, must attempt to reproduce the very rage and anger of the demonstrating masses, and this could be done either by seeking the panoramic view, in which case the photographer must not look down on the crowd but exalt it, or by capturing its most original or typical groups, symbols, banners, and participants. Of particular importance were photos of police retaliation, "pictures that show the strength and mobilization of the police forces, their heavy weaponry," and even more necessary were photographs demonstrating police brutality, "armed police officers beating unarmed workers or demonstrators," for example.[94] The anonymous advice provided in the "Picture criticism" section usually stressed the importance of finding an angle that revealed the multiplicity of the masses, for instance, by moving close to the crowd and packing the visual plane with faces and bodies in motion. Emphasis was also placed on light conditions and shutter speed; it was important not to represent masses and collectives as a dark block.[95]

A further step was taken in 1931, when *Der Arbeiter-Fotograf* asserted that worker photographers must appropriate the motion picture and start making films. Reasoning along the same lines that Walter Benjamin would later develop in his artwork essay, Karl Tölle emphasized the collective nature of filmmaking, its suitability for socialist organizations of labor, and the necessity to provide alternative worldviews to the one disseminated by bourgeois cinema.[96] Already in 1928 Willi Münzenberg established a separate magazine for the very purpose of promoting proletarian film, *Film und Volk*.

Der Arbeiter-Fotograf thus offered an entire curriculum for amateur photographers: elementary advice on technical issues and optics, a sociology of German society to help find the proper subjects, a call for political commitment, lessons in the ethics of photography, lessons in aesthetic composition of images, and outlines for efficacious photo journalism. "Preserve your old issues of the magazine," the editors exhorted, for they make up "a universal manual in photography."[97]

Crucially, the magazine explicitly sought to depersonalize photography, always emphasizing the collective as author, transmitter, and recipient of the new images of society that it produced. This was done on several levels. Theoretically, the magazine tended to criticize or condemn exhibitions, images, and photographers that exaggerated their individual authorship and originality of vision. The vision that *Der Arbeiter-Fotograf* promoted strove for

universality and generality, for a worldview that could be recognized by an entire class, and it also called for "collective reportage."[98] According to this aesthetic, the worker-photographer was only secondarily an individual. Primarily, he or she was part of a production team, communicating what was true for a larger group. In practical terms, this tendency was manifested in the magazine's policy of anonymizing the photographs it published, replacing the photographer's name with his or her initials, or by attributing them to the local branch of which the photographer was a member. Moreover, the magazine invited its readership to transmit and publish critical views and articles of photographs published in former issues, thus inviting the worker-photographers to become critics of one another and of their own trade.[99] The August 1932 issue went one step further as its entire material—articles, pictures, headlines, layout—was collectively edited by the Berlin section of the worker photographers association. In this way, what was displayed in *Der Arbeiter-Fotograf* was related less to specific individuals than to an imagined—and often idealized—collectivity, whose members communicated to one another not as a set of autonomous minds or individual creators but as people sharing one and the same habitus and debating how to truthfully exhibit and represent it.[100] The publishers and editors of the magazine never really ceded their gatekeeping function, of course, but they appear to have striven for the realization of the ideal.

Such were the different steps in what Franz Höllering, editor of *Der Arbeiter-Fotograf*, in 1928 called "the conquest of the machines of observation [*die Eroberung der beobachtenden Maschinen*]" (see figure 4.10). He mentioned that after the destruction of the Justizpalast in Vienna the year before, workers were brought before the courts on the basis of photographic identification. This demonstrated how the bourgeoisie used "the machines of observation" against the working classes and made it all the more important that the proletariat, "creator and champion of the future," learn how to "master the machines," Höllering argued.[101] Once accomplished, this conquest would also yield a new eye, or mode of vision, which no longer observed "the face of the masses" from afar or transformed the working classes into what Theodor Geiger called optical masses but that was an organ of the masses themselves. For the proletarian and the bourgeois have different senses, argued Edwin Hoernle in one of his articles. The world looks different depending on what one's eyes have been trained to perceive, and this training largely corresponds to

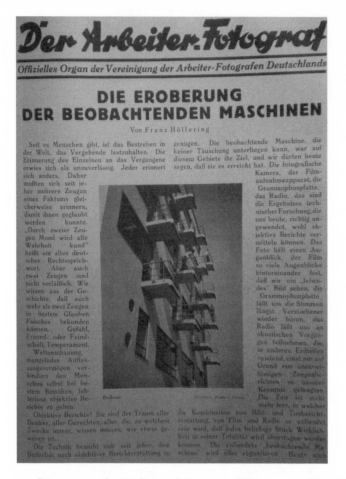

FIGURE 4.10 "Conquering the Machines of Observation." First page of *Der Arbeiter-Fotograf.* June 1928. *Source:* Photo: David Torell.

one's class affiliation. What the one registers sharply is hazy for the other. Hence the importance of technical and organizational apparatuses able to register, enlarge, and disseminate what the worker's eye is able to see.[102] Attaining its own instrument of visual perception, the mass would then cease being a mass and transform itself into a seeing collective. Hoernle exhorted: "We are the eye of our class and we teach our brothers to use their eyes!" (see figure 4.11).[103] This is how *Der Arbeiter-Fotograf* invented a collective vision, a social eye, what Hoernle called a class-eye, and what Moholy-Nagy called a socialism of vision. The result was a new mode of political and aesthetic representation.

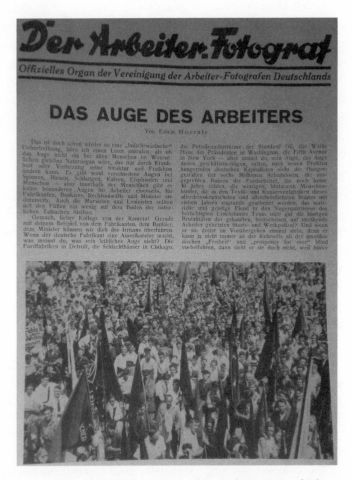

FIGURE 4.11 "The Worker's Eye." First page of *Der Arbeiter-Fotograf.* July 1930. *Source:*
Photo: David Torell.

The history of *Der Arbeiter-Fotograf* has usually been told as the con-
tributions the magazine made to the development of early documen-
tary aesthetics or as part of labor history and the emergence of modern
working-class culture in Germany or even as the creation of a proletarian
counterculture and public sphere.[104] However, the implications and legacy
of *Der Arbeiter-Fotograf* go beyond the history of the documentary and the
labor movement. The magazine and its photographic didactics is a concrete
example of the process that Benjamin had in mind when speaking about
the work of art as being absorbed by the masses or when speaking about the
importance of attaining "literacy" in matters of photography.

Why is this so important? Because the magazine contributed to a transformation of what Ernst Jünger had called the forms of the power struggle. Unlike the transformation embraced by Jünger, however, the transformation did in this case emerge from below, from people themselves, who by expanding the field of vision of journalism and culture succeeded in representing those who had been without representation. Indeed, the Employers' Organization of Germany recognized the threat—workers, "sneaking around with cameras," documenting workplaces and police methods, were upsetting status quo—and it asked the state attorney to have the Association of Worker Photographers banned under pretexts of industrial espionage.[105] The police, too, felt threatened, and on several occasions police officers attacked proletarian photographers and destroyed their cameras and footage.[106] *Der Arbeiter-Fotograf*, then, symbolizes the conquest of optical means whereby ordinary people, or those referred to as *the masses*, could participate in the "power struggle." This entailed unexpected possibilities, enabling an act of representation corresponding to what Benjamin had called for: the appearance of the mass gave way to the reality of class.

40. THE GAZE OF THE MASSES

In Weimar culture the border between aesthetics and politics was transgressed in all art forms and literary genres but perhaps no more so than in the performing arts. In the midst of the rolling social and political crises following World War I a young generation of playwrights and directors rejected what they saw on European stages, especially the psychologically oriented naturalist drama with a bourgeois individual as hero. They wanted a new theater that would be able to intervene into the urgent problems of the day, from famine to right-wing violence and from capitalist domination to women's rights, and with that theater they wanted to make a new world. Searching for dramatic forms adequate to the task, they looked back upon what they imagined to have been the situation in ancient Greece, in which the theater was the cultural center of society, an aesthetic prism reflecting communal tensions and concerns. No longer a temple of art separated from society, theater became a social and political arena, representing the social body of the nation, and in that respect as important as the parliament and the press.[107]

In a memoir written in 1949 Béla Balázs recalls radical theater of the early 1930s. The stage: Friedrichstraße. The actors: a handful of anonymous actors from the group Die Ketzer (The Heretics) mixing with the crowd. The play: a young man standing in front of an upscale grocery store suddenly collapses and falls to the ground; another man comes rushing, kneels down, and starts unbuttoning his torn and soiled shirt to help him breathe.

That was all of it, and the rest was improvisation, writes Balázs.[108] As other passersby approached, a crowd soon gathered around the apparent victim, forming a half circle on the sidewalk against the backdrop of the store window stuffed with sausages, cheese, and caviar. "What's the matter with him? What's wrong?" someone asked. "You all know what's the matter," said the man standing on his knees. "Hunger! That's what's the matter. Can't you figure that one out for yourselves?"

It was theater in its crudest form, writes Balázs. Yet in the 1930s depression, theater of this kind was at one with the drama of everyday life. Ignited by the simulated collapse, the Friedrichstraße drama continued from its own momentum as onlookers started debating unemployment, social injustice, economic depression, malnourishment, and the cost of living, at the same time throwing resentful eyes at well-dressed customers entering the luxury foods store. "Of course," one man shouted. "Every day, that hunger. I'm also out of work." If the situation grew tense police would arrive to disperse the assembly and start interrogating people. By that time, however, the actors would already be on their way to another street corner, another temporary stage on which to agitate for social justice.[109]

Street theater was frequent in this period because local and regional authorities issued an increasing number of decrees and prohibitions against cultural events and manifestations said to disturb public order, to which agitation and propaganda, agitprop, groups responded by leaving their more permanent stages and initiating clandestine performances.[110] The drama form itself was not new. Ambulating performances in streets and squares hark back to the origins of theater history in Dionysian festivals or medieval pageants in which the entire population would reenact the foundational moments of their community. Left-wing theater groups renewed the genre during the German revolution in 1918–1919, much inspired by the cultural politics launched by the Communist Party in the Soviet Union. A common source of inspiration were the utopian ideas of the young Richard Wagner's *Die Kunst und die Revolution* (1849) and Romain Rolland's

Théâtre du peuple (1903), which envisioned a revolutionary theater where the entire people would recognize and celebrate its unity.[111] Journalists and cultural workers formed touring companies for agitprop, staging recent political events in order to educate and agitate "the masses." By the late 1920s every town in Germany had its own agitprop companies, organized by an association called Arbeiter-Theater-Bund Deutschlands, loosely linked to Germany's Communist Party and the largest theater organization in Europe outside Russia. Béla Balázs served for some years as the artistic director of its national office and as artistic leader of Die Ketzer.[112] What these performances looked like may be glimpsed in Slatán Dudow and Bertolt Brecht's film *Kuhle Wampe, or Who Owns the World* from 1932. Documentary sections from a communist youth camp outside Berlin show athletic competitions, political songs and speeches, leisurely discussions, and distribution of pamphlets, as well as the agitprop company Das Rote Sprachrohr (The Red Mouthpiece), the members of which are dressed in red and perform on an open-air arena stage with their "Song of the United Red Front": "We are the red mouthpiece / mouthpiece of the masses, that's us." All is combined into a cinematic montage that offers a tour through the young proletarian collective.[113]

The aim was not to disseminate art and culture to the people but to agitate and instruct, wrote Erwin Piscator about the intentions behind his own Proletarian Theater, founded in 1920: "not theater for the proletariat, but proletarian theater."[114] Although Piscator's Proletarisches Theater was short lived, its celebrated performances and the director's subsequent productions—now organized within the framework of the so-called Piscator Collective or Piscator Stage—became points of reference for all attempts to use the stage as a political arena in the interwar period. Piscator's theater became a motor for a series of efforts to rethink and remake the relation of aesthetics and politics, in which many of the best writers and artists of the Weimar Republic got involved, including Béla Balázs, Georg Grosz, Ernst Toller, John Heartfield, and László Moholy-Nagy. Some of them had been active in the Dada movement, which immediately after the war had proclaimed the end of art. For Dadaism, the only art conceivable was one that destroyed the institution of art, now depicted as a realm of dead monuments, hollow idealism, and dangerous delusions. If many soon came to abandon Dada, they did so in order not to proclaim a new and superior aesthetic but to use art as a means to political ends. Piscator's choice was

unambiguous: "What the leadership of the proletarian theater must strive for," he explained, is "simplicity in expression and composition, a clear and unequivocal influence on the audience of workers, subordination of every artistic intention to the revolutionary goal: conscious emphasis on and propagation of the idea of the class struggle."[115] In Piscator's view, theater could achieve this by investigating what he called historical truth, that is, the truth as expounded by Marxist theory. "By witnessing the unfolding of all problems in their larger context and tracing their ultimate effects, the masses will realize the inevitability of the fate that we depict and the only way to overcome it."[116]

In another context, Piscator explained that in its most flourishing moments "theater was always something deeply bound to the community of the people; and today when the broad masses of the people have awakened politically, and when they justifiably demand to fill the form of the state with their own contents, the fate of the theater, if it is not to remain a pretentious occupation of the top five hundred, is for better or for worse tied to the necessities, demands, and sufferings of these masses."[117]

Such a program presented formidable practical tasks. How to use theater to convey a true representation of capitalist society? How to make the masses, or the working classes, see that truth? How to get the working classes to the theater in the first place? Carrying out such ambitions would presuppose a successful method for turning the working classes into the major audience of the theater and also into its main actor. Piscator's ambition was no less than this. "Theater wants the people and must go to the people, and nobody can forbid theater the experiments serving to discover the way that leads to the people."[118]

In agitprop and street theater, this task had been resolved by leaving the theater house to perform in parks, fields, streets, workers' halls, and other places where people gathered. This remained a possibility for political performances throughout the interwar period, but it imposed firm limits. The actors had to make do with simple means, small stages, few rehearsals, and tight budgets. Piscator soon tried other ways of expanding the stage to social and political areas that had received little dramatic attention or none at all. The result was a revolutionary idea of the performing arts—and new functions for dramatists, actors, stage directors, and everyone else involved, including the audience. At its boldest, Piscator's idea manifested itself in his collaboration with Walter Gropius, resulting in their shared vision for

what they called the Total Theater—at once a building and a conception—capable of housing mass audiences of several thousands and adapted to the technology and flexibility demanded by Piscator's aims. What would be placed on stage in this theater, ideally, was society itself.

Piscator's aesthetic had two foundations. The first one should already be clear: he wished to reconnect theater to the life of society, the people, and the proletariat, in other words, to the agent that in Weimar society was called the masses. The second pillar was technology, from moving images to stage lifts and conveyor belts, which Piscator deployed in his productions to create an entirely new multimedia experience. His ideas were based precisely on the two new realities—masses and media technology—that Benjamin some years later would identify as the determinants of modern works of art. By incorporating technology into art, Piscator's theater wanted to liberate technology from its purely instrumental aspects and thus to undermine the two bourgeois notions of technology as progress and art as an autonomous realm separated from society and the tastes of ordinary people. In this attempt to close the gap between aesthetics and society, Piscator emerged as a major exponent of what Peter Bürger has called the historical avant-garde.[119]

The masses were significant in several ways for Piscator's political theater. First, they were the audience that theater should address and influence and in whose interest it should operate. In an important article from 1919 Béla Balázs had outlined the principles for a Marxist dramaturgy, placing great emphasis on theater's ability to further the class consciousness of its audience. Traces of mainstream crowd psychology are evident in Balázs's argument. He valorized theater as a collective experience able to create "a mass-soul, a mass which is not formed from the isolated atoms of heaped-up individuals, but a mass that in its Dionysian enthusiasm really achieves a unified consciousness." Balázs stressed that "the crowd is the soul and the significance of stage plays."[120]

However, even though theater had a hypnotic potential, it must not manipulate the crowd nor speak solely to its emotions. Piscator balanced emotional impact against intellectual clarity in his productions. Enthusiasm or contemplation, emotional release or rational understanding: political theater would have to be a synthesis of both yet always calibrated so as to direct the audience's passions toward rational and radical political action. To Sergei Eisenstein's claim that the idea of film was to shake and electrify

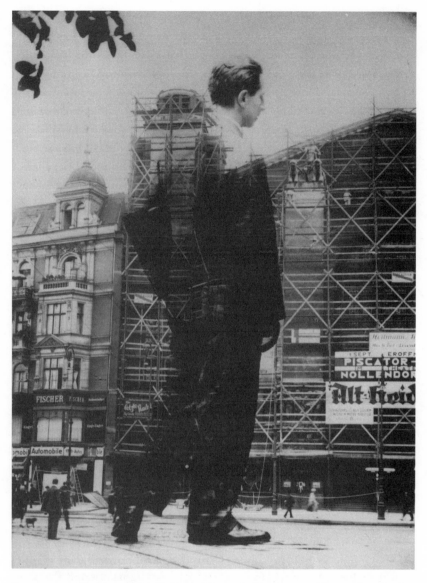

FIGURE 4.12 Photomontage with Erwin Piscator's silhouette superimposed on his theater building at Nollendorf-Platz, Berlin. Unidentified photographer, circa 1926. *Source:* Akademie der Künste, Berlin: Piscator-Sammlung Sign. 4.

the masses, Piscator retorted that boxing matches and horse races would then suffice just as well—"we don't just want to enthuse, we wish to transmit clarity and recognition."[121] An example of Piscator's way of combining fault-less socialist pedagogy with electrifying entertainment was his *Revue Roter Rummel* (1924). All elements of cheap entertainment were present here, and much else as well. The form was borrowed from popular music-hall per-formances. The show consisted of fourteen separate episodes, or "pictures," which featured music, song, slide-projection, action painting, boxing, acro-batics, film, dance, slogans, and statistics. This bewitching mix was loosely arranged around a common theme and framed by a running commentary in the shape of two actors impersonating the views and reactions of the typical bourgeois and proletarian. The enacted *varieté* of events, sketches, songs, and bravura numbers was thus used as a vehicle for addressing the ongoing exploitation of Germany's laboring classes.[122]

Piscator's aim was to transform the audience into a thinking and arguing collective. To this end he constantly downplayed the role of individuality. This applied to the actors, who were advised not to portray individual char-acters but enact collective movements, social groups, and historical tenden-cies. It also applied to the author of the drama, who was asked not to deliver a finished script with detailed stage instructions and not to assert his indi-vidual authority in the interpretation of the drama but to deliver a material to be reworked and adapted by the director in collaboration with the pro-duction team. Finally, it applied to the audience, which was not addressed as a number of isolated people but as parts of a crowd sharing in the same experience and participating in the production of the performance.

Piscator's achievement, and the reason for his lasting fame, was his suc-cessful invention of various ways to represent on stage what may be called the space-time of modernity and capitalism. The objective was to instruct the audience about the order of the world, to help spectators understand their common predicament, and to encourage them to joint action. In order to realize this, Piscator had to introduce into the drama not only the social classes but also the global context that determined their positions. Drama was transformed into a conflict between supra-individual forces, giving concrete theatrical expression to abstract realities such as class struggle, inflation, economic conjuncture, oil production, surplus value, jurispru-dence, and imperial war and demonstrating how these were at the heart of social contradictions and local realities. Piscator here added advanced

technology and mass media to the usual toolkit of dramatic special effects. The acting and dialogue of individual actors were cut down and combined with other dramatic elements into a new performative syntax. Placards and texts were blazoned to comment on the action on stage. Pictorial or photographic documents as well as entire film sequences were projected onto screens and gauzes to provide background or visualize alternative lines of action. Loudspeakers announced messages or transmitted speeches that further elucidated the plot. All this took place on a new, open, and flexible stage. Piscator abandoned not just the curtain wall, separating seats from stage, but removed the three other walls as well, thus allowing the stage to expand horizontally and vertically by way of a complex machinery of lifts and rolling bands, tiered scaffolding with ramps and platforms extending in several dimensions so as to suggest hierarchic and spatial divisions of society (figure 4.13).

This was the *Piscator-Bühne* which enthralled and infuriated Germany's world of theater in the interwar period. A contemporary review of Piscator's 1929 production of Walter Mehring's *Der Kaufmann von Berlin* (The merchant of Berlin), deserves quoting for its remarkable characterization of the dauntless integration of technology and collectivity that transformed Piscator's performances into multimedia spectacles:

FIGURE 4.13 The Piscator Stage. Model with ramps and platforms suggesting hierarchical divisions of society. Unidentified photographer, circa 1925. *Source:* Akademie der Künste, Berlin: Piscator-Center Sign. 635.

Complete series of contemporary news-headlines are thrown by the film onto the familiar gauze-wall . . . the historical moments . . . the incredible sums, marks numbered in billions, flicker like a blizzard over the "fourth wall." . . . Rathenau, Erzberger appear like ghosts out of thin air . . . the antique chorus-form of "mass man" comes photographically, scientifically, objectively to life in this ghost-film of air and newspaper-clippings. . . . "The Street" was never brought onto the stage like this before. Modern mass drama must, by god, indeed be played out in the streets. We take the town bus through the film canyons of apartment buildings. . . . Two treadmills run across the revolving-stage which turns round itself in a different direction. On this the tempo-march of the streets unreels with thousands of paces forwards and backwards, to the right and left. . . . *Space* has its own *role*: Streets are the place of traffic.[123]

Hanns Eisler wrote the music for *Der Kaufmann von Berlin*. Lázsló Moholy-Nagy did the stage design. His sketches for the stage decoration still convey an idea of the sheer complexity of the social imaginary behind Piscator's productions (figure 4.14). In Moholy-Nagy's huge photoplastic montages various collectives emerge into view as from nothingness, moving toward the focal point of the viewer and the center of the historical stage. Not all Berlin's theater audience appreciated Piscator's daring innovations; most were perplexed, some appalled. "Piscator stirs up civil war!" two reviewers complained.[124]

Moholy-Nagy also did the cover for Piscator's book *Das Politische Theater*, published in 1929 and dedicated to "the proletariat of Berlin." The image consists of a photomontage set against red background (figure 4.15). The area in the lower left is covered by a cut-out photograph of a worker's demonstration consisting of innumerable heads and bodies carrying red banners and flags. To the right is a circular structure made up of stairs, arches, and scaffolding, suggesting a perplexing arrangement of constructions and machinery. Moholy-Nagy used photographic images of Piscator's so-called Globus-stage at Berlin's Nollendorfplatz for this montage. The structure evokes the idea of a globe, and the masses emerging from the left seem about to enter into it. Some of them have already occupied the interior of the spheroid space. Piscator constantly stressed the need to level all barriers between audience and theater. In the cover image, Moholy-Nagy pasted

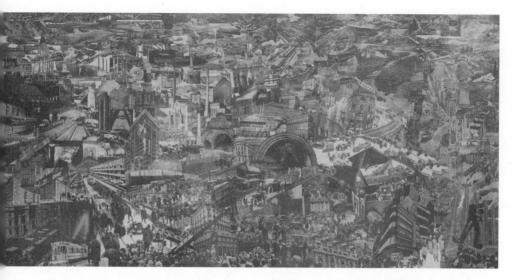

FIGURE 4.14 László Moholy-Nagy, stage design for *Der Kaufmann von Berlin* (The merchant of Berlin), directed by Erwin Piscator, 1929. Gelatin silver, 8.3 x 16.7 cm. *Source:* The J. Paul Getty Museum, Los Angeles. © Estate of László Moholy-Nagy/Artists Rights Society (ARS), New York/BUS Sweden 2012.

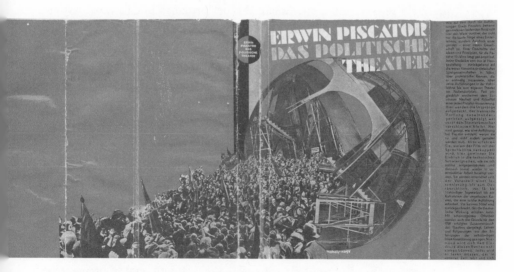

FIGURE 4.15 László Moholy-Nagy, cover for Erwin Piscator's *Das politische Theater*, 1929. *Source:* © László Moholy-Nagy/Artists Rights Society (ARS), New York/BUS Sweden 2012. Photo: David Torell.

the depicted collective to the scaffolds and stairs of the theatrical interior, suggesting that they are both the audience entering the global arena and the workers handling its complicated machinery. It is a congenial rendering of Piscator's conception of theater as a fusion of masses and technology into a new conception of art, where the aesthetic form is inseparable from the self-representation of the people.

41. TOTAL THEATER

Eric Mühsam, veteran of the Bavarian republic, set down the working rules for the Piscator stage in Berlin. He envisioned a thoroughly collective organization at all levels. The theater staff would form a dramaturgical collective, and it was realized along principles of equality, communal responsibility, and companionship.[125] The acting, as already mentioned, would also be executed so as to evoke collective forces and conflicts rather than individual and existential ones. Most importantly, political theater wanted to transform a presumably passive and disengaged audience into an active producing collective. The collective that produced theater would thus be extended to the audience, which was no longer expected to just passively receive and contemplate the performance but to take part in it. Piscator's own documentation shows what such a goal entailed. For instance, he relates the successful opening in July 1925 of *Trotz Alledem!* (In spite of everything!), a historical revue based on events from World War I to the German Revolution, which featured twenty-three historical episodes separated by short films (figure 4.16). The production also included documentary photography, stage decorations by John Heartfield, an arena stage encircled by the audience, a sixty-five-foot battleship representing British imperialism, and reenactments of political speeches by Karl Liebknecht and Rosa Luxemburg.[126] "The dress rehearsal was utter chaos. Two hundred people ran around shouting at one another," writes Piscator. He goes on to render the opening night. Every seat was taken; steps, aisles, entrances were full to bursting:

> The living masses were filled from the outset with wild excitement at being there to watch, and you could feel an incredible, willing receptivity out in the audience that you get only with the proletariat.

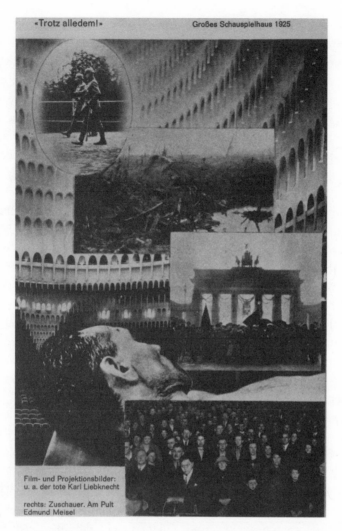

FIGURE 4.16 Erwin Piscator, poster for *Trotz alledem!*, 1925. Akademie der Künste, Berlin. *Source:* Akademie der Künste, Berlin: Piscator-Sammlung Sign. 38.

But this inner willingness quickly turned into active participation: the masses took over the direction. The people who filled the house had for the most part been actively involved in the period, and what we were showing them was in a true sense their own fate, their own tragedy being acted out before their eyes. Theater had become reality, and soon it was not a case of the stage confronting the audience, but one big assembly, one big battlefield, one massive demonstration. It was this unity that proved that evening that political theater could be effective agitation.[127]

Similar impressions have been recorded from other performances. In Piscator's 1929 play about women's reproductive rights—§ 218: Frauen in Not (Paragraph 218: women in despair), written by Carl Credé, and one of the most successful productions of the Piscator Collective—the audience was encouraged to accompany the action with comments, shouts, and speeches. After the end of the performance, the audience was asked to hold a vote on section 218 of the criminal code (establishing the illegality of abortion and sentencing the pregnant woman as well as anyone who assisted in her abortion to a five-year prison term). The vote always resulted in rejection of the law. In this way, the completion of the play would correspond to a public meeting, or an ad hoc tribunal vested with the legitimacy of the popular will, or, in other words, a democratic assembly.[128]

For Piscator, the secret of political theater was not primarily the creation of new acting techniques or dramatic scripts, and in this sense he was partly at odds with Bertolt Brecht's aesthetic. Political theater had to be founded on the integration and proper use of technology, above all, media technology. A new stage and theatrical environment would then bring about new acting techniques, new scripts, and the sought-after involvement of the audience, Piscator argued:

And just as the public has adapted itself to new housing, because it is more appropriate, more spacious, free of dust, more economic, and therefore also more aesthetically beautiful, so it will also adapt itself to modern theater, to a new theater architecture, a new theatrical space, a new stage, and to special effects of that stage: the turning floors, the conveyor belts, the automatic escalators, the mechanical bridges, the functional stage floors, the lighting from underneath, to

film and projections, and to the dissolution of the border between spectator and stage.[129]

According to this optimistic argument, technology would allow the theater to erase the division between audience and actors and allow for public participation en masse, thereby democratizing the theatrical arena. Once the invisible wall was torn down, technology would also be used to project the public into a simulated space of reality and history, a model space in which world-historical forces were rendered present by mediated sounds, signs, and images. Mass media such as photography, cinema, and press typography provided models and material.

Needless to say, existing theater houses could not satisfy Piscator's ambitions. He called for a theater that could house three to four thousand spectators, and the machinery inside should be top of the line. "I imagine something like a theater-machine, as inherently technical as a typewriter, an apparatus that would be equipped with the most modern lightning-systems, with lifts and revolves in vertical and horizontal planes, with a multiplicity of film-projectors, with loudspeaker relays, etc."[130] Seeking to concretize these plans, Piscator in 1927 commissioned Walter Gropius, then director of the Bauhaus school in Dessau, to draw up plans for a theater building adequate to his needs. The plan was referred to as the Total Theater (Das Totaltheater).[131] At once a dramaturgic and an architectural conception, the Total Theater would be completely flexible. Gropius conceived of machinery that made it possible to move the stage into the midst of the seats. The interior could thus be transformed into amphitheater, picture-frame theater, or arena theater, depending on the character of the production. Everything from Aeschylus, Shakespeare, and Molière to Chekhov, Ibsen, Toller, Brecht, and modern documentary drama would thus be performed with equal ease, in addition to circus performances, political meetings, operas, cinema, and sports events.

If agitprop had abandoned the stage and moved out into society, the Total Theater sought to place society as such on stage. In the words of theater historian Stefan Woll, the projected Total Theater of Gropius and Piscator was an idea that perhaps for the first time would realize the role of theater as a constituting power of the social community and the cultural and political consciousness of the people.[132] According to Piscator's definition, Total Theater was "a building that is 'totally' performable, in which the

spectator as the spatial center is surrounded by a 'total' stage and is 'totally' confronted by it. The simultaneity of historical events, the coevalness of social and political action and reaction may be represented simultaneously on this stage, on this stage-totality."[133]

Today, the design of Gropius and Piscator appears as the summa of the radical tendencies and projects that characterized the effort to renew theater as an institution after World War I. More importantly, the project encapsulates one of the more interesting ideas about collective self-representation produced in Weimar culture. Piscator's theater was explicitly built as a house for the masses, in which technology would enable them to gain a true image and idea of their historical and social predicament. In transgressing or erasing the boundary between audience and drama, Piscator urges us to think of theater as encompassing society in its totality.

Gropius and Piscator's project was thus conceived through what Benjamin called the matrix of the masses. It was to be built so as to invent a new form of art based on collectivity rather than individuality. Integrating modern media technology, theater would become a space in which the masses would also absorb the work of art. Stefan Woll emphasizes the collective character of this process, in which the art object is at once dispersed among and embodied by the collective. "Unfolding as a mass phenomenon, the theatrical event of the Total Theater should be turned into an event for the masses, thereby helping to found the reputation of the Total Theater as a genuine mass theater."[134]

It must be asked whether Piscator's project really differed from fascist aesthetics through which Nazism later would allow the German people to enjoy itself in festivals and mass arenas.[135] Is not the Total Theater of Gropius and Piscator a totalitarian theater, with the director-genius operating the controls of his theater machine in order to produce the desirable reactions in the collectives under his command? The difference and similarity between Piscator's aesthetics and fascist experiments in collective representation seems to duplicate the difference and similarity between communism and national socialism as such. However, in contrast to the mass ornament analyzed by Kracauer, or to later mass celebrations staged by Nazism, Piscator's idea of the mass never presumed or sought to achieve an organic harmony and seamless unity of the people. Piscator's ideal remained that of the rowdy democratic assembly, shot through with differences, not unlike the meetings taking place in the workers' councils during the German revolution.

It should also be recalled that his theater was partly tuned to appeal to Berlin's sophisticated theatergoers, who wanted to see the latest marvels of performance art. Often, it drew far more attention from Berlin's segment of middle-class intellectuals than from the working-class population in Wedding and Neukölln. Nowhere in Piscator's productions do we encounter the communion of leader and mass that was a standard feature when fascism was performed. While fascist aesthetics taught the masses to enjoy and draw meaning from their subordination under the leader, thereby transforming them into what Klaus Theweleit calls a "block," or a "molar" mass, Piscator's aesthetics had as its explicit objective to teach the members of a proletarian public to trust their own senses and minds; his masses remained a multiple and "molecular" agent.

Meanwhile, the highly utopian dimension of Piscator's project cannot be overlooked. It embraced the possibility of theater to allow the people to represent themselves and to authenticate that representation as the truth of their historical being. This was a space in which the sociologically divided people, numberless isolated and alienated individuals, were able to experience one another as companions. Theater would thus offer them an experience of community that capitalist society denied them, and this experience would help them not only to survive that denial but also to struggle against it. Underlying this aesthetic is thus a vision that saw in the masses or the proletariat a representative not just of the people in some narrow national sense but of humanity beyond class divisions and any social divides. In Paul Tillich's socialist theology, developed in the same years, the masses were posited as a coming human community embodying an ideal that transcended "the opposition between masses and individuals." In this utopian register, the audience or collective formation for which Gropius and Piscator's theater was planned, answers to the universal agency that Tillich ascribed to Germany's working classes.[136]

Looking at Gropius's drafts for the Total Theater, one realizes that the floor plan of the cross-sectioned building resembles an eye (figures 4.17–20).[137] The seat rows located in the oval form of the building cover the area corresponding to the iris. The lines that mark out how film and sound projections are to be used radiate from periphery to center through the iris. Slightly off center in the oval is a circular form symbolizing the stage and the proscenium, the focal point of action. In Gropius's design it has the appearance of a pupil, an opening through which the world is perceived.

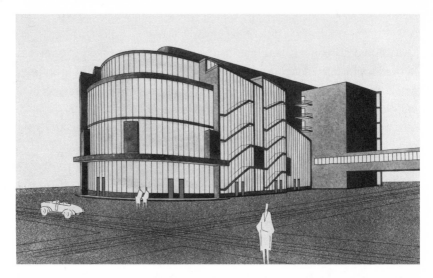

FIGURE 4.17 Walter Gropius, drawing for Erwin Piscator's Total Theater. Panorama with exterior of building. *Source:* Harvard Art Museums/Busch-Reisinger Museum, Gift of Walter Gropius, BRGA.24.100. Photo: Imaging Department © President and Fellows of Harvard College.

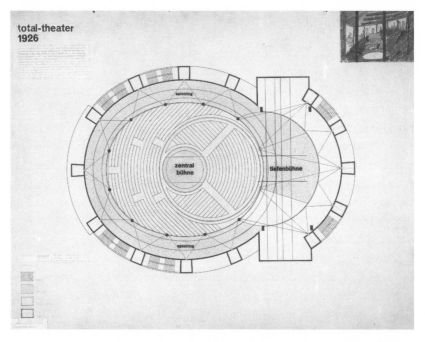

FIGURE 4.18 Walter Gropius, drawing for Erwin Piscator's Total Theater, 1927. Central stage, floor plan, and interior perspective. *Source:* Harvard Art Museums/Busch-Reisinger Museum, Gift of Walter Gropius, BRGA.24.87. Photo: Imaging Department © President and Fellows of Harvard College.

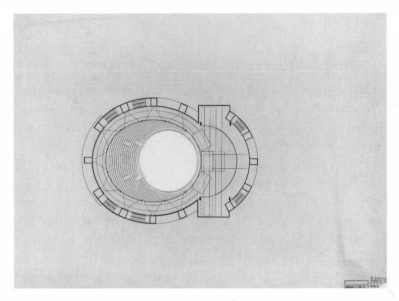

FIGURE 4.19 Floor plan for Erwin Piscator's Total Theater. Unidentified artist, 1927. *Source:* Harvard Art Museums/Busch-Reisinger Museum, Gift of Ise Gropius, BRGA.24.126. Photo: Imaging Department © President and Fellows of Harvard College.

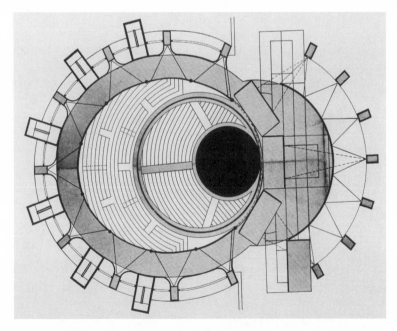

FIGURE 4.20 Walter Gropius, floor plan for Erwin Piscator's Total Theater, 1927. *Source:* Harvard Art Museums/Busch-Reisinger Museum, Gift of Walter Gropius, BRGA.24.72. Photo: Imaging Department © President and Fellows of Harvard College.

Just as the human eye is elastic, giving the pupil horizontal and vertical movement, so would the stage of the Total Theater be able to turn and move in order to place itself either in the front of the seating area or in its midst. The architecture of the theatrical space would adjust to the environment and adapt its senses to the emotional atmosphere of the audience and the forms and contents of the play.

Total Theater thus becomes an eye through which the audience perceives society. Perhaps, this is also how Piscator envisioned the aim of political theater: to help the public acquire an additional eye through which the collective could perceive what was invisible to each one individually: the relations structuring their economy, their society, and their life. In this way, the Total Theater becomes a social eye, an aesthetic vision that can be attributed only to the collective. The allegedly blind fools of the masses have finally got organs to see with, and society is able to glimpse a representation of its own being: the unfathomable forms of the collective.

5

Coda: Remnants of Weimar

This book has engaged critically with the idea and image of the masses in interwar European culture. Germany and Austria have been in the focus. For historical reasons the discourse on the masses in these two countries was more intense and contentious than in other intellectual milieus. However, comparable images and theories of the masses, as well as derivatives of the German discourse, circulated everywhere from Scandinavia to the Iberian Peninsula and throughout the world.

It should be clear that the mass was a dominant theme in the culture of the Weimar Republic and Austria's first republic, or even an intellectual and political obsession. My coverage of this theme is far from complete. Other intellectual projects and aesthetic works deserve to be analyzed from the point of view that I have applied, and I think that would strengthen the general conclusion: the mass was an organizing signifier for German thought, arts, and culture in the interwar period.

My argument is that this signifier, the mass, ultimately refers to crises of political, cultural, and aesthetic representation. Following Hannah Arendt, we may see the masses as the numberless people who lacked political voice and representation. However, the masses may also be seen as an issue that reveals the very uncertainty as to how to represent the nation and the people in the first place, and which thus indicates political contingency in pure form. In this sense, "the mass" does not, strictly speaking, designate anything or anybody; rather, masses are produced, through acts of representation, as the excluded part in relation to which a "people," "culture," or "nation" is enabled to identify itself as a community. This also explains why masses are located at the very limit of the polis, the outlying area of culture, and the hazy horizon of sociological scholarship. They are the periphery that determines the location of the center.

But if this is the right way to theorize the category of the mass, it implies that it must always be historicized. In the Weimar period there was no consensus as to who held the right to speak in the name of the German nation. There was minimal agreement on the principle of democracy but not on how to realize that principle, and there was an increasing sense that the Weimar constitution and the parliamentary system were illegitimate. Deep discord concerning the right definition of the sovereign people and its legitimate representation explains why the mass was such a useful term in this period. First, and most commonly, the term was a negative designation of people *not* meeting required criteria. Through strategies of reversal employed by left-wing forces, it could also be used as a signifier for the "real" people, unjustly excluded, in whose name a new politics and culture must speak. In both cases, the mass was a signifier referring to the precarious institution of democracy in interwar Germany and Austria. In a third modus, the mass also referred to the sheer indeterminacy and fluidity of the social sphere, about which so many interwar Germans and Austrians testify. Here, each human being was potentially a man and woman in the crowd, or an atom in a mass. Unable to represent herself through any stable identity or place of belonging, the human subject was thrown into a society demanding mobility as well as duplicity. Intellectuals such as Brecht, Kracauer, and Musil magnified this understanding of the mass, diagnosing the experience of modernity as an experience of radical contingency, without any firm ways of representing either the collective or the individual.

One specific conclusion to be drawn from this investigation is that the mass was a term with multiple meanings, yet all of them related to, and energized by, the impossibility of providing society with a coherent representation. In the first chapter we saw how one single event—habitually described as a mass event—was given three different interpretations. Heimito von Doderer assumed the position of the detached individual looking at the demonstration from a distance, seeing only irrational violence and colored dots, and interpreting it as an outburst of collective madness. Elias Canetti took part in the demonstration and used it as departure for a new theory of the collective life of humanity, which, ultimately, presupposed a radical distance from the mass but at the same time recognized that the mass represents an instinct and a need within each human being. Karl Kraus, for his part, identified himself with the perspective of the demonstrators, gathering the accounts of persons who had been witnesses to it, after which he concluded that the mass was a fabrication made by those that claimed to speak in the name of Austria and who needed to justify their position by violently marginalizing the protesting people as irrational elements.

One event? One mass? Maybe. But in that case a mass with multiple intentions, faces, and voices, impossible to unify into a single whole except from a position of distance and isolation. In order to analyze the mass historically, a radical perspectivism is therefore called for. This mode of analysis should try to occupy as many vantage points as possible, ideally as many as the number of minds and bodies involved in the event or movement under examination.

German artists and intellectuals drew the aesthetic and epistemological consequences of this by developing the art of the montage, discarding linear narratives and organic visual compositions. I have embraced a similar standpoint in this book not just through its disposition, in which the argument progresses by way of separate examples and analyses that fall into a larger theoretical and historical pattern. Above all, this perspectivism is detectable in the larger movement of my narrative, in which I have tried to portray the masses first as a remote object, and toward the end as something very near, at which point they eventually dissolve into the plural perceptual apparatus of, say, worker photographers and revolving theater stages.

An epistemological choice is involved in this movement from distance to proximity, from looking at the face of the mass to assuming the gaze of the masses. One's explanation of mass behavior will largely depend on where

the stress is put. Needless to say, the choice involved is also a political one. On the one hand we may claim the right to speak on behalf of others who are distant from our own position and at the margins of our life world. On the other hand, we may enter the crowd and perceive the world from the same perspective and with the same senses as the people around.

A second conclusion may also be drawn. If "the mass" is a term with multiple meanings, why accept the strong tendency in scholarship to confine the historical analysis of the issue of the masses to the fields of fascism, mass psychology, and popular culture, those three being the areas to which debates on the masses are usually related? The mass was a term of global significance in interwar Europe, and with a particular intensity in Germany and Austria. Precisely through its global significance and its open reference to crises of political and aesthetic representation, this term may help us map the interrelationships among all the various cultural forces, aesthetic experiments, and political projects that emerged in the interwar period. This approach also allows us to see the political and aesthetic expressions of the Weimar period as so many symptoms of the failed attempt to institute democracy. It is often said that Weimar culture witnessed the explosion of mass media and that this had profound consequences as fascism took advantage of film, radio, and print. What remains to be realized, however, is that the masses as such—fluid, mobile, and mutable—were the very media in which all central political questions were posed.

"The masses" was thus the perpetually circulated and ultimately empty signifier that absorbed all political, cultural, and aesthetic energies unleashed by the crisis of representation in Germany and Austria. Despite its unreality, this phantom points us toward an essential trait of European society and culture between the wars. I have repeatedly stated that Weimar Germany and Austria's first republic were societies with weak political institutions. The lack of legitimacy that restricted the operation of their parliamentary systems is indicative of unresolved problems of political representation, which led both countries to the brink of revolution and civil war. As in all situations where political institutions have weak support, political discourse was split and operated on two levels. Chief of state, government, and national and regional assemblies, as well as civil servants, technocrats, and functionaries, managed the political discourse in the strict sense. But this discourse was swayed by a far stronger one of political distrust and cultural malaise that sprang from a sense of precariousness or imminent danger

among large sections of the population, which doubted that they were justly represented by the existing political setup.

I have stated that "the masses" were a symptom of this crisis of representation. This statement may now be qualified as implying that the idea or specter of "the masses" sprang up from the gap between the existing parliamentary system and the vast horizon of expectations for some more complete and dignified way of representing the social passions of the people. On this horizon, which featured a range of contradictory ideological interpretations of what German or Austrian society and history were about, the masses were continuously reproduced as a sign for fundamental problems that official politics had left unresolved. Depending on the speaker's worldview, this horizon portended either doom or rejuvenation, and the masses entered now as a hero, a stand-in for people being unjustly excluded, now as a villain, a name for everybody that threatened to raze social orders and cultural hierarchies.

Situated in and nourishing itself from the gap between official politics and expectations for more satisfactory representations of people and nation, the masses would shuttle between two contexts or frames of reference. They could be described as a real political force, that is, as ordinary men and women engaged in extraparliamentary demonstrations and manifestations and articulating themselves in party politics. In a different frame, they could be described as an allegory for everything and everyone that threatened the ideals on which political and cultural life was based. The masses were thus articulated and could articulate themselves not just in proper political discourse and action but in a variety of discursive registers and genres, ranging from interpellations in parliament to photography, caricature, cinema, dance performances, architectural projects, novels, and philosophical treatises. By activating ideas and fantasies of the masses, by inventing crowd symbols and crowd ornaments, by promoting mass theater and mass housing, or by warning against mass insanity, mass hysteria, mass psychosis, and the coming age of the masses, all exponents of cultural and intellectual life engaged in the overriding political problem of their period: to provide people and nation with new narratives, images, ideas, and forms in which they would recognize their historical being. This accounts for the profoundly political character of Weimar arts and literature. Because of the instability of the system of political representation, other areas of intellectual and cultural life rallied to its support, or contributed to its collapse,

by narrating, visualizing, depicting, organizing, and forming the social and political body of the people, thereby also throwing the limits of existing cultural orders and systems of representation into relief.

Thus, if the masses were a symptom of a crisis, they were also a figure for a shared concern. As an organizing term for so many cultural, intellectual, and aesthetic endeavors of the period, the masses may be seen as a secret code helping us to link seemingly unrelated social, political, ideological, artistic, scholarly, and cultural discourses, thus allowing us to diagnose the common fracture within them. Which fracture? The fracture of breakdown and defeat that generated restless searches for new forms and concepts, as well as reactionary reactivations of old ones, in the hope of reconstituting society under conditions of modernity.

There is nothing in this conclusion to support the often made claim that the interwar period's compulsive management of the masses indicated some sort of cultural deficiency or political imperfection that predestined the young republics of Germany and Austria for failures to which fascism was the only possible answer. On the contrary, if the "mass" signified many different and contradictory meanings, this should be read as an indication of political danger and instability, to be sure, but also of possibility and vitality or, put differently, of a situation that postwar Europe soon learned to forget but that may again become recognizable to us in the 2010s, which some have already dubbed a new era of crowds. For if German and Austrian culture between revolution and fascism attributed multiple meanings to the masses, this is because these societies contained political agents envisioning multiple and mutually excluding ways to represent society. Each of these proposals for representing society and the people entailed an answer to the democratic problem, and these different answers constituted or envisioned alternative political and societal futures for the polity. These future horizons were eventually closed by fascism's victory, which soon obliterated what these societies once knew as alternative paths and prospects. To revisit the multiplicity of the meaning of the masses in this period is thus also to learn of the multiple futures contained in its *Jetztzeit*, or present moment. It is to affirm Rüdiger Graf's position that, for the Weimar Republic, "the future was an open horizon of possibilities," which in turn echoes that of Peter Fritzsche: "A great deal of the political dynamic in the 1920s is obscured by the telos of Weimar's collapse."[1] One thing to retain from this book's numerous observations and analyses of the idea and image of the masses is that

far from all of them contributed to or portended Weimar's fall and the rise of fascism. Against the conventional wisdom codified by Hannah Arendt—that the "masses" emerging into the public sphere after World War I were the formal and material cause of totalitarian systems of rule—we may thus conclude that these "masses" were never anything more, and at the same time never anything less, than signs and symptoms of unresolved problems concerning the adequate political, cultural, and aesthetic representations of the socially significant passions and political desires in the public sphere. Moreover, in order to retain some sense of historical proportion in face of Hannah Arendt's influential assessment, it is prudent to add the conclusion of Weimar historian Heinrich August Winkler. Weimar's political failure had nothing to do with "the masses"; on the contrary, people lumped together under that designation often rose to defend democracy against assaults from the old elites, Winkler states. The reason for totalitarianism's swift takeover in Germany was rather that the republic's bourgeoisie lacked both democratic convictions and solidly democratic parties.[2]

Arguably, this is what the masses were about in interwar Europe as they emerged from the rift between a parliamentary system that betrayed democracy and millennial expectations of more adequate forms of governance. They were a ghost that animated the imaginary struggle between authority and anarchy—and they were the signifier that drew politics, arts, and culture together around a single nexus. Such an understanding of the masses offers a dialectical explanation of the catastrophic and destructive aspects of this society—as its leadership opted for approved authoritarianism, which then ushered in Nazi dictatorship—and also of its immense resources of invention and creativity, as artists and intellectuals tried new answers to the problem of the political constitution of society and the identity of the people. To disentangle the variegated discourses on the masses between the wars is thus to revisit the original problem of democracy.

Needless to say, this problem is as pertinent today as it was then. What is perhaps less clear in our postcontemporary situation is that aesthetics—the art of giving form, voice, and visibility to human and social experience—remains founded on the very same problem. Perhaps we are then able to finally determine more exactly the location of the masses in the cultural terrain of Germany and Austria between the wars. I have stated that they sprang from a gap between the existing system of parliamentary democracy and the horizon of alternative expectations for some more complete way of

representing the passions and interests of the people. More precisely, this means that the masses were generated by the friction between politics and aesthetics, and it shows what the two have in common as both seek to form the constituting power of the human community, that is, to determine the modes of appearance, visibility, and representation under which social life is conducted.

German and Austrian interwar culture offers many instances of that location, and previous chapters have explored some of them. But there is one image that gives a better idea than any other. In early March 1933, Siegfried Kracauer told readers of *Frankfurter Zeitung* what he had seen in the faces staring at the burned-out Reichstag in Berlin. On February 27, this symbol of Weimar democracy had been destroyed in a chain of events out of which Hitler emerged as victor. In his article, Kracauer remarked that in moments of public danger or sudden catastrophes people tend to gather to discuss what should be done. But the atmosphere he had felt outside the Reichstag had been different. The masses arriving to see the destroyed building were stunned silent. Kracauer conveyed the idea that the burning of the Reichstag had muted the voices of the people. What was destroyed, he stated, was the very hope for an order that would represent the people in a way they would acknowledge as their own. Where that hope once was, there was now a void, which was reflected in the paralysis of the onlookers as well as in the gaping window openings of the evacuated building. The demolished Reichstag owned a magic power found only at sites that have suffered sacrilege, said Kracauer, and he went on by stating that the eyes watching the building were endowed with an infernal intensity that burned "right through this symbol and disappear[ed] into the abyss that its destruction [had] opened up." As for the young people looking at the ruin, they would now spend the rest of their lives finding out the meaning and consequences of this void, which they could not yet understand.[3]

The gutted Reichstag of course recalls Vienna's destroyed Justizpalast and the collapsed city halls in Hermann Broch's *Sleepwalkers*. Ruins of democracy? Remnants of political violence? Results of failed efforts to redraw the boundaries of the political? The issue of the masses encapsulates this drama, which is brought to a close by the image of the burning Reichstag. Looking at the void left after the collapse of Weimar's experiment in democracy, the gathered public also witnessed the end of the history of the masses as I have addressed it in this book. This is a history about an ongoing and

irresolvable struggle for political and aesthetic form that had begun in 1918 and had articulated itself as a struggle of the masses, for the masses, with the masses, or, most frequently, against the masses. February 1933 blew the final whistle, the image and idea of the masses being absorbed by the blackened edifice in which all hopes for democracy vanished and from which Nazism then emerged with a solution in its own right. As we know, Hitler used the occasion to declare a state of emergency, arrest all communist members of parliament (who were blamed for the arson), and assume dictatorial powers. This brought the crisis of representation that haunted Germany and Austria in the interwar period between revolution and fascism to a temporary end. The agents of the masses were now split between those who joined the organic *Volksgemeinschaft* and those who—when not killed—dispersed and then regrouped as exiled or clandestine collectives of resistance.

NOTES

PREFACE

1. See, for instance, Stefan Jonsson, "The Ideology of Universalism," *New Left Review*, no. 63 (May–June 2010): 115–26; and Stefan Jonsson, "Network and Subaltern: Antinomies of Contemporary Theory," in *Rethinking Time: Essays on Historical Consciousness, Memory, and Representation*, ed. Hans Ruin and Andrus Ers, Södertörn University Philosophical Studies no. 10 (Södertörn, Huddinge: Södertörn University, 2011), 189–98. Earlier versions of some parts of the present book have appeared in *New German Critique*, vol. 40, no. 119 (2013); *Lettre International* (Berlin), no. 50 (2001); *Maska: Performing Arts Journal* (Ljubljana), no. 126 (2011); *Eurozine* (2012); *Kultur & Klasse* (Denmark), no. 114 (2012); *Ord och Bild* (Sweden), no. 2–3 (2001), and no. 3 (2011). Sections have also appeared in the following anthologies: *Representing the Passions: Histories, Bodies, Visions*, ed. Richard Meyer (London: Getty Research Institute, 2003); *Weimar Publics/Weimar Subjects: Rethinking the Political Culture of Germany in the 1920s*, ed. Kathleen Canning, Kerstin Barndt, Kristin Mcguire (New York: Berghahn Books, 2010); *Konsten att handla—Konsten att tänka: Hannah Arendt om det politiska*, ed. Ulricka Björk and Anders Burman (Stockholm: AXL Books, 2011).

1. INTRODUCING THE MASSES: VIENNA, 15 JULY 1927

1. The vignette that serves this section as an epigraph and the ones that open the following sections are taken from the montage of eyewitness accounts and reports that Karl Kraus collected and published in his essay "Der Hort der Republik," in his journal *Die Fackel* 29, no. 766–70 (October 1927): 1–92. Reprinted in Karl Kraus, *Schriften*, ed. Christian Wagenknecht, vol. 17, *Die Stunde des Gerichts: Aufsätze 1925–1928* (Frankfurt am Main: Suhrkamp, 1992), 237–329.

2. Elias Canetti, *The Torch in My Ear*, trans. Joachim Neugroschel (New York: Farrar, Straus, Giroux, 1982), 252. Originally published as *Die Fackel im Ohr: Lebensgeschichte 1921–1931* (Munich: Carl Hanser, 1980, 1993), 237.

3. My account of the fifteenth of July is based on previous research cited in subsequent notes; archival sources at the Verein für Geschichte der Arbeiterbewegung in Vienna, which has preserved a wealth of newspapers, magazines, pamphlets, posters, records from the Social Democratic Party; and photographic material.

4. The jury rejected the first point of accusation, "intentional homicide," but in fact affirmed, seven votes against five, that the accused were guilty of "non-deliberate manslaughter." The accused were still acquitted because a criminal sentence demanded a two-thirds majority, or eight against four. See Viktor Liebscher, "Die österreichische Geschwornengerichtsbarkeit und die Juliereignisse 1927," in *Die Ereignisse des 15. Juli 1927: Protokoll des Symposiums in Wien am 15. Juni 1977*, ed. Rudolf Neck and Adam Wandruszka, Wissenschaftliche Kommission des Theodor-Körner-Stiftungsfonds und Leopold-Kunschak-Preises zur Erforschung der österreichischen Geschichte der Jahre 1927 bis 1938, vol. 5 (Munich: R. Oldenbourg, 1979), 60–99.

5. Friedrich Austerlitz, "Die Arbeitermörder freigesprochen: der Bluttag von Schattendorf ungesühnt," *Arbeiter-Zeitung* 40, no. 193 (15 July 1927), 1.

6. The leadership of the Social Democratic Party was reluctant to condemn the verdict, for such a measure would have endangered the institution of the lay jury, codified in the Austrian constitution of 1920, which was strongly supported by the social democrats but attacked by conservative politicians. For an account of the hesitation among the social-democratic leaders on the night before July 15, see Ernst Fischer, *Erinnerungen und Reflexionen* (Reinbek bei Hamburg: Rowohlt, 1969), 167–70.

7. Otto Bauer, quoted in Kraus, "Der Hort der Republik," 2; also in Kraus, *Die Stunde des Gerichts*, 238

8. Gerhard Botz, "Der '15. Juli 1927,' seine Ursachen und Folgen," in *Österreich 1927 bis 1938: Protokoll des Symposiums in Wien 23. bis 28. Oktober 1972*, ed. Ludwig Jedlicka and Rudolf Neck, Wissenschaftliche Kommission des Theodor-Körner-Stiftungsfonds und Leopold-Kunschak-Preises zur Erforschung der österreichischen Geschichte der Jahre 1927 bis 1938, vol. 1 (Munich: R. Oldenbourg, 1973), 31. Also see Botz's account in *Gewalt in der Politik: Attentate, Zusammenstösse, Putschversuche, Unruhen in Österreich 1918 bis 1938* (Munich: Wilhelm Fink, 1983), 141–60.

9. Quoted in Botz, *Gewalt in der Politik*, 151.

10. See the report of the commission for the investigation of the July events appointed by the city council of Vienna, *Die Wahrheit über die "Polizeiaktion" am 15. Juli*, ed. Robert Danneberg (Vienna: Verlag der Wiener Volksbuchhandlung, 1927), 33–43.

11. These facts and statements were excerpted from the press by Karl Kraus and quoted in "Der Hort der Republik," 30–45; also in Kraus, *Die Stunde des Gerichts*, 263–79.

12. See Botz, *Gewalt in der Politik*, 158–164; Anton Staudinger, "Christlichsoziale Partei und Heimwehren bis 1927," in *Die Ereignisse des 15. Juli 1927: Protokoll des Symposiums in Wien am 15. Juni 1977*, ed. Rudolf Neck and Adam Wandruszka, Wissenschaftliche Kommission des Theodor-Körner-Stiftungsfonds und Leopold-Kunschak-Preises zur Erforschung der österreichischen Geschichte der Jahre 1927 bis 1938, vol. 5 (Munich: R. Oldenbourg, 1979), 110–36; and Helmut Andics, *Österreich 1804–1975*, vol. 3, *Der Staat, den keiner wollte: Österreich von der Gründung der Republik bis zur Moskauer Deklaration* (Vienna and Munich: Molden-Taschenbuch-Verlag, 1976), 148–50.

13. The importance of the fifteenth of July 1927 in the history of Austria's first republic is, of course, a matter of some debate. Largely through the work of the Wissenschaftliche Kommission des Theodor-Körner-Stiftungsfonds und des Leopold-Kunschak-Preises zur Erforschung der österreichischen Geschichte der Jahre 1927 bis 1938, a consensus has evolved among historians, and it is generally agreed that the event marks the point when the frail Austrian democracy begins regressing toward fascism. See Rudolf Neck, "Von der Koalition zur Konfrontation: Die erste Etappe," in *Die Ereignisse des 15. Juli 1927: Protokoll des Symposiums in Wien am 15. Juni 1977*, ed. Rudolf Neck and Adam Wandruszka, Wissenschaftliche Kommission des Theodor-Körner-Stiftungsfonds und Leopold-Kunschak-Preises zur Erforschung der österreichischen Geschichte der Jahre 1927 bis 1938, vol. 5 (Munich: R. Oldenbourg, 1979), 11–16. For an overview, see Ernst Hanisch, *Der Lange Schatten des Staates: Österreichische Gesellschaftsgeschichte im 20. Jahrhundert 1890–1990* (Vienna: Überreuter, 1998).

14. Canetti, *The Torch in My Ear*, 245; *Die Fackel im Ohr*, 231.

15. Paul Tillich, *Masse und Geist: Studien zur Philosophie der Masse* (Berlin and Frankfurt am Main: Verlag der Arbeitsgemeinschaft, 1922), 25.

16. Siegfried Kracauer, *From Caligari to Hitler: A Psychological History of the German Film* (1947), rev. ed. (Princeton, N.J.: Princeton University Press, 2004), 54.

17. Alfred Döblin, *Wissen und Verändern! Offene Briefe an einen jungen Menschen* (Berlin: S. Fischers Verlag, 1931), 151.

18. Alfred Vierkandt, *Gesellschaftslehre: Hauptprobleme der philosophischen Soziologie*, 2nd rev. ed. (Stuttgart: Verlag von Ferdinand Enke, 1928), 438.

19. Michael P. Steinberg, "Introduction: Benjamin and the Critique of Allegorical Reason," in *Walter Benjamin and the Demands of History*, ed. Michael P. Steinberg (Ithaca, N.Y.: Cornell University Press, 1996), 11.

20. Eric D. Weitz, *Weimar Germany: Promise and Tragedy* (Princeton, N.J.: Princeton University Press, 2007), 82.

21. René König, *Leben im Widerspruch: Versuch einer intellektuellen Autobiographie* (Frankfurt am Main: Ullstein, 1984), 62.

22. Friedrich Georg Jünger, "Einleitung," in *Das Gesicht der Demokratie: Ein Bildwerk zur Geschichte der deutschen Nachkriegszeit*, ed. Edmund Schultz (Leipzig: Verlag von Breitkopf & Härtel, 1931), 22–23.

23. Quoted in Eberhard Kolb, *The Weimar Republic*, trans. P. S. Falla and R. J. Park (London and New York: Routledge, 2005), 68.

24. Kolb, *The Weimar Republic*, 21.

25. Joseph Goebbels, "Around the Gedächtniskirche" (1928), in *The Weimar Republic Sourcebook*, ed. Anton Kaes, Martin Jay, and Edward Diemendberg (Berkeley and Los Angeles: University of California Press, 1994), 560–61.

26. See, for instance, Detlev J. K. Peukert, *The Weimar Republic: The Crisis of Classical Modernity*, trans. Richard Deveson (New York: Hill and Wang, 1989), 164–77.

27. Rainer Metzger and Christian Brandstätter, *Berlin. Die Zwanziger Jahre. Kunst und Kultur 1918–1933* (Munich: Deutscher Taschenbuch Verlag, 2006), 317.

28. Siegfried Kracauer, "Cult of Distraction," in *The Mass Ornament: Weimar Essays*, trans. and ed. Thomas Y. Levin (Cambridge, Mass.: Harvard University Press, 1995), 325; "Der Kult der Zerstreuung," in *Das Ornament der Masses. Essays* (Frankfurt am Main: Suhrkamp, 1977), 313.

29. Sabine Hake, *Topographies of Class: Modern Architecture and Mass Society in Weimar Berlin* (Ann Arbor: University of Michigan Press, 2010), 6.

30. For the case of Berlin, see Hake, *Topographies of Class*; and for the case of Vienna, see Eve Blau, *The Architecture of Red Vienna, 1919–1934* (Cambridge, Mass.: MIT Press, 1999).

31. Gustave Le Bon, *The Crowd: A Study of the Popular Mind*, 2d ed., rpt. (Marietta, Ga.: Cherokee Publishing Company, 1982), 20. Originally published in 1895 as *La psychologie des foules*, 2nd ed. (Paris: Presses Universitaires de France, 1963, rpt. 2003), 19.

32. Andreas Huyssen, "Mass Culture as Woman," in *After the Great Divide: Modernism, Mass Culture, Postmodernism* (Bloomington: Indiana University Press, 1986), 47. Also see Katharina von Ankum, ed., *Women in the Metropolis: Gender and Modernity in Weimar Culture* (Berkeley and Los Angeles: University of California Press, 1997).

33. For analyses of various such policies, see Kerstin Barndt, "Mothers, Citizens, and Consumers: Female Readers in Weimar Germany," and Kristin McGuire, "Feminist Politics Beyond the Reichstag: Helene Stöcker and Visions of Reform," in *Weimar Publics/ Weimar Subjects: Rethinking the Political Culture of Germany in the 1920s*, ed. Kathleen Canning, Kerstin Barndt, Kristin Mcguire (New York: Berghahn Books, 2010), 95–115, 138–52.

34. Weitz, *Weimar Germany*, 295.

35. Gerhard Colm, "Die Masse: Ein Beitrag zur Systematik der Gruppen," *Archiv für Sozialwissenschaft und Sozialpolitik* 52 (Tubingen: J. C. B. Mohr [Paul Siebeck], 1924): 680–694; Theodor Geiger, *Die Masse und ihre Aktion: Ein Beitrag zur Soziologie der Revolution* (Stuttgart: Ferdinand Enke, 1926); Wilhelm Vleugels, *Die Masse. Ein Beitrag zur Lehre von den sozialen Gebilden* (Munich: Duncker und Humblot, 1930); Leopold von Wiese, *System der Allgemeinen Soziologie*, 2nd ed. (Munich and Leipzig: Duncker und Humblot, 1933), 407–46.

36. Paul Reiwald, *Vom Geist der Massen: Handbuch der Massenpsychologie* (Zurich: Pan Verlag, 1946), 16. Reiwald's book is a compendious summa and popularization of key contributions to mass psychology and mass sociology during the preceding century. Published immediately after World War II, it also straddles the threshold of an era in which the social sciences would gradually disqualify the theoretical utility of "mass" or "crowd" and invent new terms and concepts for social formations and collective behavior.

37. For important studies, though limited in focus as they exclusively deal with the areas of sociology, mass psychology, and cultural philosophy, see Helmuth Berking, *Masse und Geist: Studien zur Soziologie in der Weimarer Republik* (Berlin: Wissenschaftlicher Autoren-Verlag, 1984); Helmut König, *Zivilisation und Leidenschaften: Die Masse im bürgerlichen Zeitalter* (Reinbek bei Hamburg: Rowohlt 1992); Nori Möding, *Die Angst der Bürgers vor der Masse: Zur politischen Verführbarkeit des deutschen Geistes im Ausgang seiner bürgerlichen Epoche* (Berlin: Wissenschaftlicher Autoren-Verlag, 1984); Manfred Franke, "Der Begriff der Masse in der Sozialwissenschaft: Darstellung eines Phänomens und seine Bedeutung in der Kulturkritik des 20. Jahrhunderts," Ph.D. diss., Johannes Gutenberg-Universität, Mainz, 1985; also see the highly relevant essays by Volker Heins ("Demokratie als Nervensache: Zum Verhältnis von Politik und Emotion bei Max Weber"), Thomas Noetzel ("Max Webers 'Neue Menschen'—Das Leben als Bewährungsaufstieg"), Timm Genett ("Vom Zivilisierungsagenten zur Gefolgschaft: Die Masse im politischen Denkens Robert Michaels'"), and Alex Demirovic ("Kritische Theorie bürgerlicher Herrschaft und die Widersprüchlichkeit der Massen") in the anthology *Masse—Macht—Emotionen: Zu einer politischen Soziologie der Emotionen*, ed. Ansgar Klein and Frank Nullmeier (Opladen/Wiesbaden: Westdeutscher Verlag, 1999); also to be included in this category is Alexander Mitscherlich's classic *Massenpsychologie ohne Ressentiment: Sozialpsychologische Betrachtungen* (Frankfurt am Main: Suhrkamp, 1972).

38. An exception in this context is Hake's study *Topographies of Class*. Hake emphasizes the profound ambiguity of the notion of the masses in interwar discourse, distinguishing its shifts in meaning as one moves between four registers: a phenomenological preoccupation with spatial organization, a psychological interest in emotions, a sociological description of class transformations, and an economic analysis perceiving the masses as an effect of the rationalization and quantification of work and everyday life (89–90). Hake also posits this ambiguity as a symptom of crisis, which in her view is above all a crisis affecting the identity of the white-collar working class, and she does not address the wider political and social context in which the masses emerge as a major sign of the general problem of political and cultural representation. Another exception is Annette Graczyk's examination of the literary representation of masses and crowd behavior in the early Weimar Republic. As Graczyk remarks, investigations of aesthetic representations of masses are extremely rare (*Die Masse als Erzählproblem: Unter besonderer Berücksichtigung von Carl Sternheims "Europa" und Franz Jungs "Proletarier"* [Tubingen: Max Niemeyer, 1993], 33). Recent studies also include Miriam Bratu Hansen, *Cinema and Experience: Siegfried Kracauer, Walter Benjamin, and*

Theodor W. Adorno (Berkeley and Los Angeles: University of California Press, 2011), which provides numerous fresh approaches to the analysis of the notion of the masses as it was conducted by Weimar's best-known critical intellectuals. Michael Gamper, *Masse lesen, Masse schreiben: Eine Diskurs- und Interpretationsgeschichte der Menschenmenge 1765–1930* (Munich: Wilhelm Fink Verlag, 2007), also contains many useful observations on literary and rhetorical representations of crowds in European modernity but is all too brief on the interwar period and, despite intentions to the contrary, insufficiently grounded in political theory and history.

39. Hermann Broch, "Vorschlag zur Gründung eines Forschungsinstitutes für politische Psychologie und zum Studium von Massenwahnerscheinungen," in *Kommentierte Werkausgabe*, ed. Paul Michael Lützeler, vol. 12, *Massenwahntheorie: Beiträge zu einer Psychologie der Politik* (Frankfurt am Main: Suhrkamp, 1979), 11.

40. Broch, "Vorschlag zur Gründung eines Forschungsinstitutes," 11; and Broch, "Bemerkungen zum Projekt einer 'International University', ihrer Notwendigkeit unde ihren Möglichkeiten," in *Kommentierte Werkausgabe*, ed. Paul Michael Lützeler, vol. 11, *Politische Schriften* (Frankfurt am Main: Suhrkamp, 1978), 414–427. For contextualization of Broch's proposals, see Gesa von Essen, "Hermann Brochs Ideen zur Reform der Universitäten," in *Hermann Broch: Politik, Menschenrechte—und Literatur?* ed. Thomas Eichler, Paul Michael Lützeler, and Hartmut Steinecke (Oberhausen: Athena Verlag, 2005), 231–54.

41. Peukert, *The Weimar Republic*, 281.

42. On this tradition of historical scholarship and its weakness, see Anthony McElligott, introduction to *Weimar Germany*, ed. Anthony McElligott (Oxford: Oxford University Press, 2009), 1–25; and Peter Fritzsche, "Did Weimar Fail?" *Journal of Modern History* 68, no. 3 (September 1996): 629–56.

43. According to Helmut König, in much German scholarship after World War II research on mass psychology and mass theory and research on Nazism and fascism have entered an unfortunate companionship: "the masses" serve as an explanation of fascism, and fascism as an explanation of "the masses." The result is a damaged understanding of both phenomena (*Zivilisation und Leidenschaften*, 246–55).

44. Heinrich August Winkler, *Von der Revolution zur Stabilisierung: Arbeiter und Arbeiterbewegung in der Weimarer Republik 1918 bis 1924* (Berlin: Verlag J. H. W. Dietz, 1985), 11.

45. Gustave Le Bon, *The Crowd*, xv.

46. On the origins of mass psychology, see Susanna Barrows, *Distorting Mirrors: Visions of the Crowd in Late-Nineteenth-Century France* (New Haven, Conn.: Yale University Press, 1981); Robert A. Nye, *The Origins of Crowd Psychology: Gustave Le Bon and the Crisis of Mass Democracy in the Third Republic* (London: Sage, 1975); and Erika Apfelbaum and Gregory R. McGuire, "Models of Suggestive Influence and the Disqualification of the Social Crowd," in *Changing Conceptions of Crowd Mind and Behavior*, ed. Carl F. Graumann and Serge Moscovici (New York: Springer Verlag, 1986), 27–52.

47. For early contributions of this kind in German, see Robert E. Park, *Masse und Publikum* (Bern: Lack und Grunau, 1904), published in English as *The Crowd and the Public and Other Essays*, trans. Charlotte Elsner, ed. Henry Elsner Jr. (Chicago: University of Chicago Press, 1972); Hans Gudden, *Ueber Massensuggestion und psychische Massenepidemien: Vortrag gehalten im Kaufmännischen Verein zu München* (Munich: Verlag der Aerztlichen Rundschau [Otto Gmelin], 1908); Hans Delbrück, *Geist und Masse in der Geschichte: Rede zur Feier des Geburtstages seiner Majestät des Kaisers und Königs* (Berlin: Verlag der "Preußischen Jahrbücher" Georg Stilte, 1912); Wilhelm Weygandt, *Lehre von den psychischen Epidemien* (Halle: Verlag von Carl Marhold, 1905); Wilhelm Brönner, "Zur Theorie der kollektiv-psychischen Erscheinungen," Ph.D. diss., Leipzig, Verlag von Johann Ambrosius Barth, 1910.

48. Quoted in Kraus, "Der Hort der Republik," 14; also in Kraus, *Die Stunde des Gerichts*, 253. Kraus credits the newspaper *Neue Freie Presse* for this quotation, which is allegedly taken from an eyewitness account given to the newspaper by "a German author."

49. Botz, *Gewalt in der Politik*, 143. The importance of unemployment as a cause is indicated by the disproportionately large participation in the demonstration of unemployed workers or workers from industries threatened by layoffs. See also Gerhard Botz, "Die 'Juli-Demonstranten,' ihre Motive und die quantifizierbaren Ursachen des '15. Juli 1927,'" in *Die Ereignisse des 15. Juli 1927: Protokoll des Symposiums in Wien am 15. Juni 1977*, ed. Rudolf Neck and Adam Wandruszka, Wissenschaftliche Kommission des Theodor-Körner-Stiftungsfonds und Leopold-Kunschak-Preises zur Erforschung der österreichischen Geschichte der Jahre 1927 bis 1938, vol. 5 (Munich: R. Oldenbourg, 1979), 29.

50. Fischer, *Erinnerungen und Reflexionen*, 162–164; Botz, *Gewalt in der Politik*, 142–43.

51. Anson Rabinbach, *The Crisis of Austrian Socialism: From Red Vienna to Civil War* (Chicago: University of Chicago Press, 1983), 24–31.

52. Fischer, *Erinnerungen und Reflexionen*, 162.

53. Frank Field, *The Last Days of Mankind: Karl Kraus and His Vienna* (New York: St. Martin's Press, 1967), 139.

54. Stefan Jonsson, *Subject Without Nation: Robert Musil and the History of Modern Identity* (Durham, N.C.: Duke University Press, 2000), 184–94. For an analysis of Germany's Weimar Republic as haunted by a trauma caused by war and defeat, see Anton Kaes, *Shell Shock Cinema: Weimar Culture and the Wounds of War* (Princeton, N.J.: Princeton University Press, 2009).

55. Andics, *Der Staat, den keiner wollte*, 122–24.

56. Elias Canetti, *Crowds and Power*, trans. Carol Stewart (New York: Farrar, Straus, Giroux, 1984), 16; *Masse und Macht*, new ed. (Munich: Carl Hanser, 1980), 15.

57. Canetti, *Torch in My Ear*, 245; *Fackel im Ohr*, 231.

58. Canetti, *Torch in My Ear*, 123; *Fackel im Ohr*, 119.

59. Canetti, *Torch in My Ear*, 122; *Fackel im Ohr*, 118.

60. Canetti, *Torch in My Ear*, 148; *Fackel im Ohr*, 143.

61. Canetti, *Torch in My Ear*, 142; *Fackel im Ohr*, 136f.

62. Canetti, *Torch in My Ear*, 149, translation modified; *Fackel im Ohr*, 144.

63. Le Bon, *The Crowd*, v.

64. René Descartes, *Les passions de l'âme* (1649; Paris: Librairie Générale de France, 1990), 57–74.

65. Hannah Arendt, *The Origins of Totalitarianism*, 3rd ed. (New York and London: Harcourt Brace Jovanovich, 1973), 305–40.

66. For an example of the continuing influence of Arendt's opinion, see Fransisco Budi Hardiman, *Die Herrschaft der Gleichen: Masse und totalitäre Herrschaft. Eine kritische Überprüfung der Texte von Georg Simmel, Hermann Broch, Elias Canetti und Hannah Arendt* (Frankfurt am Main: Peter Lang, 2001), which is an attempt to explain totalitarianism as caused by the masses and one in a long line of studies that designates "the masses" as the antithesis of democratic solidarity.

67. Arendt, *Origins of Totalitarianism*, 311.

68. Arendt, *Origins of Totalitarianism*, 311. Crucially, Arendt also claimed that the great appeal of totalitarian movements among the masses "meant the end of two illusions" that had been taken for granted in democratic countries. The first was that each individual had more or less felt that his or her interests were adequately represented by the system of democratic representation. The second illusion was that the masses who formed the background of political life were neutral and that those who were actively involved in politics therefore did not have to seek their active consent. Both these received ideas proved wrong as small groups, what Arendt calls mobs, of militant politicians at the margins of the established system won the masses' support for their ideas that the existing political system was corrupt, biased, emaciated, illegitimate, or in some other way incapable of representing the true will of the people.

69. Arendt, *Origins of Totalitarianism*, 314.

70. Arendt, *Origins of Totalitarianism*, 314.

71. This division, inevitably instituted through political representation, is related to but not identical with what Jacques Rancière calls "le partage du sensible," the distribution or, rather, the sharing and sharing out of the sensible, in which is determined who is visible and who is invisible, who speaks and who is silent, who is understood and who is misunderstood, whose vote is trusted and whose vote is rejected, in any given polity. See Jacques Rancière, *The Politics of Aesthetics: The Distribution of the Sensible*, trans. Gabriel Rockhill (London and New York: Continuum, 2004), 7–45. Originally published as *Le partage du sensible: Esthétique et politique* (Paris: La Fabrique, 2000).

72. See Hasso Hoffmann, *Repräsentation: Studien zur Wort- und Begriffsgeschichte von der Antike bis ins 19. Jahrhundert* (Berlin: Duncker und Humblot, 1974), 15–37, 406–62.

73. My argument about the effects of theoretical, political, and economic representations of society, and about the relations between these, draws on the rich theoretical exchange on the relation of politics and ideology—the former being a matter of representation in the sense of *Vertretung*, the latter a matter of representation in the sense of *Darstellung*—that departs from Marx's *The Eighteenth Brumaire of Louis Bonaparte*, and Lukács's *History and Class Consciousness*. For recent contributions to this discussion, see Gayatri Chakravorty Spivak, "Can the Subaltern Speak?" in *Marxism and the*

Interpretation of Culture, ed. Cary Nelson and Lawrence Grossberg (Urbana and Chicago: University of Illinois Press, 1988), 271–313, reprinted in *Can the Subaltern Speak? Reflections on the History of an Idea,* ed. Rosalind Morris (New York: Columbia University Press, 2010), 237–91; Jacques Derrida, *Spectres of Marx: The State of the Debt, the Work of Mourning, and The New International,* trans. Peggy Kamuf (New York: Routledge, 1994); and Etienne Balibar, "The Vacillation of Ideology in Marxism" and "In Search of the Proletariat: The Notion of Class Politics in Marx," in *Masses, Classes, Ideas: Studies on Politics and Philosophy Before and After Marx,* trans. James Swenson (New York: Routledge, 1994), 87–149.

74. Heimito von Doderer, *The Demons,* trans. Richard and Clara Winston (New York: Knopf, 1961), 1311. Originally published as *Die Dämonen: Nach der Chronik des Sektionsrates Geyrenhoff* (Munich: Biederstein, 1956), 1328. Further page references are given in the text, English translation first, followed by original.

75. Elizabeth C. Hesson, *Twentieth-Century Odyssey: A Study of Heimito von Doderer's* Die Dämonen (Columbia, S.C.: Camden House, 1982), 20–53.

76. Claudio Magris, *Der habsburgische Mythos in der österreichischen Literatur,* trans. from Italian Madeleine von Pásztory (Salzburg: Otto Müller, 1966), 299–303.

77. Charles Baudelaire, *Mon coeur mis à nu,* in *Oeuvres complètes,* ed. Y.-G. Le Dantec and C. Pichois (Paris: Gallimard, 1961), 1274. Baudelaire made the remark in relation to the June insurrection of 1848 in Paris. For a discussion, see T. J. Clark, *The Absolute Bourgeois: Artists and Politics in France, 1848–1851,* new ed. (Berkeley and Los Angeles: University of California Press, 1999), 141–77.

78. Kraus, "Der Hort der Republik," 52; also in Kraus, *Die Stunde des Gerichts,* 294.

79. Ibid., 62 and 303, respectively.

80. Hans Weigel, *Karl Kraus; oder, die Macht der Ohnmacht* (Vienna: Fritz Molden, 1968), 271–94.

81. Canetti, *Torch in My Ear,* 246. *Fackel im Ohr,* 232.

82. Gerald Stieg, *Frucht des Feuers: Canetti, Doderer, Kraus und der Justizpalastbrand* (Vienna: Falter im ÖBV, 1990), 102.

83. Kraus, "Hort der Republik," 69.

84. Elias Canetti, *Auto-da-fé,* trans. C. V. Wedgwood (New York: Farrar, Straus, Giroux, 1984), 411, translation modified. Originally published as *Die Blendung* (1936; Munich: Carl Hanser, 1980), 449.

85. Ibid.

86. See Klaus Theweleit's account of Canetti's mass theory, "Canettis Masse-Begriff: Verschwinden der Masse? Masse & Serie," in *Ghosts: Drei leicht inkorrekte Vorträge* (Basel and Frankfurt am Main: Stroemfeld/Roter Stern, 1998), 233–34.

87. Etienne Balibar, "Spinoza, the Anti-Orwell: The Fear of the Masses," in *Masses, Classes, Ideas: Studies on Politics and Philosophy Before and After Marx,* trans. James Swenson (New York: Routledge, 1994), 3–37. Cornelius Castoriadis describes the relation of state and people as follows: "The state is an entity separated from the collectivity and instituted in such a manner as to secure the permanence of that separation" ("Pouvoir, politique, autonomie," in *Le monde morcelé* [Paris: Seuil, 1990], 124).

88. On this point, see Ranajit Guha, *Dominance Without Hegemony: History and Power in Colonial India* (Cambridge, Mass.: Harvard University Press, 1998), 1–125.

89. *Berliner Illustrirte Zeitung* 36, no. 30 (1927): 1190.

90. Julius Braunthal, *Die Wiener Julitage 1927: Ein Gedenkbuch* (Vienna: Verlag der Wiener Volksbuchandlung, 1927), 18.

91. Klaus Theweleit, *Male Fantasies*, vol. 2, *Male Bodies: Psychoanalyzing the White Terror*, trans. Erica Carter and Chris Turner (Minneapolis: University of Minnesota Press, 1989), 3–4.

92. Josef Goebbels, *Michael: Ein deutsches Schicksal in Tagebuchblättern* (Munich, 1929), 21; quoted in Theweleit, *Male Fantasies*, 2:94; translation modified.

93. Theweleit, *Male Fantasies*, 2:75–76.

94. Gilles Deleuze and Félix Guattari, *Anti-Oedipus: Capitalism and Schizophrenia*, trans. Robert Hurley, Mark Seem, and Helen R. Lane (Minneapolis: University of Minnesota Press, 1983), 340–41.

95. Tillich, *Masse und Geist*, 23.

96. Girogio Agamben, *The Coming Community*, trans. Michael Hardt (Minneapolis: University of Minnesota Press, 1993), 86.

97. Ernst von Salomon, *Die Geächteten*, in Ernst Jünger, *Der Kampf um das Reich* (Essen, 1929), 10–11; quoted in Theweleit, *Male Fantasies*, 2:4, translation modified.

98. Ernst von Salomon, *Hexenkessel Deutschland*, in Ernst Jünger, *Der Kampf um das Reich* (Essen, 1929), 19; quoted in Theweleit, *Male Fantasies*, 2:33.

99. Doderer, *Demons*, 1274; *Dämonen*, 1291.

2. AUTHORITY VERSUS ANARCHY: ALLEGORIES OF THE MASS IN SOCIOLOGY AND LITERATURE

1. For a comprehensive analysis of this development in Europe, see Geoff Eley, *Forging Democracy: The History of the Left in Europe, 1850–2000* (Oxford: Oxford University Press, 2002), 13–233.

2. For an account of the discourse on the masses as a reaction against democracy, see Stefan Jonsson, *A Brief History of the Masses: Three Revolutions* (New York: Columbia University Press, 2008), 5–117.

3. William Kornhauser, *The Politics of Mass Society* (London: Routledge and Kegan Paul, 1959), 21. Kornhauser distinguished the aristocratic criticism of mass society from the democratic one, the latter consisting of "the intellectual defense of democratic values against the rise of elites bent on total domination" (21).

4. In addition to the numerous entries on "masses" and "mass psychology" in encyclopedias of philosophy and the social sciences, which are all governed by this perspective, see Paul Reiwald, *Vom Geist der Massen: Handbuch der Massenpsychologie* (Zurich: Pan Verlag, 1946); Serge Moscovici, *The Age of the Crowd: A Historical Treatise on Mass Psychology*, trans. J. C. Whitehouse (Cambridge: Cambridge University Press; Paris: Editions de la Maison des Sciences de l'Homme, 1985); Carl F. Graumann

and Serge Moscovici, eds., *Changing Conceptions of Crowd Mind and Behavior* (New York: Springer Verlag, 1986); Peter Sloterdijk, *Die Verachtung der Massen: Versuch über Kulturkämpfe in der modernen Gesellschaft* (Frankfurt am Main: Suhrkamp, 2000); Stanley J. Tambiah, *Leveling Crowds: Ethnonationalist Conflicts and Collective Violence in South Asia* (Berkeley and Los Angeles: University of California Press, 1996); Leon Bramson, *The Political Context of Sociology* (Princeton, N.J.: Princeton University Press, 1961). For a rare exception to this body of work, see Roger L. Geiger, "Democracy and the Crowd: The Social History of an Idea in France and Italy, 1890–1914," *Societas: A Review of Social History* 7, no. 1 (1977): 47–71. As the title indicates, this essay deals not with Germany, and its historical frame is limited. Yet it is exemplary in its contextualization of crowd psychology.

5. There is thus a remarkable credulity even among critically minded scholars as regards mass psychology. Many have used Le Bon as a theoretical authority on crowds whereas those same critics would normally be reluctant to apply comparable nineteenth-century ideological paradigms as scholarly and theoretical tools for understanding social phenomena. For cautionary cases, see Serge Moscovici, "The Discovery of the Masses," in *Changing Conceptions of Crowd Mind and Behavior*, ed. Carl F. Graumann and Serge Moscovici, (New York: Springer Verlag, 1986), esp. 25; Moscovici, *The Age of the Crowd*; Jonathan Crary, *Suspensions of Perception: Attention, Spectacle, and Modern Culture* (Cambridge, Mass.: The MIT Press, 1999), 241–47; Anton Kaes, *Shell Shock Cinema: Weimar Culture and the Wounds of War* (Princeton, N.J.: Princeton University Press, 2009), 193–200; and Christine Poggi, "Mass, Pack, and Mob: Art in the Age of the Crowd," in *Crowds*, ed. Jeffrey T. Schnapp and Matthew Tiews (Stanford, Calif.: Stanford University Press, 2006), 159–202.

6. Thus, the antinomy between rational individuality and irrational masses, which marks the discourse on the crowd in the 1890s, may be interpreted as the result of the elite's effort to contain a social contradiction. By fabricating the lower classes as irrational crowds, the discourse protects the right of the upper classes to remain the representatives of society against working-class demands for universal suffrage and economic improvements. According to Michelle Perrot, in France between 1885 and 1898 there was on average almost one workers' strike per day, the number reaching its climax in 1893, when 634 strikes are reported. This is the very period when mass psychology was established as a scientific doctrine (*Les ouvriers en grève*, 2 vols. [Paris: Mouton, 1974], 2:568; quoted in Susanna Barrows, *Distorting Mirrors: Visions of the Crowd in Late-Nineteenth-Century France* [New Haven, Conn.: Yale University Press, 1981], 19).

7. Karl Jaspers, *Man in the Modern Age*, trans. Eden Paul and Cedar Paul (London: George Routledge and Sons, 1933), 241; originally published as *Die geistige Situation der Zeit* (Berlin: Walter de Gruyter, 1931), 33, 189.

8. Georg Simmel, "Massenpsychologie," *Die Zeit. Wiener Wochenschrift für Politik, Volkswirtschaft, Wissenschaft und Kunst* 5, no. 60 (23 November 1895): 119–20; reprinted, in Simmel, *Gesamtausgabe*, ed. Otthein Rammstedt, vol. 1, *Das Wesen der Materie nach Kant's Physischer Monadologie. Abhandlungen 1882–1884. Rezensionen 1883–1901*, ed. Klaus Christian Köhnke (Frankfurt am Main: Suhrkamp, 1999): 248–51.

9. Georg Simmel, "Ueber Massenverbrechen," *Die Zeit. Wiener Wochenschrift für Politik, Volkswirtschaft, Wissenschaft und Kunst* 13, no. 157 (2 October 1897): 4–6; reprint, in Simmel, *Gesamtausgabe*, 1:353–361. The title of the German translation of *La folla delinquente* is *Psychologie des Auflaufs und der Massenverbrechen*, trans. Hans Kurella (Dresden: Reissner, 1897). Notably, Simmel also introduced Gabriel Tarde and reviewed his *Les lois de l'imitation* in *Zeitschrift für Psychologie und Physiologie der Sinnesorgane* 2 (1891), 141–42; reprint, in Simmel, *Gesamtausgabe*, 1:388–400.

10. Donald N. Levine, introduction to Georg Simmel, *On Individuality and Social Forms: Selected Writings*, ed. Donald N. Levine (Chicago: University of Chicago Press, 1971), xiv; Fredric Jameson, "The Theoretical Hesitation: Benjamin's Sociological Predecessor," *Critical Inquiry* 25, no. 2 (winter 1999): 272–73.

11. Simmel, "Massenpsychologie," 119.

12. Simmel, "Massenpsychologie," 119. As Simmel later writes in *Soziologie*, the interpenetration of the social and the individual is so complete that the question as to what is what and what comes first is merely a matter of perspective. Society is made up by individuals, but these individuals are made up by society (*Soziologie: Untersuchungen über die Formen der Vergesellschaftung* [1908], new ed. [Munich and Leipzig: Duncker und Humblot, 1922], 366). In his *Fundamental Problems of Sociology* (1917, *Grundfragen der Soziologie*), Simmel provides the following definition of the human: "Man in his totality is a dynamic complex of ideas, forces, and possibilities. According to the motivations and relations of life and its changes, he makes of himself a differentiated and clearly defined phenomena. As an economic and political man, as a family member, and as a representative of an occupation, he is, as it were, an elaboration constructed ad hoc" (*Fundamental Problems of Sociology: Individual and Society*, in *The Sociology of Georg Simmel*, ed. and trans. Kurt H. Wolff [New York: Free Press, 1950, 1964], 46; *Grundfragen der Soziologie [Individuum und Gesellschaft]*, in Simmel, *Gesamtausgabe*, vol. 16, *Der Krieg und die geistigen Entscheidungen. Grundfragen der Soziologie. Vom Wesen des historischen Verstehens. Der Konflikt der modernen Kultur. Lebensanschauung*, ed. Gregor Fitzi and Otthein Rammstedt [Frankfurt am Main: Suhrkamp, 1999], 109).

13. Simmel, "Massenpsychologie," 119.

14. Simmel, "Ueber Massenverbrechen," 5.

15. Ibid.

16. Simmel, *Soziologie*, 1–2.

17. As Tönnies asserted, "The anonymous mass of the people is the original and dominating power which creates the houses, the villages, and the towns of the country. From it, too, spring the powerful and self-determined individuals of many different kinds: princes, feudal lords, knights, as well as priests, artists, scholars. As long as their economic condition is determined by the people as a whole, all their social control is conditioned by the will and power of the people" (*Community and Society*, trans. Charles P. Loomis [East Lansing: Michigan State University Press, 1957], 225).

18. Georg Simmel, *Über sociale Differenzierung* (1890), in Simmel, *Gesamtausgabe*, vol. 2, *Aufsätze 1887–1890. Über sociale Differenzierungen. Die Probleme der Geschichtsphilosophie*, ed. Heinz–Jürgen Dahme (Frankfurt am Main: Suhrkamp, 1989), 210.

19. Simmel, "Massenpsychologie," 119.

20. Simmel, *Über sociale Differenzierung*, 199–236. The analysis of mass behavior formulated here thus returns in his article on Le Bon, "Massenpsychologie" of 1895, in *Soziologie* of 1908, and in *Grundfragen der Soziologie* of 1917. The remarkable constancy of Simmel's analysis of the masses is signaled by the fact that the same formulations are repeated in all four publications.

21. This form of sociation is further increased by a related process, which concerns not so much the relation of the individual and the social level as the relation between the individual level and the size of the social community: The smaller and more homogeneous the society is, the lesser is the freedom and the differentiation of the individual within it, but the greater is also this individual's possibility to influence society. By contrast, the greater and more heterogeneous the society is, the greater is also the freedom and differentiation of the individual, yet the lesser is the individual's possibility to influence society and get social recognition. Thus, as the size of the social group increases, individual freedom increases, while individual agency decreases ("Group Expansion and the Development of Individuality," in *On Individuality and Social Forms*, ed. Donald N. Levine (Chicago: University of Chicago Press, 1971), 251–93; original in *Soziologie*, 527–573; cf. *Über sociale Differenzierung*, 169–98).

22. As Simmel further explains: "The more refined, highly developed, articulated the qualities of an individual are, the more unlikely are they to make him similar to other individuals and to form a unit with corresponding qualities in others. Rather, they tend to become incomparable; and the elements in terms of which the individual can count on adapting himself to others and forming a homogeneous mass with them, are increasingly reduced to lower and primitively more sensuous levels. This explains how it is possible for the 'folk' or 'mass' to be spoken of with contempt, without there being any need for the individual to feel himself referred to by this usage, which actually does not refer to any individual" (*Fundamental Problems of Sociology*, 32; *Grundfragen der Soziologie*, 94).

23. Simmel, *Fundamental Problems of Sociology*, 33. *Grundfragen der Soziologie* 96.

24. Georg Simmel, "Subjective Culture," in *On Individuality and Social Forms*, ed. Donald N. Levine (Chicago: University of Chicago Press, 1971), 227–34; "Vom Wesen der Kultur," in *Brücke und Tür: Essays des Philosophen zur Geschichte, Religion, Kunst und Gesellschaft*, ed. Margarete Sussman and Michael Landmann (Stuttgart: Koehler, 1957), 86–94.

25. The contradiction between the immediacy of "subjective culture" and the mediated forms of "objective culture" is a chronic feature of history, Simmel states ("The Conflict in Modern Culture," in *On Individuality and Social Forms*, ed. Donald N. Levine [Chicago: University of Chicago Press, 1971], 393). Yet only in modern culture is the conflict so acute as to reveal itself as the driving force of history: as a result, "the typically problematic situation of modern man comes into being: his sense of being surrounded by an innumerable number of cultural elements which are neither meaningless to him nor, in the final analysis meaningful. In their mass, they depress him" ("Der Begriff und die Tragödie der Kultur," in *Philosophische Kultur: Gesammelte Essais* [Leipzig: Werner Klinkhardt, 1911], 273).

26. Georg Simmel, "The Metropolis and Mental Life," in *On Individuality and Social Forms*, ed. Donald N. Levine (Chicago: University of Chicago Press, 1971), 337, translation modified; "Die Grossstädte und das Geistesleben," in Simmel, *Gesamtausgabe*, vol. 7, *Aufsätze und Abhandlungen 1901–1908, Band 1*, ed. Rüdiger Kramme, Angela Rammstedt, and Otthein Rammstedt (Frankfurt am Main: Suhrkamp, 1995), 129–30.

27. This analysis runs through Simmel's work, from *Über sociale Differenzierung* (1890), 181–90, through *Soziologie* (1908), 527–73, and "The Metropolis and Mental Life" (1903), to *Fundamental Problems of Sociology* (1917), 122–49.

28. Max Scheler, "Der Mensch im Weltalter des Ausgleichs," in *Philosophische Weltanschauung* (1929), new ed. (Berlin: Francke Verlag, 1954), 89–118.

29. Georg Simmel, "Fashion," in *On Individuality and Social Forms*, ed. Donald N. Levine (Chicago: University of Chicago Press, 1971), 296; "Die Mode," in *Philosophische Kultur*, 32.

30. Georg Simmel, *Philosophy of Money*, 2nd ed., trans. Tom Bottomore and David Frisby (London: Routledge, 1990), 283–429.

31. Levine, introduction, xiii.

32. Fritz K. Ringer, *The Decline of the German Mandarins: The German Academic Community, 1890–1933* (Cambridge, Mass.: Harvard University Press, 1969), 254.

33. In addition to sociological works analyzed in this chapter, examples are provided by, for instance, Gerhard Lehmann, *Das Kollektivbewusstsein: Systematische und historisch/kritische Vorstudien zur Soziologie* (Berlin: Junker und Dünnhaupt Verlag, 1929); Georg Stieler, *Person und Masse: Untersuchungen zur Grundlegung einer Massenpsychologie* (Leipzig: Felix Meiner Verlag, 1929); Siegfried Sieber, *Die Massenseele: Ein Beitrag zur Psychologie des Krieges, der Kunst, und der Kultur* (Dresden and Leipzig: Globus Wissenschaftliche Verlagsanstalt, 1918); and Julius R. Rossbach, *Die Massenseele: Psychologische Betrachtungen über die Entstehung von Volks- (Massen-) Bewegungen Revolutionen* (Munich: Rudolph Müller und Steinicke, 1919).

34. Helmuth Berking, *Masse und Geist: Studien zur Soziologie in der Weimarer Republik* (Berlin: Wissenschaftlicher Autoren-Verlag, 1984), 65, 66–68.

35. Werner Sombart, *Der proletarische Sozialismus ("Marxismus")*, vol. 1, *Die Lehre*, vol. 2, *Die Bewegung* (Jena: Verlag von Gustav Fischer, 1924), 2:170.

36. Rossbach, *Massenseele*, 31, 33.

37. See chapter 1, notes 37, 46.

38. For an analysis of Werner Sombart's later thought and career, see Jeffrey Herf, *Reactionary Modernism: Technology, Culture, and Politics in Weimar and the Third Reich* (Cambridge: Cambridge University Press, 1984), 130–51.

39. Andreas Huyssen, "The Vamp and the Machine: Fritz Lang's *Metropolis*," in *After the Great Divide: Modernism, Mass Culture, Postmodernism* (Bloomington: Indiana University Press, 1986), 65–81.

40. Kaes, *Shell Shock Cinema*, 196.

41. Heinrich August Winkler, *Von der Revolution zur Stabilisierung: Arbeiter und Arbeiterbewegung in der Weimarer Republik 1918 bis 1924* (Berlin: Verlag J. H. W. Dietz, 1985), 75–84.

42. Thomas Elsaesser, *Metropolis* (London: British Film Institute Publishing, 2000), 20.

43. For a discussion of the reception of *Metropolis*, see Huyssen, "The Vamp and the Machine," 65–68; Elsaesser, *Metropolis*, 42–56; as well as Holger Bachman, "The Production and Contemporary Reception of *Metropolis*," and Michael Minden, "The Critical Recption of *Metropolis*," both in *Fritz Lang's* Metropolis: *Cinematic Visions of Technology and Fear*, ed. Michael Minden and Holger Bachmann (Rochester, N. Y.: Camden House, 2000), 3–45, 47–56.

44. Luis Buñuel, "Metropolis," trans. Carol O'Sullivan, in *Fritz Lang's* Metropolis: *Cinematic Visions of Technology and Fear*, ed. Michael Minden and Holger Bachmann (Rochester, N. Y.: Camden House, 2000), 107. Originally published in *Gazeta Literaría de Madrid*, 1927.

45. Siegfried Kracauer, *From Caligari to Hitler: A Psychological History of the German Film* (1947), rev. ed. (Princeton, N.J.: Princeton University Press, 2004), 164.

46. Gerhard Colm, "Die Masse: Ein Beitrag zur Systematik der Gruppen," *Archiv für Sozialwissenschaft und Sozialpolitik* 52 (Tubingen: J. C. B. Mohr [Paul Siebeck], 1924): 680–94.

47. Wilhelm Vleugels, "Der Begriff der Masse: Ein Beitrag zur Entwicklungsgeschichte der Massentheorie," *Jahrbuch für Soziologie* 2 (Karlsruhe: Verlag G Braun, 1926), 177.

48. Theodor Geiger, *Die Masse und ihre Aktion. Ein Beitrag zur Soziologie der Revolution* (Stuttgart: Ferdinand Enke Verlag, 1926, rpnt., 1967), 1.

49. Leopold von Wiese, *System der Allgemeinen Soziologie*, 2nd ed. (Munich and Leipzig: Verlag von Duncker und Humblot, 1933), 40.

50. Vleugels, "Der Begriff der Masse," 201.

51. Alfred Vierkandt, *Gesellschaftslehre: Hauptprobleme der philosophischen Soziologie*, 2nd rev. ed. (Stuttgart: Verlag von Ferdinand Enke, 1928), 438. Also see chapter 1, section 2. One main difference between the first (1923) and second (1928) edition of this work is that Vierkandt has substantially expanded his section on *die Masse*, the quoted passage being one of the additions.

52. Geiger, *Die Masse und ihre Aktion*, 1. Interestingly, Geiger in a later work proposed a completely different genealogy of mass psychology and mass sociology than the one that became established. The founder of mass psychology, he argued, was neither Gustave Le Bon nor Gabriel Tarde nor Scipio Sighele, who had done great harm to the understanding of crowds, according to Geiger. Rather, the first study of mass psychology was G. F. Fresenius, "Die Natur der Masse," *Deutsche Viertelsjahrschrift* (1866). Geiger also mentions the contributions of Schäffle, as well as Simmel's *Über soziale Differentzierungen* (1890). See Theodor Geiger, *Sociologi: Grundrids og hovedproblemer* (Copenhagen: Nyt nordisk forlag—Arnold Busck, 1939), 335.

53. Geiger, Die *Masse und ihre Aktion*, 3.

54. Ibid., 4–5.

55. Ibid., 6.

56. Ibid.

57. The theoretical foundation and methodological procedures of interwar German sociology is concisely summarized by Geiger in his entry on "Soziologie" in the German

dictionary of sociology, *Handwörterbuch der Soziologie*, ed. Alfred Vierkandt (Stuttgart: Ferdinand Enke Verlag, 1931), 568–78. All the major social scientists of the Weimar Republic contributed to the dictionary, which, in the words of its editor, Alfred Vierkandt, amounted to a collective effort toward the "codification of sociological knowledge in Weimar Germany."

58. Wiese, *System der Allgemeinen Soziologie*, 389.

59. Colm, "Die Masse. Ein Beitrag," 680–94, esp. 682–85. Colm presents the same system, with slightly different definitions, in his entry on "Masse" in Alfred Vierkandt's dictionary of sociology (see note 57; Colm, "Masse," *Handwörterbuch der Soziologie*, ed. Alfred Vierkandt [Stuttgart: Ferdinand Enke Verlag, 1931], 353–60).

60. For an account of Hans Töndury's theory of the mass, see the dissertation of his student Heinrich Bratz, *Zum Begriff der Masse in der neueren Soziologie* (Berlin-Schöneberg: Georg Arndt, 1936), 80–90.

61. Wiese, *System der Allgemeinen Soziologie*, 392–393.

62. Colm, "Die Masse: Ein Beitrag," 681; Alfred Vierkandt, *Gesellschaftslehre*, 1st ed. (Stuttgart: Verlag von Ferdinand Enke, 1923), 354–55.

63. Theodor Geiger, "Die Massenpsychologie," appendix to *Die Masse und ihre Aktion*, 175–93; Wilhelm Vleugels, "Zu Freuds Theorien von der Psychoanalyse," *Kölner Viertels-jahrshefte für Soziologie* 3 (1923); Wilhelm Vleugels, *Die Masse. Ein Beitrag zur Lehre von den sozialen Gebilden* (Munich: Duncker und Humblot, 1930), 1–6.

64. Wiese, *System der Allgemeinen Soziologie*, 425. Vleugels, for his part, defines the active mass ("wirksame Masse") "as a transitory formation emerging from a large number of humans, being spatially co-present and oriented in one and the same direction, in which each individual participates only with the parts of his or her personality that are shared with others and hence become dominant (Vleugels, *Die Masse*, 36).

65. Theodor Geiger's critique is explicitly presented in a "polemical appendix" on mass psychology in *Die Masse und ihre Aktion*, 175–93.

66. Wiese, *System der Allgemeinen Soziologie*, 420, 425.

67. Ibid., 422.

68. Leopold von Wiese, "Die Problematik einer Soziologie der Revolution," in Ferdinand Tönnies, Leopold von Wiese, and Ludo Moritz Hartmann, *Das Wesen der Revolution. Verhandlungen des Dritten deutschen Soziologentages am 24. und 25. September 1922 in Jena. Reden und Vorträge*, Schriften der Deutschen Gesellschaft für Soziologie, series 1, vol. 3 (Tubingen: Verlag von J. C. B. Mohr [Paul Siebeck], 1923), 6–23.

69. Max Adler, "Debatte," in Ferdinand Tönnies, Leopold von Wiese, and Ludo Moritz Hartmann, *Das Wesen der Revolution. Verhandlungen des Dritten deutschen Soziologent-ages am 24. und 25. September 1922 in Jena. Reden und Vorträge*, Schriften der Deutschen Gesellschaft für Soziologie, series 1, vol. 3 (Tubingen: Verlag von J. C. B. Mohr [Paul Siebeck], 1923), 42.

70. Vleugels, *Die Masse*, xi, 9–19.

71. Berking also stresses that in Weimar sociology "the mass" is posited as a residual category covering those social formations in which the defining traits of other, alleg-edly more complex formations are absent. Whereas Berking is right to emphasize the

ideological bias behind sociology's vain efforts to define the mass, he neglects that it is also the theoretical premises of formal or general sociology itself that predisposes it to see "the mass" as the irrational residual of its effort to classify social formations (*Masse und Geist*, 72–88).

72. Berking, *Masse und Geist*, 76.

73. Wiese, *System der Allgemeinen Soziologie*, 420.

74. Ibid., 443–44.

75. Helmut König, *Zivilisation und Leidenschaften*, 153.

76. Bertolt Brecht, *The Threepenny Opera*, trans. Eric Bentley (New York: Grove Press, 1960), 28. In original: "Soldaten wohnen / Auf den Kanonen / Vom Cap bis Couch Behar / Wenn es mal regnete / Und es begegnete / Ihnen 'ne neue Rasse / 'ne braune oder blasse / Da machen sie vielleicht daraus / ihr Beefsteak Tartar" (*Die Dreigroschenoper*, in Brecht, *Gesammelte Werke*, vol. 1, *Stücke* 2 (Frankfurt am Main: Suhrkamp, 1967), 420.

77. Sombart, *Der proletarische Sozialismus*, 1:99–100.

78. Vleugels, *Die Masse*, 99.

79. Wiese, *System der Allgemeinen Soziologie*, 440.

80. Ibid., 437.

81. Gerhard Colm, *Beitrag zur Geschichte und Soziologie des Ruhraufstandes vom März–April 1920* (Essen: G. D. Baedeker Verlagsbuchhandlung, 1921), 7.

82. Ibid., 27.

83. Ibid., 93–95.

84. Ibid., 91

85. Colm, "Masse," 358. Colm developed this argument already in his 1924 contribution to the theory of the mass, in which he argued that mass formations can "come into being only in specific historical and sociological situations"—that is, only when other group formations are missing or are disintegrating. The contemporary situation was precisely a case in point, Colm argued (Colm, "Die Masse. Ein Beitrag," 692–93).

86. Edmund Burke, *Reflections on the Revolution in France* (1790; Oxford: Oxford University Press, 1993), 33.

87. Geiger, *Die Masse und ihre Aktion*, 22, 25–26.

88. Ibid., 37.

89. Ibid., 63: "The harmony of the total social organism, both in regard to the make-up of its design and in regard to the life it offers, depends on one central value that gives meaning to everything. The perpetuation of existing social formations and the validity of the values that define them are always based on a governing, representative group."

90. Ibid., 58.

91. Ibid., 44.

92. Ibid., 65.

93. Ibid., 72, 62, 167.

94. Ibid., 101.

95. Ibid., 151.

96. V. Y. Mudimbe, *L'autre face du Royaume: une introduction à la critique des langages en folie* (Lausanne: L'Age d'Homme, 1974), 93.

97. Theodor Geiger, *Die soziale Sichtung des deutschen Volkes: Soziographischer Versuch auf statistischer Grundlage* (Stuttgart: Ferdinand Enke, 1926; 2nd ed., 1967).

98. August Sander, "In der Photographie gibt es keine ungeklärten Schatten," quoted in Anne Gantefuhrer-Trier, "Zeitgenossen," in *Zeitgenossen: August Sander und die Kunstszene der 20er Jahre im Rheinland* (Cologne: Photographischen Sammlung—SK Stiftung Kultur; Gottingen: Steidl Verlag, 2000), 13. Sander's project was left unfinished at his death. He published a first portfolio of photographs in 1929: *Antlitz der Zeit: Sechsig Aufnahmen deutscher Menschen der 20. Jahrhunderts* (Munich: Kurt Wolff/ Transmare Verlag, 1929). A reconstruction of the photographic encyclopedia was published in seven volumes in 2002: *Menschen des 20 Jahrhunderts—Die Gesamtausgabe* (Cologne: Photographischen Sammlung—SK Stiftung Kultur; Munich: Schirmer Mosel Verlag, 2002).

99. Bramson, *Political Context of Sociology*, 31.

100. Eberhard Kolb, *The Weimar Republic*, trans. P. S. Falla and R. J. Park, 2nd ed. (London and New York: Routledge, 2005), 149–59.

101. Simmel, "Metropolis and Mental Life," 337, translation modified; "Die Grossstädte und das Geistesleben," 240–41.

102. Hermann Broch, "Die Straße," *Die Rettung* 1, no. 3 (1918): 5–6, republished in Broch, *Kommentierte Werkausgabe*, ed. Paul Michael Lützeler, vol. 13:1, *Briefe 1, 1913–1938* (Frankfurt am Main: Suhrkamp, 1981), 30–35. For an excellent commentary, see Wendelin Schmidt-Dengler, "'Kurzum die Hölle': Broch's Early Political Text 'Die Straße,'" in *Hermann Broch: Visionary in Exile: The 2001 Yale Symposium*, ed. Paul Michael Lützeler (Rochester, N.Y.: Camden House, 2003), 55–66.

103. Hermann Broch, *Hugo von Hoffmannsthal and his Time: The European Imagination 1860–1920*, trans. Michael P. Steinberg (Chicago: University of Chicago Press, 1984), 72–73.

104. Hermann Broch, *The Sleepwalkers*, trans. Willa Muir and Edwin Muir (New York: Pantheon Books, 1947), 399; *Die Schlafwandler*, in Broch, *Kommentierte Werkausgabe* (Frankfurt am Main: Suhrkamp, 1978), 1:445.

105. Hermann Broch, "Über die Grundlagen des Romans Die Schlafwandler," Lecture at Wiener Volkshochschule, 6 February 1931, in Broch, *Kommentierte Werkausgabe* (Frankfurt am Main: Suhrkamp, 1978), 1:731.

106. Also see Hermann Broch, "Ethische Konstruktion in den Schlafwandlern," in Broch, *Kommentierte Werkausgabe* (Frankfurt am Main: Suhrkamp, 1978), 1:727.

107. Broch, *Sleepwalkers*, 628–29; *Schlafwandler*, 692–93.

108. Hermann Broch, *Massenwahntheorie: Beiträge zu einer Psychologie der Politik*, in Broch, *Kommentierte Werkausgabe* (Frankfurt am Main: Suhrkamp, 1979), 12:78.

109. Broch, *Sleepwalkers*, 625, 637; *Schlafwandler*, 689, 703.

110. Broch, *Sleepwalkers*, 637; *Schlafwandler*, 702.

111. Broch, *Sleepwalkers*, 637; *Schlafwandler*, 702.

112. Broch, *Sleepwalkers*, 595; *Schlafwandler*, 657.

113. See Endre Kiss, "Der Dämmerzustand in philosophischer, psychologischer und romanästhetischer Beleuchtung," *Austriaca*, no. 55 (2003): 155–72.

114. Fransisco Budi Hardiman, *Die Herrschaft der Gleichen: Masse und totalitäre Herrschaft. Eine kritische Überprüfung der Texte von Georg Simmel, Hermann Broch, Elias Canetti und Hannah Arendt* (Frankfurt am Main: Peter Lang, 2001), 90–95.

115. Broch, *Massenwahntheorie*, 77–83.

116. Broch, *Sleepwalkers*, 566; *Schlafwandler*, 625.

117. Hermann Broch, *Der Bergroman*, 4 vols., ed. Frank Kress and Hans Albert Maier (Frankfurt am Main: Suhrkamp, 1969).

118. See for instance "'The City of Man'. Eine Manifest über Weltdemokratie" (1940); "Völkerbund-Resolution" (1937); "Bemerkungen zur Utopie einer 'International Bill of Rights and of Responsibilities" (1946), in Broch, *Kommentierte Werkausgabe*, vol. 11, *Politische Schriften* (Frankfurt am Main: Suhrkamp, 1978), 81–90; 195–232; 243–77. Broch's committed and tireless efforts to give greater peacekeeping powers to the League of Nations is also documented in Broch, *Völkerbund-Resolution: Das vollständige politische Pamphlet von 1937 mit Kommentar, Entwurf und Korrespondenz*, ed. Paul Michael Lützeler (Salzburg: Otto Müller Verlag, 1973); and for good commentaries, see Thomas Eichler, Paul Michael Lützeler, and Hartmut Steinecke, eds., *Hermann Broch: Politik, Menschenrechte—und Literatur?* (Oberhausen: Athena Verlag, 2005).

119. Broch, *Massenwahntheorie*, 54.

120. Michael Löwy and Robert Sayre, *Romanticism Against the Tide of Modernity*, trans. Catherine Porter (Durham, N.C.: Duke University Press, 2001), 73–83.

121. Ernestine Schlant, *Hermann Broch* (Chicago: University of Chicago Press, 1978), 60.

122. The point about Broch's work as "narrated mass psychology" is stressed by Rolf Schumann, *Die Massenwahntheorie im Spiegel der Autorenkrise: Gewalt, Anarchie und die Kunst der Sublimierung im Werk Hermann Brochs* (Frankfurt am Main: Peter Lang, 2000), 129–48.

123. Ernst Toller, *Masse Mensch. Ein Stück aus der sozialen Revolution des 20. Jahrhunderts*, in Toller, *Gesammelte Werke*, ed. John M. Spalek and Wolfgang Frühwald, vol. 2, *Dramen und Gedichte aus dem Gefängnis, 1918–1924*, 3rd ed. (Munich: Carl Hanser Verlag, 1995), 63–112; in English, *Masses Man: A Piece from the Social Revolution of the Twentieth Century*, trans. Alan Raphael Pearlman, rev. ed. (London: Oberon Books, 2011), 126–88. Further references to the drama are given in the main text, with references to the English translation first, followed by German original.

124. Wolfgang Frühwald and John M. Spalek, eds., *Der Fall Toller: Kommentar und Materialen* (Munich: Carl Hanser Verlag, 1979), 118: "This 29 of September counts as the birth moment of stage expressionism and light dramaturgy."

125. Cordula Grunow Erdman, *Die Dramen Ernst Tollers im Kontext ihrer Zeit*, Beiträge zur neueren Literaturgeschichte, series 3, vol. 133 (Heidelberg: Universitätsverlag C. Winter, 1994), 249.

126. Ernst Toller, "Bemerkungen zum deutschen Nachkriegsdrama," in Toller, *Gesammelte Werke*, vol. 1, *Kritische Schriften, Reden und Reportagen*, 2nd ed. (Munich: Carl Hanser Verlag, 1995), 127.

127. Toller modeled The Woman/Sonja Irene L on Sarah Sonja Lerch, peace activist and strike organizer at the Munich munitions factories, who in February 1918 was

detained along with Toller and other activists for undermining the German war effort. Sonja Lerch was married to a university scholar and belonged to Munich's bourgeoisie. Still in love with her husband, and crushed by his decision to punish her political activities by divorcing her, she committed suicide in prison. For Ernst Toller's account of the tragic story, see his memoirs, *I Was a German: The Autobiography of Ernst Toller*, trans. Edward Crankshaw (New York: Morrow, 1934), 111. (It should be noted that Crankshaw took great liberties with the text, in many cases producing a narrative that reinterprets Toller's account instead of translating it.) Originally published as *Eine Jugend in Deutschland*, in Toller, *Gesammelte Werke*, vol. 4, 2nd ed. (Munich: Carl Hanser Verlag, 1996), 89. See also Dieter Distl, *Ernst Toller: Eine politische Biographie* (Schrobenhausen: Verlag Benedikt Bickel, 1993), 100.

128. For an account of Toller's role in the Munich revolution, see Distl, *Ernst Toller*, 39–78.

129. As chairman of the central council of the republic's government, Ernst Toller also had to assume responsibility for the killings of eight prisoners of war, shot by red soldiers as retribution for summary executions by invading white militias under protection of the national government. This occurred without Toller's knowledge and against his explicit orders yet still under his executive leadership.

130. Toller, *I Was a German*, 278; *Eine Jugend in Deutschland*, 222.

131. Toller, *I Was a German*, 278, translation modified; *Eine Jugend in Deutschland*, 222.

132. Toller, *I Was a German*, 278–79, translation modified; *Eine Jugend in Deutschland*, 222–23.

133. Max Weber, "Politik als Beruf," in *Max Weber Gesamtausgabe*, section 1, vol. 17, *Wissenschaft als Beruf 1917/1919, Politik als Beruf 1919*, ed. Wolfgang J. Mommsen, Wolfgang Schluchter, and Birgit Morgenbrod (Tubingen: J. C. B. Mohr, 1992), 157–252.

134. See Michael Hugh Fritton, *Literatur und Politik in der Novemberrevolution 1918/1919: Theorie und Praxis revolutionärer Schriftsteller in Stuttgart und München (Edwin Hoernle, Fritz Rück, Max Barthel, Ernst Toller, Erich Mühsam)*, Europäische Hochschuleschriften, series 1, Deutsche Sprache und Literatur, vol. 926 (Frankfurt am Main: Peter Lang, 1986), 196–201.

135. Ernst Toller is often described as a writer anticipating the characteristic features by which Jean-Paul Sartre in *What Is Literature?* (*Qu'est-ce que, la littérature?*) later codified the qualities of the politically committed writer and intellectual. See Erich Unglaub, "Avantgarde und Engagement. Zur Militanz in der Begriffsbildung der literarischen Moderne," in *Engagierte Literatur zwischen den Weltkriegen*, ed. Stefan Neuhaus, Rolf Selbman, and Thorsten Unger, Schriften der Ernst-Toller Gesellschaft 4 (Wurzburg: Verlag Königshausen und Neumann, 2002), 21–41.

136. Walter Benjamin, *The Origin of German Tragic Drama*, trans. John Osborne (London: Verso, 1985), 163–82.

137. Benjamin, *Origin of German Tragic Drama*, 233. Also see Beatrice Hanssen, *Walter Benjamin's Other History: Of Stones, Animals, Human Beings, and Angels* (Berkeley and Los Angeles: University of California Press, 1998), 97–102.

138. Charles Baudelaire in the sonnet "Une gravure fantastique" ("A Fantastic Engraving"), in *Les fleurs du mal* (1957), and Victor Hugo in "Les Pyramides" ("The Pyramids"), in *La légende des siècles* (1859).

139. Wiese, *System der Allgemeinen Soziologie*, 410; and Wiese, "Die Problematik einer Soziologie der Revolution," 14.

140. Rainer Maria Rilke, letter to Clara Rilke, Munich, 7 November 1918, in *Letters of Rainer Maria Rilke*, vol. 2, *1910–1926*, trans. Jane Barnard Greene and M. D. Herter Norton (New York: Norton, 1969), 180–81; Rainer Maria Rilke, *Briefe zur Politik*, ed. Joachim W. Storck (Frankfurt am Main: Insel Verlag, 1992), 229–30.

141. Hermann Broch, "Rundfunkansprache an das deutsche Volk," in *Kommentierte Werkausgabe*, ed. Paul Michael Lützeler (Frankfurt am Main: Suhrkamp, 1981), 11:241.

3. THE REVOLVING NATURE OF THE SOCIAL:
PRIMAL HORDES AND CROWDS WITHOUT QUALITIES

1. Sigmund Freud, "Thoughts for the Times on War and Death," trans. E. C. Mayne, in *The Standard Edition of the Complete Psychological Works of Sigmund Freud*, ed. James Strachey, vol. 14, *1914–1916, On the History of the Psycho-Analytic Movement: Papers on Metapsychology and Other Works* (London: Hogarth, 1957), 273–300; originally published as "Zeitgemäßes über Krieg und Tod," *Imago. Zeitschrift für Anwendung der Psychoanalyse auf die Geisteswissenschaften* 4 (1915): 1–21.

2. Freud, "Thoughts for the Times on War and Death," 288; "Zeitgemäßes über Krieg und Tod," 12.

3. Sigmund Freud, letter to Romain Rolland, 4 March 1923. *The Letters of Sigmund Freud*, ed. Ernst L. Freud, trans. Tania Stern and James Stern (New York: McGraw-Hill, 1960), 342.

4. Jacqueline Rose, introduction to Sigmund Freud, *Mass Psychology and Other Writings*, trans. J. A. Underwood, (London: Penguin, 2004), vii. Also see Jean-Michel Rey, "Freud and *Massenpsychologie*," in *Changing Conceptions of Crowd Mind and Behavior*, ed. Carl F. Grossmann and Serge Moscovici (New York: Springer-Verlag, 1986), 52–53.

5. Sigmund Freud, *Mass Psychology and Analysis of the 'I,'* in Sigmund Freud, *Mass Psychology and Other Writings*, trans. J. A. Underwood (London: Penguin, 2004), 17. Originally published as *Massenpsychologie und Ich-Analyse* (Leipzig: Psychoanalytischer Verlag, 1921). The German edition used here is *Massenpsychologie und Ich-Analyse. Die Zukunft einer Illusion* (Frankfurt am Main: Fischer Taschenbuch Verlag, 1993), which reproduces the text of vol. 13 of Freud, *Gesammelte Werke* (Frankfurt am Main: S. Fischer Verlag, 1968, 1987), 71–161. Further references to Freud's work are given in parentheses in the main text, with page reference to Underwood's translation first, and then to German original. In Anglo-American criticism, Freud's essay in usually quoted in James Strachey's canonical translation: *Group Psychology and the Analysis of the Ego*, in vol. 18 of *The Standard Edition of the Complete Psychological Works of Sigmund Freud*, ed. James Strachey (London: Hogarth, 1959). It is to be hoped that Freudian theory, criticism, and

commentary will endorse Underwood's more recent translation. Although it is not always as elegant as Strachey's, it is more rigorous and exact, and it relieves the English language user from some false problems, such as the distinction between "group" and "mass," which does not trouble the reader of the German text. Strachey's replacement of "group" for "mass" seems to have been accepted by Freud, and we can only speculate why Strachey preferred "group" to more obvious choices such as "crowd" and "mass." Plausibly, the choice of "group" reflects Freud's and Strachey's willingness to adhere to the terminology established by William McDougall, whose work *The Group Mind* (1920) was at this time the most advanced British attempt in the area of mass psychology. In some cases, however, I have found reason to modify Underwood's translation, and those are marked with an asterisk (*) after the page number.

6. Géza Róheim, "Freuds 'Massenpsychologie und Ich-Analyse.' Völkerpsychologisches." *Internationale Zeitschrift für Psychoanalyse* 8, no. 2 (1922): 209–18.

7. Sandor Ferenczi, "Freuds 'Massenpsychologie und Ich-Analyse.' Der Individualpsychologische Fortschritt," *Internationale Zeitschrift für Psychoanalyse* 8, no. 2 (1922): 206–9.

8. Céline Surprenant, *Freud's Mass Psychology: Questions of Scale* (Basingstoke: Palgrave Macmillan, 2003), 7.

9. Gustave Le Bon, *The Crowd: A Study of the Popular Mind*, 2nd ed., rpt. (Marietta, Ga.: Cherokee Publishing, 1982); originally published in 1895 as *La psychologie des foules*, 2nd ed. (Paris: Presses Universitaires de France, 1963, rpt. 2003); William McDougall, *The Group Mind: A Sketch of the Principles of Collective Psychology with Some Attempt to Apply Them to the Interpretation of National Life and Character* (New York: G. P. Putnam's Sons, 1920); Wilfred Trotter, *Instincts of the Herd in Peace and War* (New York: Macmillan, 1916).

10. Ludwig Kraškovič, *Die Psychologie der Kollektivitäten. Vortrag gehalten in der Versammlung der "Juristischen Gesellschaft in Zagreb" am 8. November 1913*, trans. (from Croatian) Sigmund von Posavec (Vukovar: Sriemske Novine, 1915); Walther Moede, "Die Massen- und Sozialpsychologie im kritischen Überblick," *Zeitschrift für pädagogische Psychologie und experimentelle Pädagogik* 16 (1915): 385–404.

11. Quoted in Ernst Jones, *The Life and Work of Sigmund Freud*, 3 vols. (London: Hogarth, 1954), 1:382.

12. For another enumeration of conflicting interpretations of Freud's mass psychology, see Helmut König, *Zivilisation und Leidenschaften: Die Masse im bürgerlichen Zeitalter* (Reinbek bei Hamburg: Rowohlt, 1992), 233–35.

13. This interpretation is supported by Freud, "Thoughts for the Times on War and Death"; "Zeitgemäßes über Krieg und Tod." Also see Michael S. Roth, *Psychoanalysis as History: Negation and Freedom in Freud* (Ithaca, N.Y.: Cornell University Press, 1987), chap. 5.

14. See Didier Anzieu, "Freud's Group Psychology: Background, Significance, and Influence," in *On Freud's "Group Psychology and the Analysis of the Ego,"* ed. Ethel Spector Person (Hillsdale, N.J.: The Analytic Press, 2001), 39–42.

15. See, for instance, Rose, introduction, ix, xxix–xxxix.

16. Paul Roazen, *Freud: Political and Social Thought* (New York: Knopf, 1968), 91.

17. See Phyllis Grosskurth, *The Secret Ring: Freud's Inner Circle and the Politics of Psychoanalysis* (Reading, Mass.: Addison-Wesley, 1991); Heinz Kohut, "Creativeness, Charisma, Group Psychology: Reflections on the Self-Analysis of Freud," *Psychological Issues* 9, no. 2/3 (1976): 379–425; Robert Caper, "Group Psychology and the Psychoanalytic Group," in *On Freud's "Group Psychology and the Analysis of the Ego,"* ed. Ethel Spector Person (Hillsdale, N.J.: The Analytic Press, 2001), 61–86.

18. This is the argument presented by Ferenczi, "Freuds 'Massenpsychologie und Ich-Analyse.' Der Individualpsychologische Fortschritt." See also Rey, "Freud and Massenpsychologie," 51–67.

19. For an account of the milieu in which these experiments took place, see Erika Apfelbaum and Gregory R. McGuire, "Models of Suggestive Influence and the Disqualification of the Social Crowd," in *Changing Conceptions of Crowd Mind and Behavior,* ed. Carl F. Grossmann and Serge Moscovici (New York: Springer-Verlag, 1986), 27–50.

20. In what is perhaps his first essay in the field of psychology, "Hypnotism and Suggestion"—written in 1888 but not published until an English version appeared posthumously in 1950—Freud tried to clarify the diffuse concept of "suggestion," which was used as an all-explanatory word in early French psychology and mass psychology. Writing about suggestion in *Massenpsychologie und Ich-Analyse,* Freud thus returns to the very earliest phase of his career. See Freud, "Hypnotism and Suggestion," in *Collected Papers,* ed. James Strachey, vol. 5, *Miscellaneous Papers, 1888–1938* (London: Hogarth, 1950), 11–24. The essay was intended as a preface to Freud's translation of Bernheim's *De la suggestion et de ses applications à la thérapeutique* (1886) but was not included in the published translation, which appeared in 1888 as *Die Suggestion und ihre Heilwirkung.*

21. This absence is easier to explain because it could not have been obvious for contemporary readers that Simmel's sociology contains a proper theory of the masses; see chapter 2, section 11.

22. König, *Zivilisation und Leidenschaften,* 235.

23. Hans Kelsen, "Der Begriff des Staates und die Sozialpsychologie. Mit besonderer Berücksichtigung von Freuds Theorie der Masse," *Imago. Zeitschrift für Anwendung der Psychoanalyse auf die Geisteswissenschaften* 8, no. 2 (1922): 97–141.

24. Similarly, but less interestingly, Alfred Adler in 1934 interpreted the idea of a mass psyche (*Massenpsyche*) as referring to communal phenomena such as language, common sense, and shared values and norms, which condition the socialization of the individual. See Adler, "Zur Massenpsychologie," *Internationale Zeitschrift für Individualpsychologie* 12, no. 3 (July–September 1934): 133–41.

25. Freud developed his theory of parricide in *Totem and Taboo,* and returned to it in *Mass Psychology and the Analysis of the 'I,'* arguing that the killing of the primal father also entailed the emergence of the individual, or of individuality as such, out of that more primordial collective being that he calls "the mass" (78; 86).

26. Theodor W. Adorno, "Freudian Theory and the Pattern of Fascist Propaganda," in *Gesammelte Schriften,* ed. Rolf Tiedemann, vol. 8, *Soziologische Schriften I* (Frankfurt am Main: Suhrkamp, 1972), 410. Ernst Simmel adhered to the same kind of analysis, albeit

of a more conservative and orthodox mass-psychological kind. Simmel maintained that anti-Semitism was best explained as an instance of "mass insanity" and that Hitler's style of leadership had been anticipated already by Gustave Le Bon ("Anti-Semitism and Mass-Psychopathology," in *Anti-Semitism: A Social Disease* [New York: International Universities Press, 1946], 33–78).

27. Adorno, "Freudian Theory and the Pattern of Fascist Propaganda," 419.

28. Max Horkheimer, preface to Theodor W. Adorno et al., *The Authoritarian Personality* (1950), new ed. (New York: Norton, 1982), xii. For an account of the empirical work of the Frankfurt School in U.S. exile, see Martin Jay, *The Dialectical Imagination: A History of the Frankfurt School and the Institute of Social Research, 1923–1950* (Boston: Little, Brown, 1973), 219–52.

29. Theodor W. Adorno et al., *Authoritarian Personality*, 475.

30. Wilhelm Reich, *The Mass Psychology of Fascism*, trans. Mary Boyd Higgins, ed. Mary Higgins and Chester M. Raphael, rev. ed. (New York: Farrar, Straus, Giroux, 1970), xiii.

31. Reich, *Mass Psychology of Fascism*, 17.

32. Reich, *Mass Psychology of Fascism*, 3–33.

33. Reich, *Mass Psychology of Fascism*, 36.

34. Reich, *Mass Psychology of Fascism*, 47.

35. Theodor W. Adorno et al., *Authoritarian Personality*, 479.

36. See Erich Fromm, *Escape from Freedom* (1941), rev. ed. (New York: Henry Holt, 1994); Erich Fromm, "Politik und Psychoanalyse" (1931), in *Analytische Sozialpsychologie*, 2 vols., ed. Helmut Dahmer (Frankfurt am Main: Suhrkamp, 1980), 1:150–57; Herbert Marcuse, *Eros and Civilization: A Philosophical Inquiry Into Freud* (Boston: Beacon Press, 1955).

37. Georg Lukács, "Freuds *Massenpsychologie*," *Rote Fahne*, no. 235 (May 21), 2; rpnt., in Georg Lukács, *Organisation und Illusion. Politische Aufsätze III, 1921–1924*, ed. J. Kammler and F. Benseler (Darmstadt-Neuwied: Luchterhand, 1977), 136–38.

38. Paul Federn, *Die vaterlose Gesellschaft. Zur Psychologie der Revolution* (Leipzig: Anzengruber; Vienna: Verlag Brüder Suschitzky, 1919).

39. Jost Hermand and Frank Trommler, *Die Kultur der Weimarer Republik* (Munich: Nymphenburger Verlagshandlung, 1978), 151–61.

40. Peter Sloterdijk, "Weltanschauungsessayistik und Zeitdiagnostik," in *Literatur der Weimarer Republik 1918–1933*, ed. Bernhard Weyergraf (Munich: Carl Hanser Verlag, 1995), 310. See also Gerhard Plumpe, *Alfred Schuler: Chaos und Neubeginn—Zur Funktion des Mythos in der Moderne* (Berlin: Agora Verlag, 1978).

41. Ernst Osterkamp, *Poesie der leeren Mitte: Stefan Georges Neues Reich* (Munich: Carl Hanser Verlag, 2010), 88–89.

42. Sigmund Freud, "My Contact With Josef Popper-Lynkeus," in *The Standard Edition of the Complete Psychological Works*, ed. James Strachey, vol. 22 *(1932–36), New Introductory Lectures on Psycho-Analysis and Other Works* (London: Hogarth, 1964), 221.

43. Elias Canetti, *The Torch in My Ear*, trans. Joachim Neugroschel (New York: Farrar, Straus, Giroux, 1982), 123; *Die Fackel im Ohr: Lebensgeschichte 1921–1931* (Munich: Carl Hanser, 1980, 1993), 142. Also see, chapter 1, section 4.

44. Quoted in Jones, *The Life and Work of Sigmund Freud*, 1:382; see this chapter, section 22.

45. For Canetti's view on the difference between himself and Freud on this point, see his interview for Adorno in *Die gespaltene Zukunft: Aufsätze und Gespräche* (Munich: Carl Hanser, 1972), 66–92.

46. For a discussion, see Stefan Jonsson, *Subject Without Nation: Robert Musil and the History of Modern Identity* (Durham, N.C.: Duke University Press, 2000), 60–96.

47. Judith Ryan, *The Vanishing Subject: Early Psychology and Literary Modernism* (Chicago: University of Chicago Press, 1991).

48. Robert Musil, *The Man Without Qualities*, trans. Sophie Wilkins and Burton Pike (New York: Knopf, 1995), 432. Originally published as *Der Mann ohne Eigenschaften*, ed. Adolf Frisé (Reinbek bei Hamburg: Rowohlt, 1978), 398.

49. Lukács, "Freuds *Massenpsychologie*," 137.

50. Klaus Theweleit, "Canettis Masse-Begriff: Verschwinden der Masse? Masse & Serie," *Ghosts: Drei leicht inkorrekte Vorträge* (Basel: Stroemfeld/Roter Stern, 1998), 241.

51. Helmut Lethen, *Cool Conduct: The Culture of Distance in Weimar Germany*, trans. Don Reneu (Berkeley: University of California Press, 2002). Lethen's "cool persona" is partly inspired by Ernst Jünger's suggestion that a new human type characterized by a "cold consciousness" emerged after World War I, but Lethen identifies related ideas in many other writers, including Walter Benjamin and Bertolt Brecht. In Jünger's view "cold consciousness" was above all indicated by an ability to see oneself as an object. See Ernst Jünger, "Über den Schmerz," in *Blätter und Steine* (Hamburg: Hanseatische Verlagsanstalt, 1934), 163–64.

52. Lethen, *Cool Conduct*, 22–26. See also Bernhard Weyergraf and Helmut Lethen, "Der Einzelne in der Massengesellschaft," in *Literatur der Weimarer Republik 1918–1933*, 636–72, some sections of which partly overlap with sections in *Cool Conduct*.

53. Lethen, *Cool Conduct*, 188.

54. Siegfried Kracauer, "Vom Erleben des Krieges," in *Schriften*, ed. Karsten Witte, vol. 5, part 1, *Aufsätze 1915–1926*, ed. Inka Mülder-Bach (Frankfurt am Main: Suhrkamp Verlag, 1990), 11–22.

55. Lethen, *Cool Conduct*, 193.

56. Lethen, *Cool Conduct*, 192.

57. Anke Gleber, *The Art of Taking a Walk: Flanerie, Literature, and Film in Weimar Culture* (Princeton, N.J.: Princeton University Press, 1999), 43.

58. Walter Benjamin, "The Return of the Flâneur," in *Selected Writings*, vol. 2, *1927–1934*, trans. Rodney Livingstone and others, ed. Michael W. Jennings, Howard Eiland, and Gary Smith (Cambridge, Mass.: Harvard University Press, 1999), 263.

59. Siegfried Kracauer, "Lokomotive über der Friedrichstraße," in *Schriften*, vol. 5, part 3, *Aufsätze 1932–1965*, ed. Inka Mülder-Bach (Frankfurt am Main: Suhrkamp Verlag, 1990), 194.

60. Musil, *Man Without Qualities*, 392; *Mann ohne Eigenschaften*, 361.

61. Gleber, *The Art of Taking a Walk*, 29.

62. Gleber, *The Art of Taking a Walk*, 68.

63. Gleber, *The Art of Taking a Walk*, 41.

64. Gleber, *The Art of Taking a Walk*, 137.

65. Gleber, *The Art of Taking a Walk*, 151–68; quotations are from Christopher Isherwood, *Goodbye to Berlin* (1939), rpnt., ed. Geoffrey Halston (London: Longman, 1980), 1; Louis Aragon, *Le Paysan de Paris*; *Pariser Landleben*, trans. Rudolf Wittkopf (Munich: Rogner and Bernhard, 1969), 56; Dziga Vertov, *Kino-Eye. The Writings of Dziga Vertov*, ed. Annette Michelson (Berkeley: University of California Press, 1984), 17.

66. Siegfried Kracauer, "Stellen-Angebote," in *Schriften*, vol. 5, part 3, *Aufsätze 1932–1965*, ed. Inka Mülder-Bach (Frankfurt am Main: Suhrkamp Verlag, 1990), 23.

67. Siegfried Kracauer, "Die Berührung. Sieben Pariser Szenen," in *Schriften*, vol. 5, part 2, *Aufsätze 1927–1931*, ed. Inka Mülder-Bach (Frankfurt am Main: Suhrkamp Verlag, 1990), 131.

68. Kracauer, "Die Berührung," 136.

69. Susan Sontag, *On Photography* (New York: Dell, 1977), 55. Also see Gleber, *The Art of Taking a Walk*, 131.

70. Kracauer, "Die Berührung," 131. Kracauer would later develop this point in his film theory, arguing that the crowd is a phenomenon virtually constructed by the moving perspective that is inherent in the film medium and able to shift between panoramic survey and close-up (Kracauer, *Theory of Film: The Redemption of Physical Reality* [1960, rev. ed. Princeton: Princeton University Press, 1997], ch. 2–3).

71. Gleber, *The Art of Taking a Walk*, 59.

72. See Siegfried Kracauer, "Das Straßenvolk in Paris," in *Schriften*, vol. 5, part 2, *Aufsätze 1927–1931*, ed. Inka Mülder-Bach (Frankfurt am Main: Suhrkamp Verlag, 1990), 39; and "Heißer Abend," in *Schriften*, vol. 5, part 3, *Aufsätze 1932–1965*, ed. Inka Mülder-Bach (Frankfurt am Main: Suhrkamp Verlag, 1990), 82.

73. Gleber, *The Art of Taking a Walk*, 172.

74. Siegfried Kracauer, *Die Entwicklung der Schmeidekunst in Berlin, Potsdam und einigen Städten der Mark vom 17. Jahrhundert bis zum Beginn des 19 Jahrhunderts* (Worms am Rhein: Wormser Verlags- und Drückereigesellschaft, 1915).

75. For a comprehensive analysis of the concept of the ornament in Kracauer, see Henrik Reeh, *Storbyens Ornamenter: Siegfried Kracauer og den moderne bykultur* (Odense: Odense Universitetsforlag, 1991).

76. Siegfried Kracauer, "Pariser Beobachtungen," in *Schriften*, vol. 5, part 2, *Aufsätze 1927–1931*, ed. Inka Mülder-Bach (Frankfurt am Main: Suhrkamp Verlag, 1990), 30.

77. Kracauer, "Heißer Abend," 82.

78. Kracauer, "Pariser Beobachtungen," 27.

79. Siegfried Kracauer, "Über Arbeitslager," in *Schriften*, vol. 5, part 3, *Aufsätze 1932–1965*, ed. Inka Mülder-Bach (Frankfurt am Main: Suhrkamp Verlag, 1990), 107–17.

80. Siegfried Kracauer, "Gestaltschau oder Politik?" in *Schriften*, vol. 5, part 3, *Aufsätze 1932–1965*, ed. Inka Mülder-Bach (Frankfurt am Main: Suhrkamp Verlag, 1990), 119–21.

81. Among all the critical and scholarly commentaries generated by Kracauer's theory of the masses, see above all Miriam Hansen, "A Self-Presentation of the Masses: Siegfried Kracauer's Curious Americanism," in *Weimar Publics/Weimar Subjects: Rethinking the*

Political Culture of Germany in the 1920s, ed. Kathleen Canning, Kerstin Barndt, and Kristin McGuire (New York: Berghahn Books, 2010), 257–78.

82. Kracauer, "Vom Erleben des Krieges," 11–22.

83. Kracauer, "Über Arbeitslager," 114.

84. Siegfried Kracauer, "The Group as Bearer of Ideas," in *The Mass Ornament: Weimar Essays*, trans. and ed. Thomas Y. Levin (Cambridge, Mass.: Harvard University Press, 1995), 152; originally published as "Die Gruppe als Ideenträger," in *Schriften*, ed. Karsten Witte, vol. 5, part 1, *Aufsätze 1915–1926*, ed. Inka Mülder-Bach (Frankfurt am Main: Suhrkamp Verlag, 1990), 179.

85. Kracauer, "The Group as Bearer of Ideas," 152; "Die Gruppe als Ideenträger," 179.

86. Kracauer, "The Group as Bearer of Ideas," 151, translation modified; "Die Gruppe als Ideenträger," 177.

87. Peter Jelavich, "Modernity, Civic Identity, and Metropolitan Entertainment: Vaudeville, Cabaret, and Revue in Berlin, 1900–1933," in *Berlin: Culture and Metropolis*, ed. Charles Haxthusen and Heidrun Suhr (Minneapolis: University of Minnesota Press, 1990), 106–7.

88. Siegfried Kracauer, "The Mass Ornament," in *The Mass Ornament: Weimar Essays*, trans. and ed. Thomas Y. Levin (Cambridge, Mass.: Harvard University Press, 1995), 78; "Das Ornament der Masse," in *Schriften*, vol. 5, part 2, *Aufsätze 1927–1931*, ed. Inka Mülder-Bach (Frankfurt am Main: Suhrkamp Verlag, 1990), 60.

89. Kracauer, "Mass Ornament," 79; "Ornament der Masse," 60.

90. Siegfried Kracauer, "Girls and Crisis," trans. Don Reneu, in *The Weimar Republic Sourcebook*, ed. Anton Kaes, Martin Jay, and Edward Diemendberg (Berkeley: University of California Press, 1994), 565; originally published as "Girls und Krise," in *Schriften*, vol. 5, part 2, *Aufsätze 1927–1931*, ed. Inka Mülder-Bach (Frankfurt am Main: Suhrkamp Verlag, 1990), 321.

91. Kracauer, "Mass Ornament," 76; "Ornament der Masse," 58.

92. Hansen, "A Self-Presentation of the Masses," 270.

93. Kracauer, "Das Straßenvolk in Paris," 39.

94. Kracauer, "Die Berührung," 136.

95. Kracauer, "Mass Ornament," 86; "Ornament der Masse," 67.

96. Bertolt Brecht, "[Notizen über] Individuum und Masse," in Brecht, *Gesammelte Werke*, vol. 20, *Schriften zur Politik und Gesellschaft* (Frankfurt am Main: Suhrkamp, 1967), 60.

97. Brecht, "[Notizen über] Individuum und Masse," 60.

98. Brecht, "[Notizen über] Individuum und Masse," 62.

99. Bertolt Brecht, "Against Georg Lukács," trans. Stuart Hood, *New Left Review*, series 1, no. 84 (1974): 40.

100. Brecht, "[Notizen über] Individuum und Masse," 60.

101. Bertolt Brecht, *Mann ist Mann*, in Brecht, *Gesammelte Werke*, vol. 1, *Stücke 1* (Frankfurt am Main: Suhrkamp, 1967), 336.

102. Musil, *Man Without Qualities*, 785–86; *Mann ohne Eigenschaften*, 723.

103. Alfred Döblin, *Berlin Alexanderplatz: The Story of Franz Biberkopf*, trans. Eugene

Jolas (New York: Continuum, 1997), 633, translation modified; originally published as *Berlin Alexanderplatz: Die Geschichte von Franz Biberkopf* (Berlin: S. Fischer Verlag, 1930), 528.

104. Alfred Döblin, "May the Individual Not Be Stunted by the Masses," trans. Don Reneu, in *The Weimar Republic Sourcebook*, ed. Anton Kaes, Martin Jay, and Edward Diemendberg (Berkeley: University of California Press, 1994), 386.

105. See Klaus R. Scherpe, "The City as Narrator: The Modern Text in Alfred Döblin's Berlin Alexanderplatz," in *Modernity and the Text: Revisions of German Modernism*, ed. Andreas Huyssen and David Bathrick (New York: Columbia University Press, 1989), 162–79.

106. Alfred Döblin, *Wissen und Verändern! Offene Briefe an einen jungen Menschen* (Berlin: S. Fischers Verlag, 1931), 151.

107. Döblin, *Wissen und Verändern!*, 150.

108. Kracauer, "Die Berührung," 131.

109. Robert Musil, *Diaries, 1899–1942*, trans. Philip Payne, ed. Mark Mirsky (New York: Basic Books, 1999), 390; Musil, *Tagebücher*, ed. Adolf Frisé, 2 vols. (Reinbek bei Hamburg: Rowohlt, 1983), 1:748.

110. That *The Man Without Qualities* is a novel about European power struggles, militant nationalism, revolutionary unrest, imperial ideology, and "die Untergang des Abendlandes" has thus long been of secondary importance to Musil scholars, and usually they do not even mention it. For more elaboration of this view, see Jonsson, *Subject Without Nation*, 274–79. Stefan Howald, "Berührungsfurcht. Die Auseinandersetzung mit der Masse bei Musil und Canetti," in *Musil-Forum* 15 (Saarbrücken: Robert Musil–Gesellschaft, 1989): 173–91, and, more comprehensively, Friedrich Bringazi, *Robert Musil und die Mythen der Nation: Nationalismus als Ausdrück subjektiver Identitätsdefekte* (Frankfurt am Main: Peter Lang, 1998), have analyzed Musil's idea and image of the masses but fail to reach interesting conclusions insofar as they identify only those aspects in Musil's work that conform to the already existing mass theories of, for instance, Le Bon and Freud. In Bringazi's reading (337–414), Musil turns out as a mouthpiece of the doctrine of mass psychology. This appears to be a simplistic view.

111. Musil, *Man Without Qualities*, 762; *Mann ohne Eigenschaften*, 723.

112. Charles Baudelaire, *Intimate Journals*, trans. Christopher Isherwood (London: Blackamore, 1930), 29; originally published as "Journaux intimes. Fusées," in Baudelaire, *Oeuvres completes*, ed. F. F. Gautier and Yves-Gérand Le Dantec, vol. 6 (Paris: Éditions de la Nouvelle Revue Française, 1937), 249.

113. For an excellent account of these aspects of Musil's novel, see Alexander Honold, *Die Stadt und der Krieg: Raum- und Zeitkonstruktion in Robert Musil's Roman "Der Mann ohne Eigenschaften,"* Musil-Studien 25 (Munich: Wilhelm Fink, 1995), 411–85.

114. Musil, *Man Without Qualities*, 3; *Mann ohne Eigenschaften*, 10.

115. See for instance Bernd-Rüdiger Hüppauf, *Von sozialer Utopie zur Mystik: Zu Robert Musils "Der Mann ohne Eigenschaften"* (Munich: Wilhelm Fink, 1971), 90–98; Hartmut Böhme, "Eine Zeit ohne Eigenschaften: Robert Musil und die Posthistoire," in *Natur und Subjekt* (Frankfurt am Main: Suhrkamp, 1988), 308–33; Ulf Schramm,

Fiktion und Reflexion: Überlegungen zu Musil und Beckett (Frankfurt am Main: Suhrkamp, 1967), 13–19; and Honold, *Die Stadt und der Krieg*, 25–94.

116. Musil, *Man Without Qualities*, 6. *Mann ohne Eigenschaften*, 12.

117. Musil, *Man Without Qualities*, 1706. *Mann ohne Eigenschaften*, 1983.

118. Musil, *Man Without Qualities*, 686; *Mann ohne Eigenschaften*, 629.

119. Musil, *Man Without Qualities*, 688–89. *Mann ohne Eigenschaften*, 631–32.

120. Musil develops this theory of the human subject's constitutive malleability and negativity in his essay "The German as Symptom" ("Der deutsche Mensch als Symptom"). See Musil, *Precision and Soul: Essays and Addresses*, ed. and trans. Burton Pike and David S. Luft (Chicago: University of Chicago Press, 1990), 164; Musil, *Gesammelte Werke*, ed. Adolf Frisé, vol. 2, *Prosa und Stücke; Kleine Prosa, Aphorismen; Autobiographisches; Essays und Reden; Kritik* (Reinbek bei Hamburg: Rowohlt, 1978), 1368.

121. Friedrich Bringazi's contention that an understanding of mass psychology is necessary for an understanding of Musil's representations of crowds and their modes of action is thus misguided. Rather than seeing *The Man Without Qualities* as an illustration of mass psychology and mass sociology, we would better attend to the ways in which the mass constitutes a situation that allows Musil's novelistic prose to go beyond existing conceptualizations of individual and mass and contribute toward that new notion of collectivity, which I have been calling a post-individualistic one. See Bringazi, *Robert Musil und die Mythen der Nation*, 337–45.

122. It remains to be explored to what extent this definition of "the social" corresponds to ancient and recent notions of "the multitude" in Spinoza's or Hardt's and Negris's sense. See the latter's *Multitude: War and Democracy in the Age of Empire* (New York: Penguin, 2004).

123. Freud, *Mass Psychology and Analysis of the 'I,'* 42; *Massenpsychologie und Ich-Analyse*, 54.

124. Musil, *Man Without Qualities*, 1117. *Mann ohne Eigenschaften*, 1029.

125. Interpreting Musil's closure of his novel as a path toward mysticism has been a dominant tendency in Musil scholarship. For influential examples, see Hüppauf, *Von sozialer Utopie zur Mystik*; Dietmar Goltschnigg, *Mystische Tradition im Roman Robert Musils: Matin Bubers "Ekstatische Konfessionen" im "Mann ohne Eigenschaften"* (Heidelberg: Lothar Stiehm, 1974); Ernst Kaiser and Eithne Wilkins, *Robert Musil: Eine Einführung in das Werk* (Stuttgart: Kohlhammer, 1962); Elisabeth Albertsen, *Ratio und "Mystik" im Werk Robert Musils* (Munich: Nymphenburger Verlagsbuchandling, 1968); Stephan Reinhardt, *Studien zur Antinomie von Intellekt und Gefühl in Musils Roman "Der Mann ohne Eigenschaften"* (Bonn: Bouvier, 1969); Gerd Müller, *Dichtung und Wissenschaft: Studien zu Robert Musils Romanen "Die Verwirrungen des Zöglings Törless" und "Der Mann ohne Eigenschaften"* (Uppsala: Almqvist and Wiksells, 1971); Renate von Heydebrand, *Die Reflexionen Ulrichs in Robert Musils Roman "Der Mann ohne Eigenschaften": Ihr Zusammenhang mit dem zeitgenössischen Denken* (Munster: Aschendorff, 1966); and, for a more general view, Martina Wagner-Egelhaaf, *Mystik der Moderne: Die Visionäre Ästhetik der deutschen Literatur im 20. Jahrhundert* (Stuttgart: Metzler, 1989).

126. Honold is one of the few Musil commentators, if not the only one, to have stressed that Musil's mysticism, in *The Man Without Qualities* and elsewhere, may be less rooted in theological and religious texts than in his own experience of World War I and the German Revolution; see Honold, *Die Stadt und der Krieg*, 443–44.

127. Robert Musil, "Europäertum, Krieg, Deutschtum," *Die neue Rundschau*, September 1914, rpnt., in Musil, *Gesammelte Werke*, ed. Adolf Frisé, vol. 2, *Prosa und Stücke; Kleine Prosa, Aphorismen; Autobiographisches; Essays und Reden; Kritik*, 1020–22.

128. Musil, "Helpless Europe," in *Precision and Soul: Essays and Addresses*, ed. and trans. Burton Pike and David S. Luft (Chicago: University of Chicago Press, 1990), 164. "Das hilflose Europa," in Musil, *Gesammelte Werke*, ed. Adolf Frisé, vol. 2, *Prosa und Stücke; Kleine Prosa, Aphorismen; Autobiographisches; Essays und Reden; Kritik*, 1092.

129. Musil, *Man Without Qualities*, 1755. *Mann ohne Eigenschaften*, 1902.

130. Musil, *Mann ohne Eigenschaften*, 1932: "Krieg ist das gleiche wie aZ."

131. Musil, *Tagebücher*, 1:826.

132. Musil, *Man Without Qualities*, 160; *Mann ohne Eigenschaften*, 152.

4. COLLECTIVE VISION: A MATRIX FOR NEW ART AND POLITICS

1. On Moholy-Nagy's photographic work during the Bauhaus years, see Eleanor M. Hight, *Picturing Modernism: Moholy-Nagy and Photography in Weimar Germany* (Cambridge, Mass.: MIT Press, 1995).

2. Lázsló Moholy-Nagy, "Photography Is Creation with Light," in Krisztina Passuth, *Moholy-Nagy* (London: Thames and Hudson, 1985), 304. Originally published as "Fotografie ist Lichtgestaltung," *Bauhaus: Zeitschrift für Bau und Gestaltung* 2, no. 1 (1928): 2–9.

3. Arguing that the photoplastic technique is grounded in the intellectual and ocular gymnastics which most city dwellers are compelled to perform daily, Moholy-Nagy explains how it works: "We travel by streetcar and look out of the window; a car is following us, its windows also transparent, through which we see a shop with equally transparent windows: in the shop we see customers and salespeople; a person opens the door, people pass by the shop, a policeman holds up a cyclist. We take in all this within the moment, because the windows are transparent and everything happens within our field of vision. A similar process takes place in photoplastics on another level, not as a summary but as a synthesis. . . . By means of photography we can thus express experiences and speculative interrelationships otherwise unattainable to the same extent" (Moholy-Nagy, "Photography Is Creation with Light," 304).

4. Moholy-Nagy, "Photography Is Creation with Light," 305.

5. Ibid.

6. Quoted in Susanna Barrows, *Distorting Mirrors: Visions of the Crowd in Late-Nineteenth-Century France* (New Haven, Conn.: Yale University Press, 1981), 132, 141.

7. Gustave Le Bon, *The Crowd: A Study of the Popular Mind*, 2nd ed., rpt. (Marietta, Ga.: Cherokee Publishing Company, 1982), 17, 113; originally published in 1895 as *La psychologie des foules*, 2nd ed. (Paris: Presses Universitaires de France, 1963, rpt. 2003). Le

Bon concluded that the masses "are so bent on obedience that they instinctively submit to whoever declares himself to be their master" (*The Crowd*, 117).

8. I am indebted to Heinrich Dilly, who pointed out this parallel to me.

9. Le Bon, *The Crowd*, 6.

10. Hippolyte Taine, *Histoire de la littérature anglaise*, 4 vols. (Paris: Hachette, 1902–1907), 1:viii.

11. In interwar Germany, fascism associated the masses with feminine qualities that needed to be purged or subdued in order to transform the masses into the organized body of the army, the nation, and *das Volk*. See Klaus Theweleit, *Male Fantasies*, vol. 2, *Male Bodies: Psychoanalyzing the White Terror*, trans. Erica Carter and Chris Turner (Minneapolis: University of Minnesota Press, 1989), 3–4.

12. Werner Sombart, *Der proletarische Sozialismus ("Marxismus")*, vol. 2, *Die Bewegung* (Jena: Verlag von Gustav Fischer, 1924), 170.

13. See Kathleen Canning, "Claiming Citizenship: Suffrage and Subjectivity in Germany After the First World War," in *Weimar Publics/Weimar Subjects: Rethinking the Political Culture of Germany in the 1920s*, ed. Kathleen Canning, Kerstin Barndt, and Kristin McGuire (New York: Berghahn Books, 2010), 116–37; and Katharina von Ankum, ed. *Women in the Metropolis: Gender and Modernity in Weimar Culture*, (Berkeley: University of California Press, 1997).

14. Bertolt Brecht, *Die heilige Johanna der Schlachthöfe*, in Brecht, *Gesammelte Werke*, vol. 2, *Stücke 2* (Frankfurt am Main, 1967), 733–34.

15. Anton Kaes suggests, but without providing any substantiation, that Fritz Lang may have modeled her on communist leader Rosa Luxemburg, which makes sense given the anticommunist and antirevolutionary tendency of *Metropolis* (Kaes, *Shell Shock Cinema: Weimar Culture and the Wounds of War* [Princeton, N.J.: Princeton University Press, 2009], 196).

16. Quoted by Hans-Thies Lehmann, *Das Politische Schreiben: Essays zu Theatertexten* (Berlin: Theater der Zeit, Recherchen 12, 2002), 8.

17. Canning, "Claiming Citizenship," 116–37.

18. For interpretative hints and historical contexts pertaining to Brandt's photomontages, see Elizabeth Otto, "The Secret History of Photomontage: On the Origins of the Composite Form and the Weimar Photomontages of Marianne Brandt," in *Weimar Publics/Weimar Subjects: Rethinking the Political Culture of Germany in the 1920s*, ed. Kathleen Canning, Kerstin Barndt, and Kristin McGuire (New York: Berghahn Books, 2010), 66–92; and *Tempo, tempo! Bauhaus-Photomontagen von Marianne Brandt / Tempo, Tempo! The Bauhaus photomontages of Marianne Brandt*, bilingual ed., Bauhaus-Archiv, Berlin (Berlin: Jovis, 2005).

19. Lázsló Moholy-Nagy, "Constructivism and the Proletariat," in *Moholy-Nagy*, ed. Richard Kostelanetz, Documentary Monographs in Modern Art (London: Penguin, 1971), 185. Originally published in *MA* (Budapest), May 1922.

20. Walter Benjamin, "Paris, Capital of the Nineteenth Century, Exposé of 1939," in *The Arcades Project*, trans. Howard Eiland and Kevin McLaughlin (Cambridge, Mass.: Harvard University Press, 1999), 20.

21. Benjamin, *Arcades Project* [M3a, 4], 423. The signum within square brackets refers

to Benjamin's classification system for his entries. Further references to the *Arcades Project* include Benjamin's classification and page reference to the English translation.

22. Walter Benjamin, "News About Flowers," in *Selected Writings*, ed. Michael W. Jennings, vol. 2, *1927–1934*, trans. Rodney Livingstone et al., ed. Michael W. Jennings, Howard Eiland, and Gary Smith (Cambridge, Mass.: Harvard University Press, 1999), 155–56.

23. Benjamin, "News About Flowers," 156–57.

24. Alfred Döblin, "Faces, Images, and Their Truth," introduction to August Sander, *Face of Our Time*, trans. Michael Robertson (Munich: Schirmer's Visual Library, 1994), 11; originally published as "Von Gesichtern, Bildern und Ihrer Wahrheit," in August Sander, *Antlitz der Zeit: Sechsig Aufnahmen deutscher Menschen der 20. Jahrhunderts* (Munich: Kurt Wolff/Transmare Verlag, 1929).

25. Walter Benjamin, "Work of Art in the Age of Its Technological Reproducibility: Third Version," *Selected Writings*, vol. 4, *1938–1940*, trans. Edmund Jephcott et al., ed. Howard Eiland and Michael W. Jennings (Cambridge, Mass.: Harvard University Press, 2003), 268.

26. Walter Benjamin, "On Some Motifs in Baudelaire," in *Selected Writings*, vol. 4, *1938–1940*, trans. Edmund Jephcott et al., ed. Howard Eiland and Michael W. Jennings (Cambridge, Mass.: Harvard University Press, 2003), 321, 323.

27. Theodor W. Adorno to Walter Benjamin, 1 February 1939, in Benjamin, *Selected Writings*, vol. 4, *1938–1940*, trans. Edmund Jephcott et al., ed. Howard Eiland and Michael W. Jennings (Cambridge, Mass.: Harvard University Press, 2003), 204.

28. See Susan Buck-Morss, *The Dialectics of Seeing: Walter Benjamin and the Arcades Project* (Cambridge, Mass.: MIT Press, 1989), esp. 205–15.

29. Miriam Bratu Hansen, *Cinema and Experience: Siegfried Kracauer, Walter Benjamin, and Theodor W. Adorno* (Berkeley: University of California Press, 2011), 97.

30. See Michael Opitz and Erdmut Wizisla, eds., *Benjamins Begriffe*, 2 vols., (Frankfurt am Main: Suhrkamp, 2000); and Burkhardt Lindner, ed., *Benjamin-Handbuch: Leben—Werk—Wirkung* (Stuttgart and Weimar: J. B. Metzler, 2006). Indeed, the virtual industry of Benjamin scholarship has paid little attention to his theory of the mass, and no one has related it to other treatments of the same topic in Weimar culture. Given the importance of the notion of the masses in Benjamin's period and the fact that his essays on Baudelaire elaborate a history of the masses, supported by a rich archive of empirical detail and textual interpretations, the scarcity of commentary on this aspect of Benjamin's work is surprising. In addition to Miriam Hansen's recent work, the most important contribution is Susan Buck-Morss's contextual reading of Benjamin's essay "The Work of Art in the Age of Reproducibility": "Aesthetics and Anaesthetics: Walter Benjamin's Artwork Essay Reconsidered," *October* 62 (Autumn 1992): 3–41.

31. Hansen, *Cinema and Experience*, 63.

32. An additional difficulty, of course, is that the various translations into English and French of these terms are inconsistent.

33. Walter Benjamin, "Central Park," in *Selected Writings*, vol. 4, *1938–1940*, trans. Edmund Jephcott et al., ed. Howard Eiland and Michael W. Jennings (Cambridge, Mass.: Harvard University Press, 2003), 187; "Zentralpark," in *Gesammelte Schriften*, vol.

1, *Abhandlungen*, ed. Hermann Schweppenhäuser and Rolf Tiedemann, 2 parts (Frankfurt am Main: Suhrkamp, 1991), part 2:686.

34. Benjamin, "On Some Motifs in Baudelaire," 321.

35. Benjamin, *Arcades Project* [M3a, 4], 43.

36. Benjamin, *Arcades Project* [U18, 5], 602.

37. Benjamin, *Arcades Project* [M21a, 2], 455.

38. Benjamin, *Arcades Project* [J81a, 1], 370–71; translation modified.

39. Benjamin, "Central Park," 171.

40. Benjamin, *Arcades Project* [m4, 1], 804.

41. Benjamin, *Arcades Project* [[H°, 1], 844.

42. Benjamin, *Arcades Project* [L1, 3], 405.

43. Benjamin, *Arcades Project* [M16, 3], 446.

44. Benjamin, *Arcades Project* [J81a, 1], 370.

45. Benjamin, "On Some Motifs in Baudelaire," 322.

46. Benjamin, "On Some Motifs in Baudelaire," 323.

47. Benjamin, "On Some Motifs in Baudelaire," 323.

48. Benjamin, "Paris, Capital of the Nineteenth Century. Exposé of 1939," 54.

49. Benjamin, *Arcades Project* [M16, 3], 446.

50. Benjamin, *Arcades Project* [J59, 2], 334.

51. Walter Benjamin, "The Paris of the Second Empire in Baudelaire," in *Selected Writings*, vol. 4, *1938–1940*, trans. Edmund Jephcott et al., ed. Howard Eiland and Michael W. Jennings (Cambridge, Mass.: Harvard University Press, 2003), 31.

52. Benjamin quotes Baudelaire's definition of the poet: "The poet enjoys the incomparable privilege of being himself and someone else, as he sees fit. Like those roving souls in search of a body, he enters another person whenever he wishes. For him alone, all is open; and if certain places seem closed to him, it is because in his view they are not worth visiting." Having cited these words apparently describing the sovereign poet as a figure of pure individuality, Benjamin explains: "The commodity itself is the speaker here" ("The Paris of the Second Empire in Baudelaire," 32).

53. Benjamin, *Arcades Project* [J81a, 1], 370–71; translation modified.

54. Walter Benjamin, "Work of Art in the Age of Reproducibility: Second Version," in *Selected Writings*, vol. 3, *1935–1938*, trans. Edmund Jephcott, Howard Eiland et al., ed. Howard Eiland and Michael W. Jennings (Cambridge, Mass.: Harvard University Press, 2002), 129.

55. Ibid.

56. Benjamin, "Work of Art in the Age of Reproducibility: Second Version," 129–30.

57. Benjamin, *Arcades Project* [O, 68], 863. Susan Buck-Morss analyzes this program in great detail in *Dialectics of Seeing*, 285–330.

58. Walter Benjamin, "On the Concept of History," in *Selected Writings*, vol. 4, *1938–1940*, trans. Edmund Jephcott et al., ed. Howard Eiland and Michael W. Jennings (Cambridge, Mass.: Harvard University Press, 2003), 395.

59. Theodor W. Adorno and Gretel Karplus to Walter Benjamin, 2–4 August 1935, in Theodor Adorno and Walter Benjamin, *The Complete Correspondence, 1928–1940*,

ed. Henri Lonitz, trans. Nicholas Walker (Cambridge, Mass.: Harvard University Press, 1999), 111. For a discussion of the Adorno's dispute with Benjamin on this point, see Richard Wolin, *Walter Benjamin: An Aesthetic of Redemption* (New York: Columbia University, 1982), 180–81.

60. Walter Benjamin to Theodor W. Adorno, 9 December 1938, Adorno and Benjamin, *Complete Correspondence*, 291.

61. Walter Benjamin, "Gespräche mit Brecht," in *Versuche über Brecht*, ed. Rolf Tiedemann (Frankfurt am Main: Suhrkamp, 1981), 150.

62. In contrast to Hansen's assessment in *Cinema and Experience*, I would argue that it is rather the proletariat that is an elusive and abstract category in Benjamin's work, a category with a barely *stipulated* agency, whereas "the masses" is a fully concrete notion worked through in all its aspects and appearances.

63. Jacques Rancière, "The Archaeomodern Turn," in *Walter Benjamin and the Demands of History*, ed. Michael P. Steinberg (Ithaca, N.Y.: Cornell University Press, 1996), 33.

64. Benjamin, *Arcades Project* [J66a, 5], 347.

65. Karl Marx, *Capital*, 1:6.

66. Benjamin, *Arcades Project* [J75, 2], 361.

67. Benjamin's major analysis of the experience and worldview of the artisan is "The Storyteller: Observations on the Works of Nikolai Leskov," in *Selected Writings*, vol. 3, *1935–1938*, trans. Edmund Jephcott, Howard Eiland et al., ed. Howard Eiland and Michael W. Jennings (Cambridge, Mass.: Harvard University Press, 2002), 143–66. On children's culture, see Benjamin's articles "Old Toys," "The Cultural History of Toys," "Toys and Play," "Program for a Proletarian Children's Theater," "Children's Literature," in *Selected Writings*, ed. Michael W. Jennings, vol. 2, *1927–1934*, trans. Rodney Livingstone et al., ed. Michael W. Jennings, Howard Eiland, and Gary Smith (Cambridge, Mass.: Harvard University Press, 1999), 98–102, 113–21, 201–6, 250–56; and, of course, his memoirs "Berlin Childhood Around 1900," in *Selected Writings*, vol. 3, *1935–1938*, trans. Edmund Jephcott, Howard Eiland et al., ed. Howard Eiland and Michael W. Jennings (Cambridge, Mass.: Harvard University Press, 2002), 344–413.

68. Benjamin, "Work of Art in the Age of Reproducibility: Third Version," 262.

69. Ibid.

70. See, for instance, Burkhardt Lindner's essay "Das Kunstwerk im Zeitalter seiner technischen Reproduzierbarkeit," in *Benjamin-Handbuch: Leben—Werk—Wirkung*, ed. Burkhardt Lindner (Stuttgart and Weimar: J. B. Metzler, 2006), 229–51, esp. 232; Detlev Schöttker, "Kommentar," in Walter Benjamin, *Das Kunstwerk im Zeitalter seiner technischen Reproduzierbarkeit und weitere Dokumente* (Frankfurt am Main: Suhrkamp, 2007), 99–156. This is also the gist of Miriam Hansen's reading (*Cinema and Experience*, 75–103). However, most comments on Benjamin's tendency to attribute messianic qualities to the proletariat perceive his idea only as an expression of an exaggerated optimism as regards the new aesthetic of cinema and mass reproducibility. And they fail to see its rootedness in Benjamin's notion of the masses as the commodified petty-bourgeois class in need of an "awakening" in order to prevent it from succumbing to fascism. Put

simply, they fail to see the connection between the analysis of collectivity in the artwork essay and that in the *Arcades Project*.

71. Benjamin, "Work of Art in the Age of Reproducibility: Third Version," 267; "Das Kunstwerk im Zeitalter seiner technischen Reproduzierbarkeit," in Benjamin, *Gesammelte Schriften*, vol. 2, *Aufsätze, Essays, Vorträge*, ed. Hermann Schweppenhäuser and Rolf Tiedemann, 3 parts (Frankfurt am Main: Suhrkamp, 1977), part 2:464: "Die Masse ist eine Matrix, aus der gegenwärtig alles gewohnte Verhalten Kunstwerken gegenüber neu geboren hervorgeht."

72. Benjamin, "Work of Art in the Age of Reproducibility: Third Version," 268.

73. The clearest statement on this is Benjamin's 1934 address "The Author as Producer," in which he appropriates Brecht's term. Translated into more programmatic language, Benjamin's suggestion implied that cultural producers possessing the required skills in writing, photography, cinema, theater, and music would need to join the masses so as to enable them to represent themselves. Furthermore, a transformation of narrative and visual forms was needed to offer the masses an adequate representational space. All this presupposed an abolishment of capitalist ownership of cultural technology so as to enable the masses' control of their means of aesthetic self-representation. Newspapers, film studios, record companies, and radio stations would have to be socialized (Benjamin, "The Author as Producer," in *Selected Writings*, ed. Michael W. Jennings, vol. 2, *1927–1934*, trans. Rodney Livingstone et al., ed. Michael W. Jennings, Howard Eiland, and Gary Smith [Cambridge, Mass.: Harvard University Press, 1999], 768–82). For a less utopian interpretation of Benjamin's argument and its resonances in modern and contemporary cultural production, see Jonathan Beller, *The Cinematic Mode of Production: Attention, Economy, and the Society of the Spectacle* (Lebanon, NH: University Press of New England, 2006).

74. Benjamin, "Work of Art in the Age of Reproducibility: Second Version," 129.

75. Jean Baudrillard, *À l'ombre des majorités silencieuses ou la fin du social* (Paris: Denoël/Gonthier, 1982); Siegfried Kracauer, "Die Wartenden," in Kracauer, *Schriften*, ed. Karsten Witte, vol. 5, part 1, *Aufsätze 1915–1926*, ed. Inka Mülder-Bach (Frankfurt am Main: Suhrkamp Verlag, 1990), 160–69.

76. Ernst Jünger, "Einleitung," in *Die Veränderte Welt: Eine Bilderfibel unserer Zeit*, ed. Edmund Schultz (Breslau: Wilhelm Gottl. Korn Verlag, 1933), 9.

77. Edmund Schultz, ed., *Die Veränderte Welt: Eine Bilderfibel unserer Zeit* (Breslau: Wilhelm Gottl. Korn Verlag, 1933), 33.

78. Jünger, "Einleitung," 9.

79. Schultz, ed., *Die Veränderte Welt*, 36.

80. See Ernst Jünger, "Über die Gefahr," in *Der gefährliche Augenblick: Eine Sammlung von Bildern und Berichten*, ed. Ferdinand Bucholtz (Berlin: Junker und Dünnhaupt Verlag, 1931), 11–16. For an analysis of Ernst Jünger's ideas on photography's ability to erase individuality and decipher the new face of the mass, see Brigitte Werneburg, "Ernst Jünger and the Transformed World," trans. Christopher Phillips, *October* 62 (Autumn 1992): 42–64. Werneburg's article also includes a useful overview of similar books of photographs published in the Weimar Republic, none of them, however, as influential as Jünger and Bucholtz, *Der gefährliche Augenblick*.

81. Schultz, ed., *Die Veränderte Welt*, 31–41.

82. Jeffrey T. Schnapp, "The Mass Panorama," *Modernism/Modernity* 9, no. 2 (April 2002): 272. Also see Schnapp "Mob Porn," in *Crowds*, ed. Jeffrey T. Schnapp and Matthew Tiews (Stanford, Calif.: Stanford University Press, 2006), 1–44; and Schnapp, *Staging Fascism: 18 BL and the Theater of Masses for Masses* (Stanford, Calif.: Stanford University Press, 2006).

83. Friedrich Georg Jünger, "Einleitung," in *Das Gesicht der Demokratie: Ein Bildwerk zur Geschichte der deutschen Nachkriegszeit*, ed. Edmund Schultz (Leipzig: Verlag von Breitkopf und Härtel, 1931), 13.

84. Edmund Schultz, ed., *Das Gesicht der Demokratie: Ein Bildwerk zur Geschichte der deutschen Nachkriegszeit* (Leipzig: Verlag von Breitkopf und Härtel, 1931), 151–52; also see 21–24, 121–32.

85. *Arbeiter-Illustrierte Zeitung*, 25 March 1926. Translated by David Evans and Sylvia Gohl in *Photography/Politics: One* (London: Photography Workshop, 1979).

86. *Arbeiter-Illustrierte Zeitung*, 25 March 1926.

87. W[illi] M[ünzenberg], "Die Internationale der Arbeiter-Fotografen," *Der Arbeiter-Fotograf* 1, no. 5 (January 1927): 3–4.

88. In an article written just five years after the founding of the German worker-photographer movement, Münzenberg sums up its unexpected success and sets new tasks and aims for the future, including an international conference, exhibitions, and increased collaboration with sister organizations throughout Europe (Willi Münzenberg, "Aufgaben und Ziele der internationalen Arbeiter-Fotografen-Bewegung," *Der Arbeiter-Fotograf* 5, no. 5 [1931]: 99). For a history of *Der Arbeiter-Fotograf*, see Joachim Büthe et al., *Der Arbeiter-Fotograf: Dokumente und Beiträge zur Arbeiterfotografie 1926–1932* (Cologne: Prometh Verlag, 1977), 15–19, 34–45. In addition to scholarly and critical articles, this publication also includes a rich selection of facsimile pages from *Der Arbeiter-Fotograf*.

89. Walter Nettelbeck, "Was hältst Du von der Kleinbildkamera?" *Der Arbeiter-Fotograf* 5, no. 5 (1931): 101–2; reproduced in Büthe et al., *Der Arbeiter-Fotograf: Dokumente und Beiträge*, 67.

90. "Wohnungsnot und Arbeiterfotograf," *Der Arbeiter-Fotograf* 1, no. 6 (February 1927): 14–15.

91. Walter Nettelbeck, "Polizei dieser Polizei," *Der Arbeiter-Fotograf* 3, no. 8 (August 1928): 147.

92. In original, "Nur wer rasch berichtet, berichtet gut!"; the slogan is from "Arbeiterfotograf und aktuelle Bildberichterstattung," which urges worker photograpers to bring in pictures that are topical and newsworthy, *Der Arbeiter-Fotograf* 1, no. 3 (November 1926).

93. See Durus [pseudonym], "Fotomontage, Fotogramm," *Der Arbeiter-Fotograf* 5, no. 7 (July 1931): 166–68, and "Fotomontage als Waffe im Klassenkampf," *Der Arbeiter-Fotograf* 6, no. 3 (1932): 55–57.

94. "Was interessiert den Arbeiter-Fotografen bei Demonstrationen?" *Der Arbeiter-Fotograf* 1, no. 7 (March 1927): 14–15.

95. "Bilderkritik: Soll der Arbeiter-Fotograf Massenaufnahmen machen?" *Der Arbeiter-Fotograf* 3, no. 9 (September 1929): 184–85.

96. Karl Tölle, "Können Arbeiter Filmen?" *Der Arbeiter-Fotograf* 5, no. 6 (June 1931): 133–34.

97. "An unsere Leser," *Der Arbeiter-Fotograf* 4, no. 1 (January 1930): 18.

98. Arthur Blumenthal, "Mehr Kollektivarbeit!" *Der Arbeiter-Fotograf* 4, no. 10 (October 1930): 229.

99. "Zur allgemeinen Kritik," *Der Arbeiter-Fotograf* 2, no. 4 (December 1927): 10.

100. On the question of collectivity in *Der Arbeiter-Fotograf*, see Olivier Lugon, "Das kollektive Auge: Die Inszenierung des Kollektivs in der Zeitschrift 'Der Arbeiter-Fotograf,'" in *Die Eroberung der beobachtenden Maschinen: Zur Arbeiterfotografie der Weimarer Republik*, ed. Wolfgang Hesse (Leipzig: Leipziger Universitätsverlag, 2012), 257–84.

101. Franz Höllering, "Die Eroberung der beobachtenden Maschinen," *Der Arbeiter-Fotograf* 3, no. 10 (June 1928): 3–4.

102. Edwin Hoernle, "Das Auge des Arbeiters," *Der Arbeiter-Fotograf* 4, no. 7 (July 1930): 152.

103. Hoernle, "Das Auge des Arbeiters," 154.

104. For a discussion of the legacy of *Der Arbeiter-Fotograf* and other worker-photographers' organizations in the interwar period, see the essays in *Photography/Politics: One*; as well as the recent, more comprehensive, but less innovative, *Die Eroberung der beobachtenden Maschinen: Zur Arbeiterfotografie der Weimarer Republik*, ed. Wolfgang Hesse.

105. See "Betriebsspionage?" *Der Arbeiter-Fotograf* 2, no. 5 (January 1928): 5–6; and W[illi] M[ünzenberg], "Die Internationale der Arbeiter-Fotografen," 3–4.

106. One instance is reported from the May 1 demonstrations in Berlin 1929: "Polizei gegen die Gesetze," *Der Arbeiter-Fotograf* 3, no. 6 (June 1929): 108. Reports of police harassments of photographers were repeatedly printed under the headline "Gummiknüppel kontra Kamera" (Batons against camera).

107. According to Jost Hermand and Frank Trommeler, theater was the art form of Weimar culture that was most thoroughly politicized and influenced by the German Revolution of 1918. An important cause of the transformation was that theater in the Weimar Republic became a public concern and responsibility as the state, region, or municipality stepped in to support and help develop German theater, which previously had been an art form that was either encouraged and supported by the court, the imperial administration, or other donors, or else part of popular culture, with numberless private theater companies performing around the country (Jost Hermand and Frank Trommler, *Die Kultur der Weimarer Republik* [Munich: Nymphenburger Verlagshandlung, 1978], 193–201). Cf. Erwin Piscator, *Das politische Theater* (Berlin: Adalbert Schultz Verlag, 1929), 45; translated as *The Political Theater: A History, 1914–1929*, trans. Hugh Rorrison (New York: Avon Books, 1978).

108. Béla Balázs, "Theater auf der Straße," in *Deutsches Arbeitertheater 1918–1933*, 2 vols., ed. Ludwig Hoffmann and Daniel Hoffmann-Ostwald (Berlin: Henschelverlag Kunst und Gesellschaft, 1977), 2:455.

109. Balázs, "Theater auf der Straße," 2:455.

110. See Arthur Pieck, "Polizeiknüppel über Deutschland," in *Deutsches Arbeitertheater 1918–1933*, 2 vols., ed. Ludwig Hoffmann and Daniel Hoffmann-Ostwald (Berlin: Henschelverlag Kunst und Gesellschaft, 1977), 2:271–76; and Ludwig Hoffmann, "Einleitung," in *Deutsches Arbeitertheater 1918–1933*, 2 vols., ed. Ludwig Hoffmann and Daniel Hoffmann-Ostwald (Berlin: Henschelverlag Kunst und Gesellschaft, 1977), 1:38–46.

111. Lars Kleberg, *Theater as Action: Soviet Russian Avant-garde Aesthetics* (New York: NYU Press, 1993).

112. Balázs, "Theater auf der Straße," 453–54.

113. Slatan Dudow et al., *Kuhle Wampe oder Wem gehört die Welt?* DVD (Frankfurt am Main: Filmedition Suhrkamp, 2008); Bertolt Brecht, *Kuhle Wampe: Protokoll des Films und Materialen*, ed. Wolfgang Gersch and Werner Hecht (Frankfurt am Main: Suhrkamp, 1969), 60.

114. Piscator, *Das politische Theater*, 36.

115. Erwin Piscator, "Über Grundlagen und Aufgaben des proletarischen Theaters," in *Deutsches Arbeitertheater 1918–1933*, 2 vols., ed. Ludwig Hoffmann and Daniel Hoffmann-Ostwald (Berlin: Henschelverlag Kunst und Gesellschaft, 1977), 1:69.

116. Erwin Piscator, "Bühne der Gegenwart und Zukunft," in Piscator, *Theater der Auseinandersetzung: Ausgewählte Schriften und Reden* (Frankfurt am Main: Suhrkamp, 1977), 20.

117. Erwin Piscator, "Grundzätzliches," in program brochure, *Gastspiel der Piscatorbühne, Carl Credé, § 218: Gequälte Menschen*, 7, Berlin Akademie der Künste, Piscator-Center, signum 69.

118. Erwin Piscator, "'Technik': Anklage und Freispruch," in Piscator, *Theater der Auseinandersetzung: Ausgewählte Schriften und Reden* (Frankfurt am Main: Suhrkamp, 1977), 76.

119. Peter Bürger, *Theory of the Avant-garde*, trans. Michael Shaw (Minneapolis: University of Minnesota Press, 1984). Cf. Andreas Huyssen, *After the Great Divide: Modernism, Mass Culture, Postmodernism* (Bloomington: Indiana University Press, 1986), 1–15.

120. Béla Balázs, "Das Theater des Volkes," *Die neue Schaubühne* 1, no. 7 (1919): 201.

121. Erwin Piscator in *Rote Fahne*, 1 January 1928; quoted in Innes, *Erwin Piscator's Political Theatre: The Development of Modern Drama* (Cambridge: Cambridge University Press, 1972), 30.

122. Piscator, *Das politische Theater*, 61. See also Innes, *Erwin Piscator's Political Theatre*, 43–47.

123. Bernhard Diebold, review, *Frankfurter Zeitung*, 11 September 1929; quoted in Innes, *Erwin Piscator's Political Theater*, 72–73.

124. "Piscator darf zum Bürgerkrieg hetzen," anonymous review in *Der Tag*, 8 September 1929; and Ludwig Sternaux, "'Dreck! Weg damit!' Was Piscator dem deutschen Theaterpublikum bieten kann," details of publication unknown, Akademie der Künste, Piscator-Sammlung, signum 355.

125. Eric Mühsam, "Richtlinien für das dramaturgische Kollektiv der Piscator-Bühne," in Piscator, *Das politische Theater* (Berlin: Adalbert Schultz Verlag, 1929), 142.

126. The play premiered in Grosses Schauspielhaus, one of Berlin's largest theaters, on 12 July 1925, the opening day of the congress of the Communist Party (KPD).

127. Piscator, *Das politische Theater*, 69–70.

128. *Blätter der Piscatorbühne-Kollektiv*, no. 8, Frauen in Not: Weg mit dem § 218 (April 1930): 8.

129. Erwin Piscator, "Technik—eine künstlerische Notwendigkeit des modernen Theaters," in *Theater der Auseinandersetzung: Ausgewählte Schriften und Reden* (Frankfurt am Main: Suhrkamp, 1977), 112–13.

130. Piscator, *Das politische Theater*, 122–23.

131. Piscator's conception of the Total Theater (*Das Totaltheater*) should be distinguished from what in the Soviet Union of the same period was called "total theater," which referred mainly to outdoor socialist mass festivities and dramas in which thousands of people would be directed to reenact major events of the Russian revolution. For this, see Malte Rolf, *Das sowjetische Massenfest* (Hamburg: Hamburger Edition, 2006). It should also be distinguished from Lázsló Moholy-Nagy's ideas for what he called the Theater of Totality (*"Theater der Totalität"*), which was a technical synthesis in which machines, geometric figures, spirals, spheres, and other three-dimensional objects would be animated by machines and made to perform on stage. On the difference between these conceptions, see Stefan Woll, *Das Totaltheater: Ein Projekt von Walter Gropius und Erwin Piscator* (Berlin: Gesellschaft für Theatergeschichte, 1984), 120–22.

132. Woll, *Das Totaltheater*, 109.

133. Erwin Piscator, "Totaltheater und totales Theater," in *Theater der Auseinandersetzung*, 136.

134. Woll, *Das Totaltheater*, 136.

135. See Ingemar Karlsson and Arne Ruth, *Samhället som teater: estetik och politik i Tredje riket* (Stockholm: Liber förlag, 1984). For a comparable analysis of theater in fascist Italy, see Schnapp, *Staging Fascism*.

136. Paul Tillich, *Masse und Geist: Studien zur Philosophie der Masse* (Berlin and Frankfurt am Main: Verlag der Arbeitsgemeinschaft, 1922), 25–55.

137. Akademie der Künste, Berlin, Piscator-Sammlung, signum 511.

5. CODA: REMNANTS OF WEIMAR

1. Rüdiger Graf, *Die Zukunft der Weimarer Republik: Krisen und Zukunftsaneignungen in Deutschland, 1918–1933* (Munich: R. Oldenbourg Verlag, 2008), 13; Peter Fritzsche, "Did Weimar Fail?" *Journal of Modern History* 68, no. 3 (September 1996): 630.

2. Heinrich August Winkler, *Von der Revolution zur Stabilisierung: Arbeiter und Arbeiterbewegung in der Weimarer Republik 1918 bis 1924* (Berlin: Verlag J. H. W. Dietz, 1985), 15.

3. Siegfried Kracauer, "Rund um den Reichstag," in Kracauer, *Schriften*, ed. Karsten Witte, vol. 5, part 3, *Aufsätze 1932–1965*, ed. Inka Mülder-Bach (Frankfurt am Main: Suhrkamp Verlag, 1990), 216.

INDEX